Pilchuck

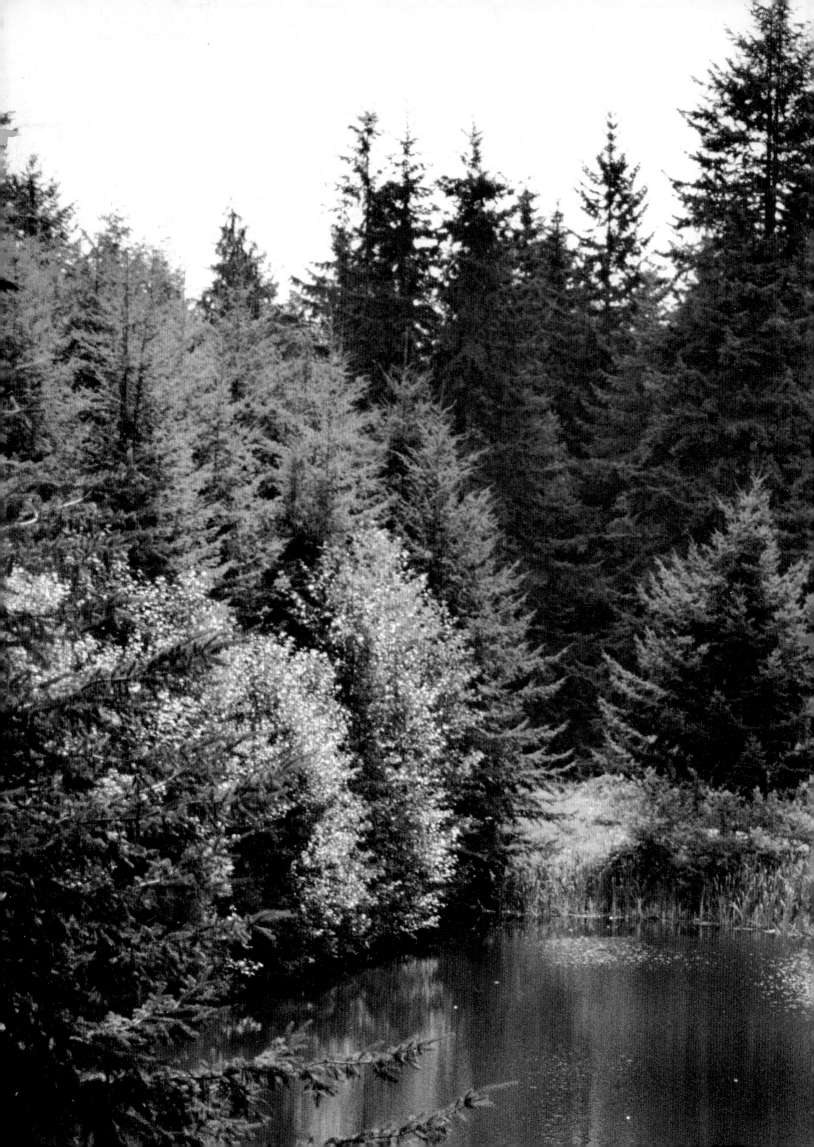

Pilchuck:
A Glass School

Tina Oldknow

with a foreword by Maya Lin and
an interview with Dale Chihuly by Patterson Sims

Pilchuck Glass School
in association with the University of Washington Press, Seattle

Edited by Suzanne Kotz

Designed by Katy Homans and Phil Kovacevich

Cover photography by Russell Johnson

Printed and bound in Italy

Library of Congress Cataloging-in-Publication Data
Oldknow, Tina.
 Pilchuck : a glass school / by Tina Oldknow.
 p. cm.
 Includes bibliographical references and index.
 ISBN 0-295-97559-8
 1. Pilchuck Glass School. 2. Glassware—Washington (State)—Stanwood—
History—20th century. 3. Glass art—Washington (State)—Stanwood—
History—20th century. I. Title.
NK5512.O43 1996
748'.09797'71—dc20 96-16615

For information about the Pilchuck Glass School and its programs, write to Pilchuck Glass School, 315 Second Avenue South, Suite 200, Seattle, Washington, 98104, or visit the school's Web site at http://www.pilchuck.com.

Contents

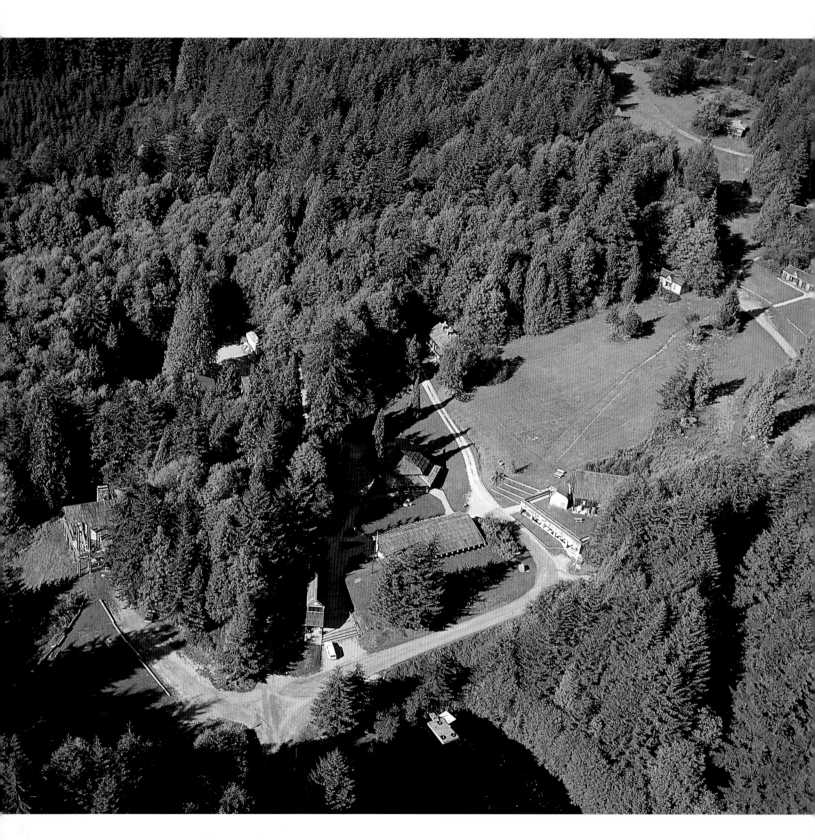

Pilchuck Glass School,
1995.

Foreword

I grew up surrounded by the studio arts. My father, a well-known ceramist and dean of the art school at Ohio University, introduced me to the visual arts at an early age. I watched my father as he learned to blow glass and I was fascinated, but I was young and not allowed to try. Two decades later, my desire to work in glass was finally realized when I became an artist-in-residence at Pilchuck Glass School.

At Pilchuck I discovered how absolutely different glassblowing is from anything else I have encountered. From the intense exposure to fierce heat to the incredibly delicate way in which you must balance the molten glass, the process is an exercise in contrasts and extremes. Those dynamics are what make glass so exciting to be around. The opportunity to work at Pilchuck allowed me to push myself in new directions. And as this book will show you, Pilchuck itself has grown the way any artist evolves: you begin small, with a passion and some good technical skill, then you see where you can go. You get comfortable with what you can do, and then you start to push yourself. You seek out new teachers—the best in your field. You experiment with new materials, new processes, new ways of thinking. You start collaborating with others from wildly diverse backgrounds to add new dimension to your art and to expand your horizons. You keep on pushing, refining your technique, getting better and better at your art.

Knowing Pilchuck's international scope and reputation, I arrived expecting a high-powered art school environment. I was amazed to find the school's fundamental, down-to-earth funkiness; its very low-key, unegotistical approach to creativity; and its strong sense of solitude and privacy. I was able to reconnect with an aesthetic I had known as a child and found a wonderful welcome-home, a place where artist and artisan work and grow together, where ideas are thrown into a melting pot and reshaped into new forms. At Pilchuck the whole world opens up to the artist. The possibilities are endless.

There is an energy at Pilchuck that is just charged and which can never disappear because it is in the nature of glass itself. In the pages that follow, you will see how that energy has grown from one small bright ember to a blaze of creativity—one that has helped countless artists from around the globe to spark their ideas and to ignite their creative processes. I am delighted and grateful to be counted among them.

Maya Lin

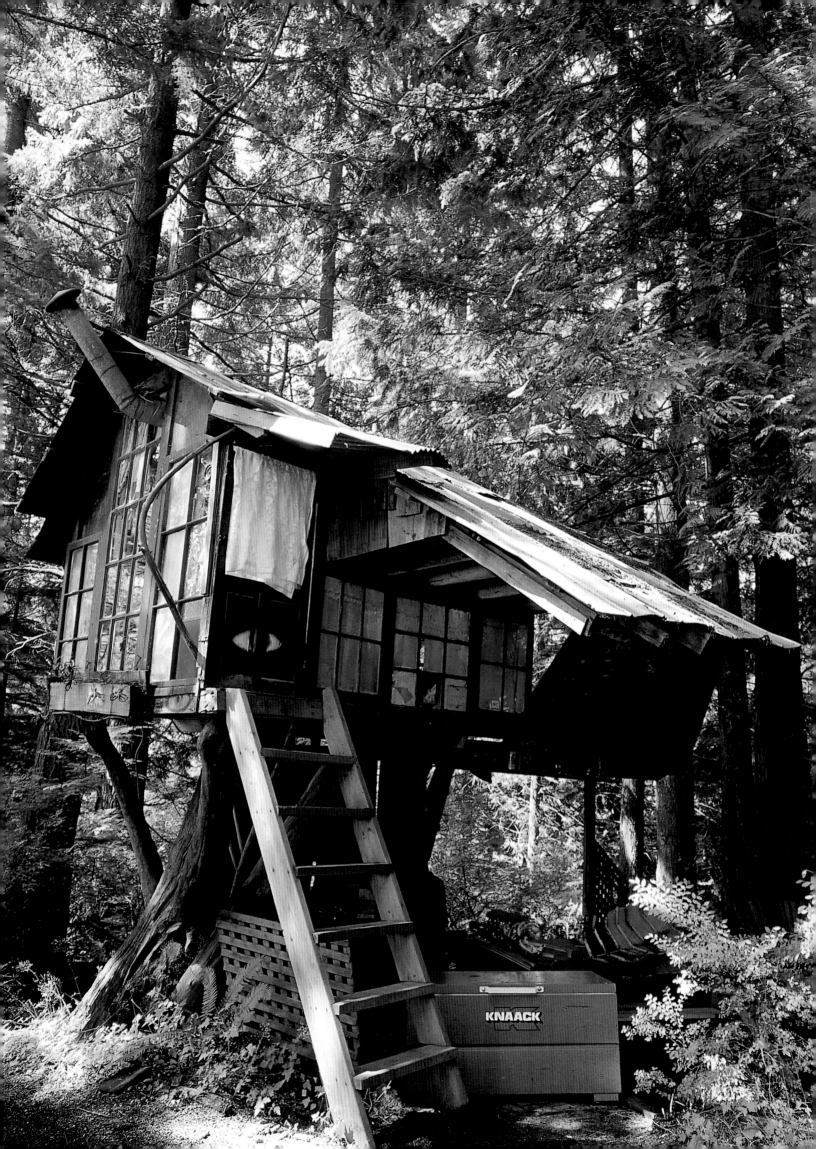

Acknowledgments

Pilchuck Glass School began with a simple notion: Dale Chihuly wanted to gather a group of artists to blow glass in the Northwest. But it took more than boundless enthusiasm to make that first summer happen twenty-five years ago. Through a major donation of funds and a site, Anne Gould Hauberg and John Hauberg turned Dale's dream into reality and in the process gave life to their belief in the value of creative freedom and artistic experimentation. We owe the existence of the school to these three visionaries—to their incredible foresight, determination, and generosity, and to their willingness to risk artistic and financial failure. The foundation they created paved the way for thousands of artists to reach for that same level of bold experimentation and creative risk-taking.

As trustees and staff of Pilchuck Glass School planned for its twenty-fifth anniversary year, trustee Richard Swanson observed that it is the "responsibility and privilege of those whose lives have been enriched by the Pilchuck experience to find ways to impart it to others." With this publication, then, we honor the Pilchuck founders, the artists who continue to breathe life into the school, and all who have given their best to Pilchuck and in turn have been forever changed by glass art. We have documented this story to inspire others to push forward, to believe in the power of art, to create community in their lives, and to find a way to make ideals become real.

This book would not have been possible without the encouragement of the board of trustees and the initial financial support of Doug Anderson and John Hauberg. For two years, a board book committee diligently has shepherded the project though planning, research, and writing, and we are deeply grateful to its members: Patricia Baillargeon, Gretchen M. Boeing, Dale Chihuly, Fritz Dreisbach, John Hauberg, Joey Kirkpatrick, Benjamin Moore, and Robert Seidl. Very special thanks are extended to Doug Anderson, chair of the committee, whose unwavering leadership guided this project through all stages of its creation and production. We also are grateful for the ongoing support shown for this project by Don Ellegood and Pat Soden at the University of Washington Press. Lastly, our overwhelming gratitude goes to Tina Oldknow for her tireless research and ingenious sleuthing and, especially, for giving a voice to all that is Pilchuck.

Marjorie Levy
Executive Director

Stump house built by artist Buster Simpson.

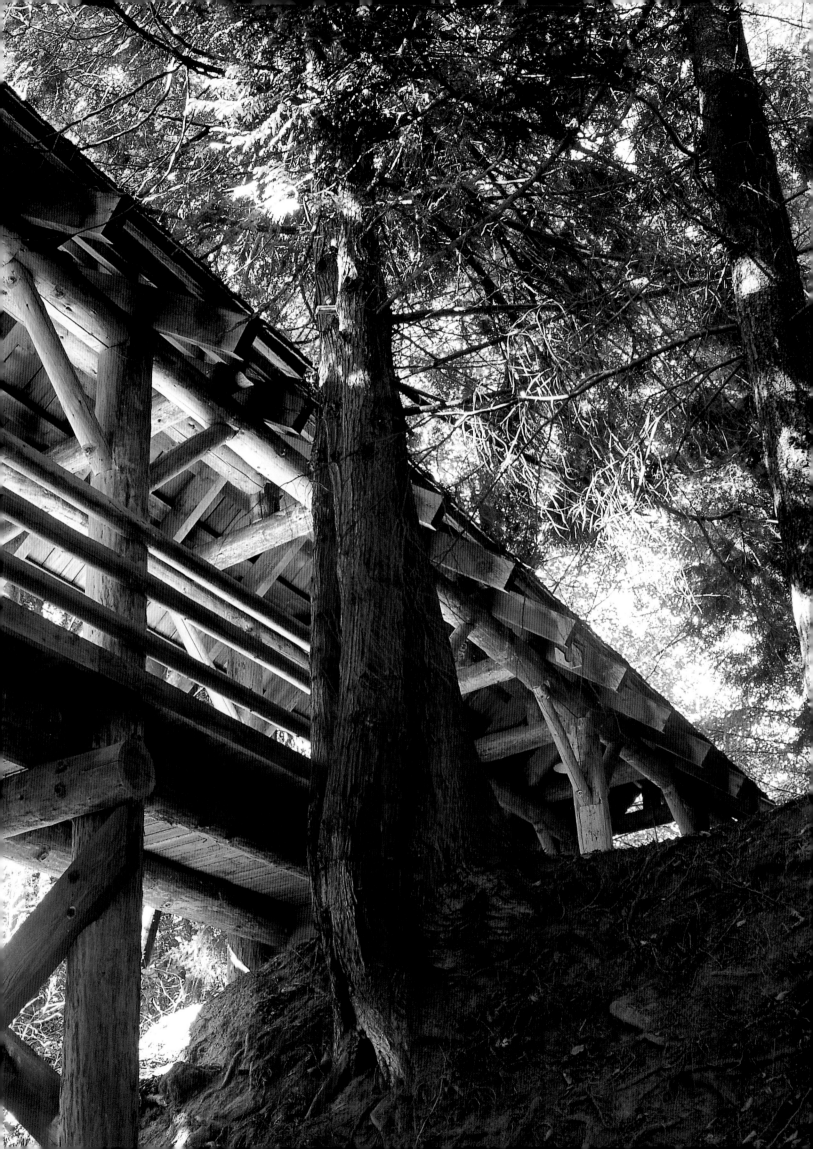

A Remarkable Synergism:
Pilchuck Artists and the Board of Trustees

Art organizations characteristically emerge in a burst of artistic endeavor or in response to a dream and the promise of financial help. Very few such enterprises, however, exhibit the combination of intense creativity and continuity of enthusiastic support that has caused such excitement and growth at Pilchuck over the last twenty-five years. Clearly something special happened to bring Pilchuck Glass School to its present prominence.

Some items can be isolated. Pilchuck began with the favorable coming together of founders Dale Chihuly, Anne Gould Hauberg, and John Hauberg. The early work of Chihuly and other young artists, done with primitive tools and little equipment, fascinated the Haubergs. The practical knowledge of the arts and financial guidance from the Haubergs, coupled with the unbridled creativity of a group of artists, inspired all who were close enough to observe the phenomenon and led to ever-increasing artistic and financial commitments. One effort followed another, vistas were opened, and challenges met, which in the aggregate led to the school's initial success.

How could such a small association of individuals grow to the magnitude and prominence that the organization enjoys in its twenty-fifth year and beyond? It was certainly fortuitous that the school began with the complete artistic freedom made possible by Anne Gould Hauberg and John Hauberg. True freedom of expression has been an essential operating pattern at Pilchuck. In addition, and of no little consequence, the Haubergs generously provided and wisely administered financial support. They brought in others for help and guidance on architecture, administration, programs, equipment, and other needs.

The organization of the board of trustees gradually evolved from a small society of friends—including early trustees Patricia Baillargeon, Johanne Hewitt, Frank Kitchell, Joseph McCarthy, Philip Padelford, and Sam and Gladys Rubinstein—to a larger group of colleagues. The structure of the board was formalized in 1988, and officers, committees, and advisers were established. This represented a significant challenge for the school, which had become accustomed to the security of John Hauberg's executive ability. Financial and leadership strength was further developed through careful selection and expansion of the board of trustees to yield a better balance of experience, talents, and geographic representation. Rarely does a board provide such spontaneous support or create such an impact as it does at Pilchuck. Indeed, the trustees' dynamic and continuing commitment of finances, time, and effort parallels the commitment of the artists to the school and its programs. The concentrated yet varied accomplishments of the board, combined with the creative energy of the artists, describe in a few words how the school achieved and maintained its intensity.

Footbridge to the
Pilchuck lodge.

The scope of all the board committees cannot be chronicled within the confines of this short essay. However, the work of committees such as board operations, development, personnel, and the executive committee must be noted as important contributions to the direction, strength, and stability of the school. These committees are involved in guiding the executive director and staff, determining compensation, defining the makeup and function of the board, finding development opportunities, and the very important recruitment and selection of new trustees. Because of the size and scope of the board, the executive committee, comprising all board vice presidents and committee chairs, provides a workable path for decisions that do not need, or cannot wait for, full board action.

The vast contributions made by board members through committee work are too numerous and specific to enumerate. The following brief outline notes some of the many important committee activities.

Finance and Fundraising Committees

As programs and successes accelerated at Pilchuck, there arose the inescapable need for more financial support. Two trustees deserve singular credit for their dedication, patience, and orderly work toward that end: George Davis, who led the ways and means committee for many years, and Jeffrey Atkin, who followed as treasurer in 1984. They displayed skill and wisdom in inspiring contributions and managing funds, and their reports to the board reflected their competence while delivering a measure of humor that made fundraising and finance seem like joyous endeavors.

The creation of a substantial capital fund has long been elusive, but an exciting five-year drive is underway to establish a special fund of $3.4 million, which will greatly buttress the school's base of support. This campaign is being very ably led by Jon and Mary Shirley. This fund will provide vital improvements in staff housing, increased studio space, safe and up-to-date glassworking equipment, and a sound endowment fund.

Auction Committee

As in many nonprofit educational institutions, student tuition at Pilchuck provides less than half its operating costs, so fundraising is a formidable challenge. For more than a decade, the premier source of funding has been Pilchuck's annual gala auction of artworks in glass, generously contributed by all the remarkably talented artists who make Pilchuck the phenomenon that it is. The auctions are chaired by one or two trustees and involve the entire board. Again, it is the hallmark of the unique spirit of the organization that auction chairs have always voluntarily come forward to accept this complex assignment. The cooperation between the artists and the board on this major event is another example of the synergism that has done so much to create the special environment of Pilchuck. While providing major funding for the school, the auction also functions to introduce the work of lesser-known and emerging artists to an assembly of as many as nine-hundred discerning collectors and advocates of art in glass. From 1980 to 1995 the following trustees served as auction chairs: Roger Christiansen; John Ormsby; George and Mary Davis and Johanne Hewitt; Rebecca Benaroya and Gary Glant; Christina Lockwood and Robert Thurston; Gary and Vicki Glant; Gretchen M. Boeing and

Cabin built by
Carolyn Silk.

"Corner" house built by
Richard and Susan
Posner.

Dale Chihuly's cabin.

The director's cabin.

Gallery/office.

Interior of the lodge.

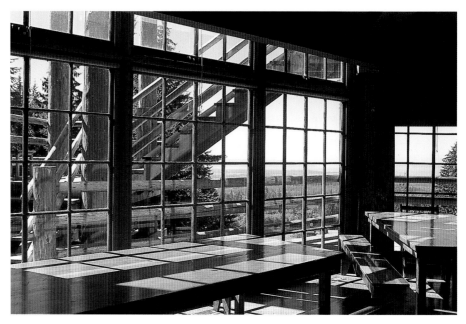

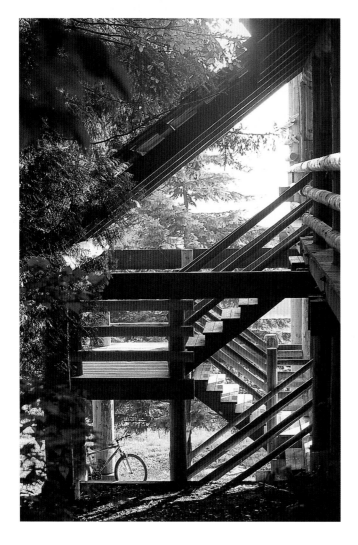

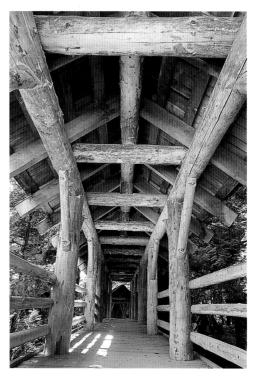

Footbridge to the lodge.

Lodge stairs.

C. David Hughbanks (two years); Babo Olanie and Mary Shirley; Christina Lockwood and Cindy McNae; Susan Brotman and Cindy McNae; Gretchen M. Boeing; Mary Shirley; Cindy McNae; and David Bennett and Sheri Kersch-Schultz.

Building and Grounds Committee

The Haubergs made a most fortunate early gift of the beautiful property on which the Pilchuck campus is located and its elegant early wood buildings, which were designed by Thomas Bosworth. They set the architectural tone for all the buildings to follow. The continuity of design and function has been protected and well served by a dedicated building and grounds committee comprising trustees and Pilchuck staff. The committee has devised much-needed facilities for water supply, fire protection, storage, maintenance, and housing that provide good function at reasonable cost without disturbing the overall design and harmony of the natural setting. Resisting the usual urge to expand, the board wisely set a cap of one hundred people in residence as a reasonable maximum that the property could sustain without degradation. Thus this committee can literally plan for a "completed campus," which can feature excellence of facilities over ever-increasing population.

Long-Range Planning Committee

The early leaders of the school had a creative, instinctive vision for the future, but with so many pressures for change and growth, it was finally recognized that a more formal approach to planning was needed. In 1984 the newly formed long-range planning committee, which I chaired, issued a preliminary document which was followed, in 1993, by a comprehensive report prepared under the very able leadership of trustee Richard Swanson and with the encouragement of president C. David Hughbanks. This committee provides an effective forum for both artists and trustees as it invites the dreams and aspirations of all concerned. The 1993 report, which will necessarily be revised from time to time, states the mission, objectives, and directions that guide major actions. It is a beacon for consistent direction, yet also a marker for carefully considered changes to accommodate evolving needs.

Artistic Program Advisory Committee

Close communication of plans and objectives between artists and the board is critical and yet is inherently difficult. Committee members are geographically dispersed and thus not easy to assemble. Meetings can expose points of friction between the artists and the administration, yet this aspect of the board, this willingness to openly and wholeheartedly disagree, argue, and compromise in what trustee Phillip Jacobson has called a "creative friction short of flames," ultimately has led to a more well-defined and integrated board. In 1990 board president John Anderson led the move to invite artists onto the board and encouraged the formation of the artistic program advisory committee. The committee has yielded important information on artists' goals and priorities.

International Council

It is not surprising that the Pilchuck Glass School would develop international relationships, considering the long heritage of glassworking in so many countries. It has been important for Pilchuck, as an internationally recognized institution, to create a team of

international artists and arts professionals to foster broader communications, to explore new prospects, and in general to integrate the activities and explore the potential of the school on a global scale. The international council first was proposed in 1981 by trustee Patricia Baillargeon and had its inaugural meeting in 1984 with Thomas Buechner, former director of the Corning Museum of Glass, as first chair. This committee presently is guided by Phillip Jacobson. The council's twenty-six current members represent fifteen countries.

Advisory Council

As the years passed some longstanding trustees understandably asked to be relieved of active participation in the affairs of Pilchuck. To retain the benefit of their experience and accumulated wisdom, the board created a special advisory group to provide continuing guidance. These people have retained a high level of interest in the school, and now, from a more detached position, provide a valuable overall perspective on direction and balance of activities, discover new opportunities, and build sound relationships with the public.

Presidents and Board of Trustees

In its formative years, the volunteer leadership of the Pilchuck Glass School was not highly structured but was certainly efficient under the close direction of John Hauberg. After a suitable period of gradually lessening involvement, Hauberg announced the end of his fruitful seventeen-year leadership of Pilchuck Glass School in 1988. He wisely reasoned that if the school was to survive on a long-term basis, greater financial and personal participation from a broader range of people was essential. To insure a diverse and effective leadership, it was agreed that board presidents serve a term of only two years.

My own tenure as president of the board of trustees occurred in the first two years following John Hauberg's exceptional reign. I quickly observed the fierce interest in defining the "Pilchuck spirit" on the part of both trustees and artists, an intensity that at times caused me to think of the two groups as natural enemies. Yet it was stimulating to observe the forging of practical solutions through what I call "respectful combat," a process which revealed philosophies, exposed convictions, and strengthened relationships. The wonderful artists are properly honored in our history, and Pilchuck Glass School belongs to them. In my personal experience, I have found the Pilchuck trustees to be competent, spirited, spontaneous, imaginative, responsive, dedicated, and interesting beyond what any president might expect.

John Anderson was president from 1990 to 1992, a difficult period of transition when many organizational changes, including the resignation of the director, occurred. It is a tribute to his dedication that he also served as interim director during the time it took to install a new director. Demonstrating his total dedication to the task, John was at the school office, day after day, for most of a year. John is a natural leader, and his position on issues was always decisive and clear. He spent much time in person-to-person talks with artists and trustees, mediating problems, and was always able to find humor in a situation. He was not one to avoid a problem or let it exist for long without reme-

dial action. Pilchuck Glass School has been greatly enriched by his presence. In the true "Pilchuck spirit," he gave much and asked for nothing in return.

C. David Hughbanks, president from 1992 to 1994, was a perceptive leader who could sense problems early and marshal people to provide solutions. His broad experience in public affairs was valuable in creating a strong public profile for Pilchuck, and his network of acquaintances was extremely helpful in enlisting additional support and in recruiting new board members. He was quick to understand the nuances of relationships between artists and trustees. Due to his excellent organizational abilities and easy manner, the meetings at which he presided were truly happy events. He was particularly instrumental in attracting and enlisting younger members who have brought a new dimension of support and excitement to the board. He had the invaluable foresight to strengthen and broaden the board's committee structure, building a stronger base for the entire school.

Mark Haley, serving from 1994 to 1996, is a splendid leader who has the special ability to encourage cooperation and garner support from the board. His mind is clear on issues, and he has no hesitation in articulately expressing his position. His manner is warm and friendly, and his humor contagious. Mark believes that the board reflects all the strong emotions that Pilchuck inspires as well as the stresses that can emerge from them. In his own words, he encourages the "honest debate of strong feelings," believing that "conflicts are so helpful, they should be institutionalized." For Mark, the clash of ideas causes the blossoming of new ideas. It is refreshing and appropriate that this vigorous young president could preside over the auspicious events of the twenty-fifth anniversary of the school. In 1996 Mark Haley was succeeded as board president by Randall Rubenstein.

Recent Trustees Any record of an institution's history naturally tends to illuminate early actions and people involved as the organization took shape. The Pilchuck Glass School operated for most of its years with a board of trustees numbering less than twenty, and involvement was direct and personal. In response to the rapid advance of the school, the board was increased in recent years to the present fifty-one members. The majority of the present board is of recent tenure, and many reside outside the Pacific Northwest, serving as ambassadors for Pilchuck throughout the country. Thanks to the careful selections made by the board operations committee, new members provide great enthusiasm, spirit, and competence, and show complete willingness to give active support. Their presence gives promise that the Pilchuck Glass School will have a greater reservoir of new ideas and spirit to invigorate the organization and lead it to even greater achievement.

Robert J. Seidl

A Founder's Perspective:
Conversation with Dale Chihuly

Patterson Sims, deputy director for education and research support, Museum of Modern Art, New York, conducted the following interview with Dale Chihuly, cofounder of Pilchuck Glass School, on December 19, 1995.

What do you think are the most important issues in educating artists?

The crucial thing about educating artists is the opportunity for artists—for young artists—to be around more mature artists. I never cared that much about the technical aspects. Pilchuck has always offered the technical things, but I have always believed that you learn the techniques you need. Some of Pilchuck's best teachers are not the best technicians and, God knows, some of the best technicians are not the best teachers.

My concept of how to teach began at the Rhode Island School of Design [RISD], where I never gave students assignments or problems. All I did was bring people together, assign them work times, and have them work. My prerequisites were that all students have a studio, which was not otherwise required, and that they have a telephone, a typewriter, and a camera.

I forced all my students at RISD to present their work in the form of slides only, and I never looked at their actual work—I mean, I would go occasionally to their studios, but only when they were at the end of a course. Twice a semester we would all go into a room, and each student would bring a tray of slides, and together we would look only at the slides that they had made of their art. They could do anything they wanted with the camera, and that would suffice for work. For my purposes the photos of their work were as important as the work they had made. If they could make a piece out of a photomontage, that was as good as making the real thing.

When I was a student at RISD, if you took a drawing class, teaching took the form of critiques. Every student would put a drawing up on the wall, and the teacher would come in and take down the ones he or she didn't like and rip them up. It's amazing, but faculty still taught that way.

My approach was to tell the students what I thought their best work was, but that was all I'd do. There were a lot of complaints in the beginning from the students that "we don't get enough attention." That fell on deaf ears because I wanted them to work on their own. Sometimes I'd bring in good artists for them to meet with.

Did your most effective teaching occur at Haystack Mountain School of Crafts [in Deer Isle, Maine], at RISD, or at Pilchuck?

I think I was more effective when I was younger. I've gotten progressively less effective as I've become more interested in my own work. The more involved I got in my own

The Pilchuck landscape.

work, the harder it was to separate and divide time to do anything else. I quit teaching at RISD in 1980, the year that my sales—$18,000—matched my teaching salary. Italo Scanga, Dan Dailey, and a lot of people tried to talk me out of quitting teaching, but I never hesitated for a minute. I knew that I would never teach as well as I had before I started really selling work. Being a good teacher has everything to do with energy, enthusiasm, and simply being excited, and for me, those conditions existed best at the beginning of my career.

Can you describe how you tried to synthesize what you liked about Haystack, RISD, and Penland School of Crafts [near Asheville, North Carolina] into Pilchuck?

Location and small size were the first components we sought. At Haystack, the obvious thing was the setting. You know, it was so idyllic, and it seemed that everybody who went to Haystack was bound to have a pretty good experience. In the late 1960s and early 1970s, when Pilchuck was starting, everybody wanted to go to the country. Providence or Detroit or Chicago were just not where you wanted to be. Haystack is about a third the size of Penland, and I really wanted Pilchuck to be, like Haystack, a place where you can meet almost everyone who is there. All and all Haystack and its director, Francis Merritt, were my biggest influences.

The other ingredient for a great school is great faculty. I tried to bring a RISD faculty to a setting that was more like Haystack. I believed then and still believe now that all you need is to put bright people out in a wonderful place and give them interesting teachers and courses. A good teacher, to me, is a good artist. The example of work, as much as teaching skill, is the strongest influence on students.

Finally, just as I feel about my own work as an artist, if you want to accomplish anything, you have to concentrate and to specialize. Unlike the other schools, Pilchuck was always just about one material, glass.

Had you ever been to the site of Pilchuck before?

When I thought about starting Pilchuck, my impetus was not necessarily to go to the Northwest, but it certainly felt right to come out west. I'm much more attracted to Asia than I am to Europe. We were going to start the school down by Tacoma, Washington, in Rosedale, because a friend of mine had some acreage there. Then Jack Larsen connected me with John and Anne Gould Hauberg, whom I had only met briefly before. John Hauberg told me that we could have one of the farms he owned around Pilchuck Mountain, 50 miles north of Seattle. That same night, I believe, John Landon and I discovered the beautiful site of the school, up the hill from the farm property. We then proceeded to try to talk John into letting us go there, to which he agreed. I realized it was sort of odd to ask for the raw site, because we were turning down farm buildings, electricity, and telephones. It was all part of this "back to the earth" movement, and I could see that John thought, "Why do they want to be up here when they could have any of a number of farms?" We gave all that up to go to a site that had nothing.

The Pilchuck landscape.

Would you like to say anything more about the early years of Pilchuck?

Pilchuck was sort of a fluke. It's very hard to say whether I would have been inspired to forge ahead if we hadn't gotten grant money and a site so easily. Only two faculty members from each member institution were eligible for a grant from the Union of Independent Colleges of Art, and a lot of people at RISD applied for it. It was really intended to be used for research to do your own work. But having received the official sanction, the $2,000 grant, and a supply of committed students who could attend for free, Pilchuck still could not have happened without John Hauberg and Anne Gould Hauberg. Beyond what we raised from the grant, we needed another $7,000 to cover our costs.

We were so involved in what we were doing that first summer that we probably didn't even think about what the next summer would be like or if there would be one. Even though John and Anne came up to the school a lot and we developed great mutual respect, I was not that close to John Hauberg. But at the end of the first summer, John asked me how much money we'd spent above the $2,000 and what our budget would be for next year. I hadn't thought that much whether the school might continue. But off the top of my head, I said we'd need $25,000 to do it the following summer, and John agreed to fund it.

After the second summer, I decided I wasn't right as a director. I wanted to be an artist, and I wasn't organized enough to be a director. I went to the Caribbean to figure out whether I wanted to continue Pilchuck, and I decided that I didn't. I resolved, however, that I would go back for the third summer to try to get the school on course. My curriculum was still based on the notion that if you have good students and good faculty, that was all you needed. The better the faculty, the better the students. I knew that if you get the word out, then students will come. Though it was usually a matter of first-come, first-served, we discovered that a lot of the more interesting students were not always the most talented. In time the hobbyists began to appear. Now we accept about half the applicants, plus or minus.

With the expansion of the annual auction, the strength of the board, and other signs of the tremendous growth of and respect for studio glass, Pilchuck has succeeded beyond my expectations. The school engages students no less than faculty and glass collectors and enthusiasts. All that seems pretty amazing; I certainly never thought the school would last twenty-five years.

Did you always perceive Pilchuck as a summer school?

Remember I was teaching full-time at RISD, and by the fourth summer of Pilchuck I phased out and Fritz Dreisbach, Rob Adamson, and others ran it with the director, Mimi Pierce. Even then I don't think I missed a summer, even if it was only to stop in briefly. But by the fifth or sixth summer, it didn't feel like the school was heading in the right direction, and so I got involved again. Around that point I talked John Hauberg into getting Tom Bosworth to be the director. Part of that deal was that I would come back, but Tom became the director.

Did Pilchuck keep you more involved with glass, or do you think you would have been involved with glass no matter what?

I always wanted to keep Pilchuck connected to glass because it is always better to specialize. For example, I designed the sets for a Seattle Opera production, but I am not sure I'd do another set because I felt I was lucky to pull that one off. It's hard to compete against David Hockney. If you want to be a good set designer, you really need to get involved in set design, and, for me, that would be at the expense of a lot of other things.

Glass has satisfied my need to really understand the material that I am working with and to comprehend and exploit its unique properties of light and transparency. I can sometimes switch over to neon, plastic, or ice but only because they connect to the properties of glass. I can't really imagine working in bronze. I do like to draw, which comes from years of just drawing, but I don't like printmaking or painting on canvas. I suppose I could be a good printmaker or painter if I could really spend time at it. I need to be assured that I've mastered a medium or material, and glass is the only one that I feel completely at ease in.

How has your role changed at Pilchuck?

In the very beginning, I was in charge of picking the faculty and inviting the people who would come. I was in charge of writing whatever proposals were needed for grants and money-raising. I was also responsible for the technical end, but by the second summer Fritz Dreisbach took over in that area, particularly with equipment. But building the equipment was my big thing, as was resolving disputes about what was needed among the various factions at the school, such as those who wanted to make the school a commune. I was very focused on the equipment. The second summer we needed to rebuild the school from the ground up.

I guess I have had a big effect on the school without even knowing it, by just being there at the beginning and being around for so long. Apparently I have had a major presence and influence at Pilchuck even without actually being there.

How has Pilchuck changed?

The school was not very structured in the beginning, then it got more structured. At a certain point, about fifteen years ago, we hit upon a kind of formula for teaching and working that was really successful. In 1980 we introduced the artists-in-residence program, which allowed artists to work independently and to make serious projects, to make it more like it was in the beginning. That freedom is not usually possible for a teaching faculty member, though certain Pilchuck faculty, like Dan Dailey, Bertil Vallien, and probably Therman Statom, are able to do a body of work and teach at the same time. I always liked it better when artists could do a body of their own work, even if it meant a loss of some student satisfaction. The most recent truly innovative things we started were the development around 1990 of the emerging artists-in-residence and printmaking programs.

Pilchuck's importance as an international glass center has had a lot to do with communication. In this last decade, it's been more about people meeting each other than

about learning technique. I now see Pilchuck as the ultimate international conference, giving people who come from Japan the chance to meet people from Spain. Most conferences I go to are not nearly as good as the results of going to Pilchuck. Our sessions and classes bond people together. The summer sessions are like perfect conferences. There's a talk or two every day. The common bond that develops among the participants is finally the reason why people want to come. The original charisma, spirit, and idealism that infused Pilchuck has also gone out to the wider world and influenced the whole world of glass and beyond.

Are there any ways to improve Pilchuck?

It's very hard to buck something that's successful. But I would like to see more—more artists, really good artists, up there. You can't beat the influence of a really great artist on young people. So I would like to see more of that. It's hard to achieve the right balance between a creative, free-flowing atmosphere and the structure of classes. Inevitably you are always battling time, resources, and the complexities of visiting artists' schedules.

It is not the super-star artists I would want for Pilchuck. Older artists are usually too self-centered. The ones I'd seek are really involved with their work, yet have the energy to share with younger people. Even mid-career artists might not be as good as younger ones would be at taking advantage of Pilchuck's facilities.

I've always been a risk-taker, and I get bored easily. If something new comes up, I'll latch on to it. It's easy for me to take risks because it's only my life. Though recently that's not really true. I have a lot of people who work for me and about whom I'm concerned. It's probably harder for Pilchuck to be as risky as I am. But I think that Pilchuck should look at itself to decide what risks it should take. Despite its success, there needs to be a continual process where it tries to figure out what else it might do.

Could you ever envision starting another Pilchuck?

No, I couldn't. That's for sure. Other schools have begun that are like it, such as the glass school on the island of Niijima in Japan, and other schools in Japan. But I doubt—at least at this point—if very many of them are as successful as Pilchuck.

I would like to see other institutions get started that could offer something different, but yet be complementary to Pilchuck. For instance, I would like to see a noncollecting institution with a hands-on hot shop and with a significant, changing artist-in-residence program where artists make major installations for a big, adjacent, public gallery space. Unlike some private hot shops, the public could watch the glassblowing. It would be very accessible, lively, and changing all the time.

The other option I'd like to explore occurred to me when a young glassblower asked how my "Chihuly over Venice" project was going to affect young people. He was frustrated to think that young artists would never be able to have such opportunities to work in large commercial glass factories. It made me realize I might be able to open up those factories to them. If I can succeed in this project, maybe it will influence the factories to open the door for other artists to come in and work as well.

Do you think Pilchuck will be around for another twenty-five years?

My guess is that it will be. Because once you get as established as we are, and as long as you have good directors and a good board, the institution will survive.

I lecture a lot around the country, and people ask me about Pilchuck all the time. The students love it; I hear people say all the time, "Well, I went to Pilchuck, and I had a great time" or "I want to go to Pilchuck." It seems to be, more than ever, a place where people want to go. Three weeks at Pilchuck is money well spent. If you are a weaver or a potter, you go to Haystack or Penland, but at Pilchuck, the whole school is its subject: there are no distractions.

So what has Pilchuck meant to you over the last twenty-five years?

I am such a future-oriented person, it's very hard for me to remember how things affect me from the past. But it's obviously been very important to me. Without Pilchuck, I might not have grown as much as an artist. I learned a lot of things about technique from the people who pass through Pilchuck, especially the foreigners. Almost all my best friends are people that I met at Pilchuck.

I'm a team person. I've always worked with a lot of people, and I've always wanted a lot of people around. I really enjoyed bringing people together. Pilchuck was a way to learn about what was going on in the world of glass, and to connect with people I wanted to know and whose work and ideas I admired. The school took on a new relevance in 1980 when I quit teaching and was drawn back to the Northwest to work there in the winters. God knows, the Northwest has been good to me and has had a major influence on me in ways I can't even comprehend.

Of all the things in my life, Pilchuck's probably the entity that I have stayed connected to the longest. We've had a need for each other. We are concerned about each other. Yet periodically and certainly for the last few years I've been so damn busy that I haven't been up there much. I would like to see my activities slow down and have an opportunity to be more involved in Pilchuck, though I am not sure what I would add as the current leadership is so strong.

It was a very good feeling when I went up there this summer for the twenty-fifth reunion. I don't go to my high school reunions. I am not much on reunions, but there was a really good feeling up there. Several hundred people converged from around the world to be at this event. Important past faculty and students came together and everyone had a good time.

I'm always given more credit than I deserve for Pilchuck. I did get it started, but the shape it took is due to many people. Whatever role I've played in Pilchuck, the dream has become a wildly successful reality. Pilchuck helped to establish a material and a region as its capital. It has given a lot of people a way to do what they wanted to do. It allowed hundreds of people from the U.S.—and foreigners as well—to make their livelihood from working with glass.

Pilchuck is second only to art in what I feel best about in the last twenty-five years. Along with RISD, it gave so much to my life. I can't imagine my life without it.

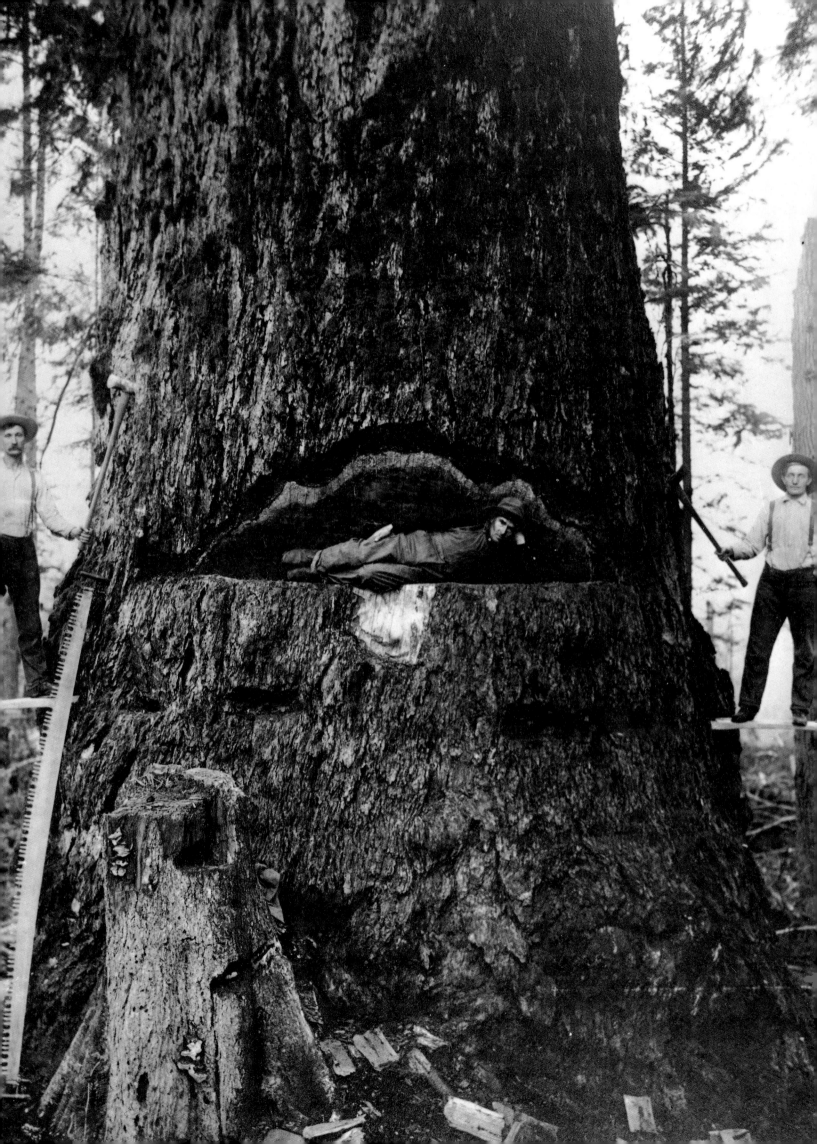

The Pilchuck Tree Farm

There is no place for the sluggard or weakling in the Puget Sound basin. Its prizes are many and rich, but they are for the strong, the vigilant, the active, the stout of heart. . . . Almost everywhere over its surface is a dense growth of giant firs and cedars and hemlocks, in places excluding almost entirely from the soil the sun's warmth. The mild climate, the long growing season, the abundance of rain cause vegetation to spring forth in almost tropical luxuriance. . . . Almost irresistible is this rush of green.

—An Illustrated History of Skagit and Snohomish Counties, 1906[1]

Approximately one hour north of downtown Seattle and two hours south of Vancouver, British Columbia, via U.S. Interstate 5, the Pilchuck Glass School sits on 54 acres of forested land in the foothills of a rugged coastal range known as the Cascade Mountains. At an elevation of 1,000 feet, the school commands a majestic western view of the Stillaguamish and Skagit river deltas as well as the San Juan Islands and Puget Sound. On a good day, the Strait of Juan de Fuca glimmers in the distance, hinting at the Pacific Ocean beyond, and the rain forests and snow-tipped mountains of the Olympic Peninsula come into view. To the south, the glaciated volcano Mount Rainier may appear, and to the north, its Cascade sibling, Mount Baker. The Cascades rise abruptly to the east, blanketed by their thick green pelt of big timber. Dark forests and clear rivers appear ancient, mythic. There is no question that this is an enchanted place.

Pilchuck means "red water" in Chinook jargon, "pil" for "red," and "chuck" for "water." A regional, intertribal trade language composed of French, English, and Native American words, Chinook jargon was used extensively among traders, settlers, and native communities. The "red water" refers to the rust-tinted, iron-rich waters of the Pilchuck River which have their headwaters at Mount Pilchuck, a 5,334-foot peak in central Snohomish County. From its mountain source, the Pilchuck River flows west and southwest, 32 miles downriver to its end at the Snohomish River confluence in the city of Snohomish. The river shares its name with Pilchuck Creek to the north, which rises on the south side of the Cultus Mountains, and flows southwest through the community of Pilchuck, once the site of a steam-fired sawmill, with accompanying living quarters, hotel, and school. The mill at Pilchuck shut down in 1922 when its owner, Parker-Bell Lumber Company, sold out to timber baron E. G. English.[2]

The cluster of homes that constitutes the present-day community of Pilchuck lies near the center of a 15,500-acre managed forest owned by Pilchuck Tree Farm. Perhaps the most famous Pilchuck of all, however, is not the community, mountain, or river but a child of the Pilchuck Tree Farm that has become a potent spot for growing talent: the Pilchuck Glass School.

Pilchuck Glass School is located on Victoria Hill, in the Victoria community of the town of Stanwood, Washington. According to the 1906 Illustrated History of Skagit and Snohomish Counties, the first Euro-American settlement "of any kind in the vicinity" was

The McMurray Fir, photographed ca. 1906 by Darius Kinsey. Darius Kinsey Collection, Whatcom Museum of History and Art, Bellingham, Washington.

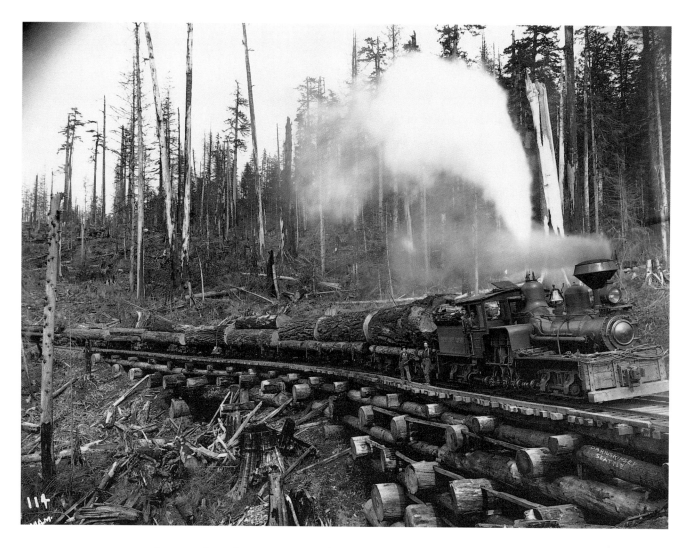

By the turn of this century, logging operations were in full swing in and around Victoria Hill, the site of Pilchuck Glass School. This English Lumber Company locomotive was photographed about 1902 by Darius Kinsey near Sedro-Wooley, Washington. Darius Kinsey Collection, Whatcom Museum of History and Art, Bellingham, Washington.

a saloon and trading post opened in 1866 by Robert Fulton. Later that year, the "Fulton place was bought by George Kyle who got a post office established there: it was known as Centerville." Because Centerville proved to be too popular a name, the United States Post Office requested that it be changed. In 1877 Centerville's postmaster and tavern keeper, D. O. Pearson, picked Stanwood, his wife's maiden name.[3]

The community of Victoria, situated about 10 miles east and slightly north of Stanwood, was first surveyed in 1875. By 1900 the Victoria Shingle Mill was in full operation at its millpond site near the base of Victoria Hill. In 1909 English Lumber Company established its Tyee Unit Camp 3 at the Victoria mill, and by 1910–12, "there were some 35 houses strung out in one little area around the pond."[4]

During this same period, from 1909 to 1911, English Lumber Company operated its Camp 3 on Victoria Hill, near the present-day site of Pilchuck Glass School: "Camp 3 [was] . . . built high on the slopes of [Victoria] Hill where the woods lines incorporated the use of no fewer than fourteen switchbacks." The only structure on the site when the Pilchuck Glass School began in 1971 was a decrepit cottage that might date back to the days of English Lumber's Camp 3. Certainly English Grade Road leading to the school today and many of the logging roads on the school property are old railroad grades that were first cut by English Lumber Company at the turn of this century.[5]

By 1915 most of the first-growth Douglas firs, cedars, and hemlocks on the crown of Victoria Hill had been logged. One of the few colossi to remain was the so-called McMurray Fir, a mammoth Douglas fir that stood nearly 200 feet high and measured more than 16 feet in diameter 4 feet from the ground. While this height and girth might be expected for the biggest cedars, in a Douglas fir it is positively unnatural. "The largest trees in Sound country are cedar and usually hollow," says the *Illustrated History*, "but some very large, solid fir trees have been found and reported to the local press."[7]

In the early 1900s, sections of the giant trees of Snohomish and Skagit counties were exhibited at world's fairs and smaller expositions, where they "invariably attracted much attention."[8] A similar fate awaited the McMurray Fir, which was destined for the celebrated Alaska-Yukon-Pacific Exposition of 1909, to be held in Seattle. The tree purportedly was to be cut down and stripped of its branches, which would be reattached to the trunk at the fair site. According to Duane Weston of Pilchuck Tree Farm, the scheme quickly folded: "They discovered, after they got into it a ways, that [the tree] was so big they didn't have saw lengths long enough to fell it. . . . They were going to have to widen some of the road cuts . . . to get it out of the woods. So, they just got the undercut in it, took a picture, and let it stand." Made vulnerable by the undercut, the McMurray Fir eventually burned. What was left, by the 1970s, was a legendary snag, or dead tree, towering 100 feet high. By the late 1980s, the monolith had collapsed and was buried in dense brush.

While the logging history of Victoria Hill is well documented, there is little known about the area's native populations, the aboriginal Stillaguamish (River People), Skagit and Sauk, and the Snohomish (Tidewater People), Tulalip, Swinomish, and Lummi.[10] No evidence of human habitation, other than by loggers, has been found on Victoria Hill, whose dark, dripping forest and heavy undergrowth might have been simply too inhospitable, especially when compared to the low-lying rivers, teeming with fish and abundant in birds and game.

According to early-twentieth-century sources, the native people of the area did rely on the forest for an intriguing form of burial: The deceased was laid in a canoe, which was placed in a tree. When the body had decomposed and freed the spirit, the bones were gathered and taken away for burial.[11] It is tempting to imagine that the famed giants of Victoria Hill once served such a noble function, and that their venerable stumps, such a unique feature of the Pilchuck landscape today, might house ancient souls.

The Early Years
1971–1976

Art stands against history . . . for art subjects reality to laws other than the established ones. . . . But in its struggle with history, art subjects itself to history: history enters the definition of art.

—Herbert Marcuse, quoted by Abbie Hoffman in
Woodstock Nation, 1969

Pilchuck . . . became the dream of many, and not just one. Dale Chihuly was part of the creation . . . but Dale didn't create Pilchuck. Pilchuck created itself.

—John Landon, first-year Pilchuck "faculty"

The magical aspect of what we did, it was like opening a door to something that was there. . . . And because of that experience, we all got to step through that door.

—Michael Nourot, first-year Pilchuck "student"

the NO DEPOSIT *lots of returns* GLASS *etc.* WORKSHOP

FREE TUITION - YOU PROVIDE FOOD AND CAMPING EQUIPMENT

SEE YOUR DEAN ABOUT PARTICULARS

OR DALE CHIHULY AT RHODE ISLAND SCHOOL OF DESIGN, PROVIDENCE, R.I.

OR RUTH TAMURA AT CALIFORNIA COLLEGE OF ARTS AND CRAFTS AT OAKLAND

PUGET SOUND, STATE OF WASHINGTON JUNE 1st AUGUST 1st

VISITS TO OLYMPIC NATIONAL FOREST, RAINFOREST SAN JUAN ISLANDS, CASCADE MTS MOUNT RAINIER, PACIFIC OCEAN, DALE'S MOTHER'S HOUSE

Coming Northwest

When Dale Chihuly first thought of starting a summer workshop for glass in an isolated, pastoral setting, he turned to his homeland, the Pacific Northwest. During the mid and late 1960s, the West held a special attraction for youth all across the country. California, in particular, offered the Bay Area with the University of California at Berkeley—the birthplace of student activism—and the Haight-Ashbury district of San Francisco—the center of the drug culture—as an important pilgrimage site for a counterculture bent

We liked the idea of art students hitting the road and heading West to work in a rugged new landscape.

—Dale Chihuly[1]

on social revolution. By 1968 the migration to rural communities in Northern California, primarily to escape harassment in the city, had begun.[2] Before long, groups of counterculture youth discovered the "new landscape" of Oregon and Washington, where alternative lifestyles, if not exactly welcomed, were tolerated. The West, historically receptive to new ideas, was a good place for Americans who expected to change their world. It was also a good place for artists to explore the possibilities of a newly rediscovered art medium: glass.

For years we have been hearing that glass would become one of the basic materials available to contemporary craftsmen. Indications can be now seen on many sides that this prediction has come true.

—Paul Perrot, director, Corning Museum of Glass, 1961[3]

In September 1961 ceramist Robert Arneson was throwing pots at a state fair. One pot reminded him of a quart-size bottle of beer, so he made a ceramic cap for it, and added the words "No Deposit, No Return." In this moment Arneson claims to have made his break with conventional ceramics and redirected the course of his ceramic art.[4] In 1971, when Dale Chihuly and Ruth Tamura advertised a "No Deposit, Lots of Returns Glass Etc. Workshop," a humorous reference to Arneson perhaps, they were just as serious in their intent to break with traditional glassmaking. And they, too, would transform the art.

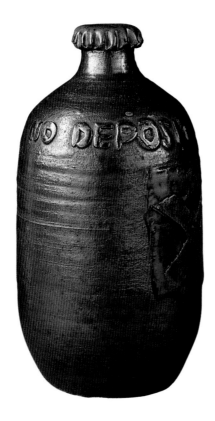

Robert Arneson (American, 1930–1992), *No Deposit No Return*, 1961. Earthenware, 12 x 6 x 6 in. Los Angeles County Museum of Art, purchased with funds provided by the Smits Ceramics Fund, Modern Art Deaccession Fund, and the Decorative Arts Council.

Opposite: Poster advertising Pilchuck's first summer workshop. Drawn by Art Wood, 1971.

Almost all the early glassblowers started as potters, not painters or sculptors, and their sensibilities were informed by a different, though parallel, art history. The 1950s and 1960s were as revolutionary a time in ceramics as in painting—particularly in California—with Robert Arneson, the king of pop/funk, and Peter Voulkos, the star abstract-expressionist potter, whose improvisational approach tested the boundaries between painting,

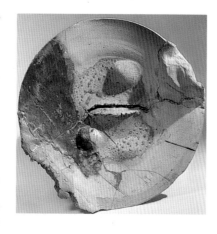

sculpture, and ceramics. But glass was different. Modernism in glass was represented, on the one hand, by the innovative Scandinavian and Italian designs of the 1950s and, on the other, by the isolated, halting experiments in slumping and fusing—that is, melting glass in kilns—in the United States during the late 1950s and early 1960s. Glass did not have an avant-garde past: for this "new" medium, the late 1960s through the late 1970s was the breakthrough decade.

By the mid 1960s the new "sculptural," rather than functional, ceramics had taken over at the University of Washington in Seattle, according to LaMar Harrington, former

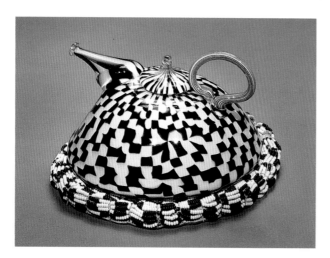

director of the university's Henry Art Gallery. "In the move away from functional concerns," Harrington wrote, "the artists of the Northwest, in addition to being affected by California abstract-expressionist ceramics, were also influenced by . . . pop art and even more deeply by the attitudes of the so-called funk artists based at the University of California at Davis under sculptor Robert Arneson."[5] The University of Washington ceramics staff included Harold Myers, Robert Sperry, Rudy Autio, and Howard Kottler, and with graduate students such as Fred

Bauer and Patti Warashina, the program was the most vital art scene in Seattle. "Ceramics was a much more dynamic field . . . than glass . . . up through the mid 1970s," recalls Joseph Monsen, Seattle art collector. "I began looking [to collect] glass . . . [but] ceramics was so far ahead, it was much more interesting. Glass had not really coalesced."[6]

By 1968 Bauer and Warashina were teaching at the University of Washington, and

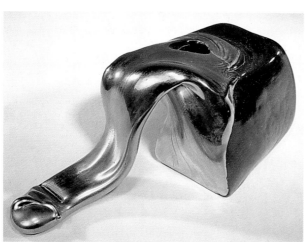

two years later Bauer hired Richard Marquis, a ceramist turned glassblower as a replacement for Howard Kottler, who was on sabbatical. Marquis had studied at the University of California at Berkeley with Ron Nagle and Stephen de Staebler, both former students of Peter Voulkos. But Marquis was at the university to start a program in glass, a medium that interested both Bauer and Kottler. Kottler had attended one of the historic studio glass workshops at the Toledo Museum of Art in 1962, while he was a graduate student at Ohio State

University, and in 1968 he set up a furnace at the University of Washington with one of his students, Clair Colquitt. Kottler made a series of expressionistic, globular bottle

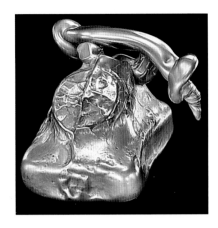

Erwin Eisch (German, b. 1927), *Telefon*, 1971. Mold-blown glass with gold luster decoration, 5⅞ x 6⅞ x 8 in. Corning Museum of Glass, Corning, New York.

forms fairly characteristic of glassblowing at the time, but added an interesting twist in the form of silver- and gold-lustered jackets. Although Kottler soon gave up glassblowing because he "hated the heat and the fact that you have to work so quickly," his funk-influenced, lustered "bottles" are remarkably similar in approach to works German glass artist Erwin Eisch would develop independently about the same time.[7]

Although glass has been handblown for centuries, it was not until 1962 that the material became available to American artists to work in their private studios. Glassworking historically had been the province of guilds and factories as a purely commercial enterprise, and glassmaking techniques were jealously protected against would-be industrial spies. In classical antiquity, Rome led the European glass industry, and during the Renaissance, Venice was in the forefront. Two hundred years later, important commercial centers for glassmaking had been established throughout Europe and, after about 1650, in America as well. The revolutionary concept of an "art glass," however, was not born until the late nineteenth century, inspired by the arts and crafts movement in England and, especially, the art nouveau movement in France. While Louis Comfort Tiffany (1848–1933) was becoming famous in America, Emile Gallé (1846–1904) was the undisputed French leader of the new art glass. These visionary artists—both designers and factory owners—were the first to see the unlimited artistic possibilities of the medium. But to work the material, any would-be artist or designer had to be connected with a factory: the separation of artist-designer and craft tradesman had long been the standard. Individuals responsible for the look and feel of the glass never actually handled the material. That was the domain of the glassmaker.

A small number of artists attempted to craft hot glass in the first part of the twentieth century, but efforts to work with it outside the factory were almost nonexistent.[9] The first artists to take a real interest in manipulating molten glass appear to have

My own work consists above all in the execution of personal dreams. . . . I am not only responsible for the uses that can be made of crystal but also for the point of departure in this adventure. . . . It is I who have infused [glass] . . . with the means for touching us: the worrisome blackness or the delicate morbidezza of soft rose petals.

—Emile Gallé, ca. 1889[8]

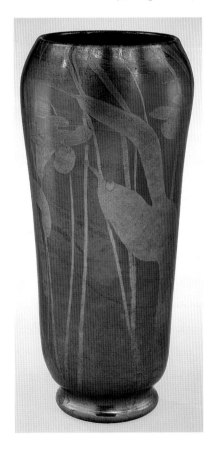

Tiffany Furnaces, Corona, Long Island, New York. *Favrile Vase*, ca. 1900–28. Glass, luster, h. 13¾ in. The Tiffany style made its mark on studio glass in the early 1970s when artists rediscovered fuming techniques. Corning Museum of Glass, Corning, New York, gift of Edgar Kaufmann Jr.

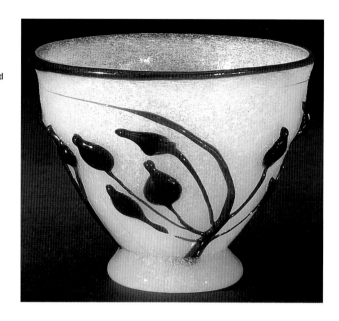

Jean Sala (Spanish, worked in France, 1895–1976), *Footed Bowl*, ca. 1930–40. Blown glass with applied decoration, h. 4 in. Corning Museum of Glass, Corning, New York.

been the Frenchmen Maurice Marinot (1882–1960) and Jean Sala (1895–1976). Marinot first painted in enamels on blanks—that is, undecorated blown vessels—made in a friend's factory, and later worked the glass himself. Sometime in the late 1940s or early 1950s, Jean Sala, the son of a Spanish glass master, built his own hot glass facility in the Montparnasse section of Paris. Sala fanned his small furnace with a hand bellows, melted batch and cullet, and blew glass on his own. His studio was probably the first to be dedicated solely to the artistic use of glass by an individual glassblower.[10]

In the United States Harvey Littleton was making tentative steps toward developing a one-person glass studio. A professor of ceramics at the University of Wisconsin at Madison, Littleton melted glass in a ceramic kiln in 1958 to make his first rough experiments. In 1959 he reported on his progress at the third annual conference of the American Craftsmen's Council in upstate New York. The artist-craftsman's fear that the craft of glassblowing was being lost in an increasingly mechanized America was very real: with the exception of stained glass, no more than half a dozen American artists, at that time, were attempting to work in the medium.

In 1961 the fourth national conference of the American Craftsmen's Council was held at the University of Washington. A panel chaired by Corning Museum of Glass

Harvey K. Littleton (American, b. 1922), *Vessel*, 1965. Blown #475 fiberglass marbles, silver oxide decoration, h. 4½ in. Corning Museum of Glass, Corning, New York.

curator Kenneth Wilson explored future possibilities for the glass medium in America. In discussing Littleton's findings, conference panelists began to see glassblowing "as a real possibility rather than just a dream." At this same panel, artists Michael Higgins, Edris Eckhardt, John Burton, and Seattlite Russell Day presented their work in kiln forming—including casting, slumping, and fusing—and lampwork, a technique in which glass rods are melted and formed with the aid of a small gas torch or burner. The panel urged Littleton to make studio glassblowing a reality. He immediately started looking for a suitable place to set up an experimental glass workshop.[11]

Otto Wittmann, director of the Toledo Museum of Art—which houses one of the country's most important glass collections in the hometown of Libbey Glass—offered the resources of the museum and its art school to Littleton.[12] They agreed to hold a glass-

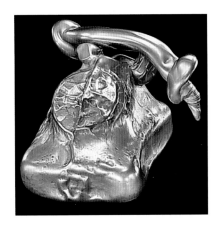

Erwin Eisch (German, b. 1927), *Telefon,* 1971. Mold-blown glass with gold luster decoration, 5⅞ x 6⅞ x 8 in. Corning Museum of Glass, Corning, New York.

forms fairly characteristic of glassblowing at the time, but added an interesting twist in the form of silver- and gold-lustered jackets. Although Kottler soon gave up glassblowing because he "hated the heat and the fact that you have to work so quickly," his funk-influenced, lustered "bottles" are remarkably similar in approach to works German glass artist Erwin Eisch would develop independently about the same time.[7]

Although glass has been handblown for centuries, it was not until 1962 that the material became available to American artists to work in their private studios. Glassworking historically had been the province of guilds and factories as a purely commercial enterprise, and glassmaking techniques were jealously protected against would-be industrial spies. In classical antiquity, Rome led the European glass industry, and during the Renaissance, Venice was in the forefront. Two hundred years later, important commercial centers for glassmaking had been established throughout Europe and, after about 1650, in America as well. The revolutionary concept of an "art glass," however, was not born until the late nineteenth century, inspired by the arts and crafts movement in England and, especially,

My own work consists above all in the execution of personal dreams. . . . I am not only responsible for the uses that can be made of crystal but also for the point of departure in this adventure. . . . It is I who have infused [glass] . . . with the means for touching us: the worrisome blackness or the delicate morbidezza of soft rose petals.

—Emile Gallé, ca. 1889[8]

the art nouveau movement in France. While Louis Comfort Tiffany (1848–1933) was becoming famous in America, Emile Gallé (1846–1904) was the undisputed French leader of the new art glass. These visionary artists—both designers and factory owners—were the first to see the unlimited artistic possibilities of the medium. But to work the material, any would-be artist or designer had to be connected with a factory: the separation of artist-designer and craft tradesman had long been the standard. Individuals responsible for the look and feel of the glass never actually handled the material. That was the domain of the glassmaker.

A small number of artists attempted to craft hot glass in the first part of the twentieth century, but efforts to work with it outside the factory were almost nonexistent.[9] The first artists to take a real interest in manipulating molten glass appear to have

Tiffany Furnaces, Corona, Long Island, New York. *Favrile Vase,* ca. 1900–28. Glass, luster, h. 13¾ in. The Tiffany style made its mark on studio glass in the early 1970s when artists rediscovered fuming techniques. Corning Museum of Glass, Corning, New York, gift of Edgar Kaufmann Jr.

Jean Sala (Spanish, worked in France, 1895–1976), *Footed Bowl*, ca. 1930–40. Blown glass with applied decoration, h. 4 in. Corning Museum of Glass, Corning, New York.

been the Frenchmen Maurice Marinot (1882–1960) and Jean Sala (1895–1976). Marinot first painted in enamels on blanks—that is, undecorated blown vessels—made in a friend's factory, and later worked the glass himself. Sometime in the late 1940s or early 1950s, Jean Sala, the son of a Spanish glass master, built his own hot glass facility in the Montparnasse section of Paris. Sala fanned his small furnace with a hand bellows, melted batch and cullet, and blew glass on his own. His studio was probably the first to be dedicated solely to the artistic use of glass by an individual glassblower.[10]

In the United States Harvey Littleton was making tentative steps toward developing a one-person glass studio. A professor of ceramics at the University of Wisconsin at Madison, Littleton melted glass in a ceramic kiln in 1958 to make his first rough experiments. In 1959 he reported on his progress at the third annual conference of the American Craftsmen's Council in upstate New York. The artist-craftsman's fear that the craft of glassblowing was being lost in an increasingly mechanized America was very real: with the exception of stained glass, no more than half a dozen American artists, at that time, were attempting to work in the medium.

In 1961 the fourth national conference of the American Craftsmen's Council was held at the University of Washington. A panel chaired by Corning Museum of Glass

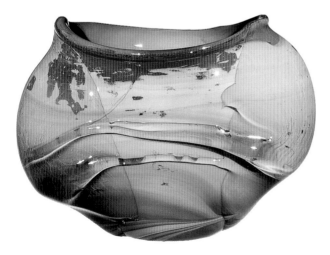

curator Kenneth Wilson explored future possibilities for the glass medium in America. In discussing Littleton's findings, conference panelists began to see glassblowing "as a real possibility rather than just a dream." At this same panel, artists Michael Higgins, Edris Eckhardt, John Burton, and Seattlite Russell Day presented their work in kiln forming—including casting, slumping, and fusing—and lampwork, a technique in which glass rods are melted and formed with the aid of a small gas torch or burner. The panel urged Littleton to make studio

Harvey K. Littleton (American, b. 1922), *Vessel*, 1965. Blown #475 fiberglass marbles, silver oxide decoration, h. 4½ in. Corning Museum of Glass, Corning, New York.

glassblowing a reality. He immediately started looking for a suitable place to set up an experimental glass workshop.[11]

Otto Wittmann, director of the Toledo Museum of Art—which houses one of the country's most important glass collections in the hometown of Libbey Glass—offered the resources of the museum and its art school to Littleton.[12] They agreed to hold a glass-

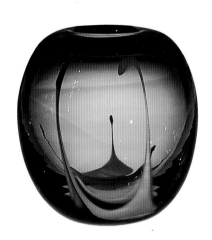

Dominick Labino
(American, 1910–1987),
Vessel, 1969. Blown
gold ruby glass,
h. 4⅜ in.
Corning Museum of Glass,
Corning, New York.

blowing workshop during the last week of March 1962. Norman Schulman, the ceramics instructor at the Toledo Museum's School of Design, assisted in the program, as did Dominick Labino, vice president and director of research at Johns-Manville Fiber Glass Corporation, who gave much-needed technical advice. Harvey Leafgreen, a retired glassblower from Libbey-Owens, provided his hands-on expertise. The fire bricks for the furnace crucible were assembled in a storage building on museum grounds, and a burner and a glass recipe were obtained. No one had any experience in batching glass, and the first melt was unworkable. Labino then provided some of his formulated fiberglass marbles, which would easily melt at a lower temperature, and suggested converting the furnace format from a crucible to a tank to melt the marbles. The adjustments did the trick, and studio glass was born.

The first Toledo workshop was followed by a two-week seminar in late June 1962.[13] Howard Kottler attended the second workshop and notes that "about fifteen people from all over the country, most of them [Littleton's] friends, attended."[14] Harvey Leafgreen demonstrated blowing techniques, and according to Kottler, "it was all pretty disorganized and technically primitive."[15] Glass pieces were annealed in a vermiculite-filled can, and because they did not properly cool, most of them cracked.

In Seattle, meanwhile, artists Russell Day and Stephen Fuller were conducting their own experiments in fusing glass, using kiln-forming techniques pioneered with varying degrees of success by artists such as Maurice Heaton, Michael and Frances Higgins, and Edris Eckhardt.[16] "I laboriously laid out a fantasy of colored glass and glass rocks and fired it," wrote Day in his 1957 MFA thesis for the University of Washington. "The room was filled with a heavy, sooty black smoke, very acrid and penetrating. Hardly able to wait for the kiln to cool so I could look at my masterpiece, I was somewhat shocked to find that numerous small explosions had taken place, and that instead of one piece of fused glass, I had thousands of fragments of glass scattered all over the kiln."[17] Fuller, also at the University of Washington, was attempting to interlace strips of softened glass in abstract compositions. In 1964 Russell Day, now teaching at Everett Community College north of Seattle, attended Harvey Littleton's four-week summer workshop at the University of Wisconsin in Madison, another historic seminar. Also present were Erwin Eisch; Robert Fritz, who would start the glass program at California State University in San Jose in the fall of 1964; and Marvin Lipofsky, who would start the glass programs at the University of California at Berkeley (1964) and the California College of Arts and Crafts in Oakland (1967).

Upon his return from Madison, Russell Day encouraged one of his students at Everett Community College, Bill Boysen, to study with Harvey Littleton, and in the following year, 1965, he suggested the same to student Michael Whitley. And in 1966, Day

helped yet another glass acolyte—Dale Chihuly—get to Wisconsin.[18] Bill Boysen, who built the first glass studio for the Penland School of Crafts in rural North Carolina in 1965, set up a glass department in 1966 at the University of Southern Illinois in Carbondale.[19] Michael Whitley—whom Littleton remembers as a gifted student[20]—returned and set up glassblowing classes at Highline Community College, in Des Moines, Washington, in 1968. Whitley later instituted a more extensive program at Central Washington University in Ellensburg, which he ran until his untimely death in the early 1970s. In 1968 Howard Kottler undertook his brief experiments in glassblowing at the University of Washington, and by the following year, other Northwest colleges almost simultaneously introduced glass. Glass programs were expanded in 1969 at Everett Community College by Russell Day and instituted at Pacific Lutheran University in Tacoma by ceramist David Keyes;[21] glassblowing classes were offered at Western Washington University in Bellingham and Washington State University in Pullman.[22] Richard Marquis started his program at the University of Washington in 1970, but for administrative and economic reasons, it lasted only one year. It was not for another year, with the success of the Pilchuck experiment, that Seattle's studio glass movement truly began to flourish.

Here is this completely unique material: it's transparent, translucent, and opaque, anything you want it to be. . . . You can make form with your own human breath.

—Dale Chihuly[23]

Dale Chihuly first worked with glass in the early 1960s as an interior design major at the University of Washington.[24] Weaving was his main focus, but by 1964 he was incorporating fused glass and metal into his tapestries. He made one large window piece of fiber, metal, and glass for his mother's home, and produced others to sell. Anne Gould Hauberg, who would become a significant supporter, purchased two glass and fiber weavings. In 1965 Chihuly met textile designer Jack Lenor Larsen, who also would become an influential friend and mentor.

Chihuly graduated from the University of Washington with a BA in interior design in 1965. That same year he blew glass alone for the first time. "I had this little studio in south Seattle," Chihuly remembers, "[where] I began to learn how glass melted and how you could fuse it together. One night I melted some stained glass between four bricks and put a pipe in there and gathered some glass and blew a bubble. . . . From that point on, I wanted to be a glassblower."[25] Impressed by Chihuly's experiments, Russell Day urged Chihuly to study with Harvey Littleton.[26] Day recalls seeing Chihuly reach into his kiln to manipulate the glass, wearing only asbestos gloves for protection. "Chihuly was afraid of nothing," says Day. "He could make mistakes and it wouldn't get him down. . . . [He] didn't worry about what he was told he could do, he just did what he wanted to. . . . He had an insatiable drive and a capacity for working his tail off."[27]

Chihuly entered Littleton's program at the University of Wisconsin in Madison in 1966 and stayed a year: "I was totally infatuated, completely absorbed in the concept of being a glassblower because to see this bubble come out at the end of this blowpipe

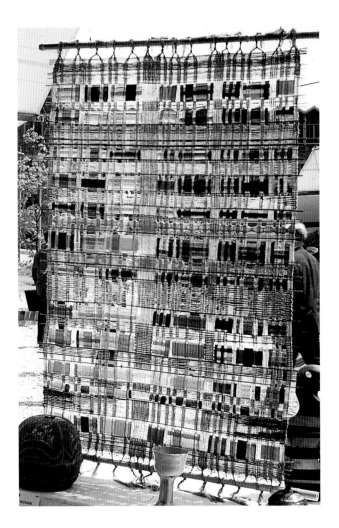

[was] magical. . . . You can't blow any other material. . . . My initial interest was really the glassblowing. And when I first started blowing glass, I didn't make vases and I didn't start where you were supposed to start."[28]

At Madison, Chihuly discovered ways of working that would influence his own approach to glassblowing. The most significant of these was collaboration. The first person Chihuly blew glass with was a gifted fellow student named Fritz Dreisbach, who would become an invaluable colleague. Other art students offered guidance and advice. "Interior design doesn't give you any background in making art," remarks Chihuly, "but I began to learn about art and what art was by being with these talented people." Chihuly's experiences in Madison led him, in 1967, to Providence, where he enrolled in the MFA program at the Rhode Island School of Design (RISD). "There really weren't any glassblowers there," Chihuly recalls, "but they had a furnace."[29]

Chihuly received his MFA from RISD in 1968 and for the first time taught glassblowing that summer at Haystack Mountain School of Crafts in Deer Isle, Maine, on the strength of a recommendation from Jack Lenor Larsen. Inspired by the visionary leadership of Haystack's founding director, Francis Merritt, the intense focus on learning and working, and the bucolic surroundings of "salty air, moss-covered woods, and clean, coastal light,"[30] Chihuly dreamed of a similar school devoted to glass that would be located in the Pacific Northwest, perhaps on one of the San Juan Islands of Washington State.

During a visit to the Northwest in July 1968, Chihuly gave glassblowing demonstrations at the Pacific Northwest Arts and Crafts Fair in Bellevue, Washington. The *Seattle Post-Intelligencer* observed:

The hot spot was the glassblowing furnace of award-winning Tacoma glassblower Dale Chihuly, 26, who drew perspiring crowds throughout the day to watch close-up demonstrations of his artistry. Chihuly, winner of a Louis Comfort Tiffany Grant in glassblowing last year . . . clearly was the fair's no. 1 crowd attractor. Throughout the warm day, thousands of fairgoers braved the reflected heat of Chihuly's furnace to watch him fashion gem-like glass

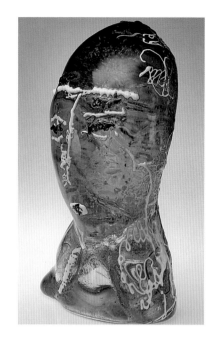

bowls before their eyes. It was the first such glassblowing set-up in the Northwest. The special fire bricks will be donated to the University of Washington which will offer a course in glassblowing for the first time this year.[31]

Chihuly was awarded a Fulbright grant, in the late fall of 1968, to study glassblowing at the famous Venini factory, directed by Ludovico Santillana, on Venice's historic Murano Island. Thomas Bosworth, a young architect on the faculty at RISD who would later create the signature buildings for the Pilchuck campus, sat on the committee that awarded Chihuly this important grant.[32] During the 1950s and 1960s, artists from Europe and the United States, including such luminaries as Pablo Picasso, Max Ernst, Alexander Calder, Oskar Kokoschka, Alberto Giacometti, Hans Arp, and Mark Tobey, were invited to design glassware for this forward-looking Venetian glass-house. Chihuly recalls his experience as the first representative of the new American studio glass movement to penetrate the walls of the venerable firm of Venini:

During my last year of graduate school at the Rhode Island School of Design, I wrote to all the glass factories in Italy, hoping that one of them might take me on as an apprentice or

Above: Mark Tobey (American, 1890–1976), *Volto,* 1974. Cast glass with applied decoration, 15 x 8¼ x 7¼ in. The influential Northwest painter designed this head for the Fucina degli Angeli glassworks, operated by Egidio Costantini in Murano, Italy.
The Toledo Museum of Art, Ohio, gift of George and Dorothy Saxe.

Right: Venini Fabbrica, Murano, Italy, 1978.

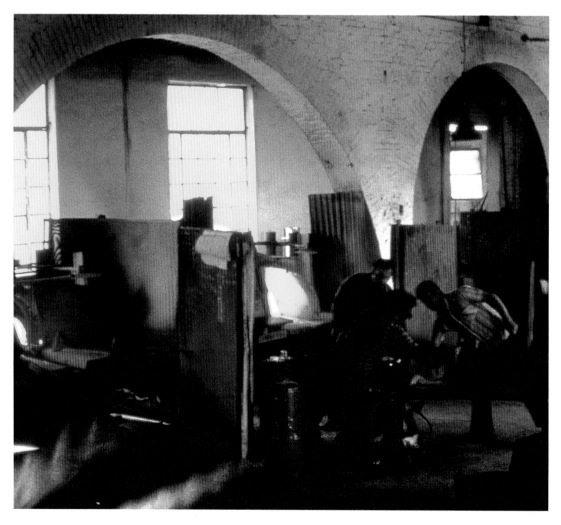

Paolo Venini (Italian, 1895–1959), *Fazzoletto (Handkerchief) Vase*, ca. 1950. Blown *zanfirico* glass, diam. 11½ x 12 in. *Zanfirico* glass was Venini's interpretation of sixteenth-century Venetian *filigrana* (filigree) techniques. The graceful form of the "handkerchief" was popular throughout the 1950s.
Los Angeles County Museum of Art, gift of Mr. and Mrs. Glenn W. Tripp.

just let me watch. Only one factory, the famous Venini, started by Paolo Venini in the 1920s, responded with an invitation that looked promising. . . . This project put me in close contact with the masters of the factory, and I learned and observed the way in which the Italians blew glass. It changed my attitude and ideas about glassblowing forever.[33]

At Venini Chihuly observed the expert teamwork between masters, gaffers, and apprentices as well as the flawless Italian technique. He absorbed not only a feel for classical design and proportion but the light, sound, color, and joie de vivre that is Venetian glass at its best. The informal, almost domestic, ambiance of the factory, where a pot of boiling water was always on hand for pasta, made an equally distinct impression. For his part, Chihuly introduced the Venini craftsmen to the idea of glassblowing as one complete artistic process, from design to fabrication.[34] While this approach was embraced by American studio glass artists, it was foreign to most European glassworkers.

In the spring of 1969 Chihuly left Murano and went to Germany to meet Erwin Eisch, whose family ran a glass factory in Frauenau. Eisch remembers, "We had some talk, and he did a little blowing in my workshop."[35] Eisch had encouraged his factory workers to experiment with goblet forms, but they were not comfortable making even the most minute variations from set specifications. Eisch's aim was "to guide glass from the so-called circle of good form, and to release it again, and consider it as an element which might harbor a whole world of poetical possibilities."[36] As Chihuly tells it, Eisch "introduced a line for the factory in which each piece was supposed to be a little bit different. He found that the workers . . . didn't want to have the responsibility of making . . . a decision in terms of design."[37] Eisch would become the first foreign artist to visit Pilchuck, and his philosophies would become a major ideological force in the American studio glass movement.

From Germany, Chihuly continued to Prague to visit Stanislav Libenský and his wife and collaborator, Jaroslava Brychtová. This talented Czech team produced magnificently large, thick, and heavy cast-glass sculptures, which, in their strength and solidity, were the antithesis of the light, ephemeral Venetian works Chihuly had been studying in

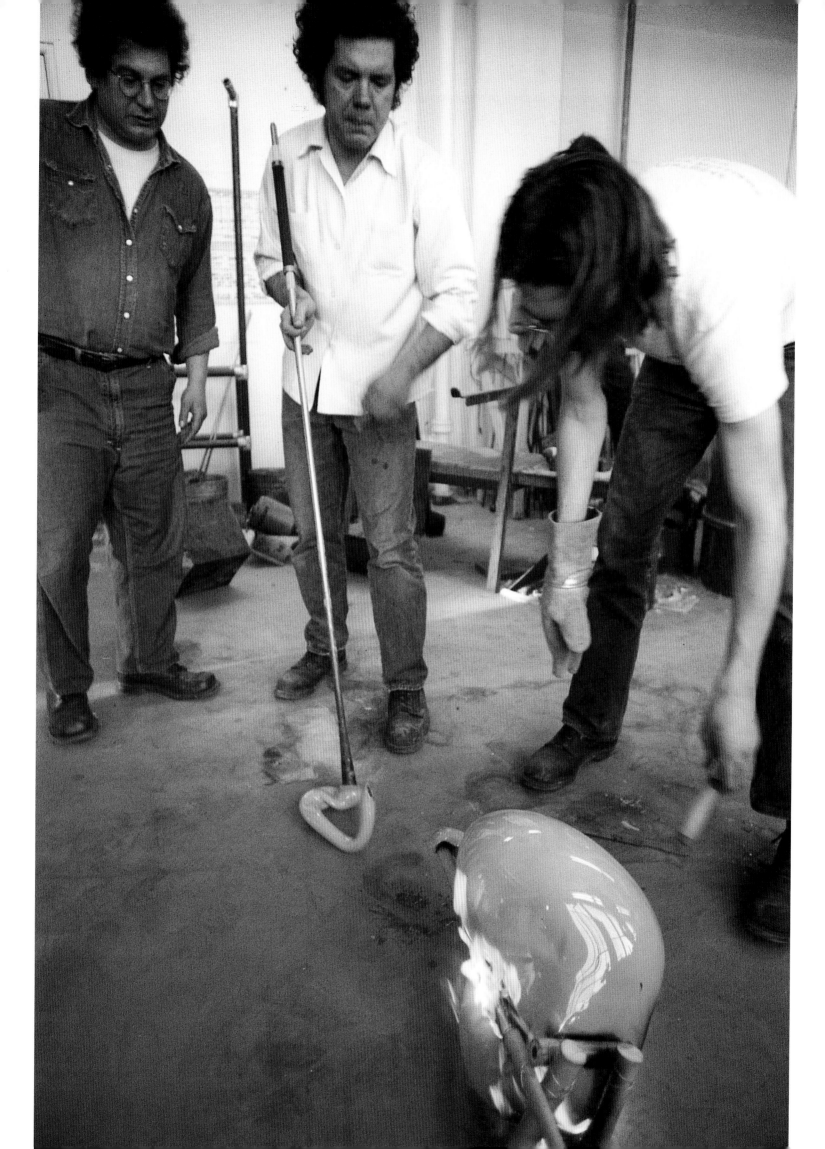

Murano. Where Eisch questioned form and explored lyricism, the Libenskýs found a firm ground in the philosophy of Czech cubism. Their pristine, geometric sculptures constituted purely formal explorations of light and color, combining a cubist approach to dimension with a metaphysical sensibility. Later, the Libenskýs, along with Eisch, would become a powerful presence at Pilchuck.

Back in Providence, in 1969, Chihuly began a ten-year stint as chairman of the then-fledgling glass department at RISD, a move that "would leave an imprint not only on the school but on the entire American glass movement."[38] His approach to teaching, distilled from his experiences at the University of Wisconsin, RISD, Haystack, and Venini, was eminently practical. Chihuly says, "I concocted a simple but effective teaching philosophy . . . a variation on the classic atelier model—[which] seemed to work."[39] He encouraged his students to live and breathe the medium, to work hard as they devised projects on their own, and then, with the help of accomplished visiting artists, to develop the skills they needed to realize their ideas. Fred Tschida, a student assistant, observed Chihuly's style: "Dale had a lot of energy, he had a lot of students around and people that were dedicated to his . . . ideas. . . . They were dealing with issues of form and sculpture and . . . installation."[40] It was at RISD that Chihuly's plans for a glass school coalesced.

Chihuly had become acquainted with the Italian-born sculptor Italo Scanga, formerly an instructor at RISD, in 1967, when he had returned to the school to give a guest lecture. Chihuly was attracted to the social and symbolic content of Scanga's work which stood apart from the then-fashionable minimalist investigations of pure form. Scanga and Chihuly collaborated on several projects at RISD, including one, in 1971, which involved blowing hot glass into a coffin-shaped bamboo mold. "Jamie [Carpenter] and I blew glass into a mold Italo had made out of bamboo," says Chihuly. "Needless to say, it burned up instantly, but I guess we succeeded in making some sort of anti–Vietnam War statement."[41]

Chihuly recalls: "Those first months at RISD amounted to the most creative, highly charged institutional experience I'd ever been a part of. The energy flying around the place was enough to make your head spin."[42] His early students—James (Jamie) Carpenter, Dan Dailey, Michael Glancy, Therman Statom, and Mary Ann (Toots) Zynsky among them—rose to the challenge and sailed beyond. Carpenter and Chihuly had hit it off immediately and in 1970 began a five-year collaboration in which they "pushed glass to its maximum potential as a sculptural medium."[43] With the help of Carpenter and Scanga, Chihuly would continue to push the limits of glass, finding a new point of departure in the mythic landscape of the Pacific Northwest, a fertile place for his unorthodox ideas to flourish.

Left to right: Italo Scanga, Dale Chihuly, and James Carpenter blowing into a bamboo mold in the glass shop at the Rhode Island School of Design, Providence, April 1971.

The Idea Is Born

Youth makes the revolution. Be strong. Be beautiful.

—Abbie Hoffman[1]

A news summary of 1969 reflects both the hope and despair facing American youth at the turn of the decade. The year saw the trial of Sirhan Sirhan for the assassination of Robert F. Kennedy, the historic moon landing of Apollo 11, the Woodstock Music Festival, the Manson Family murders, the closing of People's Park in Berkeley at the hands of the National Guard, and the My Lai massacre. The Vietnam War raged on, as did civil violence and disorder on college campuses across the country. Student activists seized University Hall at Harvard to demand an end to ROTC recruitment, and armed black militants gathered on Cornell University's campus during Parents' Weekend. Actions such as these led Columbia University to seek court injunctions against property seizure by students, and eleven states passed laws against campus disruptions. Three-hundred-fifty alternative, "free" universities were founded; Beat writer Jack Kerouac died at age forty-seven; the Hirshhorn Museum and Sculpture Garden, the Smithsonian's national museum for contemporary art, broke ground in Washington, D.C.; and people were into astrology and the philosophy of R. D. Laing.

In this doomstruck era of Nixon . . . we are all wired into a survival trip. . . . [Timothy Leary] crashed around America selling "consciousness expansion" without ever giving a thought to the grim, meat-hook realities that were lying in wait for all the people who took him too seriously. . . . The realities were already fixed; the illness was understood to be terminal, and the engines of the Movement were long since aggressively dissipated by the rush to self-preservation. . . . "Consciousness expansion" went out with LBJ . . . and it is worth noting, historically, that downers came in with Nixon.

—Hunter S. Thompson[2]

In spite of the promise of a new decade, 1970 was no less turbulent. Women and gays started to assert their rights; Philadelphia police were clashing with Black Panthers; musicians Janis Joplin and Jimi Hendrix died of drug overdoses; the Beatles disbanded; Berkeley police routinely tear-gassed students; radical activist Weathermen fled underground; President Nixon ordered the bombing of Cambodia; and four students were shot to death at Kent State University, Ohio, when the National Guard fired into a crowd of antiwar protesters. It was the height of the second civil war: America was killing its enemies in Southeast Asia and its youth at home.

The reaction to the bombing of Cambodia and the tragedy at Kent State was immediate across the country. Student strikes were called at every university and college campus in Rhode Island, and the Rhode Island School of Design was fully engaged in the development of its own antiwar "machine." A Providence newspaper headline proclaimed, "At RISD 'Strike Central' Artists Fight 'Kentbodia.'" Although RISD was rumored to be the visual arts center for nationwide strike activity, most of the 35,000-plus posters designed and printed on campus were distributed within the state. Striking

National Guardsmen level loaded M-1 rifles at a flag-waving student on the day of the fatal shootings, Kent State University, Ohio, May 4, 1970.

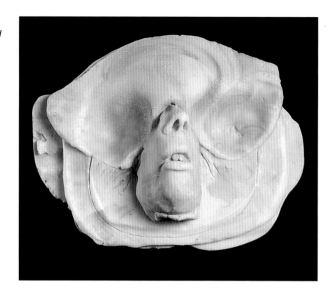

RISD students took to "displaying fractured and distorted American flags," and a group of students organized by Dale Chihuly and John Landon, a graduate student in sculpture, erected a large billboard.[3] Landon remembers that he and Chihuly "literally would drive down the street, collecting people off the street to work on this project."[4] Sited at the corner of Benefit and Waterman streets, the billboard measured 16 by 24 feet, weighed 1,000 pounds, and carried the following message:

The streets of our country are in turmoil. The universities are full of students rebelling and rioting. Communists are seeking to destroy our country. Russia is threatening us with her might and the republic is in danger. Elect us and we shall restore law and order. We will be respected by the nations of the world for law and order. Without law and order, our republic will fall. Adolf Hitler, 1932[5]

The disturbing similarity of these words to those which easily might have been spoken by President Nixon, and many other representatives of the U.S. government, was not lost on the populace of Providence. Citizens challenged the authenticity of the Hitler attribution, and a Providence newspaper article carefully traced the provenance of the quote. It had first appeared in print in a book by Supreme Court Justice William O. Douglas, from where it had been picked up and widely circulated by the media. The Providence paper reported, "The RISD sign was prepared by Dale Chihuly, an instructor

We were right in the thick of the social and political ferment that was starting to rock the nation in the late 1960s, and it was . . . intoxicating.

—Dale Chihuly[6]

in ceramics [*sic*]. A spokesman for the school said that Mr. Chihuly had seen the quotation in the *Washington Post* and other newspapers. Mr. Chihuly was not immediately available for comment."[7]

Just as intent as Chihuly's political statement was his dedication to furthering the cause of glass and its use as an artistic medium. At the time glassblowers throughout the country were undertaking demonstrations and workshops wherever and whenever they could. Fritz Dreisbach recalls: "We . . . were on the road and traveling around, doing these workshops and getting people excited. It was no different than doing gigs, being a musician. You pile in a van with your blowpipe and your guitar. It was a lot of that same kind of feeling, [of] spreading the gospel."[8] John Landon remarks that he and Chihuly "hashed around a lot of ideas about putting glass studios on the road . . . and having semitrucks with walls that opened. We were [like] traveling minstrels."

Robert Naess (American, b. 1943), *Political Nose Cup*, 1972. Blown glass with *murrine* decoration, 4⅛ x 5¼ x 2⅞ in. Collection Robert L. Pfannebecker, Lancaster, Pennsylvania.

It was during the downtime resulting from the RISD student strike, says Landon, that he and Chihuly began to talk seriously about starting a glass school:[9]

The original concept was somehow to meld together glass, which at that point no one had mastered . . . [and other media]. I certainly lobbied, and I think Dale agreed . . . for a place where artists were away from straight lines, and I also lobbied for having multimedia so that artists could work together. So that glass artists could actually be involved in the more aesthetic, abstract things, like painting and so on. . . . We had talked about this [as] . . . a sort of wilderness school experience.

Sometime during the fall of 1970 or winter of 1971, Chihuly approached Ruth Tamura, who was running the glass department at the California College of Arts and Crafts (CCAC) in Oakland, with his idea for a summer glass school in the Northwest. He had heard that the Union of Independent Colleges of Art (UICA) was inviting faculty to apply for a $2,000 research grant. Marshall Borris, a student of Ruth Tamura's, remembers that he first met Chihuly when he was a student at CCAC in the winter of 1971: "We [Chihuly, Tamura, and Borris] all met and discussed the idea, and

Dale Chihuly always dreamed of making a place that was . . . very much inspired by Haystack Mountain School of Crafts. But it wasn't to be . . . only for glass.

—Toots Zynsky[10]

Chihuly said he was putting things together to get a grant from the Union of Independent Colleges of Art."[11]

Chihuly and Tamura jointly applied to UICA to support a summer workshop in glass, with Chihuly representing the Rhode Island School of Design and Tamura the California College of Arts and Crafts. Of all the schools belonging to UICA, CCAC was the closest, geographically, to the Northwest. Chances of being awarded the grant were increased by the cooperation of East and West Coast schools in the project.[12]

Chihuly and Tamura were awarded the grant and by the spring of 1971 had the $2,000 in hand. Part of their stated purpose was "to experiment with methods other than those used in conventional college art classes and conduct an outdoor workshop so students would receive inspiration from nature."[13] Chihuly recalls that the project was considered "highly irregular, if not outright crazy."[14] The grant specified that two promising art students, one with a background in glass and one with no background in the medium, would be chosen by the deans of each of UICA's eight member colleges. This consortium included the California College of Arts and Crafts, Cleveland Art Institute, Kansas City Art Institute, Maryland College of Art, Minneapolis Institute of Art, Philadelphia College of Art, Rhode Island School of Design, and the San Francisco Art Institute. The art students would attend the summer program free of charge, but academic credits, apparently, had to be worked out on an individual basis. Tamura remembers that she "arranged for students from her school to receive three academic credits by paying fifty dollars."[15]

Dale couldn't have come at a better moment.
—John Hauberg

Hoping to attract applicants in addition to the sixteen students from UICA schools, Chihuly distributed a poster to other universities and art schools: "My good friend Art Wood . . . designed a recruiting poster for us. In the imagined setting for the school that flowed from Art's pen, huge Douglas firs stood above the waters of Puget Sound, with the craggy, glaciated summits of the Cascade range towering in the distance."[16] Wood's pastoral rendering was strangely close to the truth, although at the time of the poster's distribution, Chihuly still did not know where the summer school would occur.

In the spring of 1971, Chihuly came to Seattle, ostensibly to scout locations and to meet with John and Anne Gould Hauberg, art patrons whose advice Jack Lenor Larsen had encouraged him to seek. Chihuly recalls: "I called Jack Lenor Larsen and told him . . . that I was looking for a place to start this school which I probably only dreamed would last longer than one summer. Jack Larsen called Annie Gould Hauberg and told [her] that I was looking for a place to start the school."[17]

It was a unique moment of three people coming together. Dale was full of energy and had a vision, John liked the idea of something happening at the tree farm, and I believed in artists and creative people.
—Anne Gould Hauberg

Chihuly was already considering an offer from an old high-school friend, Paul Inveen, who had volunteered his house in Rosedale, on the Kitsap Peninsula, which had convenient bridge access to Tacoma and Seattle. With this option in mind, but still

Early 1960s view of the Pilchuck Tree Farm property. The reservoir, now called the Pilchuck pond, was dammed and substantially enlarged in the mid 1960s.

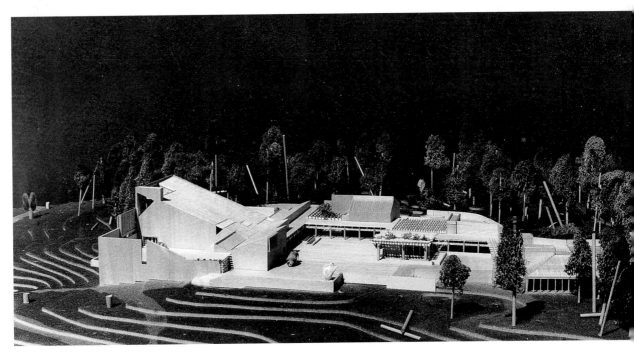

Model for the Mark Tobey Museum of Northwest Arts and Crafts, once planned for the site that eventually became the Pilchuck Glass School.

entertaining the idea of an island location, Chihuly called on the Haubergs. John Hauberg remembers: "We had [received] a letter from Jack Larsen saying he was sending out a young man . . . named Dale Chihuly who wanted to start a glass center up in the San Juan Islands. He . . . dropped in, right out of the blue. He called Annie when he got here, and he never got to the San Juan Islands."[18] Philip Padelford, an early Pilchuck trustee, says: "I think Anne was very keen on Chihuly . . . and John was a little cool, so Anne, Chihuly, and I . . . had lunch, and we listened to him describe what he had in mind. I came away convinced he was a pretty confident guy and one worth working with."[19] According to Anne Gould Hauberg, this was a "very key luncheon. Phil . . . told John that Dale was a serious person and had a good idea."[20]

Hauberg dissuaded Chihuly from pursuing an island location, because of the inconvenience of ferry travel, and offered him the use of a site on his own property. It was, Chihuly recalls, "an abandoned barn, farmhouse, and outbuildings on a corner of a tree farm [the Haubergs] owned 50 miles north of Seattle. They called the place Pilchuck."[21] John Hauberg had begun to acquire land for tree farming in the late 1940s, and he bought the 2,400-acre tract where the Pilchuck Glass School would be founded in the mid 1950s. In the late 1960s Hauberg decided to develop part of the property, and plans were created for the construction of three golf courses and several villages, collectively known as the Tatoosh development.[22]

From the beginning, Anne Gould Hauberg, a passionate supporter of Northwest artists, envisioned that the development would include some kind of arts organization or activity. John Hauberg recounts, "We were thinking about building a museum called the Mark Tobey Museum of Northwest Arts and Crafts."[23] The museum, which also would function as an arts center, would occupy a magnificent hilltop site with a 180-degree view of Puget Sound, the San Juan Islands, and the Olympic Mountains. But plans came to a sudden halt when Tobey vetoed the project. "Tobey took serious exception to the idea that the museum, which would be named after him, would be out in the country," says John Hauberg.[24] Anne Gould Hauberg remembers: "Tobey . . . said, 'I'm not a country person, I don't want my museum in the country.' And so, that was that."[25] The project was abandoned, and by the mid 1970s so were plans for the development, a victim of rising interest rates.

But Anne Gould Hauberg had continued to hold out hope for the site as an art center. An uncompromising idealist and visionary, she has always, as she says, "cared that creative people are supported."[26] The daughter of renowned Northwest architect Carl F. Gould, who designed many of Seattle's landmark buildings, Hauberg as a child studied at the Cornish School of Art under the then-unknown painter Mark Tobey. As an adult, Anne Gould Hauberg became a close friend and ardent supporter of Tobey's, and the idea of Pilchuck as an art center was part of her dream. Since the 1950s, John and Anne Gould Hauberg had been involved in a vast number of personal and civic arts projects, and had been steadfast advocates for developmentally disabled children. According to John Hauberg, "Annie wanted very badly to have some kind of art enterprise up there on

So we found that place where the hot shop [is] . . . and we literally did kick our heels in the ground and say, "I don't know, it looks pretty good to me!"

— John Landon

the hill. It's such a beautiful site . . . it deserved some attention as a public spot. And I agreed with that, although I didn't agree with very many of her ideas as to what was to be done with it. So when Dale came along and proposed the school, which obviously was to be just temporary, we thought, 'Gee, what a great thing to get people's attention.'"

The day after Hauberg proposed the use of his property to Chihuly, he took him to see it. "I walked [Chihuly] maybe five miles over the hills," Hauberg says, "which didn't really have any trees on them in 1971." Anne Gould Hauberg explains that "Dale didn't ask for much. He had $2,000 and he had the students and [we had] . . . a blank piece of property. We weren't bringing in water . . . [or] electricity. Dale was willing to do the whole bit."[27]

Chihuly returned to Rhode Island and began to assemble a team to go out West for the summer. "I was mostly just trying—as I did at RISD—to get the hippest . . . people I could . . . who had the energy," explains Chihuly. "It was quite an eclectic mix."[28] Chihuly wrote John Landon, who had moved to Montana in 1970 after receiving his MFA from RISD, about joining his crew. Landon suggested that Chihuly fly to Missoula and drive with him to Seattle. At the time, Landon was living on an island in Flathead Lake and had gained considerable knowledge of outdoor survival. These skills would prove essential at Pilchuck, where everyone would be living outside for the first few summers.

While waiting for Chihuly to arrive, Landon decided to make a shelter to bring with him. He had been studying the Sioux, and thought, "Well, we're going out to the Cascades, I think I'll build myself a tipi. I'd heard that it rained but I wasn't sure. . . . So, I took old parachutes and I did it all according to the Sioux [way]. I got the poles on the island, peeled them, and set the whole thing up so I knew that it worked." Meanwhile, Chihuly arranged to rendezvous at his mother's house in Tacoma, Washington, with the RISD group, which included James Carpenter, Robert Hendrickson, Chris Pinney, and Toots Zynsky, who would transport the glassblowing equipment from Providence and help set up camp.

In May 1971 Chihuly flew to Missoula, where Landon met him: "I came off the island and drove down, 50 miles or whatever, picked him up at the airport, took him back up to the island." They stowed Landon's gear,

Dale Chihuly and John Hauberg at Pilchuck, 1982.

The site of the first hot shop, 1971.

including tipi poles, tarps, and World War II wall tents, into a boat which they piloted 2½ miles to shore: "[With about] 4 inches of freeboard, [we were] very calm but both sort of looking at each other and saying, 'Is this adventure starting out great or are we going to sink?'" They made it and, in Landon's fully loaded truck, with 14-foot tipi poles preceding them, headed for Viola Chihuly's house.

Not long after their arrival, Chihuly and Landon went to Rosedale to inspect Paul Inveen's property. Landon remembers that the site—with a house—was tempting, but "I hadn't moved from fabulous Montana to stick myself . . . in a house. [The area] was rural . . . but it was tame." They then headed to Stanwood to see the Hauberg tree farm, on which stood a little white house and an old milk barn. Landon remembers this site as "ideal, it had a milk barn [with] stalls. It wouldn't have taken much to whip [it] into shape. . . . People could have tented out back, whatever. But I guess it was the romance of the idea. We decided to head on up the road the following day and see what was there." Chihuly and Landon walked up a logging road, which is still the main road into the school. Although much of the land had been cleared of trees, it appeared rustic and pristine. Pasture had replaced forest, and local farmers were allowed to graze their cattle there to keep brush down.

"I don't know what got us up on that hill," says Chihuly, "but we went up and looked." Passing a pond, they went up a small hill, and the view was "wide open . . . it

> The philosophy behind it really was that we were going West. . . . We went West with the idea that we might not come back. . . . It was the time of alternative education, when institutions were being questioned and analyzed. . . . The West was the West. It was so beautiful.
>
> —Toots Zynsky

was spectacular." It was here, they decided, that their school in the wilderness absolutely had to be, despite the site's primitive conditions. Chihuly describes the setting:

Landon and I were immediately drawn to . . . a hilltop clearing that had a commanding view of Puget Sound and the Skagit River valley. . . . Unfortunately, this hilltop, with which we had fallen hopelessly in love, had nothing on it but a bunch of cows—no buildings, no electricity, [or] utilities of any kind. . . . We decided we would rather build Pilchuck from scratch than move into the existing, less spectacular site. . . . It was actually one of the most daring things we did. Because it would have been much easier to stay down on the farm.[29]

Chihuly quickly composed a letter to the Haubergs proposing that the summer school use the unimproved site. Hauberg immediately agreed. Chihuly remembers: "After walking back and forth across the hill . . . with its striking views down to the salt water and beyond . . . Hauberg, Landon, and I agreed that the Pilchuck hot shop should be built on the site where it stands today."[30] As Landon remarks, "the idea had to be born," and so it was.

1971: The Peanut Farm

Make no mistake: That first summer up there was a rough one—in some ways it was the worst summer I remember. But it was also the best summer I can remember.

—Dale Chihuly[1]

James Carpenter, Robert Hendrickson, Chris Pinney, and Toots Zynsky arrived in Tacoma, Washington, on May 29, 1971. Driving furnace materials and glassblowing equipment crosscountry in Chihuly's van, they had left Providence with Paul Inveen's address in Rosedale as their final destination.[2] Only after stopping at Viola Chihuly's house did they discover that the workshop's location had been changed to Stanwood.[3]

Students were to start arriving on the first of June in Tacoma, and they also would rendezvous at Viola Chihuly's home before heading to Stanwood. There was little time for preparation at the workshop site. Construction of the hot shop began first. Shovels were procured, and everyone started digging and leveling the ground to make a pad. Dale Chihuly and the RISD group temporarily moved into the little white house, next to the milk barn, while Landon set up his tipi in a meadow near the hilltop vantage known as Inspiration Point. Located more than a mile from the hot shop site, the white house was a helpful transition from domestic, urban living to roughing it outdoors in the mud and the rain.

It was an accomplishment to blow glass in an open field. . . . In many ways, it was rather amazing.

—Ruth Tamura

Western Washington is famous for its rain but also is known for its mild summers, generally characterized by long stretches of warm, dry weather. From June 1 to July 14 during the summer of 1971, however, daily temperatures in the Seattle area averaged in the high 50s to 60s, and weather forecasts indicated a chance of rain almost every single day.[4] Unlike some towns and islands of Puget Sound, Pilchuck does not fall in the region's "rain shadow" but in the Cascade foothills, a geographic area that attracts all kinds of weather. And not one person among the first Pilchuck group, except John Landon, was prepared for it.

"We specified that [the students] . . . should bring camping equipment," says Toots Zynsky. "And no one showed up with any camping equipment. . . . We were all camped out between the house and the barn for the first week or so. . . . [It looked] . . . like a refugee camp." Peet Robison remembers

All the rain that was in the clouds dropped on Pilchuck that summer. It was a muddy mess.

—John Hauberg[5]

that Chihuly drove him and some other students up to Pilchuck in his van. When they arrived, Chihuly said, "There it is!" Robison said, "What? Where is it?" It was then that Robison and the others realized that they would be building the hot shop and their shelters, but, he says, "it didn't bother me. . . . That was a lot of fun."[6]

During the first two weeks of June, Chihuly, Landon, and the RISD group were joined by graphic artist Art Wood and students from across the country. The first-year

Left to right: Dale Chihuly, Robert Hendrickson, and James Carpenter, 1971.

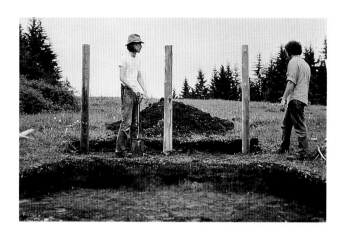

James Carpenter (left) and Dale Chihuly break ground for the hot shop, June 1971.

students included Marshall Borris, Susan Lawson, Michael Nourot, and Tony Lent from the California College of Arts and Crafts, Oakland; Chris Federighi from the Cleveland Art Institute; Robert Sestock from the Detroit Institute of Art; Peet Robison and William Carlson from the Kansas City Art Institute; Debbie Goldenthal from the Maryland College of Art; Arthur Eng and Jonathan Block, a Seattle native, from the Philadelphia College of Art; Chris Harding from the Rhode Island School of Design; and Toby Kahn and a student from the San Francisco Art Institute remembered only as "Rob." Other students included Mark Prieto, Rick de Monet, and Michael Rushford.[7] Most of the students were eighteen or nineteen years old, and Chihuly, the oldest, was almost thirty.

It was so frigging wet you couldn't start a fire with a blowtorch.

—John Landon

Toots Zynsky recalls:

There were eighteen students. There was supposed to be a total of sixteen students from the eight colleges. A couple of them sent extra because they didn't know what to do with them. So there were eighteen. One after another, we would go to get them at the plane, it was two guys, two guys, two guys, three guys, one guy, one girl . . . a girl! We wound up with eighteen guys and three girls on the worksite. . . .

[But] there were no real students the first summer. There were no teacher-student relationships. It was a total learning, sharing [experience]. . . . People just giving information to each other and doing things together.[8]

The quality of working independently to achieve the goals of the group was not accidental. The first Pilchuck catalogue (1972) stated: "We feel we successfully offered an alternative to the traditional schools of art and craft education. By encouraging people to design their own program and direction, new demands were made on their initiative and imagination."[9] Thomas Bosworth recalls the first Pilchuck summer as an "experiment in alternative education," in which the "making of art merged with the rest of life—cooking and eating, building shelters and work facilities. It

Students, 1971.

was a counterculture gesture."[10] The first weeks at the site were a strenuous test of these philosophies. "When I think about it," says Zynsky, "it's a miracle that anyone stayed. That was definitely a summer where the whole was more than the sum of the parts."

The tipi that John Landon made set in place a tone and a quality
and a statement about living. It was absolutely first-class.

—Anne Gould Hauberg[11]

John Landon's Sioux-
style tipi at Inspiration
Point, 1971.

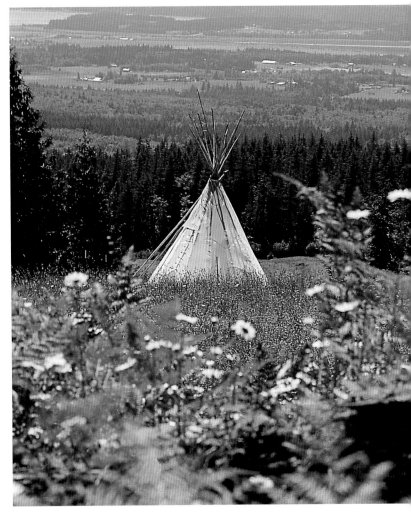

Left to right: John
Landon, Dale Chihuly,
Michael Nourot, and
Debbie Goldenthal,
1971.

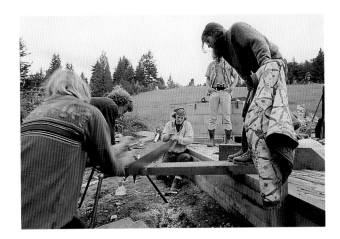

View of the initial fram-
ing of the hot shop, June
1971. The "railroad
shack," the only exist-
ing on-site structure,
is visible in the
background.

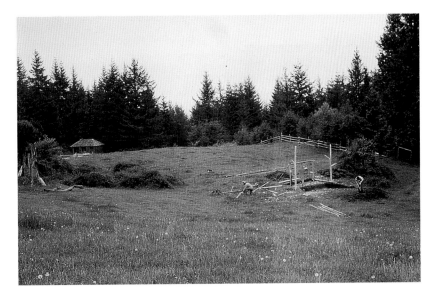

While continuing to dig, level, and install a hot shop floor, the group raised moving everyone to the site to its first priority. Richard Marquis, who was teaching glassblowing in the ceramics department at the University of Washington, told Chihuly about Boeing and state surplus outlets: "I took Dale and Marshall [Borris] . . . [and] we went out and got a bunch of Army tents to set up at Pilchuck."[12] Zynsky recalls, "Dale was a great scrambler. . . . We all went down [to the surplus store] and luckily, they had just

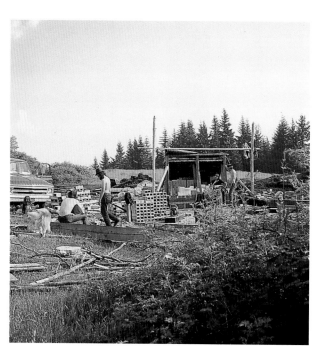

A lean-to outfitted with a sod roof protected materials while the hot shop floor bricks were readied for laying, June 1971.

gotten in a shipment of down sleeping bags . . . so we got everybody sleeping bags and these big tents."[13]

When the surplus gear was delivered to the site, James Carpenter remembers that everyone, "each on their own, started setting up tents . . . or whatever was needed."[14] But tents pitched directly on the ground—either in open, muddy areas; wet, thigh-high grass; or dripping forest—did little to increase comfort. "It was pretty soggy," recalls Zynsky. "And we were working in the rain all the time. We would wake up with slug trails over our sleeping bags every morning." Borris remembers, "We lived in tents for the summer. At the beginning . . . I had a van and I had to sleep in the van, it was so wet." "Other than John Landon's tipi," says Ruth Tamura, "there were no structural dwellings of any kind. The first year was van living."

The immediate area of the Pilchuck campus possessed only three structures at the beginning of the first summer: John Landon's Sioux-style tipi, a wood food cache built

Assembling bricks for the hot shop floor, June 1971.

by Landon (which survived until the winter of 1995 as the oldest Pilchuck School structure), and an old shack, possibly dating from the early 1900s. This so-called railroad shack once had served the English Lumber Company trains that had hauled big trees at the turn of this century. The Pilchuck crew "kicked the mice out of that place" and used it for storage. Landon's cache protected food from local wildlife, notably bears. These structures soon were joined by the hand-built hot shop and, at the end of the summer, by the beginnings of a shed with a shower and toilets (now used as a photography studio). A trench-type latrine was engineered, Michael

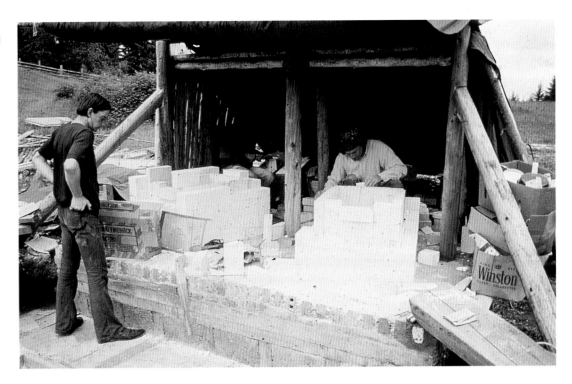

Nourot remembers, "by those of us who had military experience," and dug along the downhill side of the main road.[15]

In spite of constant rain, during the first two weeks, work progressed quickly on the construction of the pad, made of bricks and tiles, and the furnaces. "We would meet early in the morning [to plan the day's work]," says Toots Zynsky:

No one had a watch. We didn't even know what time we were getting up. We were hippies, okay? People have to understand that. No watches, no underwear, no nothing. So, we were getting up when the sun came up. We didn't know about this area, about the latitude. We would work, work, work until it seemed about midday, then [eat]. . . . The only time we did see the sun was when it was between the clouds, way out over the [water]. . . . It gave us a little hope. And we were usually eating about then. Then, finally . . . someone showed up with a watch and we realized we'd been getting up around 4:30 in the morning, eating at 3:00 p.m., and going to bed at 11:00 p.m.

Materials for the hot shop and shelters came from a variety of sources: state and educational surplus (via Richard Marquis), the Stanwood dump and auctions in Snohomish, donations from the Northwestern Glass Company (via Roger Ek, a cousin of Chihuly's), the hardware store in nearby Mount Vernon, and local thrift shops. Chihuly remembers that Jonathan Block had a knack with the telephone. They set him up in the white house, with his wife, Cathy, where "he became Pilchuck's version of Milo Minderbinder, scamming materials for the school with a zeal that was awesome to behold.

It's always a spiritual happening when you fire up a new furnace.

—Michael Nourot

A natural wheeler-dealer, Jonathan procured much of what we needed from government and Boeing surplus outlets."[16] Zynsky recalls that "it was like a scavenger hunt. In the morning, we would make a list and people would say, 'I'll do that' and 'Okay, you can do that.'"

The biggest challenge was getting the furnaces going. The group was united by their intense desire to blow glass and, almost as strongly, by the promise of heat. Marshall Borris recalls that they "proceeded to clear an area and build furnaces. We made a sort of stepped arrangement in the hillside and poured some cement into it, and we had fire bricks and castable refractory, and we built the furnaces of fire bricks and cast the arch crowns [roofs] of the glass furnaces." A wood lean-to with a sod roof was built behind the furnaces to store the raw materials (called "batch") for making hot glass. A propane tank was obtained with John Hauberg's help, and bricks and some of the batch ingredients were donated by the Northwestern Glass Company (now Ball Glass Container Corporation) in Seattle. Richard Marquis came up to the site with supplies from the University of Washington and saw a bunch of wet people ankle-deep in mud: "I didn't think any good work would be made because they were up against so many odds. It was just pouring down rain."

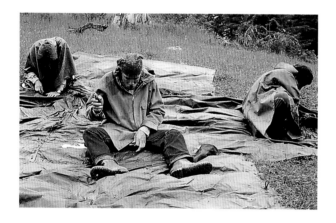

Michael Nourot (center) and others sewing the first hot shop roof, June 1971.

Poles to support the hot shop roof were collected from the forest, cut, peeled, and prepared. Michael Nourot, who had a background in textile arts, and others sewed the roof from Army tents and tarps. "We were building the furnaces in conjunction with the roof," recalls Nourot. "We realized right away that we weren't going to be blowing any glass unless we could keep the rain off." Chihuly says, "I still have a vivid image of Michael, sitting on his butt in the tall grass of the hillside, stitching together the Army-surplus tents to make a circus-style roof for the hot shop."[17] Meanwhile, the propane truck showed up with tanks of fuel. After only sixteen days, everything was ready. It was time to light the furnaces.

Finally there was heat. And glass? The two furnaces were working, but there were still technical problems to sort out. Wanting to start from scratch, Dale Chihuly and James Carpenter had decided to mix, or "batch," the raw glass ingredients themselves, as many independent glassworkers did at the time. Their other option would have been to remelt broken-up pieces of glass, called cullet or frit, which is what most school glass studios did. "We received materials, such as soda ash and sand, free from Northwestern Glass Company, and we got [other] formula constituents from an aluminum recycling place," says Marshall Borris. They

I don't know who [blew the first piece of glass]. . . .
It wasn't important.
—Toots Zynsky

measured the purchased and donated chemicals into a barrel and mixed them by rolling the barrel down a hill. It was certainly not the way most glass professionals did it, but neither was blowing glass in an open field, in the rain, with no electricity. But that was the point. They had to find their own way.

The ongoing rain and moisture caused the batch chemicals to harden. "We had no cullet," recalls Michael Nourot. "We tried to melt batch to start with [but] . . . we had problems getting the heat up high enough. We had two furnaces, so we would melt in

The completed furnaces. Glass was melted in one furnace while the other was in use. A pipe warmer sits between the furnaces.

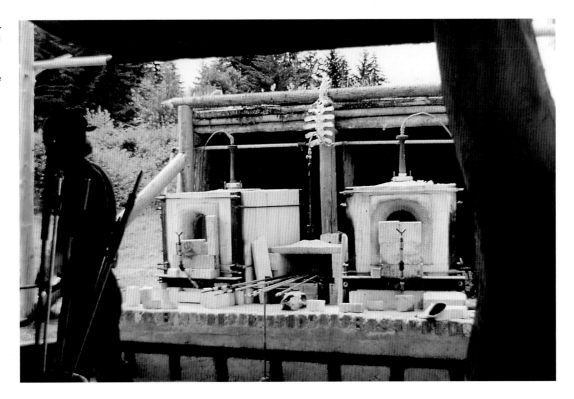

one and work out of the other one." Ultimately the group turned to facilities at the University of Washington. They used a large natural-gas-fired furnace in the former Fire Arts Building to melt and to frit, a process in which glass ingredients are premelted and the molten glass then cooled in water and broken up, making it easier and less time-consuming to melt the glass again on site. Richard Marquis remarks that melting at the university, for Pilchuck, was essentially free: "The furnace was not metered." "We pulled the glass out of the furnaces and poured water on it to make frit," remembers Marshall Borris. "We then remelted it [in the Pilchuck furnaces] . . . because it takes a lower temperature to remelt the glass [cullet] than it does to make the initial batch." Marquis adds that, after fritting, the glass was loaded into someone's van and transported to Pilchuck. "They drove [the cullet] . . . in this van, with steam coming out the back, up Highway 5 to Pilchuck. . . . It looked like the car was on fire!"

Glass was the impetus.

—John Landon

Other equipment had to be made, or somehow obtained, with little or no money. Blowing glass requires—in addition to a furnace and glass—assorted tools, a bench or chair with arms, a steel-topped table called a marver, and an annealing oven in which to gradually cool hot forms. Unannealed glass is volatile and unpredictable: spontaneous breakage is common, and the glass may even explode. Annealing ovens are generally electric, and now the fanciest are computer-driven. But Pilchuck's first summer was strictly low-tech, and the annealing oven was run on quirky propane burners. "We used concrete blocks and [old] . . . bricks and insulated it with dirt," says Marshall Borris. "Farm-type furnace nozzles that they used to heat barns [were run] . . . under the annealing oven, and we used a V-block insulation for the top." Michael Nourot remembers Nick Gavagnarro, a welder and a friend of Chihuly's from Seattle: "He helped us invent things.

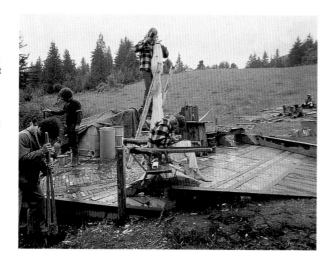

Robert Hendrickson and John Landon carve the "swan" bench, 1971. The scroll bench, carved by Toby Kahn, appears at the right. Dale Chihuly and a student work on the left; in the background, students sew the hot shop roof.

The first burner we used on the annealing oven was a grass-burning device . . . [used] along the sides of highways. He helped us convert that into equipment." It was crude, but it worked.

Nick Gavagnarro also helped make tools. James Carpenter had brought blowpipes, used to gather glass from the furnace, blow bubbles, and form objects, and punties, used to add bits of glass onto the blowpipe or to transfer an object for finishing the top end. But other tools were needed. People carved their own paddles and blocks, used for shaping the hot glass, from pitch-free fruitwood. "We all sat around with our wood and our chisels," says Peet Robison. "We carved . . . and chipped and soaked them all night and identified them with funny handles." Metal tables and old car parts scrounged at the Stanwood dump made, with Gavagnarro's help, great tongs and jacks for shaping bubbles, and optic molds for making impressions on hot glass. Steel arms, or rails, also were needed for the bench, known historically as the Glassmaker's Chair. Pilchuck's first

Dale Chihuly blowing a free-form shape, 1971.

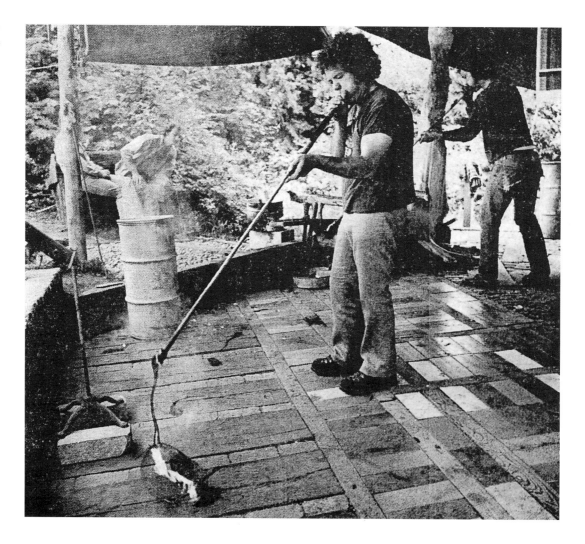

bench, called the "swan" bench, was carved from a cedar snag by John Landon and Robert Hendrickson, who carved a bird on top.[18] Toby Kahn carved an elaborate scroll

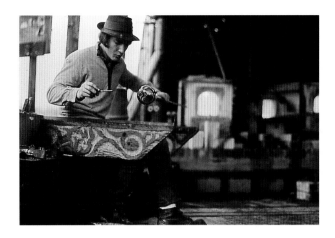

Jonathan Block shaping a vessel at the scroll bench carved by Toby Kahn, with furnaces in the background, 1971.

design on a second bench put together from found logs. The remains of Landon's bench, looking like driftwood stuck into the ground, still stand next to the hot shop.

Pilchuck's founding "make-do" attitude allowed individuals complete freedom in deciding how needs and problems—domestic or artistic—would be approached and solved. This was the heart of the Pilchuck experiment. It was important to question dogma, and this position extended to blowing glass. Chihuly wanted his group at Pilchuck, like his students at RISD, to find new ways of working blown glass, to explore form, and to approach vessels as sculpture rather than functional containers.

No one seems to remember who blew the first bubble, nor, as Toots Zynsky remarks, was it particularly relevant. It was a group process orchestrated by Dale Chihuly and James Carpenter, and a group discovery. The blown bubble—the first glass made at Pilchuck—branded the school as a place primarily for hot glass techniques (that is, blowing) as opposed to warm (casting, slumping, fusing, lampwork) or cold (stained, engraved, painted) methods.

The first summer was blown glass only. Most students had little or no experience in glassblowing and made simple vessels. According to John Landon, "hardly anything besides a beer mug" came out of the first summer, and it seems that, in spite of Chihuly's interest in sculpture, most activity was focused on the type of expressionistic, functional-blob craft wares that were so popular in the early 1970s, when imperfections and other shortcomings were treasured as hallmarks of the handmade. Chihuly did devise, with

Students from eight colleges from across the nation have gathered at a woodland setting, near Stanwood, to participate in the revival of what a decade ago was described as a "dying art": glassblowing.

—*Stanwood News*, 1971[19]

Carpenter, an installation in a mud pond near the propane tanks. They made, and then floated, a series of glass bubbles on the water. When the water dried up a few weeks later, the bubbles disappeared along with the pond. "The idea of making goblets and vases was not what we were interested in," claims Chihuly. "We did a lot of projects outside, temporary projects. It was a time . . . when you didn't think about permanency in any way."[20]

Nevertheless, vessels predominated, and the first one made at Pilchuck is reputedly an unusual cobalt-blue goblet, now owned by Anne Gould Hauberg, signed "Dale Chihuly." Photographs accompanying the first newspaper article written about Pilchuck, which appeared on July 7, 1971, in the *Stanwood News*, show Marshall Borris and Michael Nourot at Toby Kahn's carved scrollwork bench, blowing a small two-handled

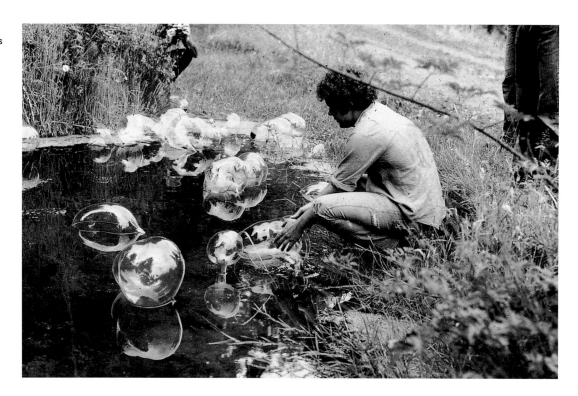

The first art installation at Pilchuck was a series of large, blown glass bubbles sited in a mud pond behind the hot shop. Chihuly places the forms on the pond while Buster Simpson documents the event.

vase with applied glass trails, a characteristic object of the period. Writer Cliff Danielson reported:

This goblet reportedly was the first object blown at Pilchuck. Collection Anne Gould Hauberg, Seattle

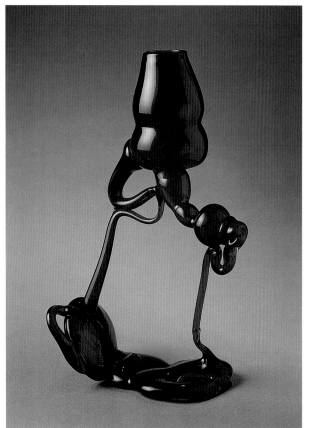

Some of the students are interested in glassblowing from primarily a utilitarian standpoint. Others are mainly interested in it as another form of art. There is demand for the products of either interest . . . but there is nothing for sale at the colony. "We're here to learn," one told the News *representative. . . . The students are not anxious to encourage visitors. . . . Nevertheless, "we are interested in telling the people of the community what we're doing so they won't think we're just a bunch of hippies," one student said in an oblique reference to his group's hair style and mode of dress, which in several cases is rather outstanding.*[21]

Judging by the cobalt blue of Chihuly's goblet, the Pilchuck group early on attempted to make glass of different colors by adding metal oxides to the batch. No one knew to use the now-ubiquitous German glass color bars, and so colors were mixed in the traditional way, in small pot furnaces or larger tanks.[22] Problems of compatibility were rife between glasses of different colors, or between colorless and colored glass. Speculation about the properties of different metals was rampant, and misinformation about achieving certain colors, persistent.

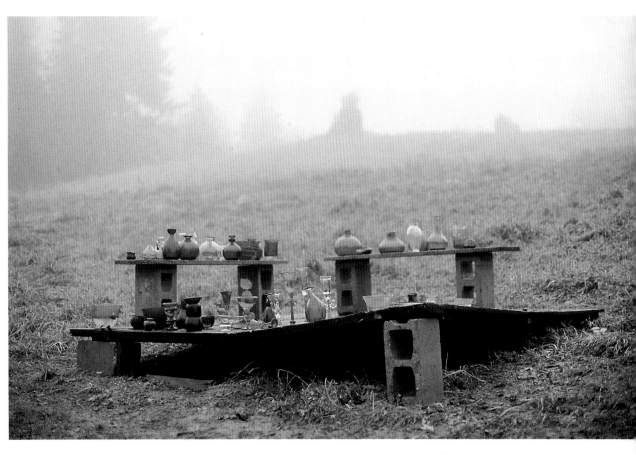

Richard Marquis vividly remembers one morning at the university that summer: "I came into school and found Marshall Borris, who was in charge of melting and fritting

I was just mesmerized by glassblowing. Immediately, before I even tried it. Just watched them blow a few pieces. . . . I felt, just let me have that blowpipe.

—Peet Robison

the glass for Pilchuck, [and an assistant] doing something at the furnace. . . . They were trying to get nickels out of the tank. I said, 'Nickels?' They were trying

to make a nickel green [glass] and someone had told them that for a hundred pounds of batch, you put in a dollar's worth of nickels! I said, 'I don't think so!' So there were these coins fused to the bottom of the tank. . . . I remember . . . chunks of glass with nickels inside of them." Marquis says, "It was just the early days, you know . . . and somebody was having a good laugh."

The Peanut Farm is the brainchild of Dale Chihuly. For several years [he] has dreamed of a summer workshop where work and living, art and nature, could be brought together.

—First Pilchuck catalogue, 1972

In late June of 1971, James Carpenter left the Pilchuck workshop for North Carolina to teach a session at the Penland School of Crafts near Asheville, and then traveled to Italy, on a Fulbright fellowship, to work at Venini. Just before Carpenter left, Lewis (Buster) Simpson rode into camp on his

BMW motorcycle. Chihuly had met Simpson, an environmental artist, earlier that year at the Rhode Island School of Design, and had invited him to help set up Pilchuck,

although Simpson recalls that he had little impact on the first summer: "By the time I got there, a fair amount of the work of building the furnaces and putting up a tent over the hot shop had already been done. . . . That first year I just met the various personalities involved: Jamie Carpenter and John Landon and Dale and Robert Hendrickson . . . and Toots [Zynsky]."[23] These influential personalities—Chihuly and Carpenter, Landon, Hendrickson, and Zynsky—all left their own artistic stamp on the fledgling school.

John Landon "just kept it going," remembers "student" Peet Robison. "He was a mountain man [and] really taught us how to deal with the elements, how to tough it out and deal with the cold. . . . He was really part of the glue." "Landon built this beautiful tipi," Zynsky recalls. "It stood up on the hill. It was magical, it was so beautiful. We would have campfires and eat there at night when it rained." Michael Nourot remembers "some crazy nights we had up there. . . . They were . . . very primitive, spiritual experiences." Landon's expertise in outdoor living and his humorous storytelling kept up morale. Both he and Buster Simpson encouraged students to consider the ways and means by which they lived as important to their art as the objects they created.

Simpson, in the early years of the school, attempted to combine his video and performance work with glass. Grounded in the environment and its human community, his art investigated ecological, anthropological, and sociopolitical issues. Simpson had designed and built sets at the Woodstock Music Festival, and his friendship with musician Commander Cody of the Lost Planet Airmen was as impressive to the students as his outlook on living and making art. "He was really into music," remembers Peet Robison. "And he was turning us all on to music. Just being spiritual, conceptual. . . . We had a lot of very deep talks."[24]

Everybody kept complaining about . . . the slugs.
—Ruth Tamura

Spiritual, environmental, and lifestyle concerns also were addressed by Robert Hendrickson, a painter who called himself White Eagle. The roots of most New Age thought in the 1990s actually go back to the 1920s, when alternative spiritual concepts, Eastern philosophies, and utopian experiments enjoyed a widespread popularity. But the ecology movement—a political call to action distinct from the centuries-old, pastoral imaginings of a simpler, back-to-nature existence—was born in the late 1960s and was directly influenced by a growing popular awareness of Native American beliefs. Environmental issues and the practices of non-Western belief systems were new and exciting areas to be explored and discussed in the early 1970s. In addition to doing a lot of building, Hendrickson "was our spiritual leader," says Toots Zynsky. Chihuly remembers that Hendrickson had worked in New York as an assistant to artists Kenneth Noland and Dan Flavin, but then dropped out.[25] At Pilchuck, Hendrickson "was just a presence, around," recalls James Carpenter. "He was into Indian mysticism. He was very much a part of nature and tried to understand those forces."

Toots Zynsky was one of the few women at Pilchuck in 1971, and "one of the few women in glass, period," as Ruth Tamura succinctly puts it. While she worked on the

John Landon eats dinner
off the end of a machete,
1971.

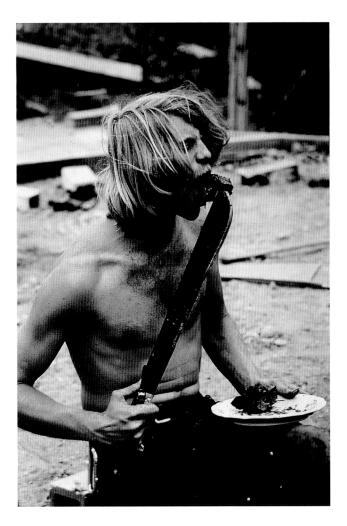

Toots Zynsky, 1971.

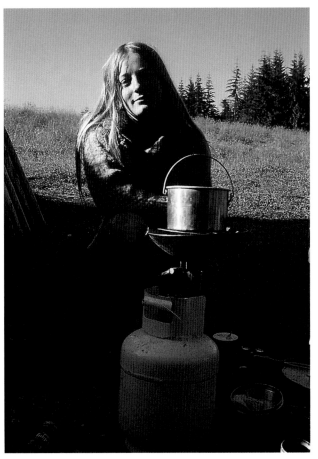

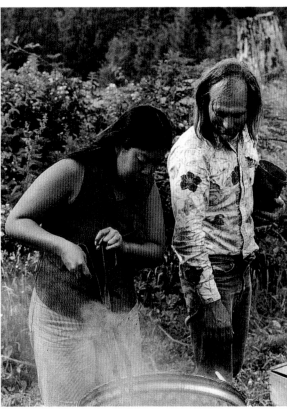

Ruth Tamura and Buster
Simpson, 1971.

ideology of the school with Dale Chihuly and Buster Simpson, Zynsky focused on building and subsistence. During the first week at the site, she tackled the most pressing problem: food. Neither she nor any of the men cooked. "I didn't know how to cook to save my life," she remembers. "I used to call up Ma Chihuly and say, 'Ma, give me a recipe. I'm going to cook for these guys because there's no one else around to do it.'"

The only kitchen was at the white house, more than a mile from the hillside, so many people either went into town, to the local taverns, or made simple meals at their campfires. "People were cooking their own food at first," says Zynsky. "But it quickly became obvious that it was easier for one person to build a campfire that everyone could cook over . . . and safer. Also, when it was raining, it was difficult to find a place to make a fire. Making eighteen different ones was out of the question."

The camp stove, 1971.

It was not long before people formed cooking groups. Store-bought food often was supplemented with local flora, such as greens and chanterelles scavenged in the meadows and forest, and amateur botanist James Carpenter helped those who were interested in distinguishing mushrooms appropriate for dining from others destined for more esoteric use. Arthur Eng's big wok turned out to be the perfect cooking vessel, since the only water available for cooking and cleaning was from the creek, and the fewer pots to be cleaned, the better.

Festive communal cookouts involved the whole camp. Toots Zynsky remembers preparing a "whole sinkful" of chickens with ceramist Patti Warashina, who had brought her students up from Seattle to visit. "She and I made . . . chicken with ginger and peanut butter and honey, and the next sink was full of strawberries everyone had picked. We barbecued on an old steel bed frame." Bedsprings, in fact, turned out to be the grill of choice for chicken and salmon.

From the beginning, Pilchuck's unorthodox program and beautiful though muddy location lured visitors. The hot shop had been running for about two weeks when Fritz Dreisbach, then teaching glassblowing at the California College of Arts and Crafts in Oakland, showed up. "It was the Fourth of July weekend and I had four days off from teaching, so I grabbed a couple of students and threw them in the back of my van and we drove up," says Dreisbach. "There was nothing to see . . . [from the road]. You had to [walk] . . . over the hill and down into the hollow to see what was going on. What was there looked like a circus tent . . . and it was drizzling rain and there was mud everywhere. And of course everybody immediately congregated to the heat and noise and light [of the furnaces]."

Seattle glass artist Rob Adamson who, like Dreisbach, would put in many years at Pilchuck, also visited that first summer. "I heard that these guys were at the so-called

Peanut Farm . . . and I went up to see what was going on. There were a couple of furnaces in the field. It looked pretty barbaric."[26]

In the meantime, Ruth Tamura, the codirector of the Pilchuck workshop, had yet to arrive. She had been delayed in Berkeley with car trouble and finally drove up with artist Randy Strong. "It was in July," Tamura remembers. "It wasn't raining at the time . . . but I could see that everyone needed some drying out. I slept in my car." Zynsky remembers that Tamura showed up "when the sun came out" and right before Marty Streich, a jeweler and instructor at the California College of Arts and Crafts, arrived for a site visit and assessment, as stipulated by the Union of Independent Colleges of Art grant. Chihuly and Tamura managed to put Streich up in a small, prefabricated house located on adjacent Hauberg property. "I went up to visit the site at Dean Tollefson's request and stayed about four days. It was very muddy! I didn't have the faintest idea [of what I would find]," recalls Streich. "And I was impressed with the excitement, energy . . . and enthusiasm. They had only been open three weeks but they had already built two furnaces and had a tank of propane. It seemed strange to have glassblowing out there, in the middle of nowhere . . . but Chihuly

Without a risk-taking attitude, a place like Pilchuck never would have survived.

—John Landon

pulled it off. I sensed the power and drive in Chihuly . . . and got the feeling that this was very important to the Haubergs. It was a very interesting and exciting experiment."[27]

During the first summer, Anne Gould Hauberg often visited the workshop. "I felt very strongly that there should be something [certifying] that you'd been to Pilchuck," she remarks. "Like a passport, a secret passport." One day she, Buster Simpson, and some students, were throwing out ideas for an appropriate memento when they looked at the peanuts they were shelling and eating. Simpson ended up casting the peanuts in bronze, and because he used actual shells, each cast peanut was unique. Anne Hauberg explains, "The bronze peanut came first. Then we decided to call it the Peanut Farm. Then everybody thought it was like going to the nuthouse. Which was fine with me!"[28] Although Chihuly didn't particularly care for the nickname, it stuck for a couple of years, and some consider it to be the school's original name.

Buster Simpson gave the bronze peanuts to Anne Hauberg who, Michael Nourot remembers, threw a party for everyone at a restaurant in Stanwood. "She gave out the bronze peanuts . . . to everybody that had participated. . . . It was a free pass, forever, kind of thing." Anne Hauberg carried her bronze peanut on her key ring from that night until July 1995, when she finally parted with it, placing it inside a time capsule—which will not be opened for another quarter-century—planted in a grove of birch trees during the school's twenty-fifth reunion celebration.

To help pay for the propane used to fire the furnaces, in late July the group decided to take a selection of glass down to the annual craft fair in the nearby town of Anacortes. John Hauberg remembers that "the kids built a glory hole [for working hot glass]

Anne Gould Hauberg stands to make a toast at the party where she awarded bronze peanuts to first-year attendees, July 1971. Toots Zynsky and Dale Chihuly are seated to her right.

in a pickup truck. They didn't know that you had to pay a fee to [exhibit at the fair] so . . . they parked the truck a block away and began to blow glass. And all the people came out from the fair to watch them."[29] "We blew some glass, annealed it and everything," says Peet Robison. "We drew quite a bunch of onlookers. They had never seen anything like this in their lives. A bunch of hippies and all this weird lumpy stuff." They set out a table of wares, and Michael Nourot handled transactions.

Buoyed by the unexpected and positive response to the Anacortes event, the glassblowers decided to hold an open house and glass sale at Pilchuck. "No one was thinking about money then," says Zynsky. "We wanted to make these things, and we were practically giving them away." People from the local community came to check out the scene. "I think there was a curiosity," says Ruth Tamura, "because glass production wasn't as well known as it is today."

The Anacortes craft fair, July 1971.

Ruth Tamura and Robert Sestock with makeshift tables of glasswares to be sold at Pilchuck's first open house, late July/early August 1971.

The open house attracted the local press, and the second article written about Pilchuck appeared later that fall in the *Everett Herald*. Photographs of glass for sale appeared with shots of Ruth Tamura and Dale Chihuly blowing glass—Chihuly blowing a free-form bubble sculpture and Tamura blowing a more traditional vessel. The purpose of the workshop, as explained to the *Herald,* was "to experiment with methods other than those used in conventional college art classes and conduct an outdoor workshop so students would receive inspiration from nature." "Dale emphasizes," added the *Herald,* "the idea of the workshop is not to make money but to permit students to concentrate on glass while living in a serene natural setting." The paper reported that two students, Jonathan Block and Michael Nourot, would continue blowing glass at Pilchuck through the fall.[30]

On a photo postcard of people blowing glass in the first Pilchuck hot shop, Dale Chihuly wrote to Francis Merritt, director of Haystack Mountain School of Crafts:

"Things are going just fine. I'm very happy with the students and the shop—I think I'll be doing it again next summer. My only problem is that I spent $3,000 over the grant, but it's a good cause to go in debt for."[31] By the end of the summer, that debt had grown. As Chihuly tells it, "John Hauberg came to me and said, 'I know this cost you more than $2,000, how much money did you spend?'" Chihuly told Hauberg $7,000, the approximate amount he had borrowed from a bank to keep Pilchuck going. "And," asked Hauberg, "how much would it cost to do it again next summer, if you continued to do it?" Chihuly speculated $25,000, since everything would have to be rebuilt, and he wanted to add a video program. As Chihuly remembers it, Hauberg replied, "Alright, I'll pay off your bank loan and I'll give you the $25,000 for next summer."[32] John Hauberg continued to foot those bills for many years to come.

Pilchuck's first summer drew to a close in mid August. Workshop participants were elated about their experience but relieved that it was over. Pilchuck had been a comprehensive program, an Outward Bound of art challenging mind and body. "At the Peanut Farm this summer we were simply a group of people interested in blowing glass," Chihuly told a reporter from the *Seattle Post-Intelligencer* in December 1971. "We were all in it together and we learned about one another—about survival, about glass."[33] Chihuly, James Carpenter, Buster Simpson, Ruth Tamura, and the Haubergs immediately started to plan for the next session. With Chihuly's encouragement, many of the summer survivors transferred to RISD during the 1971–72 academic year, while a small group

Pilchuck, winter 1971. decided to remain at Pilchuck to blow glass. Michael Nourot remembers that "there were

four of us that were going to stay on through the winter at Pilchuck: myself, John Landon, Peet Robison . . . and Jonathan Block." As it turned out, Robison left and did not return until the following summer, Landon came back only briefly to build a fence for the Haubergs, and Jonathan Block stayed just a short time. That left Michael Nourot, alone, determined to stick it out.

"Anne Hauberg gave me some money, and I remodeled the railroad shack," Nourot recalls. "I put in new windows and got it up to snuff to live in during the winter." Since there was no electricity, a local friend helped procure a wood-burning oven and stove. Nourot went home to California to collect his clothes and his loom, and drove back to Pilchuck. He continued to blow glass every day, weave, and experience the

Dale had the vision that it was going to be important enough to do this and he was going to do it right. And John Hauberg had the vision to support it.

—Fritz Dreisbach

forest: "There is a very mystical feeling to that spot. . . . Every day you felt the forest around you." On Sundays, John Hauberg opened the property to the public so Nourot

could sell what he had made. "People from Stanwood would come up and fool around with the glass shop, and they would bring me pies. . . . I'd sell glass and that's how I managed to pay for my propane." But obtaining fuel was increasingly difficult, and Nourot finally was forced out by the end of January when the propane truck refused to make deliveries because of worsening road conditions.

While Michael Nourot was blowing glass in the forest, Anne Gould Hauberg was organizing Pilchuck's first exhibition under the auspices of the Friends of the Crafts, a group she had cofounded with local art dealers Don Foster and Betty Willis to promote regional designers and craftspeople. The exhibition, which Richard Marquis and Toots Zynsky helped organize, featured pieces by "Peanut Farm Glass Workshop" pioneers Dale Chihuly, James Carpenter, Chris Harding, Mark Prieto, Jonathan Block, and Michael Nourot. Proceeds from the sale of the glass covered some of the summer propane bills.[34]

In New York, Chihuly and Carpenter had put together an experimental installation, entitled *Glass Forest*, for a fall 1971 exhibition at the Museum of Contemporary Crafts (now the American Craft Museum). "It was a totally new use of the technology," says neon artist Fred Tschida, "the first time anyone had ever used blown glass in a sculptural way and added neon to it." Art critic Rita Reif of the *New York Times* wrote that the environment "proved [the artists'] nonconformity," the "icy creation of tall white stalks and pretzel twists of neon" appearing to be "more art than craft."[35] John Hauberg, on a trip to New York with Anne Gould Hauberg, remembers that they "saw this fabulous installation of neon glass, of all these strange and wonderful shapes, sort of a moonscape of white neon." The use of what the Haubergs knew as a strictly craft medium to construct a large and complex conceptual environment impressed them, helping Chihuly garner their continued support.

In California, meanwhile, Ruth Tamura was putting together a program evaluation to be sent to all the summer participants. Routine questions asked if people planned ever again to blow glass, camp, or drink, and opinions were solicited on whether camp rules were needed or if more hiking trips should be planned. Two key issues came up which would recur year after year: the first regarded the frequency of public visitors, and the second asked for advice on the addition of other programs such as ceramics, weaving, photography, and metal arts. Two columns, one with names and the other with descriptive titles, challenged respondents to match the person with the personality. One can only wonder who might have been the "Best Pest Killer: Flies and Slugs Category," or the "Biggest Eater." And who was the "Sex Maniac"? Was he or she somehow involved with whomever was "Missing from Action"? Evaluation responses were sent to Dale Chihuly and Buster Simpson in anticipation of the school catalogue they would publish that winter.[36]

Back in Providence, Simpson had moved into Chihuly's studio, and, with Toots Zynsky's help, Simpson and Chihuly began to lay the groundwork for the next summer program. While glass was still the focus, artists from other disciplines were introduced, and video and photography were added.

James Carpenter
(American, b. 1949)
and Dale Chihuly
(American, b. 1941),
Glass Forest #1, 1971.
Glass, neon, argon,
500 sq. ft. Installation
for an exhibition at
the Museum of Con-
temporary Crafts, New
York, November 1971.
Courtesy Dale Chihuly,
Seattle.

Dale Chihuly (American,
b. 1941), *Glass Environ-
ment*, installation at
Pilchuck, 1971. Chihuly
used the landscape as a
point of departure, an
important element of
Pilchuck's founding
philosophy.

Chihuly wrote about the expanded program in a grant proposal:

This summer at Pilchuck we want to make available to thirty students an enlarged glass shop with additional new facilities and an expanded program. Many glassblowers, myself included, have been incorporating the use of different types of audio-visual hardware to illustrate certain glass phenomena that would be impossible to exhibit otherwise.[37]

He went on to describe the first summer at Pilchuck:

Pilchuck was a total educational experience, functioning on the premise that the way people live, learn, cook, eat, and relate to each other is all part of how they express themselves— their art. . . . Students quickly learned to take care of themselves in the woods and gained the confidence to become completely in tune with glass.

Simpson and Chihuly began enlisting a faculty, and they produced the first Pilchuck catalogue, an illustrated tabloid with the look of an underground newspaper and the style of a counterculture survival guide. A mini *Whole Earth Catalogue* of Pilchuck, it interlaced information about glass, building, cooking, and hiking with photographs, drawings, and montages. A historic photograph of a giant Tacoma fir was juxtaposed with a montage of the elongated "trees" of Chihuly and Carpenter's 1971 *Glass Forest* installation. Elsewhere in the catalogue, glass tendrils appeared on multiple video monitors. Outdoor cooking methods and actual and imagined forest dwellings were illustrated and discussed, and recipes given for local flora such as wapato, salmonberry, nettle, and watercress.

Photographs in the catalogue documented the building of the hot shop, an assortment of Pilchuck pioneers, glassblowers in front of the furnaces and pipe warmer, visitors buying glass, the finished hot shop, glass in the forest, John Landon's tipi, and Chihuly and Carpenter's installation of glass bubble floats on a mud pond. RISD student Dan Dailey created a remarkable double-page, step-by-step photo sequence of how to build a small glass furnace. This feature reflected the importance given, in the early 1970s, to the dissemination of information about glass. Glassblowers throughout the United States shared the same attitude: the more people who had access to the "new" medium, the better. As Fritz Dreisbach recalls: "We were preaching the Bible of glass."

Anyone eighteen or over could apply to Pilchuck. But the applicant had to have the "energy and enthusiasm to work for ten weeks building equipment and constructing a shelter to live in." The cost was $400—which included everything except film, shelter material, and food—plus a $2 processing fee. Applicants were urged to "send us the reasons why you think you should be a part of Pilchuck in the form of words, cassette tape, video tape, slides, film, your person, or whatever."[38] Fifteen students would be selected for the glass shop, and fifteen for the multimedia (photography and video) program. Kate Elliott, who first came to Pilchuck in 1972, remembers a file box full of the unusual things people had sent in as applications, including a full-size, frosted cake.[39]

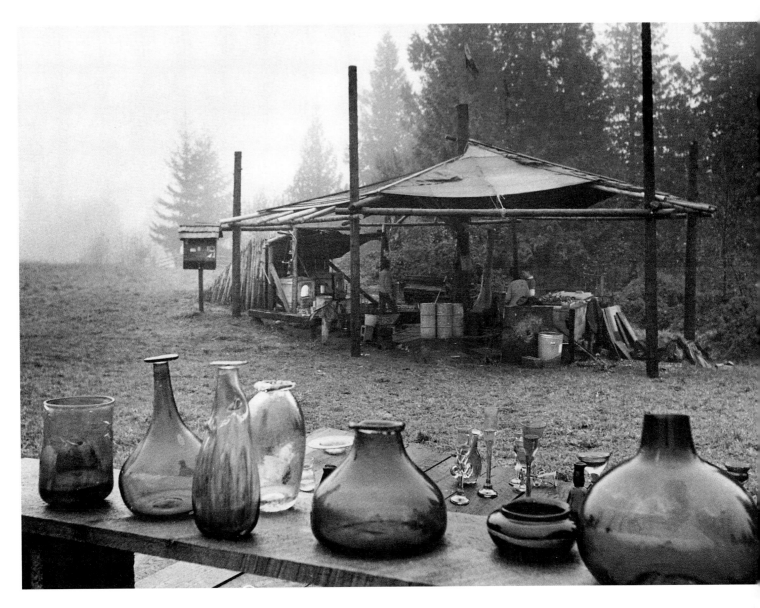

The hot shop on a rainy day, 1971.

The catalogue presented the faculty for 1972 as "some of the people that'll be at Pilchuck some of the time" and included John Benson, a photographer from Moore College; James Carpenter, described as an "expert on edible plants"; Dale Chihuly; Fritz Dreisbach, glassblower and teacher at the Penland School of Crafts; Erwin Eisch, artist and glass factory owner from Germany; Bob Hanson, photographer and filmmaker for CBS, NBC, and ABC; Chris Johanson, architect; John Landon, listed as a "scout"; Buster Simpson, responsible for "multimedia"; and Ruth Tamura. Later, artist Doug Hollis from the New School in New York and filmmaker Stan VanDerBeek from MIT were added to the roster (although VanDerBeek did not come). Chihuly and Simpson would be in charge of overseeing general operations, while visiting faculty, referred to as "guest artists and technicians," would donate periods of time ranging from two weeks to the full ten weeks of the session.[40]

The catalogue was sent out to colleges and universities nationwide, and a new poster by Art Wood was distributed to one thousand schools and museums. Chihuly and Simpson now focused on grant proposals. Although John Hauberg had promised Chihuly $25,000, Pilchuck's estimated budget for 1972 climbed to $43,000. Even with tuition, they

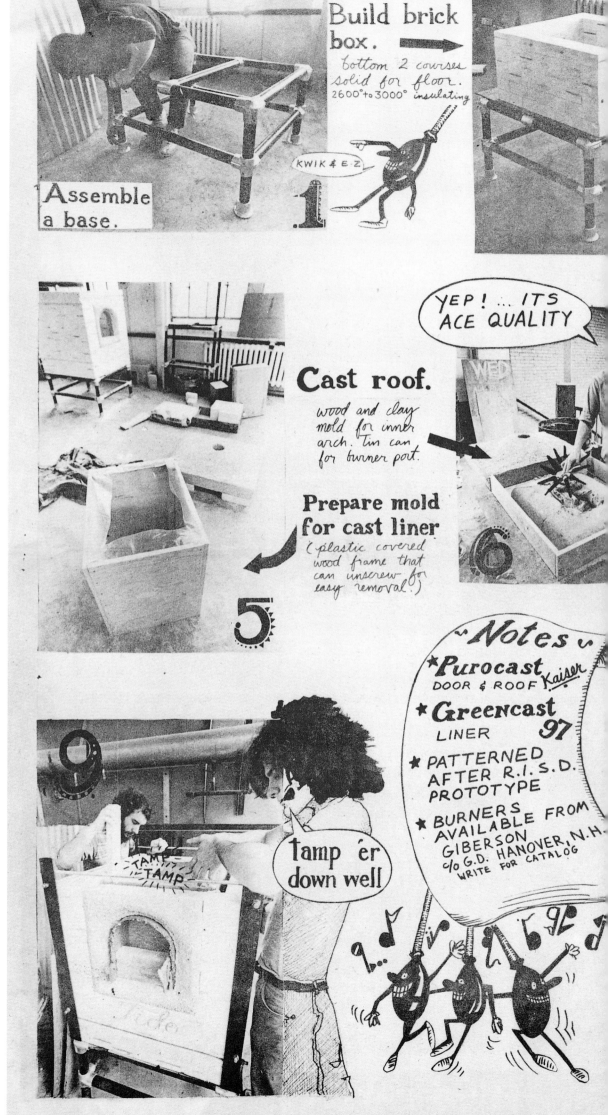

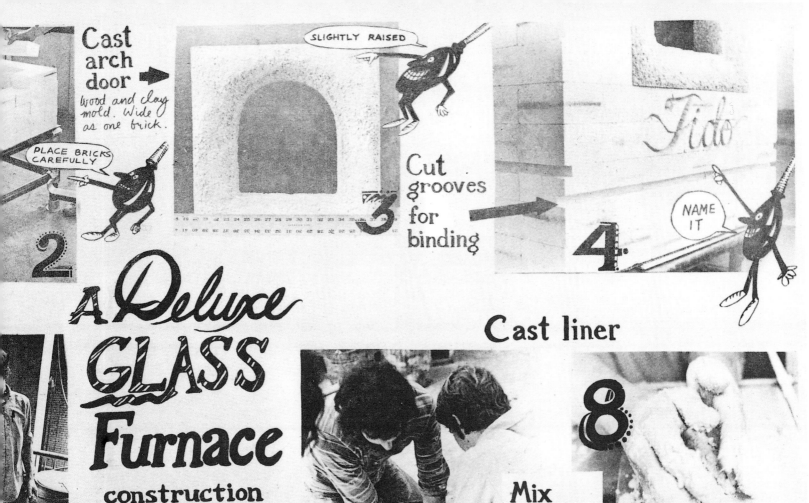

A Deluxe GLASS Furnace construction outline

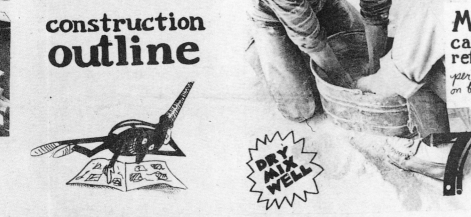

Cast liner

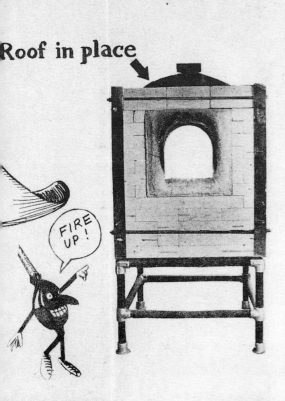

Roof in place

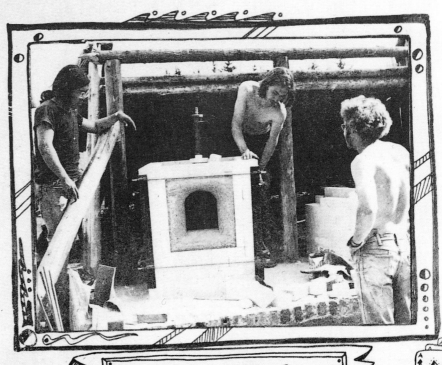

Back at the farm

would not break even, and they hoped to cover some of the Hauberg donation. The costs of the glass shop were relatively minimal: two more furnaces and annealing ovens, propane, and 15,000 pounds of glass came to only $6,500. The new media program would cost $10,000, with tools, publicity, and mailings an almost equal match. Nearly $17,000 was budgeted for the salaries of four full-time and three or four part-time staff members—who were all paid at the same rate—and all faculty travel expenses to and from Pilchuck.[41]

Chihuly and Simpson were determined to add video, photography, and audio to the Pilchuck curriculum. Video, as new a fine-art medium as glass, would be used to illustrate glassblowing techniques and to document ephemeral installations as well as visiting faculty, projects, and communal events. Other additions to the program included environmental, "living," and "structural" seminars held during the first two weeks by Chris Johanson, accompanied by architect William Morrow, to assist faculty and students in orienting themselves to outdoor living. "Our main purpose," Chihuly wrote, "is making art in a natural environment, and we should not be encumbered by any unnecessary complications brought about by adjusting to the location."[42] The guest artists, or rotating faculty, would develop projects apart from the set media programs and glassblowing sessions, since only a few people could blow at once.

Johanson and Morrow proposed that a series of improvements be made at the site. These included the addition of four composting toilets and the construction and installation of a wood-burning water heater, a shower, and a sauna by the pond. A central fireplace area was proposed which would be surrounded by a large multilevel deck. This area initially would be covered by a tarp, but walls and a roof could be added over time to create a lodge. Johanson and Morrow applied to the America the Beautiful Fund for an $800 grant to cover construction costs but did not receive it.[43]

Chihuly and Simpson sent their proposal package to fifty foundations, but only the Corning Foundation was interested enough to fly Chihuly to upstate New York for further discussion of the project. The Union of Independent Colleges of Art sent Chihuly a list of restrictions and conditions pertaining to curriculum content which prompted Chihuly to complain to John Hauberg: "The UICA seems to be made up of the same sort of bureaucratic management that has overstructured our present educational institutions to the point where a lot of the most talented people are leaving them." As it happened, UICA funding would not be an option. Dean Tollefson, then UICA's executive director, never received Chihuly's formal proposal and, from earlier correspondence, did not understand what the media program meant to accomplish. Tollefson also was miffed that UICA's name appeared without his consent on the poster advertising Pilchuck's 1972 program.[44]

Applications to foundations and federal granting agencies—coupled with John Hauberg's increasing involvement—brought into question the fledgling school's tax status. To obtain an advantageous nonprofit classification, John Hauberg arranged to have the school administered through the Pacific Northwest Arts Center (PNAC), a recently

formed nonprofit organization that he had cofounded with Anne Gould Hauberg.[45] "We used the PNAC as the sponsoring body for the first two or three years," recalls John Hauberg. "And the board of PNAC got to be the unspoken board of the school." The original Pilchuck board consisted of five PNAC people: John and Anne Gould Hauberg, Patricia Baillargeon, Joseph McCarthy, and Philip Padelford. Although the school still was considered an experiment, the beginnings of an administrative structure that would secure its future had been put into place.

1972: The Pilchuck Commune

Experience makes one discover and learn far more than long studies.

—Antonio Neri, *L'arte vetraria*, 1612[1]

If he chose his location carefully, the glassmaker could find everything he needed for his craft in the forest: sand, trees, and ferns to be burned to salts, wood for his furnace, clay for his pots, rushing streams to provide power for mills . . . [and] navigable rivers to connect the glasshouse with the outside world.

—Ada Polak, *Glass: Its Traditions and Its Makers*[2]

Many of the artists—faculty and students—invited for the second summer at Pilchuck had never worked with glass and did not go for glass alone. They were drawn by the promise of an experience in experimental living, with other artists. "Based on the conversations that I had with Buster Simpson and Dale Chihuly . . . and the early . . . materials they sent out," remembers artist Richard Posner, "I had the assumption that Pilchuck was going to be a cross between Outward Bound . . . and Black Mountain College. And that one of its very deliberate intentions was to be a laboratory for, an alternative to, traditional craft education."[3] "The environment was the primary emphasis," adds James Carpenter. "To be in an environment of nature and . . . to respond to [it]."

From Providence, Chihuly and Simpson sent out a variety of materials to the 1972 participants.[4] Faculty and students received instructions on what equipment to bring; possible ride-shares; a copy of the *Craftsman's World* newsletter; a 1960s-style brochure listing summer rodeos, berry festivals, and community fairs in Washington; copies of Curtis photographs of Northwest Coast Indians; and an excerpt from *Gourmet* magazine on the Pacific Northwest, describing the rain forests and the many types of fish, shellfish, and berries found in the region. *Gourmet* described the "plain but lovely" salal, a dense bush with blueberry-like fruit that was the bane of foresters but a boon to pie makers and Pilchuck artists interested in exploring native foods.[5]

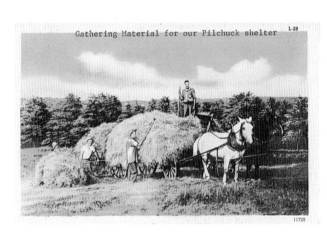

Gathering Material for our Pilchuck shelter L-29

11729

"Gathering Material for our Pilchuck Shelter": Postcard included in information packet sent to 1972 participants.

Opposite: Pilchuck population sign made in 1972 by Guy Chambers.

Simpson was rounding up friends who would come to Pilchuck as visiting artists, and while some came just for a weekend, others—like environmental artist Doug Hollis and his wife, Ruth Reichl, a food writer—moved in for the entire ten weeks. "Buster called and said, 'I'm going to go . . . with Chihuly and start a glass camp,'" recalls Hollis. "I had not met Dale before [but] I was familiar with [what] he and Jamie were doing, especially the neon."[6] Reichl, who is now news/style editor for the *New York*

Poster advertising
Pilchuck's second sum-
mer, drawn by Art Wood,
1972.

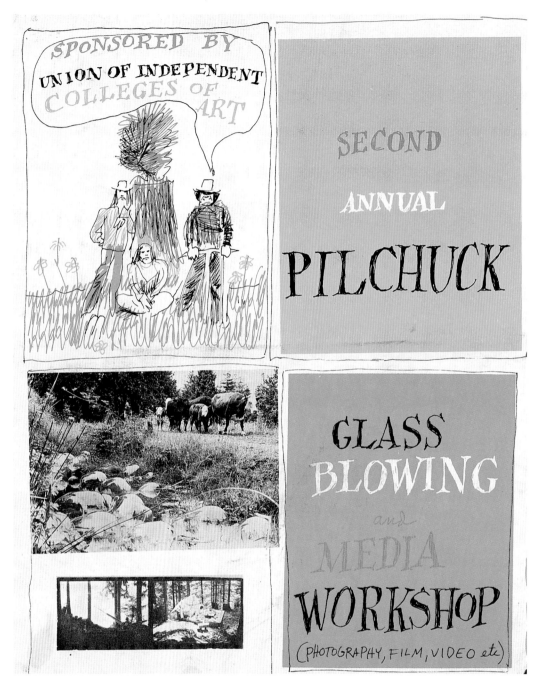

Times, remembers that she and Hollis were anxious to get out of New York: "Doug
would help people build their shelters, and I would help people cook."[7]

Preparations were underway on the hillside site by the first of June 1972. John
Hauberg had formalized a few conditions for the use of his property in a letter to
Chihuly. He instructed Chihuly,
as "operator" of the "Pilchuck
Work Shop," to limit the con-
struction of living quarters to
certain areas and to obtain per-

**[Pilchuck] was really a microcosm and a product of that particular time . . .
[of the] great curiosity and fascination of a lot of middle-class students in what
roughing it and living outdoors would be like.**

—Richard Posner

mission from Pilchuck Tree Farm personnel before cutting down or removing any trees
or brush. Glenn Greener, former land manager of the tree farm, and Duane Weston, then
managing forester, were to be consulted on all matters relating to the tree farm; if their

recommendations were not followed, stated Hauberg, "eviction can be the result." Permission was given to use the railroad shack, remodeled by Michael Nourot, for a "library and audio-visual center." Finally, Hauberg gave Chihuly standard warnings about fire hazards and liability. These simple conditions were all that Hauberg required for the next several years of the workshop's operation.[8]

In the summer of 1972 Pilchuck pioneers James Carpenter, Dale Chihuly, Robert Hendrickson, John Landon, Ruth Tamura, and Art Wood, along with "students" William Carlson, Debbie Goldenthal, Chris Harding, and Peet Robison, joined a new group of "faculty" and "staff." The newcomers included photographer John Benson and his family; electronic musician Nick Bertoni; Guy Chambers, an architect; glass artist Fritz Dreisbach; German glass artist Erwin Eisch; Chris Frayne, brother of the musician Commander Cody; photographer Bob Hanson; Doug Hollis and Ruth Reichl; architect William Morrow; glass artist Robert Naess; artist Anne Polatsek; Dutch glass artist Barbara Vaessen, who had just married James Carpenter; staff person Sally Vanover; and composer Martha Wehrer. Bruce Bartoo, Jerry Catania, ceramist Claire Conrad, and

Pilchuck, August 18, 1972. Ruth Tamura and Doug Hollis stand at the left, rear; Buster Simpson sits in the grass just in front of Tamura. Kate Elliott, Dale Chihuly, James Carpenter, and Fritz Dreisbach appear in the last row, to the right of the tree stump.

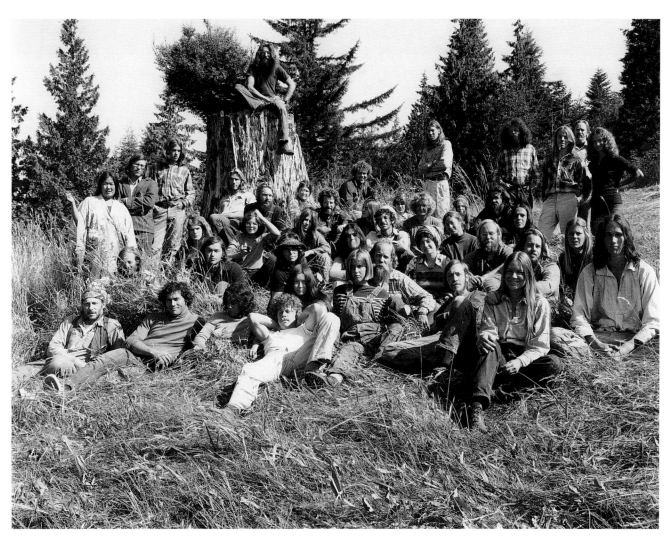

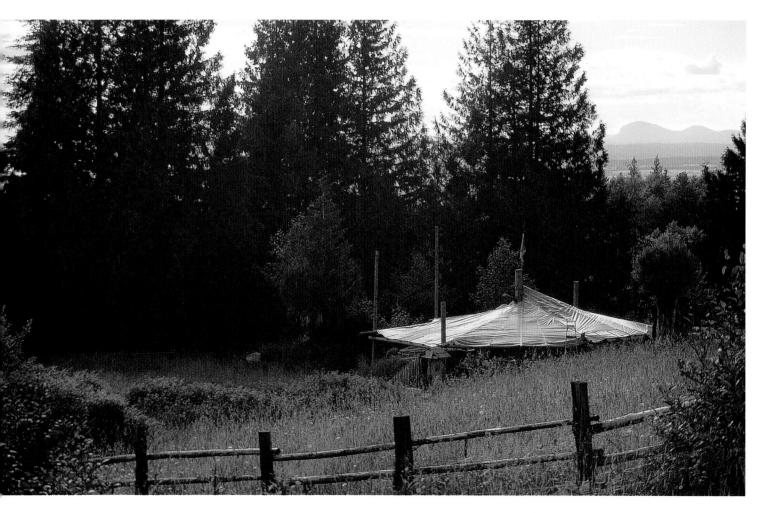

The hot shop with a new plastic roof, 1972.

Kate Elliott were among the new "students," as were Gary Enloe, Dave Gates, Kevin Gleason, Kerry Gonzales, Phillip Hastings, Dan Holmes, Elaine Hyde, Clyde Jackson, George Jercich, Bob Kaputof, Peter Larson, Ron Lies, Cynthia Lovell, Andrew Magdanz, Sue Melikian, Elsie Metcalf, Ginny Moore, Robin Orcutt, Christine Plochman, Richard Posner and his wife, Susan, Dave Seibert, Parran Sledge, Clayton Smith, Susan Weinberger, and Frank Wollager.

Visitors dropped in and out throughout the summer. Seattle glassmakers Rob Adamson and his wife, Jan Swalwell, Norman Courtney, Paul Inveen, Michael Kennedy, Richard Marquis, and Ro Purser were among the near-constant stream of guests. Pilchuck is said to have had a population of forty-nine in the summer of 1972, the figure recorded on a sign made for the school by Guy Chambers. According to Chihuly, twenty-eight of them were students.[9]

Barbara Vaessen remembers that Carpenter told her little about where they were going: "He just said that we were going to . . . a real nice place but he didn't say where. . . . We came up to Pilchuck . . . and I was wearing my best clothes . . . an old-fashioned flowered dress . . . and high heels. I had a big hat, with flowers on it. And all the students were there in shorts, their hair wild. . . . Dale was there and they were blowing glass."[10]

"There was a lot of grumbling from some people at the beginning," says media student Bruce Bartoo, "because they really wanted to come up there and do glass with Dale

Chihuly . . . [but] there wasn't even a glass shop."[11] "With Dale, you've got to look for the big picture," Ruth Tamura explains. "The first big picture was, 'We're going to blow glass in this field.' Then, 'Okay, we've done it one year and we're going to do it again.' . . . He was setting the groundwork for today. Some people chose to be part of it and some didn't."

The immediate challenges in the second year were the same as the first: build the hot shop, put together shelters, and figure out the food. Pilchuck pioneers, however, now

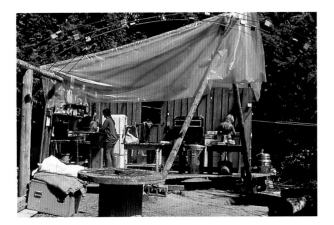

The Pilchuck kitchen, 1972.

had the benefit of hindsight and at least the beginnings of a hot shop already in place. But furnaces and annealers had to be rebuilt, and equipment reassembled. "There was so little structure and so much theater," says Ro Purser. "I remember some people being very dramatic."[12] Tempers flared when, for instance, Chihuly insisted that newly built furnaces be disassembled and moved to a new spot just a few inches away.[13]

Fritz Dreisbach relates:

The biggest complaints I can remember are that it was too wet and there wasn't enough blowing time. . . . Back then, the first two or three weeks you built furnaces. We're talking about zero blowing time. It was frustrating. . . . Now, when students arrive for the first session, the furnace is already hot, the annealers are already hot, the glory holes are hot, the kitchen is hot, and the beds are hot! But when these folks came, there was nothing except cows, long wet grass, and mud.

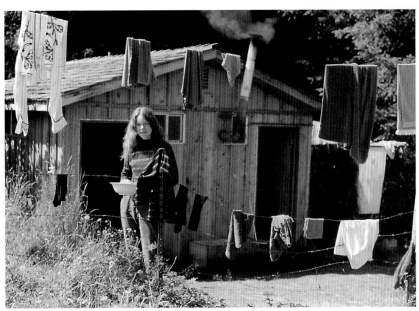

Clare Conrad in front of the bathhouse, 1972.

Bruce Bartoo recalls, "When I got up there [they were] . . . processing film in stream water. . . . I don't remember that much work really getting done because it took so long to get the hot shop up and running."

The glass shop was still run entirely on propane—there would be no electricity until the following summer—as was the makeshift kitchen, raised up on a triangular platform, partially roofed with plastic sheeting, and equipped with a propane stove and an old Servel gas refrigerator.[14] "The kitchen was a nonkitchen," remembers Ruth Reichl. "It was a platform with, I think, one stove."

James Carpenter and Dale Chihuly in the hot shop, 1972.

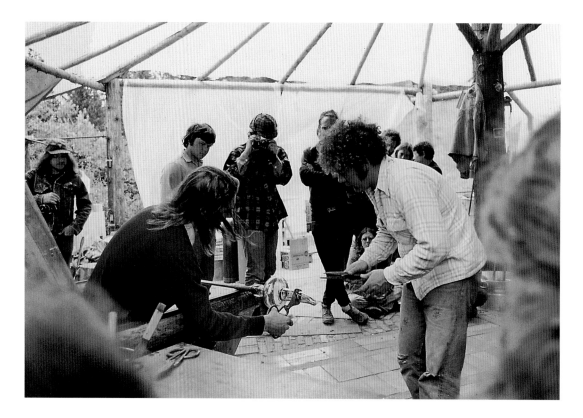

Unlike the first year, there were toilet and shower facilities, with water drawn from the creek and the pond. Since the water was of glacial temperature, Buster Simpson rigged up a wood-burning hot water heater for the shower. "You would gather up your firewood and go in," recalls Fritz Dreisbach. "Usually you showered with a friend. The friend would stoke while you showered . . . and you'd reciprocate." John Landon built an Indian-style sweat lodge on the pond.

The building of the kitchen and common eating area occasioned one of the summer's first controversies. Peet Robison remembers that they were "always joking about how we should cut down the trees so we'd have a good view." "One night at dinner we were all sitting around," adds Bruce Bartoo. "And Dale casually said, 'Wouldn't it be nice if we could see the Sound from here?' And the next night John Landon started taking out [alders]! A lot of people were upset."

You had to provide your own food and take care of yourself. It was a living experience, it wasn't just a school.
—Fritz Dreisbach

Tensions were broken when the propane truck finally pulled up. "It meant that the furnaces would get started," recalls Ruth Tamura. "We had been slaving away . . . thinking it was going to happen: 'One of these days, I'm going to blow glass, one of these days, I'm going to blow glass!'" Pilchuck's primitive setup—lukewarm furnaces, unreliable annealers, leaking roof, and wind—did not seem to deter creativity. According to Robert Naess, "A lot of good glass was created out of monstrous equipment. And the thing about the schools back then, Pilchuck included, was that the furnace design was still pretty crude, although effective."

The hot shop, with six furnaces, ran twenty-four hours a day. Batching—the careful measuring and mixing of each powdered chemical ingredient—was done in the barn next

to the white house.[15] "We took a wheelbarrow and threw in all the chemicals," remembers Peet Robison. "Weighed them out and threw them in a pile and then . . . [mixed] them by hand. Then we'd shove the [mixture] . . . into grocery bags—five pound bags of [batch]—and then throw the bags . . . into the furnace." Like all other jobs, these duties were shared, although some participated more than others. By the end of the session, new electric annealers, which ran off a generator, had replaced the old propane ones. Robert Naess remembers: "There was no division between the people who were blowing the glass and the people who fixed the equipment. . . . People really tried to learn to do everything. . . . The general sharing of energy and information was wonderful."

The idea was that it would not just be a glassblowing workshop, but . . . a workshop in life.

—Ruth Reichl

"Everybody was still a little awed by just being able to blow glass," Naess continues. "We thought we invented glassblowing." There was as much interest in creating larger, more conceptual installations as in making functional goblets and vases. Some were interested in learning specific techniques while others were drawn to free-form, "dip and drip" processes.[16] "We were making just a little bit of everything," recalls Peet Robison. "We were doing really funky wine glasses. Everyone would become involved and [we would] . . . build a giant trophy, and spend . . . an hour on it, and get it in the annealing oven. And everyone would celebrate and have a beer. And then the next morning it would break or whatever. But it didn't matter, it was the process." Ro Purser was interested in early American glass and showed people how to make lily-pad pitchers, while others blew goblets and vases with hippie/funk motifs such as Fritz Dreisbach's slug cups and Robert Levin's banana goblets or Richard Posner's vessels with political themes.[17] John Landon recalls making beer mugs fashioned with loops for hanging from a belt.

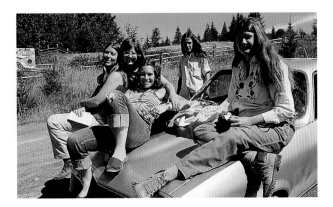

Pilchuck "students," 1972. Left to right: Ginny Moore, Anne Polatsek, a visitor, Kerry Gonzales, and Kate Elliott.

"There are no fixed schedules or classes," wrote Stephanie Miller for the *Seattle Post-Intelligencer* in August 1972. "Two 1,000-gallon propane tanks have kept the furnaces roaring continuously since early June. On a blackboard the students assign themselves the hour they want to work. . . . To outsiders Pilchuck may look like a well-kept freak farm. But a shelf display of rare glass pieces, from goblets to abstract sculpture, testifies that those who came here to create are doing so."[18]

Slide-illustrated lectures on a variety of topics, sometimes accompanied by music, were also part of the glass "curriculum." The lectures took place in one of the Hauberg's guest houses or were projected outside the railroad shack on bedsheets, with a generator providing electricity. "I had all different kinds of lectures," recalls Dale Chihuly. "One of the subjects I loved was greenhouses and conservatories, because of the glass . . . [and] I

remember one lecture I gave . . . [on] camouflage." "Dale invited John Hauberg up to show what he was into," remembers stained-glass artist Michael Kennedy. "Hauberg had a lot of really incredible slides . . . of Native American stuff. He did a few presentations."

Art Wood—who designed Pilchuck's first two posters—made a unique contribution to early Pilchuck with his puppet plays. Before joining the faculty at RISD, Wood had cofounded the Bread and Puppet Theater in Vermont. The theater was "world famous . . . for creating spectacles . . . with a conscience," remembers Richard Posner. Anyone could join Wood in making elaborate, mixed-media puppets—some incorporating glass elements—and devising dramas. "It was another art that students could get involved in or get excited about," explains Fritz Dreisbach. "They'd spend three or four weeks building the puppets . . . and then practice for a couple of weeks . . . and then there were two or three performances."

One thing Pilchuck was not about, according to Dale Chihuly, was production art glass, despite its popularity—and saleability. Others at Pilchuck, however, were more craft-oriented, their decision to make a living by blowing glass reflecting more a political than an artistic impetus. In the late 1960s and early 1970s, craft was a means by which an individual could escape the mediocrity of mainstream "bourgeois" culture, financing his or her alternative lifestyle by the highly acceptable pursuit of making objects by hand. "I'm oriented toward functional glass and pottery," explains Peet Robison. "And I could see the conceptual direction . . . Pilchuck was going in and I didn't understand it. . . . It was, 'We are not blowing glass just to make vessels, we are blowing glass to create art.' That's where I got lost! . . . What I like is making functional glass and having people buy it for a modest amount of money and use it every day. And it wasn't that that was being put down, but it wasn't explored." "We were antiproduction, no question

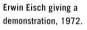

Erwin Eisch giving a demonstration, 1972.

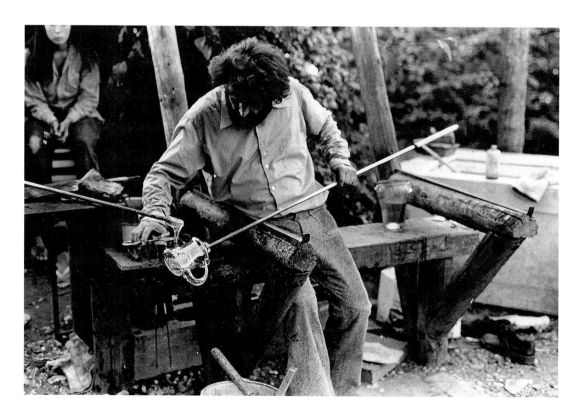

about it," comments Chihuly. "Between Buster and me and people like Erwin Eisch, we were not the place for production."

Erwin Eisch, whose glassmaking aesthetics and approach to form were—and still are—tremendously influential, drove to Pilchuck in the summer of 1972 from Haystack, where he had been teaching. "I remember Chihuly and Jamie Carpenter were there, and everything was very simple and they made the batches. . . . And some people were around and they made video," says Eisch. "Everything was very primitive. Each thing starts this way [though]. . . . Important things have to start simple from the very beginning." Eisch stayed only briefly at Pilchuck, but he discussed the development of the fledgling school with Chihuly, who was using Haystack—and its director Francis Merritt—as his model. Upon his return to Germany that fall, Eisch wrote to Merritt,

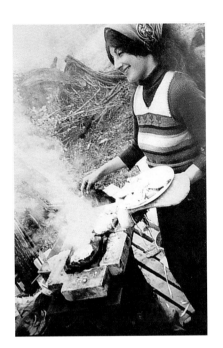

Ruth Reichl cooking pancakes on glass, 1972.

"After I have seen Pilchuck and my talk with Dale Chihuly, I got a feeling for all the work you did at Haystack. I really admire and appreciate the way you lead all these different people through the summer."[19]

No one can pinpoint the first glass "event" at Pilchuck—probably because the events started as soon as the blowing did—but in the summer of 1972, a major event was Ruth Reichl's experiment in cooking pancakes on glass. "It was pretty simple," she says. "I didn't think of it really as an art project [but as] . . . something interesting to do. That year, you could do anything." For artists like Buster Simpson and Doug Hollis, however, Reichl's culinary performance piece was considered as important as projects in other media. "I made the pancake batter," recalls Reichl, "and they pulled the hot glass out of the furnace and made patties of it [on the marver]. . . . I just put the batter right on top of it." The glass turned out to be a fine cooking surface, and Reichl made pancakes for the whole camp. Later that summer, Simpson documented Reichl making bacon and eggs on glass in a video piece entitled *Video Hot Glass Breakfast*.[20] "Neither Buster or I would ever think of food as just an art project," Reichl explains. "I mean, it's food. There would be no point in doing it if you weren't going to eat it. . . . It was the whole idea of art as about life . . . to see every minute of your life as an expression of your art."

Teaching was done primarily by demonstrations in the hot shop. James Carpenter, who had just returned from working in Italy, showed what he had learned about forming vessels with the aid of the marver. A smooth table of steel, the marver sits on top of a small, rectangular metal frame, and glassmakers roll their molten glass over it for chilling, for shaping, to execute special techniques, and to add colors. A tool with a long history, the marver's name is said to be derived from the French word *marbre*, or marble,

the material from which it originally may have been made.[21] The marver enabled glass-blowers to gain better control of larger bubbles—since it allowed them to shape and reheat for as long as they wanted—which resulted in larger vessels. Already in 1972 the limits of the scale of blown glass were being pushed.

Other techniques brought to Pilchuck in 1972 were *murrine,* first demonstrated by Robert Naess, and stained glass, originally set up by Ro Purser and later expanded by Barbara Vaessen. "I was talking about cane, *murrine,* and molds," says Naess. "Of course we were limited because all we had was clear glass, a faint blue, and a faint green. But you could still work basic cane techniques with that." In the late 1960s and early 1970s, American artists working in Italy brought back and quickly disseminated traditional Venetian cane techniques such as *murrine,* also called mosaic or *millefiori* glass, and *vetro a filigrana,* also called *latticinio* or filigree glass. Popular among ancient Roman glassmakers during the first century B.C. *murrine* can be made by bundling glass rods, or canes, of different colors into a pattern and fusing them together, with or without the aid of a mold. The fused *murrine* is then drawn out as a long thin cane and sliced into thin cross sections. These sections can then be arranged inside, or over, a mold and slumped or fused inside a casting kiln, or picked up onto a hot bubble of glass and blown, a difficult technique which Richard Marquis pioneered in the United States.

To make the *murrine* sections, the cane had to be drawn out, which Naess demonstrated. Making cane—whether plain, multicolored filigree, or *murrine*—is accomplished, essentially, by gathering glass out of the furnace with a metal rod, or punty, shaping it and adding color if appropriate, attaching a glass-topped punty to the end of it, and then stretching out the hot, taffylike glass between the two metal rods. Because the glass thins and quickly cools as it is stretched, the process must be carefully executed, with the maker usually backing across the hot shop, punty in hand. Once cooled, the long thin cane is broken up into shorter pieces to be used in a variety of ways.

Both Ro Purser and Barbara Vaessen claim to have started stained glass at Pilchuck. Although Purser may have been the first to demonstrate flat glass techniques, it was Vaessen who brought attention to the medium and kept it going. Stained glass is part of a broader category referred to as flat, or two-dimensional, glass. Flat glass can be stained glass—variegated pieces of glass that are held together by metal channels—or it can be painted, cast, sandblasted, laminated, acid etched, or engraved. Flat glass can be used in an architectural context, as a window or other element, or it can be an autonomous panel, hanging on a wall, in front of a window, suspended in air, or freestanding, like a diptych or a Japanese-style screen.

I don't remember too many formal get-togethers [to discuss work]. . . . Buster Simpson was good about discussing issues [but] . . . Chihuly has never been one to verbalize things. He just does things. . . . Dale likes to get the action going.

—James Carpenter

Robert Naess demonstrating a cane technique, 1972.

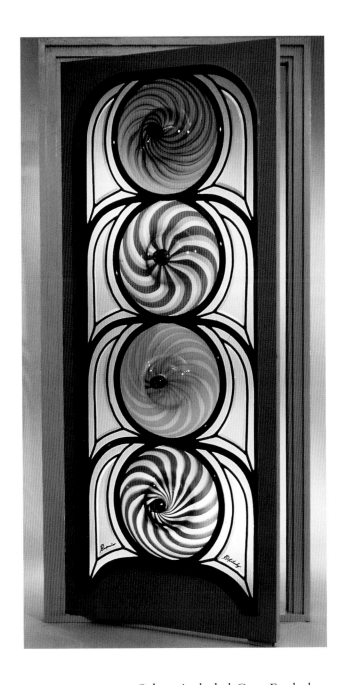

Early in the 1972 session, Purser recalls, Dale Chihuly asked him to "go down to Washington Glass Works in Seattle and get soldering irons and lead and glass," and show everyone else how to make leaded windows. Purser made a plywood table on the back deck of the hot shop and demonstrated how to "cut glass and shape it, and how to stretch the lead [channels] and solder the joins."

Barbara Vaessen came to stained glass a little later that summer because she was frustrated by blowing. "I was a glassblower and I got so jealous of all those guys who made all these beautiful pieces," Vaessen remarks. "I had to compete with Dale Chihuly and Jamie Carpenter. So I said, 'The hell with that.'" Chihuly suggested that Vaessen make some stained glass windows for the house she was building with Carpenter, and he showed her how to cut and lead. "I got the color," she says, "and I loved it so much that I never stopped doing it!"[22] Vaessen encouraged others—including Buster Simpson and his students—to experiment with the technique, and flat glass has played an important role at Pilchuck ever since.

Chihuly and Carpenter were working on their own flat glass project that summer, with Michael Kennedy in Seattle. Kennedy was one of a handful of glass artists working independently in Seattle.

James Carpenter (American, b. 1949) and Dale Chihuly (American, b. 1941), *Roundel Door*, 1972. Blown glass, lead canes, painted wood, 80 x 40 x 4 in.
Courtesy Dale Chihuly, Seattle.

James Carpenter with a roundel from the *Roundel Door*, 1972.

Others included Greg Englesby, who later ran the Ellensburg program; Steve Beasley, a student of Richard Marquis's at the University of Washington; and Rob Adamson, Norman Courtney, and Roger Vines, who together started an arts and crafts cooperative in 1971.[23] Kennedy had come up to Pilchuck during the summer of 1972 because he

was interested in making blown components for his leaded glass pieces: he wanted to make three-dimensional windows. Chihuly and Carpenter relied on Kennedy's facilities to help execute their designs for a roundel window being made for a Corning Museum of Glass exhibition. "Dale and Jamie blew the . . .

[striped] roundels . . . and I [leaded] . . . them in my studio in Pioneer Square, in Seattle," Kennedy remembers. "At the time they didn't have a cold-working area or benches." The "candy-cane" roundels were "huge and intimidating" to Peet Robison, still a novice, and Robert Naess remembers that Chihuly and Carpenter had trouble with compatibility because they were using a high-soda Italian colored glass that differed, in composition, from their clear glass: "They had to put so much soda back into their clear glass to make it compatible with the Italian canes . . . that it [became] . . . susceptible to decomposition."

In the end Chihuly and Carpenter were forced to replace some components of their piece because of incompatibility. Poorly formulated glasses and color incompatibility were frequent problems for studio glass in its first decade and sometimes resulted in "sick" and decomposing glasses. Color compatibility was a significant-enough concern that certain glassblowers, like Fritz Dreisbach, devoted much time to researching and developing compatible color systems. Because most private and commercial studios and schools now use commercially available color rods, experience in and knowledge of mixing color have rapidly declined among individual glassmakers. And as ready-made batches for clear glass are becoming standardized and regulated for maximum compatibility—and high-quality melt becomes widely available—the practice of each artist developing unique formulas is becoming a thing of the past.

We didn't want to be confined to [any one] . . . idea of what kind of space you need to live in.
—Buster Simpson

Live in your sculpture. That's a good idea. Because then people instantly connect with where they are.
—John Landon

A crucial part of Pilchuck's early program—and an essential part of the Pilchuck experience—was the building of a shelter. In 1972 the first of the so-called artists' houses were built, and while none was meant to last, a handful have survived twenty-five years of continuous use. Architect and future director Thomas Bosworth valued the more substantial houses "both as sleeping quarters and as objects of art."[24] "There was a lot of emphasis on people being original with their shelters and trying to express themselves through them," remembers Ruth Reichl. "None of the houses had numbers on them," adds John Landon, "but you always knew whose house it was. We were talking about developing a whole person, not just a glassblower." The cedar stump shelters built by Buster Simpson and Guy Chambers are an integral feature of the Pilchuck landscape today, as are the eclectic little houses built by Dale Chihuly, Richard Posner, and James Carpenter and Barbara Vaessen. One of the most ambitious and beautiful of the handmade houses, the Carpenter/Vaessen structure is now an elegant ruin whose practical function has been transformed into a purely abstract one. Symbolic of Pilchuck's spirit of experiment, its fragile condition serves as a reminder that everything is transitory, and unless well tended, even the strongest vision may fade.

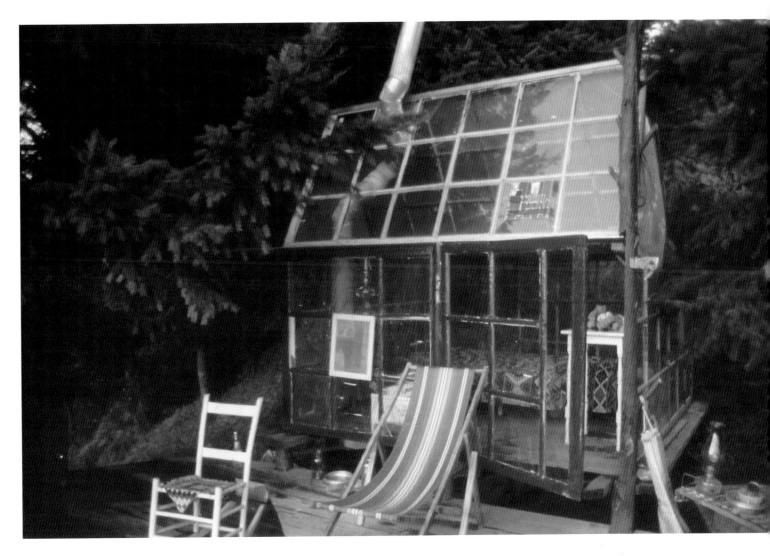

Dale Chihuly's house, 1972.

Buster Simpson, John Landon, Doug Hollis, and architects Guy Chambers, William Morrow, and Chris Johanson helped the novice builders decide what kind of shelters to construct. Each person attempted to build according to his or her needs while staying in harmony with the forest. "You had this whole landscape to work with," explains Buster Simpson. "One of my roles was discussing with people what their structure could be, as maybe an extension of their personality or whatever. . . . What kind of materials were they thinking of using? Did they like it sunny? Damp? In the woods? Basic, fundamental things."

We are trying to find our way back into the Earth family and there are few guides to show us the way.

—Sim Van der Ryn, *Handmade Houses*[26]

Tools and building materials were obtained from a variety of sources.[25] "Susan, my ex-wife, and I proceeded to go dumpster-diving," recalls Richard Posner. "We scrounged around to get materials along with the other thirty or forty [people]." Bruce Bartoo came equipped with a hammer, a wrench, and a pair of pliers. "The first day I went up to Mount Vernon," he says, "and bought some wood. I bought some nails. I bought some tar paper. And I got some used wood that was down by the pond in a pile." Peet Robison remembers that, after forays to the Stanwood dump, they would come back with "whatever we could find, throw it together, and call it a home." James Carpenter and Barbara Vaessen, more ambitious than others, visited a number of junk stores in

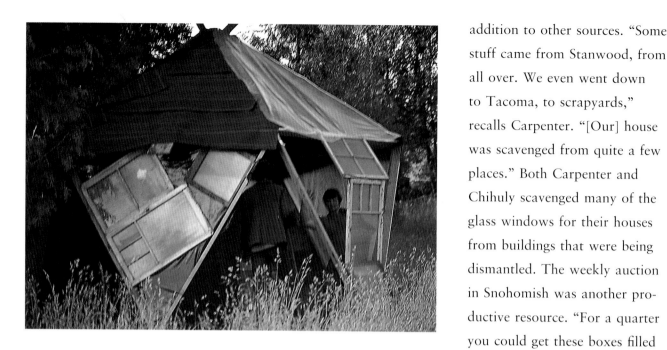

Geodesic-style shelter built by Andrew Magdanz and Gary Enloe, 1972.

addition to other sources. "Some stuff came from Stanwood, from all over. We even went down to Tacoma, to scrapyards," recalls Carpenter. "[Our] house was scavenged from quite a few places." Both Carpenter and Chihuly scavenged many of the glass windows for their houses from buildings that were being dismantled. The weekly auction in Snohomish was another productive resource. "For a quarter you could get these boxes filled with . . . all kinds of kitchen equipment, old tools," says Ruth Reichl.

According to Ruth Tamura, Buster Simpson's influence was most "instrumental in the recycling movement [at Pilchuck], with how people constructed places to live." In this, his thinking reflected the same dynamic behind the handmade houses being built at the time in Northern California. These organic, eclectic, and generally beautifully crafted homes—often made entirely of recycled and scavenged materials—were receiving increasing attention as statements of a new "standard of living," of an architecture without architects. "Most of us have grown up sharing little real experience or work," wrote Sim Van der Ryn, of the University of California at Berkeley's architecture school. "We have few rituals that celebrate our unity of mind, body, and spirit."[27] The handmade house was a reflection of the complete expression of the owner/builder's individual personality, beliefs, and values. It was this "whole" living experience that Pilchuck artists would find through the process of designing and building their own shelters.

> The whole notion that becoming an artist was some linear process was just shattered forever for me. . . . And the freedom . . . we were faced with, to make some sense of this setting, where there was no place to live or cook. . . . It was a real challenge.
>
> —Richard Posner

Structures ranged from sleeping quarters arranged inside a tarp-covered stump to full-scale constructions, such as Dale Chihuly's place, that involved several builders. The most popular form of housing consisted of plastic sheeting wrapped around bent alder branches or wire. Tents, too, were common, as were all manner of tied canvas tarps. But people soon discovered that canvas ground cloths would not keep them dry: platforms were a must. "I put up a platform . . . in the woods, two platforms, actually," remembers Bruce Bartoo. "One was the floor and another smaller one was a bunk. And then I just put up tar paper and a plastic roof over it, and I had a reasonably dry shelter. A lot of people spent three weeks building their shelters. . . . There were a lot of people who were really wet! There were these guys, they were very ambitiously trying to do a Buckminster Fuller geodesic dome. And it was a disaster! . . . [Since] I had a car, I spent a lot of time

taking people into town so that they could put their sleeping bags in a dryer." Fritz Dreisbach was too busy keeping things plumbed and fired to think about a shelter his first year, and he opted for plastic bag living. "I'd be in my sleeping bag—inside my plastic bag—and I'd hear tick . . . tick . . . tick. . . . That damn rain! Back again!"[28]

Pacific Northwest Arts Center and new Pilchuck trustees came up to visit the site with John and Anne Gould Hauberg. "There was a whole bunch of artists up there who

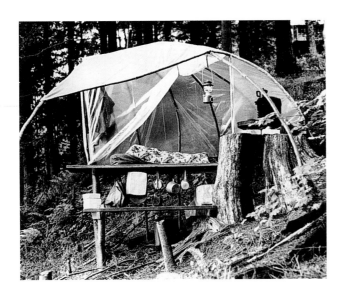

Dan Holmes's shelter, 1972.

built their own shelters . . . out of all kinds of things, packing boxes and whatever," recalls PNAC/Pilchuck president Joseph McCarthy.[29] "And that was a lot of fun except that it wasn't a very healthy place to be." Joseph Monsen remembers that it was "pretty primitive . . . almost like a hippie commune in the forest," while Patricia Baillargeon worried about people keeping dry. "You know, it's sort of quaint to look at a little house up on a stump, but a lot of those people were in small tents . . . right on the ground."[30] Architect Thomas Bosworth—who knew Dale Chihuly from RISD but who was brought into the Pilchuck fold by Anne Gould Hauberg—was often up at the site working on John Hauberg's Tatoosh development project. "It was a big, sloppy hippie operation," Bosworth remembers. "We were hippies," agrees Peet Robison. "We had hair down to our butts and there was mud everywhere."

Building continued throughout the summer. Some people, like Richard and Susan Posner, constructed a platform that summer to camp on and waited until the following

Shelter built by Doug Hollis and Ruth Reichl, 1972.

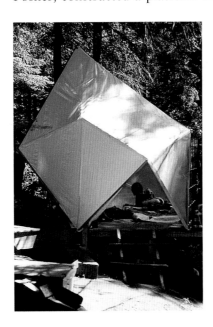

year to finish a house. The one-room Posner structure, now called the "corner house," is still nestled at the edge of a wooded ravine overlooking a small creek. From the road, the house appears to be a snug, dark cabin: only after stepping inside does a full-length glass wall, with forest view, become apparent. Meanwhile, others settled into tents on platforms, built tipis—undoubtedly inspired by John Landon's masterpiece on Inspiration Point—and other structures with varying degrees of success. Kate Elliott roped a tarp over four branches for her shelter, which proved to be so wet that she spent most of the summer sleeping in Buster Simpson's van.

People freely helped one another with their houses (although Chihuly, busy running the hot shop, hired students to work on his).[31] "I do remember that we worked on the houses," says Peet Robison. "Chris Harding [was building] in the woods . . . and I worked with him. He had some big timbers that he spanned the valley with and built this . . . hammock concept . . . on the timbers." Dan Holmes built a high platform next to a table-size stump—with a long shelf underneath to store and hang cooking utensils and gear—and covered it with a double-walled half-dome of plastic stretched over branches and a canvas tarp.[32] The outer, plastic shell of the half-dome served as a roof, while the inner tarp tent could be drawn together, in bad weather, around a sleeping bag. Like many of the structures, it was both primitive and elegant. Doug Hollis chose to build a very open and light "free-form geodesic of sorts, a linear . . . greenhouse-like structure" constructed of polyethylene panels assembled on a deck. Hollis had been working on tension structures with the renowned tent designer C. William Moss—whose invention of domed pop-tents revolutionized wilderness camping—and his idea for Pilchuck worked out beautifully. "Doug built us this amazing structure out of plastic that we lived in all summer . . . very elegant and geometric," recalls Ruth Reichl. "It was never meant to be permanent. The idea was, at the end of the summer, it would disappear with no sign, no trace of ever having been there."

> The idea was that we not ruin the area, in any way. That we live with nature [rather than] . . . in opposition to it.
>
> —Ruth Reichl

James Carpenter and Barbara Vaessen's glass house was at the other end of the spectrum: their shelter turned into a summer home that they expected to live in, while teaching at Pilchuck, for several years. "We had to go back East [in the winter] in order for Jamie to teach," says Vaessen. "But the feeling was there—strong—to come back. We were setting up something." Carpenter and Vaessen assembled their materials— mostly old glass windows and doors—and started. "We laid out all these doors on the grass," recalls Vaessen. "And then we just made four deep holes and put poles in and made a platform. And just built a house out of all the windows." The spacious house featured a kitchen/living area, bedroom, and a little room where "Jamie used to sit by himself and write," all built around a tree and open fern "garden." Carpenter dug a small well, so that they could have gravity-fed running water at the house, and installed an outhouse. They painted the interior wood of the house white, and with all the clear glass—punctuated by small stained glass panels made by Vaessen—it became a sunny, light-filled space with a spectacular view of Puget Sound.

Perhaps the most intriguing style of housing explored at Pilchuck was the stump house. The stump houses—of fir or cedar—ranged from hollowed-out trunks covered with plastic, like Peet Robison's place, to more elaborate cottages, like Buster Simpson's charming construction. The stump house has a long history in the Pacific Northwest. The first Port Angeles post office, near Lake Crescent on Washington's Olympic Peninsula, was housed inside a large cedar stump topped with a wood roof. Turn-of-the-century Northwest photographer Darius Kinsey documented quite a few of these

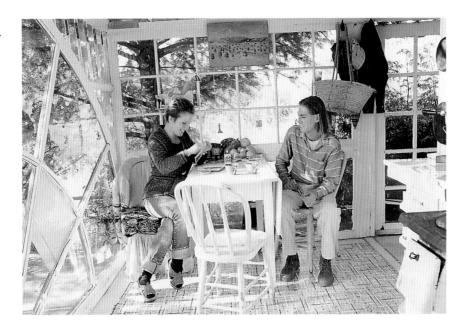

Barbara Vaessen and James Carpenter in their Pilchuck house, 1973.

Interior of the Carpenter/Vaessen house with stained glass windows by Barbara Vaessen, 1973.

For people who are into creating, what could be a better place than this kind of environment?

—Barbara Vaessen

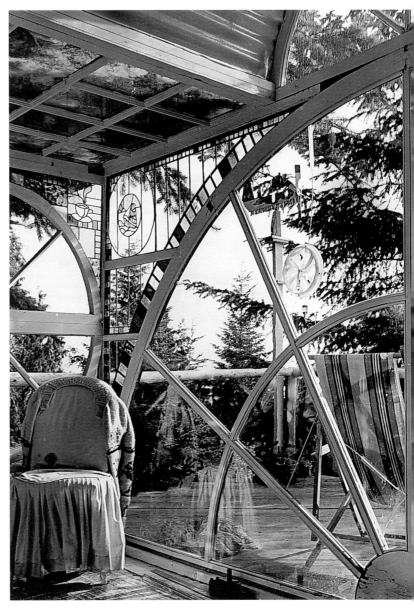

Postcard showing a
cedar stump house,
1920s.

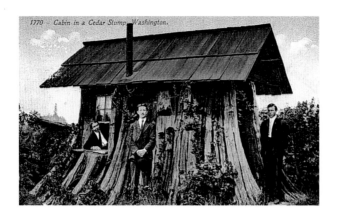

1770 - Cabin in a Cedar Stump, Washington.

dwellings. In fact cedar stump houses were touted to settlers as a good, affordable housing alternative. "This unique residence, made from a cedar stump, is in Snohomish County," reported the *Skagit County Times* on January 22, 1903. "Inside, it is one good-sized room which is boarded up and neatly papered and made as comfortable as any apartment could possibly be made."[33] There were problems with stump houses, however, not addressed by the newspaper article. "One of the worst experiences was when we woke up," remembers Robison. "We had slugs in our hair! . . . We had Bob Dylan hair then, you know, real curly, real long. That was a nightmare!"

Peet Robison inherited his stump from a 1971 student who had not returned. Robison, who had spent his first Pilchuck summer in a tent, moved in and expanded it. Almost all the housing at Pilchuck in the early years was recycled. "The poor ones, the ones that weren't so good, didn't make it," comments Fritz Dreisbach. "The ones that made it got reused. Everybody glommed onto those right away. It was sort of an honor." Robison's stump was in the trees, "about 10 feet in diameter [inside] and about 12 feet high. . . . You could almost see the shop from it." He cleaned it out,

> Here we were out in a pristine environment and it seemed ludicrous to bring our city habits with us.
>
> —Buster Simpson

Stump house built in
1972 by Guy Chambers,
photographed in 1973.

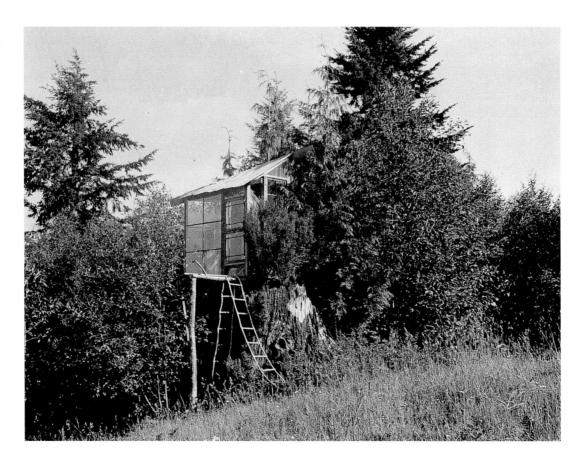

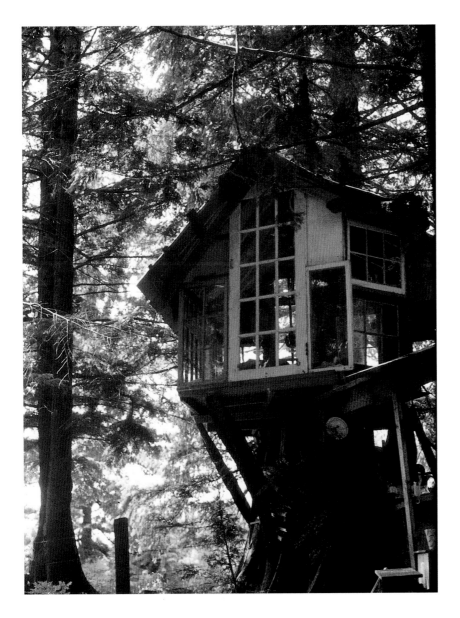

"made it a livable area," and covered the top with Visquene. According to Robert Naess, there were two or three such hollowed-out stump houses on the hillside as well as stumps with houses built on top of them.

Only two stump houses have survived: one built by Guy Chambers, later completely rebuilt by William Morris, and one built by Buster Simpson, the most intact 1972 structure still in use. Unlike Dale Chihuly's place, which has been rebuilt and expanded several times, Simpson's dwelling has remained essentially unchanged, although many of its original windows have been painted out for privacy, and the house now has electricity. Guy Chambers's structure was relatively far from the hot shop, perched down below the present-day lodge, and with its heavy mantle of green it resembled a tree house more than a stump house.[34] "Guy built a beautiful tree house," remembers Barbara Vaessen. "You had to climb up into it." A high platform attached to one side of the house served as an open-air extension off the enclosed living area and was reached, as was the house, by a homemade ladder.

Buster Simpson picked a large cedar stump in the trees at the meadow's edge—near the creek and the pond—where the faculty cabins and director's house are located today. "It happened to have a Douglas fir growing up through the middle of it," remembers Simpson. "And I kept that. . . . It came up through the middle of the room. It was a very compact little house. It had windows all around . . . from the local dump . . . and a recycled, corrugated metal roof with a kind of flying roof off the back that provided shelter for cooking. I had a wagon out there that was my barbecue. . . . It was a very simple modest place that was cozy, with a stove in it." Originally the only decorated glass in the structure were a few panes inscribed and painted by houseguest Erwin Eisch—which have disappeared over time—and a small panel of a neatly leaded foot by Barbara Vaessen which replaced a broken pane. While Simpson states that he broke the window during his sleep—by kicking it out with his foot—others recollect a more

Barbara Vaessen's "foot" window in the Simpson stump house, 1972.

romantic version. "Buster asked me, 'Can you make a little stained glass window for me, about that size?'" remembers Vaessen. "And I said, 'Sure.' So I looked at the spot where it was and the bed was right there. . . . And I said, 'Well, what happened?' Buster said, 'I was making love . . . with my girl-friend . . . [and she] pushed the window out.' So," explains Vaessen, "I made a foot—her foot—in the window."

The Pilchuck landscape in 1972 was remarkably different than it is today. The area around the hot shop and pond was cleared and open, with relatively open forest surrounding it. But all the property that has been deeded to the school over the years has been allowed to revert to forest, and what was essentially open space in 1972 is now dark and increasingly impenetrable. While the meadows have remained more or less the same, the character of the forest—the number and height of the trees—has changed dramatically. The Carpenter/Vaessen house today sits in darkness, surrounded by trees, and it is nearly impossible to imagine that there ever had been a view. "The trees have grown 60, 70, 80 feet since we first came there," says John Landon. "I don't even recognize the school anymore." Even the view at Inspiration Point is disappearing: newcomers to Pilchuck can never know how open those incredible vistas once were.

All visitors to Pilchuck were captivated by the massive cedar and fir stumps that are the site's most arresting feature. The mysterious stumps, as odd in appearance as large boulders in a flat landscape, were alive with new growth. "For these city people, coming out into the woods and seeing these giant stumps, it's not surprising they would take on a character," comments Thomas Bosworth. Bosworth understood the stumps as reflecting the "greatness of the trees" and as a metaphor for the "degradation of society, of the great things from the past." John Hauberg was interested in the stumps as well, and in the late 1960s, he hired local photographer Art Hupy to document them. The name Hauberg chose for his development project—Tatoosh—refers, he says, to these stumps. "Tatoosh in the Indian language means breast," explains Hauberg. "I guess we chose the name because I felt that the true meaning of Tatoosh was 'Mother Earth,' the nourishing alma mater, the nourishing mother. And we had these gigantic stumps which I called the breasts of Mother Earth."[35]

Some stumps were friendly and some stumps were evil.

—Peet Robison

Like the so-called nurse logs commonly seen in the rain forests of the Olympic Peninsula, the stumps supported new life. The fresh, young tree growing out of an old, weathered stump is one of Anne Gould Hauberg's favorite images, and this symbolism was not lost on the forest dwellers. "Spiritual" pilgrimages were made deep into the woods to visit the legendary snag—the so-called McMurray Fir—that resided there. John Landon never tired of enthralling his listeners with tall tree tales, and with all the atten-

tion paid to the colors, tastes, smells, sounds, and "vibes" of the woods, it is not surpris-
ing that the forest came to be understood as a truly magical place. "I think those great
stumps used to be great old chiefs," says a Pilchuck artist in 1995, unaware of the native
tradition of placing their deceased in canoes and suspending them in the trees. "And their
spirits are still living in those trunks and in the land."[36]

> [There was] a struggle between this vision of Pilchuck as a major glassblowing center and Pilchuck as a place to try living in the forest. . . . And they were competing visions.
>
> —Ruth Reichl

In 1971 Brian O'Doherty wrote, "The sixties are receding at such a speed they now have a period look. That a decade of such intense artistic activity, with sum-
mary implications not only for the making of art but for the survival of art itself. . . .
How could such a decade seem, after a year of the seventies, so far away?"[37] In art, and
in politics, generally, the transition from the power-packed 1960s to the sluggish 1970s
was difficult. By the late 1960s many artists had moved away from the "emotional disen-
gagement" of pop art and the "detached objectivity" of minimalism, writes Jonathan
Fineberg, finding themselves in a "polarized context" where intellectual activism strug-
gled with an "increasing retreat into complex, personal reference."[38] Art became personal
and the personal became political; boundaries and movements in art undefined them-
selves. The new "conceptual" art and performance arts turned attention away from
objects to artistic experience, resulting in what Lucy Lippard called the "dematerializa-
tion of the art object."[39]

Looking at Pilchuck in the early 1970s, it can be said that some of the larger issues in
art—now dovetailing with social and political agendas—were mirrored in the experimental

Student photography project with glass and bales of hay in a Pilchuck meadow, 1972.

and experiential approach taken by Pilchuck artists in everything from blowing glass to building shelters, from performance "events" to their relationship with the environment. In November 1972 Dale Chihuly wrote to Francis Merritt that "this last summer . . . I really took on more than I could handle—too many people at Pilchuck and too many projects underway."[40] Chihuly and James Carpenter were trying to make work for an upcoming exhibition, but Chihuly especially was overwhelmed by the distractions of building facilities and housing, teach-

There was no one aesthetic.

Everything was going on there.

—Toots Zynsky

ing students, and managing life in the Pilchuck commune. Lifestyle issues were edging into the limelight, and this distressed Chihuly, who was pushing for a focus on glass. Carpenter had spent most of the

Audio and video documentation of Fritz Dreisbach blowing glass, 1972.

summer building his house, which was another source of irritation. "I learned a long time ago," says Chihuly, ". . . [that] artists are builders and doers, and if you let them get focused on building, then that's what will happen. You can end up spending all year

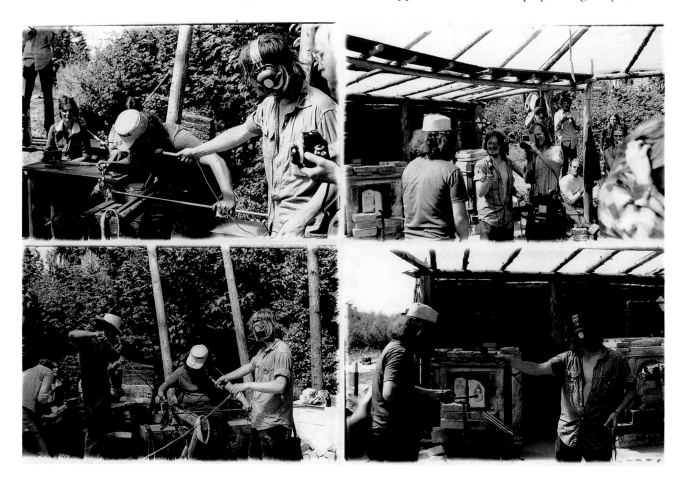

Buster Simpson drawing
with molten glass, 1972.

building the kiln or building your studio. . . . And I was afraid that if people got focused on building and solving all the living problems . . . [they wouldn't] make any art."

While Pilchuck was first and foremost about glass, the Pilchuck curriculum had a broad range in the early 1970s. Students did not spend just a two-week session at the school; they stayed for two months, and when people were not blowing, there had to be something to hold their attention.[41] No matter what they had come to Pilchuck for, artists in 1972 had much to respond to and be challenged by, and early Pilchuck projects can be better understood in the larger context of painting, sculpture, and performance than the smaller confines of glass. Outdoor installations combined glass, found objects, and video, and media work involved video, photography, and audio recordings. Glass forms were photographed in various forest or meadow locales, or documented in various states, such as inserted in stumps, buried, or broken.

Video, for example, was as new an artistic medium as studio glass: it "began" in 1965 when Sony shipped the first portable video recorders to the United States. Video quickly became allied with performance art, which had its beginnings in dada and surrealist experimental theater and followed on the heels of the beat and pop "happenings" of the 1950s and early 1960s. Performance art in the early 1970s, in turn, was influenced deeply by the multimedia events of European and American fluxus artists in the 1960s, who favored a "conceptual rigor and attentiveness to 'insignificant' phenomena."[42] In cinema, artists such as Stan VanDerBeek were "appropriating forms from the other arts, popular culture, and the materials of everyday life," writes John Hanhardt. "They transformed our perception and understanding of quotidian materials and in the process, infused the found object's iconographic powers with new meaning."[43]

Media work at Pilchuck primarily recorded artistic process—including glassmaking—and the definition of artistic process was expanded to include whatever people were doing, from making objects to building shelters to walking in the woods. Bruce Bartoo, for example, made audio recordings of Buster Simpson's interactions with Skagit County utility workers, who were questioned about the environmental implications of their presence. At that time, much of the counterculture focus was directed toward putting meaning back into life, into all the daily events—important and insignificant—that were part of living in a postnuclear age. For the artists at Pilchuck, this focus was only part of a larger investigation, which included sensory exploration and perceptual manipulation. Characteristic of this type of activity was one of Buster Simpson's 1972 projects: while

dragging a microphone along the forest floor, he filmed the microphone being dragged, juxtaposing the aural and visual records of the event. As part of his documentation of the glassmaking process, Simpson photographed manipulations of glowing, molten glass at night, shooting "infra-red flash stills of nighttime 'drawings' with glass."[44]

Chihuly and Carpenter were present at Pilchuck on and off during the summer of 1972. Besides working on their roundel windows at Michael Kennedy's studio in Seattle, they both traveled to California to do some blowing. "Dale and Jamie disappeared . . . to blow glass," says Toots Zynsky. "And while they were gone . . . [Pilchuck] was definitely taken over by the non-glassblowing contingent."[45] Although Chihuly and Simpson had worked closely in developing the faculty for Pilchuck and the school's philosophy, it became evident that two factions were developing. People who wanted to make Pilchuck a multidisciplinary art commune allied themselves with Simpson, while Chihuly concentrated, with Carpenter, on glass. In addition, the tensions of living outdoors, of increasingly complicated social and personal relationships, of building, of being wet, of blowing glass—and of not blowing glass—were coming to a head. Rob Adamson remarks, "Some students were having a hard time . . . because they had paid tuition and they weren't getting anything out of it. They weren't getting any artwork done. They came out and it rained all the time, survival was a problem. . . . Other people were totally into [it], and they got everything out of the experience. It really depended on the individual."

The most memorable social event of 1972 was an all-day graduation festival. This end-of-session party, which featured exotic foods, lots of beer, and sports of all kinds, set the tone and magnitude for all future Pilchuck festivities. "An indication of how much we bonded as a group would be the ceremony and celebration we had the last day of that session . . . which began at sunrise in the hot shop," remembers Richard Posner. "We ladled all of the glass out of the furnaces on the marvers, put other marvers on top of them and made pancakes. . . . Then we went to every person's shelter and had another [dish]. . . . From shelter to shelter . . . it was a thirty-course meal."

Later that day, Ruth Tamura hosted a graduation ceremony for the summer's participants amid a profusion of catcalls, shouted greetings, laughter, and chatter—preserved on tape by Bruce Bartoo. "Graduates," proclaimed Tamura in her address, "today we have calculated, after months of tabulations, that your class has the highest batching aptitude! Never have so few done so much for so many." With these words, Tamura handed out paper-towel diplomas, and the slug races began.

Buster Simpson is generally credited with devising the ingenious slug race course, a large board with three concentric circles, the largest measuring about 4 feet in diameter. "The course radiated out from a center spot," recalls Simpson. "Because you can't give a slug a command to do a linear course." The first slug to reach the outer circle would be the winner. People handpicked their slugs at least a week before the event, testing them for aptitude and nurturing them with special diets. Savvy trainers tried jelly to get the slugs going, while those who were less aware tried beer. "Even though they did do U-

turns and head back toward the center of the circle," comments Simpson, "it was a suc-
cessful event."

The Haubergs later threw a huge cookout for all the summer participants at their
house on Bainbridge Island. Once again, John Hauberg approached Dale Chihuly to
inquire about plans for the following year. "I said, 'Annie and I are willing, so let's do it
another summer,'" recalls Hauberg. And this time he would do even more than finance
the project: he agreed to construct a building. "It
was at the cookout, in 1972," remembers Thomas
Bosworth. "John began to think that maybe [Pil-
chuck] had more of a future. . . . He said to me,
'Why don't you do these people a building? And get
them out of that tent?'" Bosworth was only too
happy to oblige. He had been up at Pilchuck working on the Tatoosh development and
had discussed ideas for a lodge with Chihuly, Carpenter, and Simpson. Simpson had even
taken Bosworth to see some barns in the area.[46] In November Chihuly wrote to Francis
Merritt: "We've been very fortunate that the people who own the property, the Hau-
bergs, seem to be quite impressed with our efforts and are in the process of having a
lodge designed and built for us."[47]

At the end of the 1972 season, the philosophical differences between Dale Chihuly
and Buster Simpson remained unresolved. "A lot of people [were] trying to do communes
but we were probably the only ones trying to do a glass school. It could easily have turned
into a commune and not been a glass school," observes Chihuly. But Simpson had been
intrigued by the model of Black Mountain College, which had operated from 1933 to
1957 in rural North Carolina and was famous for its experimental approach to higher

> There were two camps at Pilchuck. A camp under me and
> a camp under Buster. Buster was very heavy into the
> commune thing and I wasn't. I was more into making the
> glass. Somehow, we got conflicted over it.
>
> —Dale Chihuly

education. Simpson objected to what he saw as a narrow definition of Pilchuck's mission: "If [Pilchuck] becomes exclusive . . . that goes against the Black Mountain [idea]."

Chihuly planned to take a fall semester sabbatical from the Rhode Island School of Design and had arranged for Fritz Dreisbach to teach in his place. When Pilchuck's session broke, Simpson went back east, and Chihuly, with James Carpenter and Barbara Vaessen, headed to Mexico and the Yucatan Peninsula. In Mexico Carpenter endured a mild but frightening bout of typhoid, and when he recovered, returned to the States with Vaessen.[48] Chihuly went on alone to Virgin Gorda, in the British Virgin Islands.

Chihuly's sabbatical gave him time to plan Pilchuck's 1973 program, which Chihuly, Simpson, and Carpenter had roughed out over the summer. "I went down to Virgin Gorda and I thought about [Pilchuck] for a long time," remembers Chihuly. "I was willing to build everything, like I had done in 1971, but nobody was interested. Everybody was interested in being [part] . . . of a commune. . . . A lot of the energy was sucked away by people trying to build things that I didn't care [about] . . . like the sweat lodge. . . . I wanted the energy to go toward the hot shop."[49]

Chihuly concluded that he "no longer wanted to be the director of the school, I couldn't deal with it. . . . Maybe I was good at getting it off the ground, but being the type of director I wanted to be—and I really thought of Francis Merritt at Haystack—I really couldn't do that. It wasn't my forte to be conciliatory in the right way. . . . I can motivate people and get things done, but I couldn't solve problems." Corresponding with the Haubergs from Virgin Gorda, Chihuly suggested that they might find a "camp director," someone who would run the hot shop, order supplies, supervise maintenance, and meet visitors, "all the things that usually keep me out of the glass shop when I should be there as much as possible."[50] Chihuly also forwarded plans and sketches for a "round, open-walled, barnlike" hexagonal hot shop which would have two projecting bays: one for stained glass and neon, and one for batching.[51]

From Mexico Chihuly sent a proposal to Dean Tollefson at the Union of Independent Colleges of Art, hoping to garner his support for 1973. He described the shortcomings of the 1972 program: "The last summer at Pilchuck was quite different from the summer before. We had a longer and more complicated program. . . . We tried to take on too many projects. . . . This hurt the learning situation a great deal because one of the main reasons the students paid [tuition] was to watch us work and complete major works. So next summer we are planning a program that will allow the staff to get more of their own work accomplished."[52] Chihuly, Carpenter, and Simpson had agreed to changes that would streamline the program and put the focus squarely on glass, so that Pilchuck could become an "important glass center—important in the ideas that are exchanged and in the glass that is made there."[53]

Carpenter and Chihuly planned to be at Pilchuck full-time, along with two other nonpermanent faculty in glass who would be invited for three- to six-week periods. These faculty would be encouraged to complete major works while they were at Pilchuck. The number of students in the hot shop would be cut from fifteen to ten, and

they would be encouraged to help on faculty projects in "sort of a guild system," as explained by Chihuly. The media program was eliminated for the 1973 session, although the equipment would be available to students under Buster Simpson's guidance. "Buster's main job will be to document Pilchuck and keep video and slide records of all the people that work at Pilchuck, their work and ideas," wrote Chihuly. Students would pay $400, for nine weeks, which would include a prepared breakfast and materials to make shelters, a "very successful aspect of Pilchuck."[54]

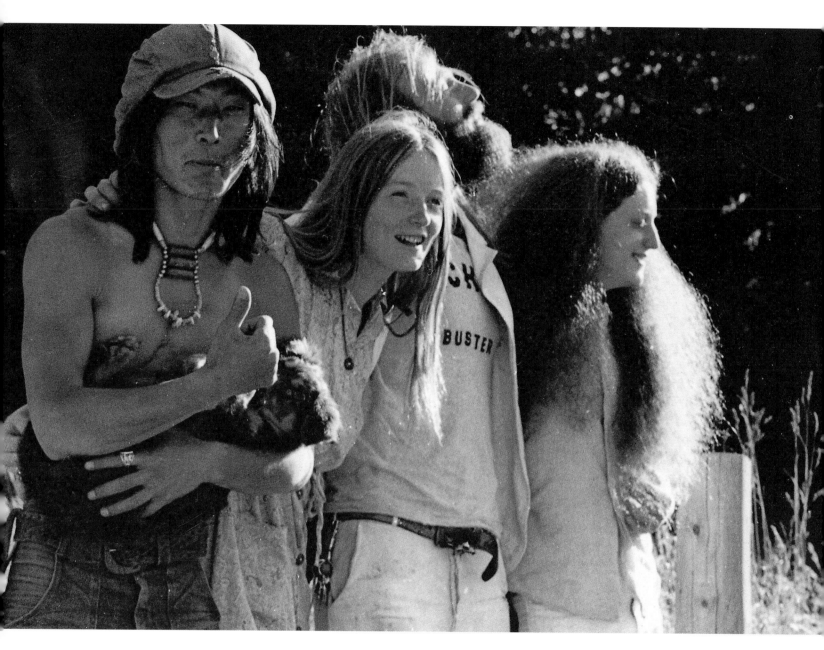

Dwan Hall, Toots Zynsky,
Buster Simpson, and Roni
Horn, 1973.

1973: Defining a School

In 1973 Richard Nixon was beginning his second term as chief executive of the United States while a Senate committee was being formed to investigate a break-in at the Democratic National Committee headquarters. "Hanoi Jane" Fonda had returned from North Vietnam just prior to the 1972 Easter Offensive, and escalation of the war was continu-

> You never know how things happen when you are in the midst of making some kind of statement or history. You don't know. You just act.
>
> —Italo Scanga[1]

ing. Terrorism erupted in Beirut and Tel Aviv, and the IRA was just launching its long siege on Belfast. In the United States, three hundred federal agents and U.S. marshals closed in on the historic site of Wounded Knee, South Dakota, which members of the American Indian Movement held for seventy-one days. In the heart of the Vatican, Michelangelo's sculpture of the *Pietà* was attacked with a sledgehammer, and, in the south of France, Pablo Picasso quietly passed away. John F. Kennedy had been dead ten years, the fuel crunch was underway, and "recession" was a new buzz word.

People with any counterculture sympathies in the early 1970s were convinced that their "revolutionary" activities, no matter how small, were part of a larger movement, and the artists at Pilchuck were no exception. Even if Pilchuck was a small experiment in the far-off woods of the Northwest, its participants recognized their involvement in non-traditional art and lifestyles as contributing to something bigger than themselves.

Pilchuck's third summer would run in a single session from June 25 through late August, with nine faculty and fifteen students, and public visitors allowed only on Sundays.[2] Because John Hauberg did not want to fund an advertising poster, none was made, although application information and slide packets of Pilchuck's activities were mailed to individuals and schools. Student acceptances were mailed in May 1973. Chihuly insisted on limiting the number of participants: his favorite postscript in letters that spring was "No friends."[3]

The 1973 program would be smaller, and the focus would be on glass. Faculty, visiting artists, and artists/guests passing through included Chihuly, Fritz Dreisbach, Buster

> I'm really uptight about the amount of people we had at Pilchuck last year. Do you think you could keep your friends away? I really had enough of that Woodstock/Community [trip] . . . last summer.
>
> —Dale Chihuly, 1973[4]

Simpson, and James Carpenter, along with Harry Anderson, Clair Colquitt, musician Frank Ferrell, sculptor Richard Fleischner, Mark Graham, Roni Horn, Michael Kennedy, John Landon, Robert Naess, Pat Oleszko, Anne Polatsek, Italo Scanga, Barbara Vaessen, and Art Wood. "Student"/staff included

Dan Holmes, Richard Posner, and Therman Statom, along with "students" Bruce Chao, Chris Clatron, Norman Courtney, Dan Dailey, Brooke de la Garza, Kate Elliott, Erica

Friedman, Dwan Hall, Robert Levin, Anne Schwab, Craig Stockwell, and Toots Zynsky.[5] As usual, these categories were loosely defined. "There was no student/teacher relationship," recalls Italo Scanga, echoing the sentiments of many of Pilchuck's early participants. "We were all the same."

"Pilchuck was founded to provide an atmosphere that would allow people to explore and discuss the new possibilities of glass, a material with which many artists have become recently involved," wrote Dale Chihuly in a 1973 statement.[6] In the work-

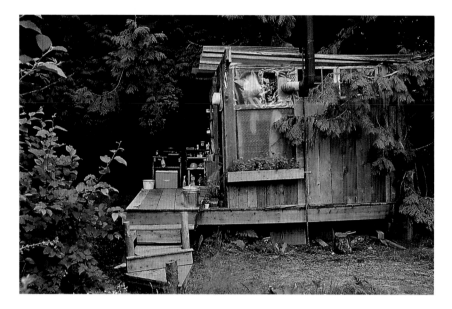

The "corner" house built by Richard and Susan Posner, 1973.

shop's 1971 session, he continued, "Pilchuck was a totally educational experience," adding that the "sense of community played an important role, although the real bond seemed to be the common interest in glass." He described the enlarged 1972 program, with its emphasis on multimedia and the introduction of photography and video. The 1973 program would, he emphasized, be different; it would focus on glass and rely on an open teaching style. "In order to provide an effective learning situation, you must provide a stimulating atmosphere," stated Chihuly. "This can be achieved by having a faculty that is very much involved in their own work, which influences the students." This concept of a teaching apprenticeship, a learn-by-doing approach, would become the general method of instruction at Pilchuck for the next five years. "The

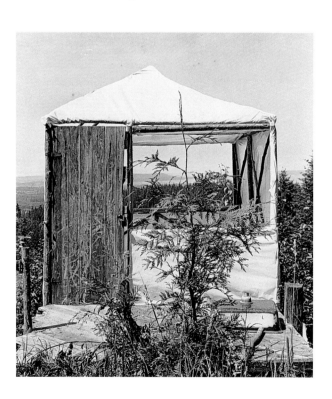

Plastic and branch shelter, 1973.

idea was to set up a situation more than to follow a formula," explains Dan Dailey. "Instead of coming in and teaching a [formal] class . . . Dale would put people together."[7]

All students coming to Pilchuck were reminded, in letters from Chihuly, to bring tools, money to cover personal expenses, a notebook of ideas for possible Pilchuck projects, and a plan for a shelter. "If you bring less than $200," he warned, "you'll end up living off of someone else and causing a lot of discomfort to

Paul Inveen came in . . . and we ate like kings under these big tents and tarps. . . . I worked half the summer as a builder and then the other half of the summer I was the "scout." I took people into the Cascades.

—John Landon

others."[8] The first week would be spent building structures and becoming familiar with the area, and "in case of rain, we will find shelter in a nearby barn or in the Pilchuck lodge." The facilities of the school—as advertised in the 1973 statement—included a "new structure for the glass shop," which was under construction, and "hopefully a darkroom if the Pilchuck lodge is completed." (The lodge, in fact, was not completed until 1978.) The new shop would have areas for stained glass and batching, and "six furnaces and three annealers" would be constructed by the opening of the session. A complete audiovisual studio, under Buster Simpson's direction, would offer a video portapak, 35mm projectors, and an 8mm camera and projector.

Chihuly envisioned that shelters would be constructed in the first week, and "during this period, Carpenter, Chihuly, and Dreisbach will be working in the glass shop on their

Kitchen and audiovisual tents, 1973.

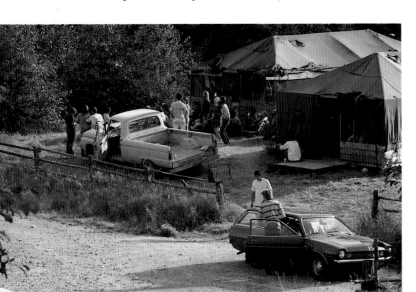

own projects, and students will be asked to only observe." Beginning the second week, however, the hot shop would move to a twenty-four-hour schedule, "allowing students and staff three to four hours of blowing time a day." "Pilchuck does not operate in a formal teaching situation," wrote Chihuly. "The advanced students are expected to help the beginners. The beginners will be expected to closely observe the advanced students, shop assistants, and faculty. This has proven to be the most effective method of learning to work with, and understanding the nature of, glass."[9] Students and staff could expect to build additional hot shop equipment, as needed, and everyone would help with chores.

At John Hauberg's request, Glenn Greener located two large Army tents which were put up side by side. One would be for cooking, the other for eating and for showing slides. "I got William G. Reed of Simpson Timber to donate the contents of a logging camp kitchen," recalls Hauberg. "We . . . [had] electricity on the campus the second year in the form of a generator, and . . . Snohomish County P.U.D. brought in power the third year." Paul Inveen was hired to cook. "Inveen was fabulous," says Landon. "We had

It seemed appropriate that the new buildings be rugged and simple, should become part of the natural setting. Logs, heavy timbers . . . and large-scale cedar shakes like those used on nineteenth-century buildings in rural Washington made sense.

—Thomas Bosworth[10]

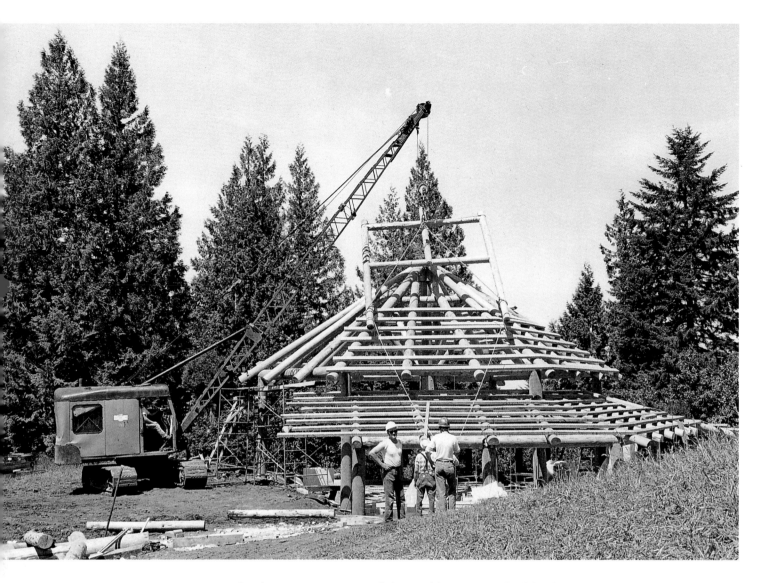

Raising the vent cover
onto the crown of the
new hot shop roof, 1973.

great food. Every once in a while we'd have a meal of fresh rainbow trout or a champagne breakfast under the big top."

A hot shop was built during the 1973 session on the exact spot, plus or minus a few feet, as the original shop. Plans had called for construction of a lodge and only a replacement roof for the hot shop, but at some point, the lodge disappeared in favor of a completely new hot shop.[11] Designed by Bosworth, with assistance from Ken McInnes and Tony Costa Haywood, and built by John Hauberg's logging crew, the hot shop has become the school's signature symbol. Rugged, romantic, and impractical, it blends the grand traditions of classical Greece and Rome with the simpler endeavors of Euro-American pioneers of the Northwest. Part barn, part Pantheon, the hot shop is the school's heart, its roaring furnaces pumping raw energy throughout the hillside. "The crew was . . . just a bunch of rough guys," remembers Bosworth. "So the joinery is very rough. And the whole thing is crude. . . . It is a primordial building. We just took the logs and dipped them in preservative and stuck them in a hole in the ground and poured concrete to stabilize them. And I made the floor of the hot shop a stepped platform so it would follow the natural contour of the land. The easiest thing to do is bulldoze and clear. But the idea was not to tamper with anything." Bosworth earned an award of

Interior of the new hot shop with Therman Statom (foreground) and Dan Holmes, 1973.

The Pilchuck campus in 1973 with the railroad shack (left), Army tents (center), and the newly completed hot shop (right).

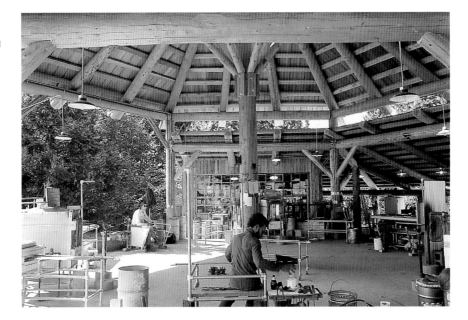

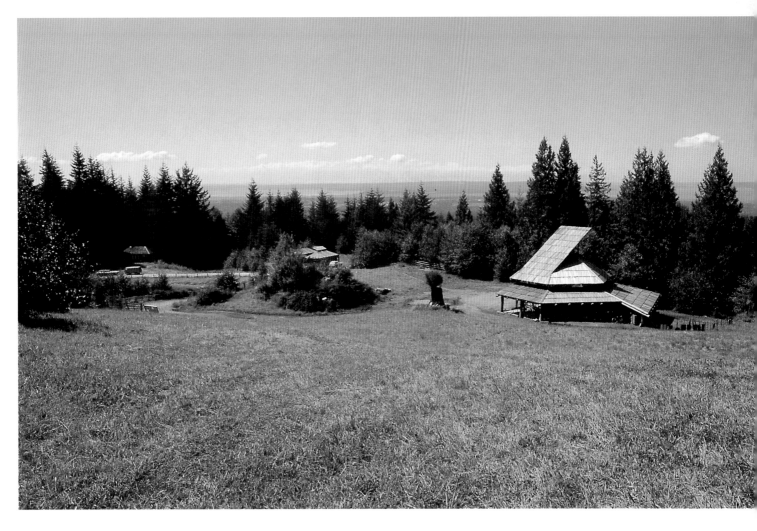

architectural excellence for the design of the hot shop the following year from the American Institute of Architects.

The hot shop cost $35,000 to build, and John Hauberg paid for it. "It never occurred to me to ask anyone else to chip in," says Hauberg. "Even at this time, you see, we were not ready to believe that we were going to be a permanent enterprise. The hot shop could have been a nice little building for [something else]. . . . Just move out the glory holes and so forth and perhaps have chamber music." Bosworth says, "We put up [the first] building with no thought that anything more might happen. It was still pretty much of an ad hoc thing."

The big fir timbers for the hot shop came from Hauberg's tree farm, as did the cedar for the massive handmade shake roof. The shakes were cut by Walt Hass, a woodsman from Arlington who was a "folk hero," says Rob Adamson. "The original independent American. . . . His artistry is in his life. Walt was the only thing that connected the students to the reality of the location."[12] Buster Simpson describes Hass as a "living treasure . . . [who] lived off the land and found his stumpage when he could. He was doing taper shakes, which is becoming a lost art."

Hass brought all kinds of food to the Pilchuck hillside: bear meat, salmon, elderberry and dandelion wines, and fruit jams, made with his wife, Anita. He taught Pilchuck artists how to manage the wet environment—how it was necessary, for example, to rub mink oil into their leather shoes to keep them dry—and how to live off the bounty of the forest. "He was a personal almanac, he was a psychiatrist, everything," says Italo Scanga. "He was a father. He had the lubrication: it was whiskey and cranberry juice. He used to start his truck with a screwdriver. You felt secure with him. He was our protector. Walt taught us about the weather and how to survive in the woods. How to use trees, how to build fires, how to kill bears, and how to catch salmon and smoke it."

> Hass knew those woods, he knew that country, he knew everything from making elderberry wine to . . . trapping. There was a link there with an earlier time in the Northwest.
>
> —Buster Simpson

Hass's taper shakes—which later would also be used for the roofs of the lodge and the footbridge—are skillfully carved from old-growth cedar and are an unusual 48 inches long. Because they are hand-split, they impart a rustic character that commercially made shingles cannot match. "Walt was looking for old windfall, first growth timber that he would cut out of the ground, and that's what the cedar shakes were made of," remembers Charles Parriott, who first came to Pilchuck in 1974. "Because that was the best wood. And Walt could sniff that out better than anybody. In the second growth, he could figure out where the first growth timber was buried below the moss."[13] Twenty-five years later, "we're constantly looking for shake mills that will [make them]," says Pilchuck's present director of operations, John Reed. "They're about four times as expensive as regular shingles. We have to find somebody who . . . has a source of old-growth cedar and is willing to split them."

Some 1973 participants lived in structures they had built the previous year, and others inherited shelters—Kate Elliott occupied John Benson's place, and Toots Zynsky and

Dwan Hall lived in the stump house built by Guy Chambers.[14] Bruce Chao put up a little house in the woods—later rebuilt by Rob Adamson and subsequently by Benjamin Moore—which is still in use. Impressed by photographs seen in *National Geographic*, Therman Statom built a small yurt in the meadow near the Carpenter/Vaessen house which was admired for its unusual design. Covered with sod on the outside, the inside—about 9 feet in diameter—had a plywood floor and yellow canvas flaps. "The yurt was ground level. . . . We put the sod on top . . . and a hole in the middle so you could have a fire," remembers Statom. "And it rained and you'd be in the middle of this field and you'd be dry. It was so romantic . . . cutting trees down, carrying them down the hill, putting them together, and putting wood on top and dirt, and living in the middle of the field . . . developing a philosophy for a structure. A lot of that influenced my work."[15] While building the yurt, Statom found shelter in the now-unused food cache. "I remember sleeping up there with a tarp and not being happy about it," says Statom. "And I was scared, scared half to death. Thinking a bear was going to come and chew me up. Porcupines."

For the 1973 session, Chihuly had asked Fritz Dreisbach to oversee the setup of the hot shop, including the building of the furnaces and annealers. "We had to rebuild the furnaces every year," says Dreisbach. "They wore out, they got beat up, the snow came, the cows came in. . . . That was one of my biggest bones of contention. . . . Do we have to reinvent the wheel every year? I realize that one reason Dale brought me to Pilchuck was because I knew a little bit about how to get these things going and make them work. That was my expertise." "Fritz was building the furnaces, Fritz was building the annealing ovens, Fritz was melting the glass, Fritz was the man," remembers Statom. Michael Kennedy recalls that Dreisbach made a concerted effort to improve the funky equipment, getting "real serious about formalizing the hot shop—the annealers, the furnaces, and plumbing—on a more permanent basis." Kennedy, along with Richard Posner, Therman Statom, Bruce Chao, and others, helped to make and install the new equipment.[16] Chihuly made arrangements with Northwestern Glass to obtain batch materials at cost.[17]

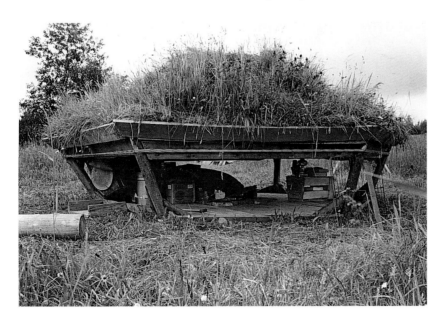

John Landon and Anne Polatsek, nicknamed Annie Pilchuck, took people on camping trips far into the Cascades, while others arranged outings to local spots. Michael

I had a meal that I'll never forget, actually. It was brown rice with thistle stocks, pine needles, and wild onions.

—Bruce Chao

Kennedy organized an expedition to Birch Bay, near the Canadian border. "We camped out and dug clams," recalls Kennedy. "Butter clams, horse clams, and geoducks." "We took trash cans from Pilchuck," adds Courtney. "We had never heard of limits!"

The Korean artist Dwan Hall was, Buster Simpson remembers, "an ace fisherman . . . [and] really connected with the environment." Foraging was a popular Pilchuck pastime, and Hall and Toots Zynsky were good at it,

We always talked about glass . . . using glass to make art. But the idea of the furnaces, the idea of the woods, the idea of water—they had to find a location to fit all those elements: air, fire, and water. Those are the basic elements of making glass.

—Italo Scanga

gleaning fruits and vegetables from processing plants in Stanwood and gathering wild strawberries and blackberries for jams. As in previous summers, community cookouts took place. Susan Posner planted a vegetable garden and baked delicious blackberry pies. Sustenance gradually was getting figured out as, little by little, lifestyle issues increasingly became organized and managed.[18]

Glassmaking, in 1973, focused on blowing in the hot shop as well as hot glass "experiments" involving other media. Fritz Dreisbach, James Carpenter, and Dale Chihuly taught blowing, while Michael Kennedy focused on stained glass. Video and photography were set up in the railroad shack, under Buster Simpson and Harry Anderson, and artists such as sculptor Italo Scanga worked on their own projects. In the hot shop "students" blew alongside "faculty," and everyone shared what they learned. Kate Elliott remembers most people were not very good with the blowpipe. "Jamie was the best . . . and Therman was actually a very good glassblower, too . . . and Bruce Chao."

Because Therman Statom could blow exceptionally large pieces, he worked chiefly with Carpenter and Chihuly on their projects. "I spent weeks and weeks in the early days practicing blowing . . . as thin as possible and as large as possible," remarks Statom. "I blew a lot, maybe six to eight hours a day. I tried all different methods of blowing. . . . From Dale . . . I learned what it took to get from point A to point B. He taught me a lot about being resourceful." Statom, like many, had been converted to glass from ceramics.

Fritz Dreisbach (right) and Bruce Chao demonstrating a technique in the new hot shop, 1973.

Rob Adamson—who met Statom in 1974—remembers that "right away Therman distinguished himself by being able to do his own things and ideas, and they were always off the wall and wild."[19] Other students, like Dan Dailey, focused on Chihuly's method of teaching: "It . . . put

an actual working situation right before the students . . . not just in front of them, like a demonstration, but involving them."

Other artists concentrated on work with video, following Carpenter's lead of using multiple media. "I did a lot of work with photographs on glass," recalls Carpenter. "And Dale and I . . . were trying to do some . . . architectural panels . . . and images about thoughts or poems about transparency and illumination, general ideas about glass as a material." Toots Zynsky remembers "dropping glass on the floor, melting paper cups on it, boiling water in paper cups on it, or dropping hot glass on plate glass on the floor and videotaping it. The shattering glass would make all these wonderful sounds and explosions." In addition to their individual video and glass work, Zynsky and Barbara Vaessen spent hours down in the photography lab at the railroad shack, developing film and making prints on out-of-date photographic paper scavenged from the Stanwood dump. Buster Simpson was involved with diverse video projects, ranging from the documentation of glass activities and personalities, such as Walt Hass, to creating short narrative subjects.

Some artists saw exercises in the hot shop that were not about object making as wasting time and glass, but others embraced the spontaneity and unpredictability of glass

Boiling water in a paper cup on hot glass, a collaborative "event" by Buster Simpson and Toots Zynsky, 1973.

"events." "I remember Dicky Fleischner coming up and making fire," recalls Therman Statom. "He got cedar and they built a structure that they poured glass over. He and Jamie Carpenter were doing this." The oily cedar exploded on contact with the hot glass, resulting in a "beautiful fire." In another project, Fleischner and Carpenter put water on the marver, poured hot glass on it, and topped it with a board with a cutout hole. While the wood burned, the steam forced bubbles through the cutout. In the meantime, Richard Posner was staging a mock archaeological dig on the site of the new hot shop, planting a hoard of vessels blown inside a mold which he fashioned in the form of the head of Winston Churchill. Posner subsequently unearthed his so-called Winston Pilchuck tumblers in an elaborately documented project.[20] Certainly the most infamous event of the summer occurred when Italo Scanga—while experimenting with different materials in the hot shop—unknowingly threw a notebook containing Fritz Dreisbach's painstakingly researched glass formulas into the furnace to create flames.[21]

From the beginning, Italo Scanga acted more as an artist-in-residence than faculty member, obsessively making work, enthusiastically enlisting the help of others, and freely sharing his remarkably broad knowledge of art history, music, and literature. Scanga's

Richard Posner shaping a vessel, 1973.

experiments and philosophies provided an especially good perspective for students coming from more intense craft backgrounds. Commercial craft glass at that time was retreating into conservatism, dominated by a Tiffany aesthetic consisting of art-nouveau-inspired, expressionistic forms with iridescent finishes. "Italo Scanga was important to Pilchuck as an instructor and as a force," says Rob Adamson. "He viewed glass not as a potential pretty vessel. He'd paint on it and break it. He was totally free with glass in an unconventional way."

Uninterested in rules and hang-ups, Scanga never hesitated to voice an opinion. "I don't know the rules, I don't know how they got there," says Scanga. "We got up early in the morning and we went to the hot shop. I would do drawings and show them to Dale and Jamie and say, 'Is this possible to do?' Or I would come in with garlic and onions and manure and put it on the glass. This stuff they learned from Venice—we were trying to break it. It became so decadent. . . . But [at Pilchuck] they tried to start afresh. Brand new. It was very primitive. . . . Rough. Very American, very Northwestern. I thought it was very, very original."

Scanga was notorious for his series of experiments with garlic. "I recall Italo coming into the hot shop and declaring, 'I'm going to make glass with garlic,'" wrote Chihuly. "His plan was to pour molten glass onto the marvering table, put a garlic flower on top of it, and then quickly cover it with another puddle of molten glass. Presto! The herb would blow a bubble as it gave off superheated garlic gas."[22]

Italo does his thing. But he would always do a body of work that would show people how easy it was to do work. Get motivated and just go in and do it. He was always an object maker.

—Dale Chihuly

During the 1973 session Scanga organized a series of site-specific installations he called the Pilchuck Projects, publishing them the following November in a small catalogue designed by Buster Simpson and Harry Anderson, and produced by Kate Elliott. "During the summer of 1973 I visited Pilchuck Glass Workshop in Washington State," wrote Scanga in the catalogue. "The area was idyllic. The stumps left from a previous cutting of the trees affected me most of all."[23]

The project involved six artists—James Carpenter, Dale Chihuly, Kate Elliott, Scanga, Anne Schwab, and Barbara Vaessen—each of whom were asked to arrange four "elements": a tree stump, lantern, dipstick, and glass. "Each artist was given a lantern and a dipstick. The tree stump and the glass were of their own choice and, in most cases, the glass was

Italo Scanga, Buster Simpson, and Dale Chihuly, 1973.

Opposite: Dale Chihuly's installation for the Pilchuck Projects, 1973.

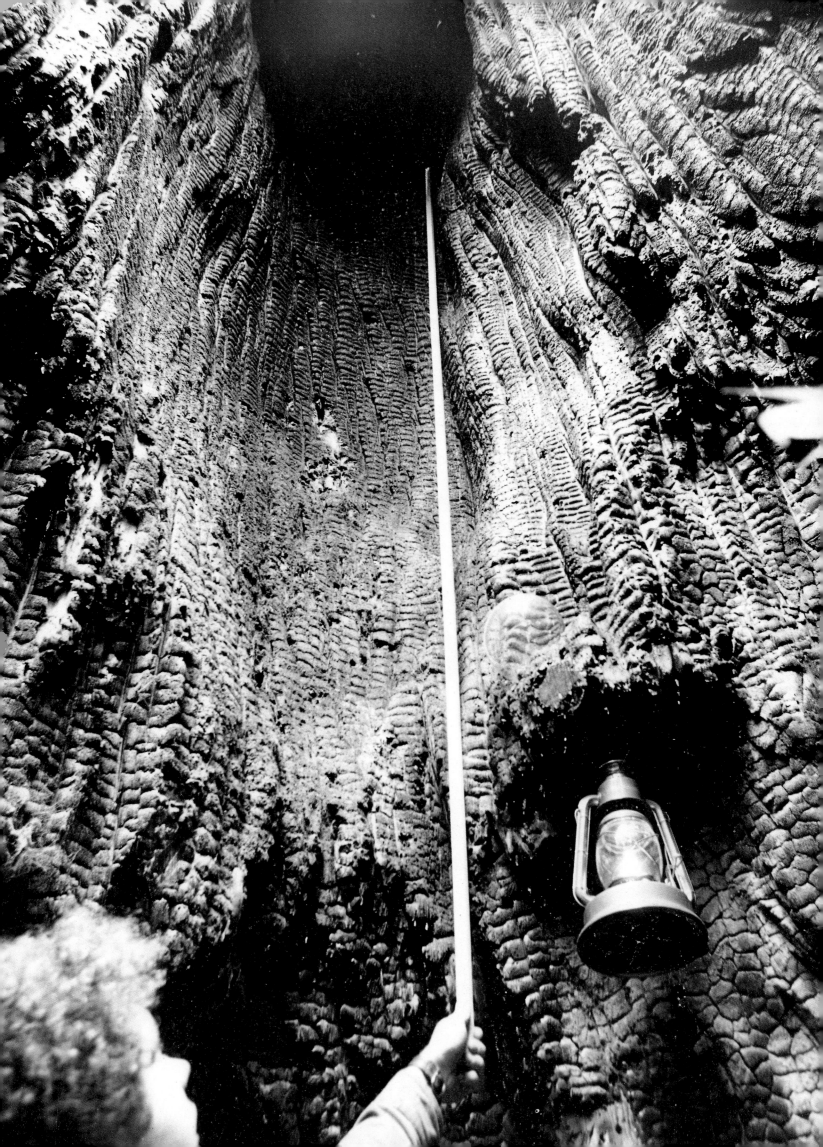

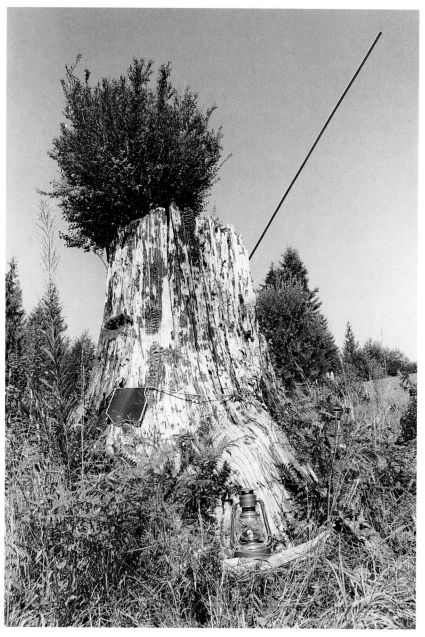

Barbara Vaessen's installation for the Pilchuck Projects, 1973.

of their own creation," Scanga wrote. The Pilchuck Projects aptly represent the artistic credo of Pilchuck's earliest years: to use glass to make art by realizing objects and concepts, to combine glass with diverse materials and documentary media, and to employ the landscape as a point of departure. Early Pilchuck was about glass, but only as one of several experimental media to be explored in the context of a counterculture community.

The two factions that had formed at Pilchuck the previous summer—the glass followers of Chihuly and the multimedia contingent backing Simpson—had returned in full force in 1973. "It wasn't a good atmosphere between the two camps," remarks Toots Zynsky. "There was this big division—the glassblowers and the people who weren't necessarily blowing glass. [The glassblowers thought] . . . glass is a precious substance that shouldn't be wasted, it should be made into beautiful objects and [the others thought] . . . we're here just to learn and do and make and talk."

Simpson's vision of Pilchuck in the larger context of the environment began to run counter to the school's fundamental principles as understood by Chihuly. Although Simpson and Chihuly agreed on the kinds of people and approaches they wanted to bring to the school, Chihuly argued for more focus on the hot shop and getting work done, while Simpson wanted a greater awareness of environmental and social issues. "I have pretty strong opinions, and there were a lot of discussions that second and primarily third year about how things were going to work," remembers Simpson. "It was becoming obvious that there were fundamental philosophical differences about the place, and given the nature of the personalities involved, there wasn't much room for collaboration." "When I came back the third summer," recalls Chihuly, "damned if Buster and I didn't go right at it again.

Fortune is like glass: it is most breakable when it shines brightest.

—Publius Syrus, 1st century B.C.[24]

We had talked it over and said, 'Look, let's try to work together.' I don't know why it went sideways."

The students had their own complaints. Not everyone was happy to be paying money to build shelters, even if they enjoyed it, and doing chores when they wanted to make art. And despite Chihuly's "no friends" dictum, a lot of visitors had come to the hillside that summer, which added to the distractions. And there were day-to-day problems. "John and Anne Hauberg came up and there were these issues," remembers Therman Statom. "Should we cut the grass or should we move some of the houses that don't look so swift into the woods so that when John comes up he doesn't have to look at [them]? That's when it all started . . . a rift in philosophy. Should we make these compromises or not?"

> **One artist in the family is enough. If you have two, you have trouble.**
>
> —Lino Tagliapietra[25]

> **You could see that the focus of the school was beginning to be pulled apart. . . . And of course John Hauberg and Buster Simpson had as much basic understanding of each other as a cougar and a bear.**
>
> —John Landon

By the end of the 1973 session, Chihuly and Simpson hardly were speaking to each other. John Hauberg remembers that "Dale had a run-in with Buster Simpson, who tried to undermine Dale's authority." Further, Hauberg saw that being the administrator and artistic director of the school was not Chihuly's first interest, and perceived that Simpson might use this as an opportunity to step in. "So, I just said, 'Dale, come on over here, I want to talk to you,'" says Hauberg. "And I said, 'You know, you're just no good as an administrator.' And Dale said, 'God, I know it.' I asked if he would mind if I brought in somebody from the outside." Chihuly undoubtedly was relieved to be offered some kind of help. The idea of bringing someone in was not new; Chihuly had broached the idea of a "camp director" with Hauberg the previous fall. The session ended with an agreement to find an administrator, and Chihuly headed back to Providence. Buster Simpson, in the meantime, had elected to stay at Pilchuck into the fall.

The actual sequence of events of Simpson's last days at Pilchuck is clouded. One day he was living at Pilchuck, and the next, John Hauberg had asked Thomas Bosworth to tell Simpson to leave immediately. Hauberg says that Simpson was asked to depart because of his disagreements with Chihuly. "Buster badmouthed Dale," explains Anne Gould Hauberg. "Buster is a revolutionary, you see. . . . I don't think it bothered Dale but it did bother John. Because if you're on the team, you don't badmouth your team."[26] "I think John saw Buster as a bit of a radical," remarks James Carpenter. "It wouldn't take long for that to boil over." "They would not have gotten along, those two, and you could just tell it in a second," adds Chihuly. "And [Simpson] was the only one there, and John used to come up to the

> **I don't know what happened, to tell you the truth.**
>
> —James Carpenter

> **Somebody knew the story at some point.**
>
> —Dale Chihuly

> **I'm not really sure.**
>
> —Buster Simpson

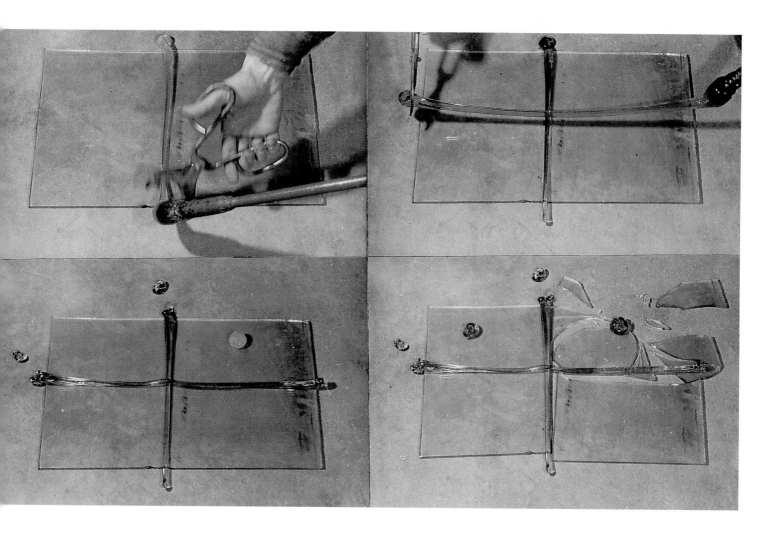

Buster Simpson
(American, b. 1942) and
Toots Zynsky (American,
b. 1951), *Hot Glass /
Plate Glass*, 1973.
Photo documentation of
video "event."

property a lot at that time. . . . I heard . . . that there were some political aspects to it.
. . . That's all I ever heard."

In an unpublished review of a 1981 Seattle exhibition, art critic Matthew Kangas
offered another, albeit undocumented, viewpoint: "Buster Simpson's tenure at Pilchuck
(1971–73) came to an abrupt end when patron and founder John Hauberg reportedly
viewed the artist's *Hot Glass on Plate Glass* videotapes (done in collaboration with Mary
Ann Zynsky) and summarily dismissed him. Those tapes occupy a place within the his-
tory of Northwest art akin to Duchamp's readymade snow shovels and urinals. They
outraged, they influenced, they captured the medium's essentials in a new way." The
videotapes that Hauberg supposedly viewed showed Simpson "laying crosses of hot
molten glass on solid plate and allowing it to crack and shatter on camera."[27] Thomas
Bosworth, an unwilling player in this drama, remembers only that Simpson had written
a proposal to Hauberg, asking to stay on at Pilchuck to do a project he had in mind.
Hauberg rejected Simpson's proposal but "he stayed on regardless," says Bosworth.
"And that was the problem."

When Simpson left, so did Pilchuck's media program—which had been the source
of much of the experimental work made at the workshop—causing the school, says John
Landon, to contract "back into almost strictly glass." Building shelters would no longer
be encouraged, and although community would always be very important to Pilchuck,

the experiment in alternative living had ended. Pilchuck the school remained, but Pilchuck the commune was over.

James Hazeltine (left)
and Dale Chihuly at
Pilchuck, 1974. The
food cache built by John
Landon appears in the
background.

1974–1976: The Pilchuck Glass Center

As artists were experimenting with glass and alternative lifestyles at Pilchuck, John Hauberg was looking into a number of possibilities for his tree farm property. In July 1972 the Haubergs had announced the formation of the Pacific Northwest Arts Center (PNAC)—an arts organization devoted to exploring the "mystique of creativity in the Northwest."[2] The PNAC's first director was James Hazeltine, and James Plaut, secretary-general of the World Crafts Council, was its program adviser. A regional arts center was envisioned for the tree farm site, with an adjunct art gallery in downtown Seattle. "We hope that there will be a restaurant and that there will be things for sale, too," Hauberg told the *Seattle Times*, ". . . such as the work from the glassblowing workshop which will be a part of PNAC as long as Dale Chihuly wants to direct it."[3] By November 1972 John Hauberg had asked Plaut, who had been instrumental in the development of Old Sturbridge Village, a "living history" museum outside Boston, to present a progress report on PNAC activities.

"The accepted and chartered purpose of Pacific Northwest Arts Center," wrote Plaut, "is that it should become a multifaceted cultural complex celebrating and illuminating the arts of the Pacific Northwest region—the traditional and contemporary visual and performing arts."[4] Plaut suggested that the Pilchuck Workshop (the school's official

James Plaut (left) and Thomas Bosworth at Pilchuck, 1974.

name in 1973, changed to the Pilchuck Glass Center in 1974) and PNAC's in-town gallery, opened in August 1972, be looked upon as "elements of a larger, more well-rounded program." Further, stated Plaut, "We should not be deluded into believing that the present physical structures and range of activities are acceptable as a permanent solution." Plaut was convinced that "Dale Chihuly's workshop" would become an increasingly significant undertaking, gaining further status and reputation, and not remain "the isolated phenomenon that it is now."

In March 1973 the *Seattle Post-Intelligencer* announced that a new board president would succeed the Seattle Art Museum's longtime president and founding director Richard E. Fuller. "When Dr. Richard E. Fuller [recently] stepped down from his position," reported the *Post-Intelligencer*, "he left a space that was almost larger than life, and to fill that gap, the museum trustees have chosen a big man in all respects, John H.

Hauberg."[5] Hauberg had been associated with the museum for several years, but with this new position, he could no longer devote as much time as he would like to PNAC, and especially to Pilchuck. Joseph McCarthy, PNAC trustee and former dean of the graduate school at the University of Washington, remembers that Hauberg called him soon after the museum's announcement. "He said, 'Joe . . . they've just invited me to take over as president . . . when Dick Fuller retires. And I really can't do that and go ahead with Pilchuck. . . . Why don't you take over Pilchuck and be the president?'" Hauberg assured McCarthy that he didn't need to know anything about glass—he just needed to handle the budget.

With McCarthy installed as president of Pilchuck and PNAC, Hauberg turned to finding someone to manage the school's day-to-day operations. Mimi Pierce, an acquaintance of the Haubergs who had some art school experience as head of public relations at the Cornish College of the Arts in Seattle, first heard that the Haubergs "were looking for someone to do a study of Pilchuck, including the building enterprise they had planned there."[6] James Plaut's vision, it seemed, was too much of a commitment for PNAC.

> **After Pilchuck's third year . . . there was disagreement in the ranks. . . . I was asked to do a three-month study on the [glass workshop] and the umbrella organization [PNAC] to determine if one or both programs should be disbanded.**
>
> **— Mimi Pierce[7]**

"I felt Jim's ideas were too expensive and too vast for what we could do at that point," recalls PNAC trustee Joseph Monsen. "Having [organized] . . . Sturbridge Village, he visualized the whole thing full-fledged, and we didn't have the financial base for that."

Mimi Pierce visited Pilchuck with Anne Gould Hauberg at the end of the 1973 session. The Haubergs asked her, on behalf of PNAC, to prepare a report on the feasibility of the Pilchuck Workshop and PNAC program, and drafted her to manage PNAC's Seattle gallery, with Tom Wilson as curator.[8] Pierce interviewed a range of people, including artists, grant makers, and even the mayor of Everett. In her October 1973 report, she recommended that both Pilchuck and PNAC continue to operate.[9] She suggested that the name "Freeborn Hill" be used for the Pilchuck Workshop and a planned recreational and cultural park, with "Pacific Northwest Arts Center" used only for the Seattle gallery. As envisioned by Pierce, the Freeborn Hill Recreational and Cultural Park would subsidize cultural activities on the tree farm site. Pierce's initial scenario included campsites, hayrides, swimming holes, a trading post, artisan booths, and a gas station, which by 1980 would be joined by a children's barn and Indian villages.

Pierce proposed separate facilities for the Pilchuck Workshop, which would be a more serious, educational endeavor. Additional facilities for glassblowing, ceramics, weaving, and woodworking would be located within the Freeborn Hill park, where "artists in action" would be just one of the tourist attractions. In a grant application, Pierce wrote:

During the last several months we have been in contact with major summer workshop centers throughout the country. . . . We have looked particularly at the programs and scheduling of Haystack School of Crafts in Maine and Penland School of Crafts in North Carolina. In time, we hope to offer [at Pilchuck], as they do, facilities for enamel, ceramics, metal, wood, textiles, jewelry, mosaic, and photography, as well as glass.[10]

With all this planning and visualizing, however, no one thought to involve Dale Chihuly. "I was totally against any other medium being up there," Chihuly says. "Dale just killed the [Freeborn Hill] idea," recalls Rob Adamson. "'Whatever you do, don't encourage it,' were his basic words." Although Freeborn Hill never came close to being a reality, the idea of defraying the costs of glassblowing at Pilchuck by introducing new media—painting, ceramics, or other "fire arts"—continually surfaced. The PNAC/Pilchuck board discussed numerous configurations. "I remember many meetings," says trustee Patricia Baillargeon. "Would we have photography? Would we have weaving? Would we have ceramics? I don't think you can say it was decided just once. It was always, 'Well, let's see how this year flies.' It's easier to look back now than it was then . . . when the school was only two or three years old, and know how strong glass was going to be, and how innovative." John and Anne Gould Hauberg both promoted expansion to other media. "I said [to Chihuly] . . . 'Annie and I think that maybe we ought to expand into weaving,'" recalls John Hauberg. "Weaving and pottery took care of about 80 percent of the people who called themselves craftspeople. But Dale just begged us not to do that." Chihuly, Fritz Dreisbach, Rob Adamson, and Dan Dailey all lobbied to keep Pilchuck a glass school and to make it the best it could be.

Rob Adamson on the blowpipe, 1974.

By December 1973 Pierce had been hired as acting director of Pilchuck. Inquiries about Pilchuck's 1974 program had begun to trickle in. "[But] we didn't have a faculty, we didn't have any application forms," remembers Pierce.[11] An enrollment poster was quickly printed and circulated, attracting more than one hundred applicants. Rob Adamson, whom Pierce had met while organizing a show of Northwest glass for PNAC's Seattle gallery, would run the hot shop (assisted by Norman Courtney), order glass and equipment, and maintain the school's eight furnaces. Like so many Pilchuck staff, he ended up doing much more than he originally was hired to do.

Pilchuck's 1974 advertising poster featured photographs of the hot shop—showing Therman Statom and James Carpenter blowing glass and a view of stained glass tables—

as well as a summer schedule and faculty listing. Two three-week workshops, limited to eighteen students, were offered. A $350 fee for each session included "instruction, tent shelter, board, and all glass fees." The decision to create two sessions was based on course lengths at Penland and Haystack. "Formerly, we have offered programs of eight weeks' duration," explained Mimi Pierce in a 1973 grant application. "The 'magic' at Haystack and Penland, however, is based on three-week sessions."[12] Fritz Dreisbach, coming from Penland in North Carolina, and Marvin Lipofsky, from the California College of Arts and Crafts in Oakland, would teach the first session, and Dale Chihuly—with James Carpenter—and Fritz Dreisbach would teach the second. Paul Marioni taught for the first time in 1974 as a guest instructor in stained glass, and Russell Day served as a program adviser. Later, a special intersession workshop was added—the three-day "Northwest Seminar"—taught by Chihuly, Dreisbach, and Lipofsky and aimed at "art instructors in all fields and practicing glass professionals."[13]

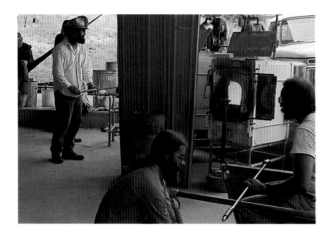

Left to right: Fritz Dreisbach, student Charles Parriott, and Marvin Lipofsky, first session, 1974.

The month of August was reserved for Pilchuck's first artist-in-residence program, a masters/apprentice session organized by Dale Chihuly for artists of recognized reputation. The artists-in-residence—Chihuly, Carpenter, Italo Scanga, and Dreisbach—were expected to do their own projects. Charles Parriott and Benjamin Moore, who first attended Pilchuck as students in 1974, remember that two teams of student-assistants were asked to stay on as apprentices.[14] Rob Adamson and Robert Levin worked with Fritz Dreisbach while Erica Friedman, Phil Hastings, Eric Hopkins, Moore, and Parriott worked with Carpenter, Chihuly, and Scanga. Kate Elliott and Barbara Vaessen also stayed through August to work on some leaded glass panels designed by Carpenter and Chihuly for the Corning Museum.[15]

Other students enrolling at Pilchuck for the first time in 1974, most of whom stayed the entire summer, included Rick Bernstein, Darrah Cole, Lark Dalton, Toby Goldman, Larry Lazin, Mark McDonnell, Paul Neuman, Flo Perkins, and Waine Ryzak. Local glass artists Steve Beasley, Gary Galbrook, Marten Haggland, Dave Keyes, Stan

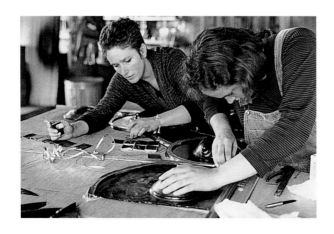

Barbara Vaessen (left) and Darrah Cole working on *The Corning Wall* in the stained glass area of the hot shop, August 1974.

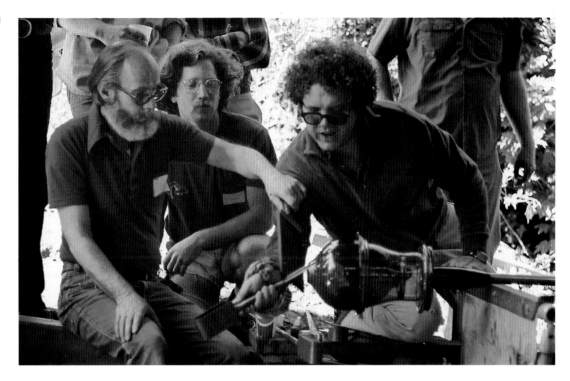

Price, Roger Vines—and Steve Bidwell and Jack Wax from the Archie Bray Foundation in Helena, Montana—came up for the three-day seminar, which featured glassblowing demonstrations, slide lectures, technical forums, and Dreisbach's famous roast pig.[16] Harvey Littleton, the so-called father of American studio glass, visited Pilchuck for the first time, and he led an informal discussion at Inspiration Point. Even with the school's fine-tuning of its program, Pilchuck still kept a fairly low profile. "We liked our anonymity," recalls Paul Marioni. "In fact, if you called the Stanwood operator, you could not get Pilchuck's telephone number. . . . You had to know somebody that was there to get the phone number and find directions to the school."[17]

Mimi Pierce brought a new level of organization to Pilchuck. She developed procedures, kept detailed records, and operated within a strict budget. Although Chihuly was organized—especially with Toots Zynsky's and, later, Kate Elliott's help—he had relatively little interest in keeping records or budgets. He handed all accounting matters over to Grace Bartlett, John Hauberg's assistant, and procedural questions to James Carpenter, Buster Simpson, and others. Pierce's appointment, suggests C. David Hughbanks, a Pilchuck trustee in the 1980s, "freed up Chihuly to attend to the artistic aspects of the school and allowed him to pursue his own work."[18] Bookkeeper Marge Siegel and Kate Elliott assisted Pierce with administrative duties during 1974. "Pierce certainly began to try to bring some order . . . and she seemed to have all the right instincts about what should be done," recalls LaMar Harrington, "but . . . it was still very chaotic."[20] Pierce was easygoing, a bit of a rebel herself, and she enjoyed the highly charged, creative atmosphere of the school. But many artists felt the pull of the administrative reins.

The conflict between the administration and the artists had to be, and probably made Pilchuck as good as it is today.

—Rob Adamson[19]

"Welcome, Pilchuck student."[21] This greeting, from a memo sent by Pierce to all 1974 Pilchuck participants, signaled the fundamental shift at Pilchuck from a colony of artists to a camp trying to become a school. The traditional distinction between students and faculty had emerged. Students were no longer expected to build facilities (although they helped) or their own housing, and three meals a day would be offered, except on weekends. Camp rules, in the form of a memo to faculty, staff, and students, were circulated and posted, stating Pilchuck's official view on everything from use of the telephone in the hot shop to skinny-dipping in the pond (neither encouraged). Barefoot glassblowers were advised to proceed at their own risk. "We are a glass center," wrote Pierce, "and it's everywhere." Aspiring builders were notified that "tents on platforms are provided for all students, and existing shelters are for the staff and faculty. Do not add onto your tent platform or build any new structures. . . . Our center is for glass artists, not would-be architects."[22]

Pierce cautioned that no unauthorized charges would be reimbursed by Pilchuck—a point of contention since artists felt they were not being trusted—and visitors would register and pay for their meals, just like everyone else. Visitors, in general, were discouraged, and open houses were limited to two per summer. Intended as public relations and sales events, open houses offered glassblowing demonstrations and kite-flying exhibitions,

Left to right: Erica Friedman, Dale Chihuly, and Italo Scanga in Chihuly's house at Pilchuck, 1974.

and were publicized in the local papers. PNAC requested that each student donate one or two pieces of glass for the public sale; other pieces would be handled on a commission basis, "30 percent to PNAC and the balance to the artist." The artists, however, "felt that it was their work and they shouldn't be asked to donate it," remembers Pierce. She explained that since "tuitions in no way covered the cost of having [students] there," PNAC should receive some remuneration from any sales.[23]

> The first few years at Pilchuck I stayed in Annie Hauberg's Arabian desert tent. It was . . . a large round tent that was all quilted inside with ancient Egyptian scenes. It was really beautiful. . . . It was on top of the grassy knoll . . . about where the first dormitories are.
>
> —Paul Marioni

Most of the artist-made shelters had been torn down at the end of 1973 on John Hauberg's orders; Charles Parriott remembers that only about twelve remained at the start of the 1974 season, and these were quickly claimed. Parriott moved into Therman Statom's yurt, Norman Courtney inherited Buster Simpson's stump house, Rob Adamson moved into Bruce Chao's shelter, Benjamin Moore took Guy Chambers's stump house, Kate Elliott settled into the railroad shack, and Toby Goldman moved into a stump.

The housing shortage was remedied by the installation of platforms and tents. "1974 was the year we brought in platforms . . . for tents," says Rob Adamson. "That whole hillside where the cold shop is, there were two tiers of 10-by-10-foot platforms with tents."[24] In spite of the improved facilities, living was as wet as ever. "Before you'd go to sleep," recalls Mark McDonnell, "you'd come down [to the glass shop] with your sleeping bag and dry it out by the furnace, just to get the dampness out." "I got awfully tired of being wet and cold and trying to keep up the spirits of the students who were wet and cold," remembers Pierce. "I got tired of slugs."[25]

Living at Pilchuck in 1974 and 1975 was an intense experience. Eric Hopkins recalls that sleep deprivation was rampant, and most everyone remembers that drinking, combined with a lack of sleep, made for some wild parties.[26] Late at night, the hot shop was the place for would-be risk-takers. "The danger, the fire," recalls Paul Marioni, shaking his head in disbelief. "We used to see how high we could wrap the glass around the center pole in the hot shop. It was like a ritual. We'd go

> In the early days everybody used to go up and watch the sunset together. Everybody. Lark Dalton had an old truck there, and everybody would jump on the back and go up to [Inspiration Point]. We were all together, watching the sunset. And we were, in those days, just one group.
>
> —Waine Ryzak[27]

in there and gather as much glass out of the furnace as we could, swing it around over our heads and wrap it up the center pole and see who could get it the highest. . . . Everybody worked hard, partied hard, to the point of exhaustion. . . . [You would] go home with a glazed look in your eye, proclaiming what a good time you'd had, never being able to explain it to anyone that hadn't been there!"

Social activities centered around the hot shop and the two Army surplus tents—one used for cooking, and the other for eating and showing slides. "The first tent was the kitchen and pantry, and the second tent was for eating," remembers John Hauberg. "By

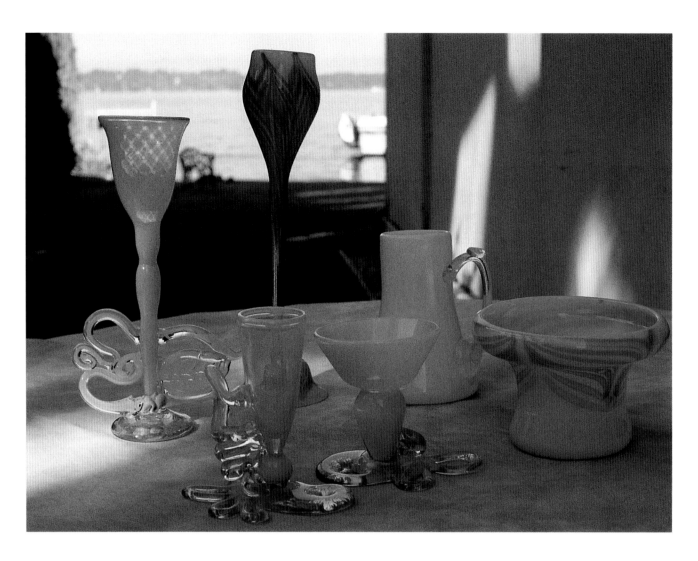

Above: Goblets and vessels made at Pilchuck from Fritz Dreisbach's formula for opal glass, 1974–75. Left to right: optic goblet with ornate handle by Fritz Dreisbach; tulip-shaped goblet with purple trailed decoration, possibly by Art Reed; two small goblets by Dale Chihuly (unsigned); mug by Jack Wax; and bowl with purple trailed decoration by Rob Adamson.
Collection Mimi Pierce, Seattle.

Right: Dale Chihuly (American, b. 1941) and Flora Mace (American, b. 1949), *Navajo Blanket Cylinder*, 1976. Blown glass with applied glass threads and powder, 12 x 6 in.
Courtesy Joey Kirkpatrick and Flora Mace, Seattle.

this time, we did have a generator and [the second tent] also served as an audiovisual room. But it leaked, God knows it leaked!" The Army surplus tents were "primitive," says Mimi Pierce, "cold on a cold day and very hot on a hot day."[28] Pierce often shopped for the camp herself, and once approached a Safeway market for a food donation. "They said, 'Would you like some eggs?'" Well, I got something like eight dozen or maybe twenty dozen eggs! And that was before we had adequate refrigeration. [Everyone] got so tired of having eggs!" By Pierce's second summer, the refrigeration problem was remedied. "We actually had a walk-in cold storage room and a large refrigerator . . . in this crazy cook tent."

Paul Inveen returned as the cook in 1974 but only lasted about two weeks with Mimi Pierce; he was replaced, remembers Charles Parriott, by "some grumpy dude from Hawaii." "When somebody would ask me what I did," says Pierce, "I said I raised funds and fired the cooks." Ryzak remembers the cook tent as "unsanitary," while Italo Scanga christened it "Da Nang."

By 1974 the kind of mixed-media experimentation that had been going on at Pilchuck during the school's first three years had ended. The focus now was glass only—reflecting the interests of Rob Adamson, Fritz Dreisbach, and, of course, Dale Chihuly.

Glass was the most exciting thing going on at RISD because of Dale Chihuly and his entourage. And we had all heard about this place, Pilchuck.

—Pike Powers[29]

Technique, bolstered by the discoveries and explorations of the late 1960s and early 1970s, took precedence. The early efforts by glassblowers traveling around the country, stopping at art schools and universities to share their knowledge and plant the seeds of future glass programs, had paid off. Technical knowledge was becoming widely available, and glass organizations and publications—such as the Glass Art Society, founded in 1971, and *Glass Art Magazine*, which first appeared in 1973—furthered the cause.

During the master/apprentice program at Pilchuck in 1974, Chihuly—who had been in Santa Fe most of the summer—experimented with a technique for drawing on glass. He fashioned designs on the marver from bits of glass and then picked up the design onto a molten bubble during the blowing process, a technique thought to have been practiced by the ancient Romans. Some techniques pioneered by American studio glass artists, as it turned out, did have historical precedents, but others were recognized only after the technique had been reinvented. Chihuly used "drawings" painstakingly put together by Kate Elliott from glass threads, and he would continue exploring this process, a year later, with Flora Mace.

Pilchuck felt the influence of the glass program at the Rhode Island School of Design, a natural outcome considering Chihuly's stewardship of both programs. Over the years many RISD students made the journey west. "There was this westward-ho movement, the RISD-Pilchuck connection," recalls Eric Hopkins. "There was a lot of driving back and forth across the country, listening to the Grateful Dead. Easterners meeting westerners and the western landscape." "Pilchuck is now international but at that time it

James Carpenter (American, b. 1949) and Dale Chihuly (American, b, 1941), *The Corning Wall*, 1974. With the assistance of Barbara Vaessen, Kate Elliott, and Phil Hastings. Blown glass roundels with glass thread decoration, cut, and leaded, 79 x 49 in. Corning Museum of Glass, New York

was pretty much RISD-transplanted, it was the RISD of the West," observes Rick Bernstein. "The whole entourage would [arrive] with all the new-wave haircuts and clothing and personalities. Pilchuck could be subtle or mellow or down-home, and all of a sudden there was this blast of East Coast [influence]."[30]

In *RISD Glass 1974*, a small photo catalogue of work produced by students, faculty, and visiting artists at RISD, the diversity of approaches to the medium—as shown by editor Dale Chihuly—is striking.[31] Pieces range from simply decorated vessels by Erica Friedman and Debbie Goldenthal to an aggressive metal-wire and glass wall-sculpture by Mary Shaffer and a minimalist cube of stacked glass sheets by Roni Horn. Bruce Chao made a room-size installation of three oversize plates of sheet glass hanging from the ceiling. Therman Statom used vessels to support large, sharp-edged triangles of sheet glass in an oversize, fanlike sculpture. Chihuly illustrated one of his cylinders, with a glass thread drawing by Kate Elliott, as well as the large panel of leaded, colorless roundels called *The Corning Wall*, which he made with James Carpenter for the Corning Museum of Glass. Sculptor Italo Scanga arranged vessels on a table. And there were the new, soon-to-be-familiar hybrids, poised somewhere between vessel and sculpture, by artists Darrah Cole and James Harmon. "A significant factor in the RISD atmosphere is the Visiting Artists Program, under the direction of Dale Chihuly, head of the Glass Department," wrote Fritz Dreisbach in 1976 for *Glass Art Magazine*. "[RISD] . . . attracts numerous critics, historians, and artists, many of whom do not use glass as their primary medium."[32]

Despite its East Coast roots, Pilchuck had a distinctly West Coast funk aspect with a strong craft bent. "There was always the RISD faction of the school and the West Coast funk faction," says Paul Marioni. "Pilchuck was sort of an East meets West thing," remembers Mark McDonnell. "We were meeting a completely different attitude in glass. Coming out of California, glass was very vessel-oriented and funky, with bright colors. At Pilchuck, Chihuly, Carpenter, and the others were trying to deal with glass as sculpture [and] glass in architecture."

Students at Pilchuck in 1974 could choose any approach they wanted: artists like Mark McDonnell came to perfect a craft, while Eric Hopkins blew bubbles and tubes, and burned drawings on wood—in a process he called pyrography—with molten glass.

Italo Scanga (center) experimenting with materials in the hot shop, observed by James Carpenter and Dale Chihuly, 1974.

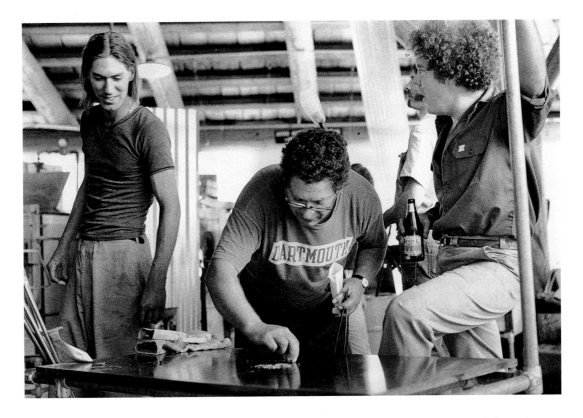

Fritz Dreisbach and Robert Levin focused on expanding traditional forms, while Italo Scanga continued his experiments combining hot glass, garlic, and manure. "As young as it was," remarks Rick Bernstein, "Pilchuck was still the place to go if you wanted glass."

Fritz Dreisbach . . . was, technically, the most incredible glassblower we'd seen.
—Mark McDonnell

Under Fritz Dreisbach, students were finding the hot shop to be a combination of discipline and spontaneous collaboration. "Fritz is, in addition to being a fine artist and craftsman, also a first-rate showman," wrote George Ghetia in a 1975 article for *Glass Art Magazine*. "The party aspect of the workshop constitutes the core of the Dreisbach experience. As he launches into what will turn out to be a two-hour slide lecture, few expect that this good-natured

Fritz Dreisbach shaping a goblet, 1974.

glassblower, drinking beer in his T-shirt, has his audience so under control."[33] As he practiced, studied, and researched his own art, Dreisbach expected his students to do the same. "Fritz was the first person in those days who really wanted us to do research, to really take a theme and [investigate] it," recalls Waine Ryzak. "To do more than just make bowls." Dreisbach also advocated group projects in the hot shop to practice teamwork and build camaraderie.

"Jack Schmidt . . . and I made a piece in 1975 that is infamous around here," relates Dreisbach. "It was called *Stump the Blower*. We were teaching together and we challenged the students. We said, "Think of anything you can and we'll blow it. If we can't blow it, we'll give you a prize.' . . . So they told us all this stuff and we blew everything. Then, without telling them what we were doing, we started this piece." "It was fantastic, it was a happening," remembers Rick Bernstein. "Jack Schmidt had one bench making a chainsaw and Fritz made a tree. Art Reed and I were in charge of the glass bits that would be brought to each person. It was a demonstration of superb skill, and inspiration too, because it showed you some of the things you could do to push the material." What they ended up with, continues Dreisbach, was a "stump with a bush on top and a notch cut in it, and a chainsaw lying in the notch. And we said, 'This is the trophy you would have gotten if you had stumped the blowers.'" The humor was Pilchuck at its insular best, but projects like *Stump the Blower* functioned as a testing ground for the abilities and talents of individual teams.

Fritz Dreisbach, Jack Schmidt, Art Reed, Rick Bernstein, and others, *Stump the Blower*, 1975. Blown and flameworked glass, h. 18 in. Collection Pilchuck Glass School

During the 1974 season John Hauberg and Thomas Bosworth planned a few changes for the campus. Two hot shop additions, in 1974 and 1975, provided an office for the director and much-needed restrooms; the stained glass studio—also called the flat shop—would be built in 1975. Uncertain of Pilchuck's permanence, Bosworth and Hauberg did not work from a specific plan for the campus, but added buildings as they became necessary. "It wasn't . . . a clear statement of vision on John Hauberg's part or anyone's part," recalls Bosworth. "It just sort of evolved. They decided that it would be great if we expanded the hot shop a little bit. . . . and then we started talking about doing a [flat] shop as well."

Dale Chihuly left the planning and implementation of the 1975 session in Fritz Dreisbach and Mimi Pierce's hands while he worked in Utah with Flora Mace, setting up a program at Snowbird Art School, outside Salt Lake City. Under the sponsorship of the Pacific Northwest Arts Center, Pilchuck Glass Center advertised two three-week sessions for 1975. At $450 per session, tuition had increased 30 percent over the previous year, yet each session attracted its maximum of fifteen students. Jack Schmidt and Mark Peiser taught the first session, followed by Fritz Dreisbach, Schmidt, and Paul Marioni for the second. Mark McDonnell and Waine Ryzak came back as students for the entire summer; 1974 students Larry Lazin, Charles Parriott, Stan Price, and Jack Wax signed up for individual sessions. Sidney Hutter was a new student in 1975, as was teaching assistant Art

Reed. Former students Rick Bernstein, Lark Dalton, Robert Levin, Benjamin Moore, and Paul Neuman returned as teaching assistants. Rob Adamson, Norman Courtney, Kate Elliott, and Marge Siegel all returned to Pilchuck as staff.[34]

To help things go more smoothly with the hot shop's tight schedule, Rob Adamson and Mimi Pierce hired teaching assistants for the first time in 1975. "[Most of] the staff was volunteer," recalls Charles Parriott. "They didn't pay you anything, they just put you up. But you were responsible for a [great deal]. The success of the school, in my mind, was built on the good-will of the faculty and the teaching assistants. The TAs were the backbone of the school." "They called us bozos then," remembers Rick Bernstein. "We were shop technicians under Rob Adamson. There would be three shop technicians per session, and we would have an eight-hour shift. And during that shift, you would teach or take care of the equipment or do whatever needed to be done. . . . In exchange for three weeks of work, you got to be a student for three weeks [for a different session]. That was the deal."

> Each student will have regularly scheduled blowing time each day. . . . Students will become involved in shop procedures, the process of making glass including measuring, mixing, and charging the raw materials, and in melting and refining the glass. . . . There are seven furnaces, four electronically controlled annealing ovens, and facilities for working in flat glass. The Glass Center operates twenty-four hours a day, seven days a week.
>
> —1975 Pilchuck application brochure

Dale Chihuly and James Carpenter, who had decided to end their artistic collaboration, were conspicuously absent from Pilchuck in 1975. "In 1975 I quit working with Jamie . . . [who] went on to do more conceptual things," says Chihuly. "At that point I made a turn and started for the first time . . . making more functional things or container-type pieces. . . . I had just taught at the Institute of American Indian Art in Santa Fe and I had this interest in Navajo blankets and Pendleton blankets. I decided I would make a series of glass cylinders that would have these Navajo blanket designs."[35] "My interest was in processes and techniques," remarks Carpenter. "I got very tired of glassmaking myself, and that's when I moved toward photography and filmmaking." The dissolution of the Chihuly/Carpenter collaboration marked the close of a period of intense experimentation for both artists, with each settling into his own path.

> The Pilchuck Glass Center, founded four years ago, has quickly risen to a point where it is considered to be THE prestige glass school in the country, according to Dale Chihuly.
>
> —Ranny Green,
> *Seattle Times*, 1974[36]

Chihuly was still wary of immersing himself in Pilchuck's affairs, although he assured Fritz Dreisbach that he would return in 1976. Both Dreisbach and Rob Adamson made it a point to run the 1975 program as they thought Chihuly would see fit. "We were guessing what Dale wanted, because he wasn't available," recalls Adamson. Dreisbach remembers that Chihuly "wanted to make sure that . . . everyone understood, including John Hauberg and everyone else . . . that he was not bailing out, he was taking a sabbatical year off. . . . That's when the artistic director started to separate from the administrative director."

In the meantime, John Hauberg was reconfiguring Pilchuck's umbrella organization, the Pacific Northwest Arts Center. "John realized that his [Tatoosh] development was not very practical," recalls Tom Wilson. "His planning group had convinced him that the time was not right to do the development, or to proceed with the Tobey museum." More important, the Tobey museum had been rejected by Mark Tobey, who did not want a museum out in the country, and suddenly PNAC was without a program except for Pilchuck and PNAC's Seattle gallery. Hauberg, who was then president of the board of the Seattle Art Museum, convinced new director Willis Woods to take both PNAC and Pilchuck under the museum's aegis.

"In October of . . . [1974]," John Hauberg wrote to museum members, "the Pacific Northwest Arts Center merged with the Seattle Art Museum, becoming a major council of the museum. Its overall goal, that of 'celebrating the works of artists and craftsmen of the Pacific Northwest' remains unchanged, but it is anticipated that this new alignment will increase the effectiveness of both the Seattle Art Museum and the Pacific Northwest Arts Center in this area."[37] Thus PNAC became the Pacific Northwest Arts Council of the Seattle Art Museum, and Pilchuck became, for the moment, a museum school. Although Pilchuck would retain its independent direction under Mimi Pierce and Dale Chihuly, it was thought that the school would have more access to outside support through the museum, enabling it to increase funding from sources other than the Haubergs.[38]

Although the Haubergs were, by far, the financial mainstay for Pilchuck, both Chihuly and Pierce won notable grants from local and federal agencies to help defray costs. By the end of 1973, Chihuly had brought in $5,000 from the National Endowment for the Arts (NEA), $5,000 from the Union of Independent Colleges of Art—which had awarded Chihuly the original grant to start Pilchuck—as well as $2,500 from the Bloedell Foundation, $2,000 from the Corning Glass Foundation, and $800 from the Washington State Arts Commission. Chihuly also was instrumental in getting donations of materials from Northwestern Glass Company in Seattle. Pierce, a board member of the Patrons of Northwest Civic, Cultural, and Charitable Organizations (PONCHO), attracted the interest of that ambitious organization, Seattle's most important private supporter of the arts. She also located new, mostly corporate, funding sources, coming up with "$2,500 here or $1,500 there." The NEA, PONCHO, the Corning Glass Foundation, the Washington State Arts Commission, and the Western States Arts Foundation would be invaluable sources of support for Pilchuck over the coming years.[39]

By 1975 the Pilchuck board, composed of John and Anne Gould Hauberg and their PNAC friends Patricia Baillargeon, Joseph McCarthy, and Philip Padelford, decided to try to widen their circle a bit by forming a Pilchuck Policy Committee, which they invited Jack Lenor Larsen to join. In a letter to Joseph McCarthy, dated August 8, 1975, Larsen recommended that Dale Chihuly be on the new committee. "Although I don't think he should create the policy of the school," wrote Larsen, "I certainly feel he should have a voice in it," and added, "Incidentally, one thing you might consider is that we

find at the American Crafts Council that craftsmen are our best, most responsible trustees. They give the most time and are quite useful in funding areas. It took us twenty years to learn this."[40] In spite of this advice, Pilchuck would not recruit glass artists onto its board until 1990, under board president John Anderson.

In the 1975–76 *Annual Report of the Seattle Art Museum*, Joseph McCarthy, as president of the Pacific Northwest Arts Council, wrote that the "Pilchuck Glass Center . . . has continued its excellent program during the summers under the effective leadership of Mrs. Harvey Curry [Mimi Pierce], Director, and Rob Adamson, Technical Director. . . . Faculty members and students have continued a program of high quality. . . . During the report year Pilchuck was legally separated from the Council and the Museum, and is now continuing its excellent program as an independent entity."[41]

"The art museum was glad to take on PNAC because they were interested in Pacific Northwest arts," remembers John Hauberg. "But it finally got to the point where Pilchuck had to be on its own. . . . The Seattle Art Museum did not want a school—Mr. Woods was adamant about that."[42] The official reason given for the transfer, as reported by Steven Waite of the *Bellevue Journal-American*, was that "given all its other areas of community responsibilities, the Seattle Art Museum could not be actively involved in supervising the affairs of Pilchuck's primarily educational operations."[44] But Waite heard from museum insiders that the separation occurred because of the difficulty in "going to the well at the same time for badly needed financial assistance. . . . Arts grants persons agree that the money-raising potential of both . . . will be greatly enhanced by a separate corporate and tax-exempt status."

> With each successive year we got closer to the glass concept and away from anything else.
>
> —Mimi Pierce[43]

Without PNAC sponsorship, Pilchuck now had to incorporate as its own nonprofit organization. John Hauberg deeded 40 acres of his tree farm to the school and asked Seattle lawyer Frank Kitchell to file articles of incorporation and apply on May 27, 1976, for a nonprofit tax classification. Almost five years to the day of its official founding, Pilchuck became a legal entity under the name of the Pilchuck School. The management of the new Pilchuck School would be vested in a board of no less than five trustees: these were Patricia Baillargeon, Anne Gould Hauberg, John Hauberg, Frank Kitchell, and Philip Padelford. Joseph McCarthy, who remained president of the PNAC, was replaced by Frank Kitchell as president of the Pilchuck School board of directors.[45] The new board acquired three new members: Sam and Gladys Rubinstein and, later, Johanne Hewitt. "I joined the board of trustees," recalls Hewitt, "[as one] who might enjoy the challenge presented by the start-up hopes and aspirations of the artists at Pilchuck."[46]

The mission statement of the new Pilchuck School established the institution as one that would "operate exclusively for educational purposes"[47] and, specifically, would provide a "technical and general education of the highest order in the glass arts and related arts and crafts."[48] In 1976 stained glass became part of the regular curriculum, following the completion of the new 2,000-square-foot flat shop. "Unlike the centrally planned

The new, open-air flat shop designed by Thomas Bosworth, 1976.

glassblowing studio, it is linear," wrote Thomas Bosworth. "Five 15-foot bays contain space for sixteen large worktables, a raised porch for display and critiques, and a small store."[49] Bosworth explains: "We did the [flat] shop . . . based on the idea of an ancient stoa, a classical Greek concept where you have . . . a series of stalls and in front of the stalls, a long porch. . . . Stoa means porch. So the activities could spill out onto that porch." The flat shop originally was designed to connect to a continuous portico that would join with the hot shop and perhaps other buildings, but the portico was not built. The front of the new shop was entirely open, and wind, rain, and cold damp weather soon made it necessary to install space heaters and French doors, which were added in 1977.

> At Pilchuck, young people from throughout the United States and several foreign countries live in tent housing and work at one of today's most innovative art forms. . . . It is the spirit at Pilchuck which makes this workshop unique.
>
> —Patricia Baillargeon,
> *Pacific Search Magazine*, 1976[50]

Bosworth also designed three faculty cottages and a bathhouse in the meadow below Buster Simpson's stump house. "These cottages are simple one-room buildings

Faculty cottages, designed by Thomas Bosworth, completed in 1976 (photographed in 1995).

The bathhouse's open-air sink.

The bathhouse designed by Thomas Bosworth, completed in 1976 (photographed in 1995).

with generous porches and large windows," wrote Bosworth. "The occupants share a common bathhouse. Footpaths wind across meadows and through groves of trees. . . . To honor the unusual and rural beauty of the site, roads, paths, buildings, shelters, and tents have all been designed and placed to harmonize with and become part of the natural setting."[51] The faculty cottages, first occupied in 1977, were a priority, as it was becoming increasingly difficult to attract artists, says Rob Adamson, who did not mind roughing it. Wood-walled forestry tents with canvas roofs were purchased for student housing, although some students still got away with piecing together their own shelters,[52] and building was underway for a lodge, designed by Thomas Bosworth, which would be ready for the summer of 1978.

Class project in the flat shop, 1976.

The recruitment poster for "Pilchuck '76" advertised an enlarged program of three sessions of instruction in molten, cast, formed, blown, and architectural glass as well as glass technology, painting on glass, historical techniques, sculptural glass, and glass aesthetics. For the first time, each session was divided into two sections—termed "Architectural Glass" and "Molten Glass"—of approximately fifteen students each, and course descriptions were printed. Paul Marioni and James Carpenter

Art Reed (left) and Jack Schmidt in the hot shop, 1976.

each taught one session of architectural glass, while, in the hot shop, Fritz Dreisbach taught both sessions, the first with Jack Schmidt, and the second with Dan Dailey. Due to the doubling of the student population, the fee per session had been reduced from $450 to $390, which included "supervised instruction, lectures and demonstrations, lodging in tents or Pilchuck shelters, and all meals except Saturday night dinner."[53] Molten glass students and participants in the third session were charged an extra $100 lab fee.

The third session of twenty-five students—which included Thomas Buechner III, William Dexter, Stephen Dee Edwards, Susie Krasnican, Benjamin Moore, Art Reed, Waine Ryzak, Molly Stone, and Jack Wax—comprised a single section. Its focus was the "Aesthetics and Nature of Glass"—team-taught by James Carpenter, Dale Chihuly, and

Italo Scanga—and it used both the glassblowing and flat glass facilities. Unlike the first two sessions, the third program would be less structured and more informal, which Chihuly and Scanga preferred.

Paul Marioni (American, b. 1941), *Journey through the Valley of the Kings,* 1975. Cut, leaded glass, 24 x 26 in. Courtesy Paul Marioni, Seattle.

Carpenter and Marioni fostered exchanges between the hot glass and flat glass studios. Carpenter was expert in both glassblowing and stained glass, and taught both. Paul Marioni, who also worked glass hot and cold, occasionally collaborated with Fritz Dreisbach. In one of their projects, they opened a blown glass cylinder to make a sheet of glass—to be used in making stained glass—in a technique Marioni had learned at Fisher AG, a German "antique" glass sheet factory. A small pane of gray-green amber glass, still installed in the office next to the hot shop, is all that remains from their experiment. A panel made by Marioni's students, inscribed "He lead and we came, 1976," is the only other window of that period still installed in its original location.

It was surprising that Chihuly managed to make it to Pilchuck at all in 1976. He had been in a serious car accident in England earlier that year and had suffered the loss of sight in his left eye. Chihuly blew a little glass, but spent most of the summer supervising and consulting. He recently had accepted an important promotion to head the sculpture department at RISD, beginning in 1977.[54]

Rob Adamson, then assistant director, and shop coordinator Norman Courtney ran the hot shop again in 1976 with teaching assistants Rick Bernstein, Richard Duggan, Andrew Magdanz, June Marsh, Benjamin Moore, Stan Price, Art Reed, and Jack Wax. "I feel that every TA is an important member of the staff," wrote Mimi Pierce in a letter to Moore. "They, probably even more than the faculty, will have close association with the students. Not only will you be helping instruct, but you will undoubtedly be the first to hear all the gripes (and the plaudits)."[55]

The summer program drew a total of ninety students, a significant increase over previous years. Pierce laid down the law on dogs and visitors: all dogs would have to be boarded "in advance," and visitors were discouraged. With full occupancy, Pilchuck was doing well: tuition covered a significant part of the school's

The openness and friendliness of the place was the first thing that struck me. . . . The minute I said I was a glassblower, even though I was somewhat of a beginner, why, it was really friendly.

—John Reed

Visiting artist Seaver Leslie making a glass thread drawing, 1976.

Glass spheres blown and installed for an open house at Pilchuck, 1976. Some of the un-annealed bubbles have already exploded.

$75,000 budget, which was supplemented by grants from PONCHO, the Washington State Arts Commission, the NEA, the Western States Arts Foundation, and the Corning Glass Foundation. Northwestern Glass in Seattle donated recycled glass,[56] and Bullseye Glass Company, in Portland, gave materials for the architectural glass studio.

Two open houses in 1976 offered demonstrations of a "variety of techniques including blowing, laminating, painting, sandblasting, carving, *latticinio*, bending, leading, and foiling." "Traditional" glass vessels and other glasswork would be exhibited, "for display or for sale." Visitors were invited to bring lunches to Inspiration Point, where picnic tables had been set up, but were warned not to pick up scrap glass since "unannealed glass often explodes."[57] The warning was necessary, Mimi Pierce remembers, because of an occurrence at the open house in 1974. Eric Hopkins was blowing gigantic bubbles, and everyone got into the act. . . . They were hanging off ladders and the roof so they could make really large, marvelous glass spheres. . . . We put the bubbles in amongst the trees and around the glass building. And it was fine until the guests arrived and [the bubbles] started exploding because they hadn't been annealed!"

By the end of the third 1976 session, Dale Chihuly and Mimi Pierce were at odds. Although Chihuly claims that he always got along with Pierce, he admits that when he came back to Pilchuck in 1976—after an absence of nearly a year—he did not like the way things were going. "I probably decided, Hey . . . I got the thing underway. I'm not going to be a good director, and it doesn't need me to be a force," says Chihuly. "But when I did come back, to be honest, I didn't like the way it felt." Thomas Bosworth,

who was frequently on campus to oversee construction, remembers Chihuly and Pierce "having it out" during her first year. While he did not know what their argument was about, Bosworth observes that "they didn't match up very well." "Mimi had trouble with

Dale," adds Rob Adamson. "Dale withdrew . . . but Mimi was on a bit of a campaign. . . . She definitely wanted to have her footprint on Pilchuck."

Pierce, under John Hauberg's direction, and with colleagues Rob Adamson and Fritz Dreisbach, had made significant advances in the development of Pilchuck as a school. Tuitions were collected, programs and facilities were expanded, even accreditation was investigated but, most important, an administrative structure had been put in place that would support a focus on teaching and learning. Maybe, as Kate Elliott suggests, Pierce became too caught up with faculty and students and their interaction. "That's one of the tough things up there about being a director," Elliott observes. "You have to be involved and you have to not be involved." Board member Frank Kitchell says, "Mimi came in, and in my recollection, did a nice job of beginning to pull the strings together. And I guess . . . her idea of how to pull the strings together was a little more than Dale or the others would go along with. So Mimi opted out."[58]

Planning meeting, August 1975. Left to right: (seated) Rob Adamson, Mimi Pierce, Dale Chihuly, and Fritz Dreisbach; (standing) Sue Hauberg, Joseph McCarthy, and Anne Gould Hauberg.

Thomas Bosworth seemed a natural choice to succeed Pierce in March 1977 as director of a fast-growing Pilchuck. Bosworth could run the school—then considered a part-time activity—and still supervise building activities; he knew Chihuly; and he was already in Hauberg's employ. And he wanted to do it. Mimi Pierce believes that Hauberg felt Bosworth could give his school something she could not. "I think, very frankly, that John Hauberg suddenly realized Pilchuck was a going concern," observes Pierce. "And he wanted to be sure that he had the top people. And the right image. No housewives." Indeed, Bosworth, a Yale graduate, could give the young institution an East Coast, academic cachet that would bolster its already excellent reputation and attract students. Pilchuck was well on its way to becoming a real school, a process that would continue under Bosworth and be finished by his successor, Alice Rooney. No longer a dream or an experiment—and hardly recognizable as the primitive site it once had been—Pilchuck was quickly moving from camp to campus.

From Camp to Campus
1977–1995

Three art movements in the Pacific Northwest have had an international impact. The first was the indigenous art of Pacific Northwest Coast Indians. The second was the painting of the so-called Northwest mystics led by Mark Tobey. The third is the glass movement that was born with Pilchuck.

—William Traver, Seattle art dealer

Pilchuck is indeed physically, as well as emotionally and mentally, a life-changing place. What it taught me was that everything you do is connected.

—Joey Kirkpatrick, artist

Pilchuck reminds me of a monastery: it has the same absolute concentration, except there one is dedicated to glass.

—Klaus Moje, artist

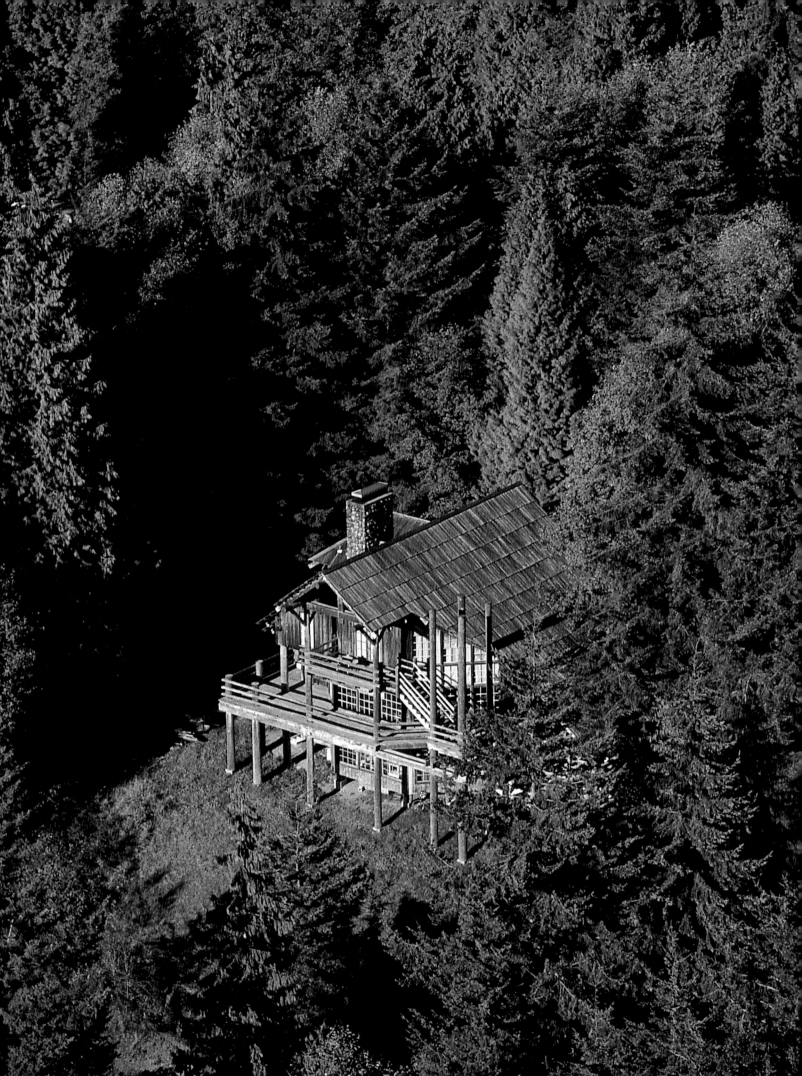

1977–1979: Building a Campus

By the time of Mimi Pierce's resignation in early 1977, Dale Chihuly, Fritz Dreisbach, and Italo Scanga were the only members of the early faculty to return regularly to Pilchuck.

Pilchuck was off and running, the early pitfalls surmounted. . . . Here was [in the making] . . . a legendary fountainhead [such] as the Bauhaus, Cranbrook, and Black Mountain College.

—Jack Lenor Larsen[1]

"It was a little strange, actually," says Doug Hollis, recalling a 1978 visit to Pilchuck, his first in five years, "[to see] the new reality of what Pilchuck had become." "This was when Pilchuck was restructured at many levels," wrote Thomas Bosworth. "The communal sharing of life's responsibilities, necessities, and simple pleasures became less important. We were all becoming more civilized."[2]

Pilchuck's hippie days were over. Swedish artist Ann Wolff, who first taught at the school in 1977, remembers that Bosworth "tried to clean up from the old hippie time,"[3] while LaMar Harrington recalls him as "authoritarian" but a "wonderful architect" who "tightened it up, got rid of the hippie influence." John Hauberg had made it clear to both Pierce and Bosworth that it was the director's job to clean up Pilchuck, impose order, and find additional funding. Pierce had introduced the concept of administration, and Thomas Bosworth would build upon it. Under Bosworth, things became "more regimented and structured," says Michael Kennedy. "Tom put a lot of restraints on what people could do, what they couldn't do, how money was spent, and a lot of people resented and rejected that," remembers Stan Price, Pilchuck's first full-time caretaker.

When Bosworth assumed the directorship, he had recently stepped down as chairman of the department of architecture at the University of Washington, and he was already Pilchuck's architect. He was "from academia," explains Dale Chihuly. "[He] knew about schools and seemed to have that administrative touch." By 1977 Bosworth had built the hot shop, the hot shop addition, the flat shop, three faculty cabins, a bathhouse, and a footbridge, and he was just completing the director's cottage. The main lodge and the lodge's covered footbridge were completed in 1978, as was the caretaker's house. These were the "core buildings" says Bosworth, the buildings that defined the campus and gave the site its character.

The design of architecture can be thought of as the struggle between image and ecology.

—Thomas Bosworth[4]

Bosworth is an unusual combination of architect and art historian—no doubt much influenced by one of his professors at Yale University, the well-known architectural historian Vincent Scully—and as a result, perhaps, his interest in building appeared to some to be more about visual than spatial concerns, more about form than function. His point of departure was the landscape. "I visited Haystack and Penland to look at [their campuses]," remembers Bosworth. "Penland looked disorganized. . . . The campus was not

The lodge at Pilchuck.

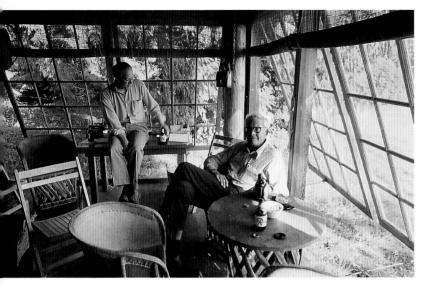

Thomas Bosworth and John Hauberg in the director's cottage, 1980.

coherent and there were buildings in different styles. . . . And then we saw Haystack, which has very beautiful buildings . . . but everything was on a grid and it spoiled the landscape. . . . So we decided to make Pilchuck somewhere between." "We wanted buildings that fit into the environment and reflected the function of the school," John Hauberg told the *Seattle Times* in 1978. "If you're going to produce something of beauty and quality, you want your environment to reflect that, to inspire you."[5]

The lodge "was a tremendous structure," wrote Karrie Jacobs in *Alaska Fest* magazine, "that looks like a rustic summer cottage built in gigantic proportions."[6] The exposed timbers, giant stone fireplace handmade from rocks gathered from Pilchuck Creek, Walt Hass's long cedar shakes, and the massive exterior stairway and posts were offset by the west window wall, which opened to the light and a spectacular view. "The basic design," wrote Bosworth, "was developed coincidentally with the glassblowing studio in 1972–73, and was substantially altered and enlarged during 1977. The panoramic western view is not fully revealed until after one has entered the structure. The main room, a barnlike space . . . serves as a dining room, lecture hall, and social center."[7] In an article written for a Japanese architectural journal, Bosworth expanded on his concept for the lodge and its proportions: "The idea of trees as primitive symbols of shelter is a recurring theme in architecture and is appropriate to the early buildings at Pilchuck. The four columns which support the exterior stairs . . . are exposed and unprotected. This irresponsible design act is intended as a reminder of the lonely, giant snags of the forest and of the inevitable ruination of all human con-

The lodge at Pilchuck.

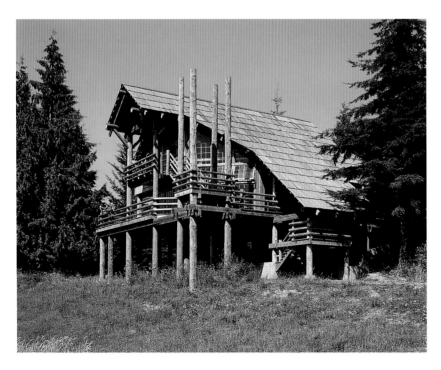

struction. . . . To me, the aging process is attractive and appropriate, and these buildings, like mature humans, become increasingly comfortable with their context as time passes."[8]

In addition to supervising his building projects, Bosworth inspected and rearranged many of the existing shelters on campus. "Bosworth's first act," recalls Charles Parriott, "was to bulldoze Therman Statom's yurt." Many of the artist-built structures were rotting and

Pilchuck is intense and vital. The expectation of living is 120 percent here.

—Thomas Bosworth, 1977[9]

The lodge interior, 1978.

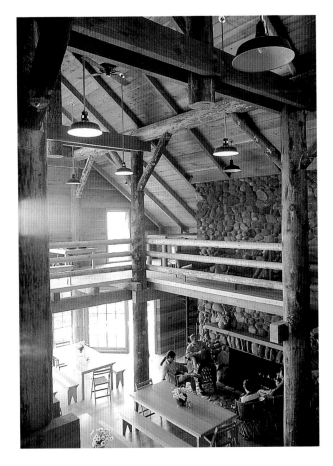

unsafe, and Bosworth preserved only those that had significant life left in them. These included the shelters built by James Carpenter and Barbara Vaessen, Guy Chambers (rebuilt by William Morris), Bruce Chao/Rob Adamson (rebuilt by Benjamin Moore), Dale Chihuly, Richard Posner, and Buster Simpson, as well as the cook shack—later called Fritz Dreisbach's cabin—originally built for Paul Inveen by John Landon. Bosworth also left Landon's food cache in place, standing in the upper meadow. "By 1977 most all the [shelters] . . . , except for the fancy ones, were down," says Rob Adamson. "A lot of old places were just falling apart because they weren't built to be permanent in the first place."

The summer 1977 program at Pilchuck was similar to the previous year. Two sessions were divided into molten glass and architectural glass sections for eighteen and sixteen students, respectively, and a third, single session on glass aesthetics was offered for twenty-five students. The third session, which considered the "total potential of glass as an art form,"[10] was team-taught by Dale Chihuly, Italo Scanga, and Kosta Boda/Åfors designer Ann Wolff, Pilchuck's first Swedish faculty member, who also set up the original acid-etching shop. Molten glass sections were taught by Fritz Dreisbach, who focused on vessel-forming techniques, and Dan Dailey, who worked with special glass techniques, such as sand casting, fusing, fuming, and laminating, in addition to traditional ones. In the architectural glass sections, Paul Marioni emphasized "glass as conceptual art," incorporating elements made in the "Molten Studio," while Ludwig Schaffrath, a German artist well known for his innovative work in stained glass, taught the aesthetics of glass in architecture as well as European techniques.

Ann Wolff (right) with a student, 1984.

Dale Chihuly, now faculty coordinator, and Rob Adamson, camp manager, ran the program, assisted by shop foreman Benjamin Moore and Richard Harned, who managed the ten teaching assistants and maintained equipment. Most teaching assistants were former students, and many would go on

to develop their own careers, later returning to the school as teachers themselves.[11] In addition to advertised faculty, visiting artists appeared sporadically during the summer—including James Carpenter and Seaver Leslie from New York, Marvin Lipofsky and Richard Posner from California, and Art Wood from Providence—as did lecturers from Pilchuck Tree Farm, Outward Bound, and the University of Washington's College of Architecture and Urban Planning.[12]

"The facilities are here," wrote Chris Aronson, a third-session student, for *Studio* magazine in February 1978. "For blowing, casting, and slumping glass, there is the magnificently multiroofed hot glass shop; for painting and firing and designing and stained

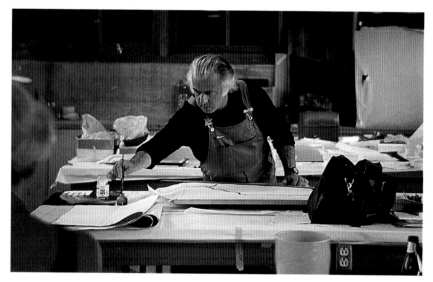

Ludwig Schaffrath in the flat shop, 1977.

glass work, there is the cold shop. Everyone has access to the sandblaster, welding equipment, grinding wheels, belt sander, and kilns. Bring your own hand tools, though. The shop tools here are in as poor condition as shop tools anywhere."[13] Aronson continues his report: "The skills are here, too. About fifty persons who share a common passion for glass: independent studio artists, professors of art specializing in glass, professional glassblowers, stained glass workers, glass sculptors, university glass students." "But," asks Aronson, "considering the vastness of the resources here, why wasn't Pilchuck Session III, 1977, the fertile and exciting milieu it could have been?"[14]

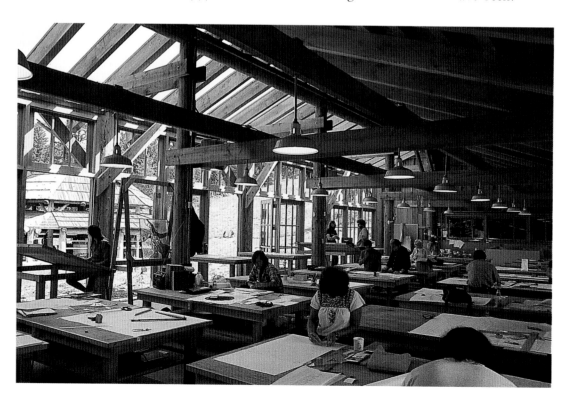

The flat shop with newly installed French doors, 1977.

Aronson's complaints touched on the ever-widening gulf at Pilchuck between artists in glass who were attending academic art schools and self-taught artisans who were interested primarily in making commercial craft products. "Despite the tents," wrote Aronson, "like sponges after a week of hard rain, despite the swimming hole and the beer . . . Pilchuck is an attempt to force, albeit ill-fittedly, this unique place into the standard hierarchical mold of an American university. . . . It is my hope that those responsible for setting policy . . . will cease their preoccupation with building a school . . . realizing that school is not an end in itself, but a period of preparation for something else, namely, life after school."[15]

Rob Adamson was one individual who found his experience at Pilchuck useful when he started his own business. "I was thinking of leaving Pilchuck before [Bosworth's tenure] because I needed to make a real living," he remembers. Adamson left Pilchuck after the 1977 session to start a successful production glass workshop in Seattle called the Glass Eye, with the help of his wife, Jan Swalwell, and artists Sonja Blomdahl, Norman Courtney, Mark Graham, Walter Lieberman, and Charles Parriott.

> My impression of the school was an open, free one. The small scale and newness brought a kind of intimacy and trust for developing things you wouldn't be able to do alone. Though glassmaking was a base, it was for me definitely not a school . . . just for glass techniques.
>
> —Ann Wolff

Among the artists at Pilchuck, there was a general perception that Bosworth was more concerned about his buildings than the glass program. "It didn't seem that he was interested in glass so much," remembers Waine Ryzak. "He fulfilled his role as a director really well, but I don't know if he was ever that excited about glass. . . . It wasn't his material." Paul Marioni, for example, had intense disagreements with Bosworth over the chilly flat shop, needed equipment, and the new French doors added to the flat shop, with tiny panes that made them inadequate for viewing stained glass.[16]

On Bosworth's part, he found the "seething, personal, confrontational things going on between various people" to be characteristic of his tenure as director. He did his best "not to become a partisan," focusing on the organization of the school and the design program for the campus. "As a director, I tried to save what I could from the past while implementing the new order," Bosworth wrote. "For the first couple of years . . . we maintained the tradition of everyone working a few hours each week for the general good—like a *kibbutz*. I remember with pleasure working the dishwashing machine and mopping the kitchen floor with Ludwig Schaffrath." The tradition faded, however, as the "importance of our individual responsibilities" gradually took precedence over the "need to contribute on all levels to the general good."[17] "Artists are basically anarchists," explains Bosworth. "So when you try to order something, as my assignment was . . . I didn't make many friends in the process." One of the more lasting changes instituted by Bosworth, says Benjamin Moore, was the practice of regular debriefings with faculty, teaching assistants, and visiting artists at the end of each session, which provided valuable feedback about the school's programs and its day-to-day management.

In an article about Pilchuck written in 1977, *Post-Intelligencer* critic R. M. Campbell observed that Dale Chihuly was interested in the "experimental, [in] stretching the technology of glass as far as it can go."[19] That summer, Chihuly had visited the Washington State Historical Society in Tacoma. "I saw the Indian baskets," he recalls, "and I said, 'I'm going to make those baskets out of glass.'"[20] Chihuly's basket series—originally called the *Pilchuck Baskets*—was a major turning point for the artist and a creative tour de force. "This was the beginning of my work with the natural elements of the glass . . . with heat and fire and gravity and centrifugal force, making shapes without any tools," says Chihuly.[21] New techniques, methods, and glass materials would multiply in the next decade, offering radically different looks and uses for studio glass.

It was about this time too that a commercial market for studio glass began to take hold. In the early years Rob Adamson, Charles Parriott, and others had sold glass at the Pike Place Market in Seattle, alongside the vegetable venders and fishmongers.[22] Dale Chihuly states, "It wasn't until 1976 . . . that I had a [solo] exhibition in a gallery. I had worked for about twelve years with glass before I ever sold any."[23] By 1977, however, Chihuly's baskets were selling for about $1,000 apiece.[24] In 1975 the Habatat Gallery in Lathrup Village, Michigan, held a survey exhibition of artists working in glass, and the show nearly sold out during its preview.[25] By 1976 New York dealer Doug Heller

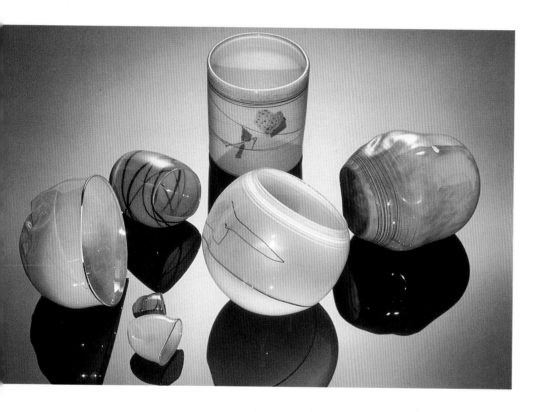

Dale Chihuly (American, b. 1941), *Baskets and Cylinders*, 1978. Blown glass and applied glass threads.
Courtesy Dale Chihuly, Seattle

was marketing only glass, unsupported by other craft media.[26] Collectors were beginning to recognize contemporary glassmaking by studio artists and to accept their work as a genuine art form.

Pilchuck's 1977 season ended with three fall exhibits in Seattle. A group show at the Polly Friedlander Gallery, curated by Dale Chihuly, featured work made that summer at Pilchuck by fifteen artists including Rob Adamson, Gary Beecham, Chihuly, Dan Dailey, Fritz Dreisbach, Paul Marioni, Benjamin Moore, Stan Price, and Ann Wolff.[27] Chihuly showed his latest Navajo cylinders and early baskets at Foster/White and at a three-person exhibit at the Seattle Art Museum. In what was the museum's first expression of interest in glass and the Pilchuck Glass School, Charles Cowles, the museum's modern

Patrick Reyntiens, Italo Scanga, Bob Bailey, and Patrick Clensay, *Tree of Life*, 1978. Leaded glass, fired enamels, 30 x 32½ in. Made at Pilchuck.

art curator, displayed Chihuly's work alongside prints and films about salmon by James Carpenter and a mixed-media installation, incorporating religious imagery and glass vessels, by Italo Scanga.[28] "Successful or not," said critic R. M. Campbell, "the three men demonstrate their unwillingness to settle for conventional forms, traditional means, usual functions. They mean to make glass . . . an important conduit for the expression of aesthetics."[29]

Pilchuck's poster for the 1978 summer program advertised three sessions, each running for three weeks, at $550 apiece. In a special June session, Roger Ek and Jerry Rhodes from Seattle's Spectrum Glass Company would teach furnace construction, and Robert Kehlmann would hold a stained glass workshop. Dan Dailey taught molten glass during the first session. The flat shop was given over to "Glass Constructions," taught in one-week stints by Robert Kehlmann, Michael Cohn, and Harvey Littleton. The second session featured Dale Chihuly in the hot shop, with Ludwig Schaffrath returning to teach architectural glass. On Thomas Bosworth's recommendation, Seattle architect Bud Schorr also offered a course in architectural design with glass.[31]

The erosion of the barrier between art and life is only possible in resident summer schools such as Pilchuck.

—Patrick Reyntiens[30]

During the third session, Dale Chihuly and Italo Scanga again team-taught glass aesthetics, but this time the class was confined to the hot shop and even more loosely structured. Students were encouraged to work on their own projects, in addition to helping Chihuly and Scanga, and there were no formal assignments. British stained-glass artist Patrick Reyntiens, in his first teaching assignment in the United States, took over the flat shop for the third session to demonstrate traditional techniques.

They ran 24-hour work schedules in the hot shop. We drew straws . . . and I ended up as TA on duty from 2:00 to 5:00 in the morning. And my blowing slot was something like 11:00 at night to 2:00 in the morning. . . . I felt I was missing a little bit of something . . . even though a quarter of the school was on that schedule too.

—Sonja Blomdahl[32]

Visiting artists in 1978 included Richard Posner, Stephen Procter, Swedish glass master Jan-Erik Ritzman, Dick Weiss, and Checco Ongaro, a Venetian glass master whom Benjamin Moore had met in Italy over the winter.[33] Ongaro's impromptu visit heralded the beginning

Benjamin Moore (left) blowing with Checco Ongaro in the hot shop, 1978.

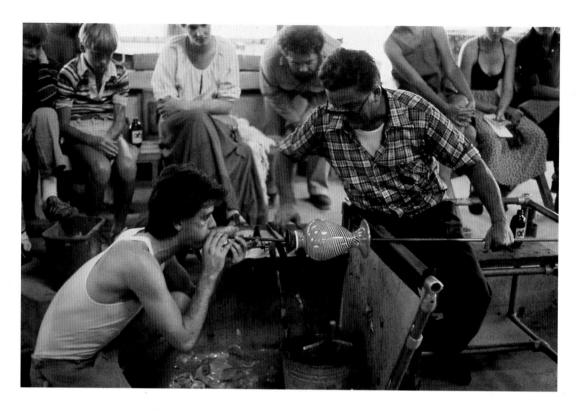

of a long and influential relationship with the glassmakers and *maestros* of Murano, the tiny island situated off the legendary lagoons of Venice. "The opportunity to watch a master blower in the hot shop," says Patrick Reyntiens, "is not unlike a master class on the piano or violin."[34]

Staff for 1978 included Benjamin Moore, again shop supervisor, who divided Rob Adamson's former duties with "bursar" Stan Price, and ten teaching assistants. Moore was assisted by John Reed, a glass artist who taught at the University of Alberta in Edmonton. Reed had first visited the school in 1976 and enrolled as a student in 1977, staying through the summer to batch. He was hired part-time in 1978 and became full-time staff in 1979.

On Stan Price's recommendation, William Morris was hired as truck driver in 1978, and Richard Royal was put on maintenance. "I was pretty much a neophyte," remembers Morris. "I had blown a little glass at Central Washington University and before that at Chico State in California and was really taken by it. I'll never forget my first day at Pilchuck. It was about two weeks before the summer started and . . . the first thing I did was to dig a 150-foot ditch to lay propane line. And I loved every shovelful! I was just enamored . . . [of everything]."[35] Betsy Haight was hired as the secretary—assisting Thomas Bosworth with administrative duties—and Patty Green came to run the school's small store, which sold glass tools and supplies. Cooks continued to be problematic, and like Mimi Pierce, Bosworth went through his fair share of them. Elaine Bosworth once had to take over during a kitchen crisis, and after two cooks had been ousted, Stan Price's wife, Colleen, found herself heading up the kitchen staff midway through the 1978 season with Celia Hemer and first-session teaching assistant Sonja Blomdahl.[36]

Bear sightings around the Pilchuck campus inspired a notorious practical joke during the third session of 1978. "One night [in 1977] we were talking about . . . Italo's [terrors],"

remembers Norman Courtney. "He was making all these pieces about fear . . . and we were saying . . . we should dress up in bear suits or lion suits. . . . The next summer, I planned it and . . . we rented a bear suit. . . . I put [it] on and Dale led Italo back over toward the faculty cabins." "Norman stood up in the bear suit and Italo screamed," says Charles Parriott. "I walked up to him and wrapped the paws around him," adds Courtney. "And as I was doing it, I said, 'Italo, it's okay, it's me, Norman.' . . . He made me put that damn bear suit back on about ten times to take pictures with Checco Ongaro, who also was there."

There are lots of great art schools where you can go and be around artists, but there aren't a lot of places [where] you can study glass and be around a lot of artists— glass artists.

—Dale Chihuly[37]

"Just a short note to say how much I enjoyed my stay with all of you at Pilchuck," wrote Harvey Littleton to Dale Chihuly and Thomas Bosworth in 1978. "All of the improvements have made the school unique in the world."[38] But in spite of the good sentiments, high energy, and international talent that Pilchuck attracted, the 1978 season had been undersubscribed. Chihuly, who attributed this to a lack of publicity, encouraged Bosworth and the board to put money toward a "knock-out poster," the development of a brochure, and advertising for 1979. "I don't feel we can afford to hold back on advertising," wrote Chihuly to Bosworth in November 1978. "If we want to get the projected number of students, somebody is going to have to pay for the advertising—people still don't know about Pilchuck and, if they do, they have to be reminded."[39] In the meantime, recalls John Hauberg, Chihuly and other artists lectured about Pilchuck at colleges and art schools across the country to drum up attendance.[40] Anne Gould Hauberg convinced William Traver to hold a Pilchuck show in his Seattle gallery that December which featured blown and flat glass by thirty-seven faculty, staff, and visiting artists from the 1978 sessions.[41]

"We all seem to be pretty much in agreement about the direction Pilchuck should go," wrote Chihuly to John Hauberg and Bosworth. "I came away feeling Pilchuck for the time being should remain primarily a glass school offering one or two special sessions each summer—something important, fresh, and exciting, like Christo or ?"[42] But the specter of other media still loomed. "Permanent housing and a new craft will be added by 1980," read the minutes of a November 1978 board meeting.[43] Clearly some changes would be made despite Chihuly's advocacy of a single medium.

Chihuly's limited eyesight—the result of his 1976 car wreck—made it difficult for him to blow, and eventually he gave it up. Even before that, those who cherished the idea that a craftsperson should be entirely responsible for his or her work had criticized Chihuly for his collaborations and his Venetian-style use of teams of helpers. But his innovative techniques, pioneered in the late 1970s, influenced an entire generation of

artists working in glass, a fact that could not be overlooked even by his critics. William Morris remembers his first encounter with Chihuly: "I picked Dale up at the airport . . . and we drove up to Pilchuck together. I had . . . heard that he didn't make his own work and I was appalled." Later that night Morris saw Chihuly giving a glassblowing demonstration to two students: "And it was one of the most inspiring demos I had ever seen. Because Dale approached the glass and dealt with it without any tools, just using heat, centrifugal force, and gravity. And I thought that was brilliant." On the spot, Morris offered to assist Chihuly, beginning a close collaboration that would last for ten years.

As part of the push to attract more students to Pilchuck, Chihuly and Benjamin Moore brought together a more international faculty for 1979, and the program was expanded to four sessions. Faculty and students would be assisted by nineteen teaching assistants, almost double the number of the previous year.

Bringing in the Europeans made Pilchuck what it is.

—Norman Courtney

"Wow! What a great schedule of sessions at Pilchuck for 1979," wrote artist Michael Glancy in a note to Thomas Bosworth. "The finest assemblage of glass artists as faculty I have seen."[44] The first session offered advanced glassblowing with Dan Dailey and Joel Philip Myers, and stained glass with Katherine Bunnell and Paul Marioni. Fritz Dreisbach and Richard Marquis taught glassblowing in the second session, and Ludwig Schaffrath taught architectural glass in the flat shop.

As far as a Venetian glass master for Pilchuck '79, I have another dandy lined up. His name is Lino Tagliapietra. . . . [He] speaks no English, but will be great with the students. . . . [He is] a very unique and rare Venetian glass master.

—Benjamin Moore, 1979[45]

Chihuly would teach advanced glassblowing in the third session. He handpicked his assistant, Flora Mace, who had collaborated with him on glass thread drawings for his Navajo blanket cylinders. "She's the best in the country at . . . drawing with the torch," Chihuly wrote to Bosworth, "and would be a great asset."[46] Session III also featured instruction in intermediate glassblowing—taught by Benjamin Moore with visiting artist Lino Tagliapietra—as well as two flat glass sections. Painting, fusing, and slumping were taught by well-known German artists Klaus Moje and Isgard Moje-Wohlgemuth, and acid etching and sandblasting by Ann Wolff, who brought along a master glassblower from Kosta Boda/Åfors, Wilke Adolfsson. Session IV had Dale Chihuly and Italo Scanga in the hot shop with Patrick Reyntiens, and British artist Brian Clarke in the flat shop.

Pilchuck staff had grown by 1979. Benjamin Moore—who was called shops supervisor—also served as educational coordinator with Dale Chihuly, and Richard Harned was hired as Moore's assistant, in charge of the darkroom and acid-etching facilities set up in the school's original bathhouse. Stan Price was bursar and caretaker. On Moore's recommendation, John Reed came on as the hot shop technician, William Morris took charge of batching, and Ed McIlvane became flat glass coordinator. David Schwarz, like Morris a recruit from Central Washington University, drove the school truck, and three

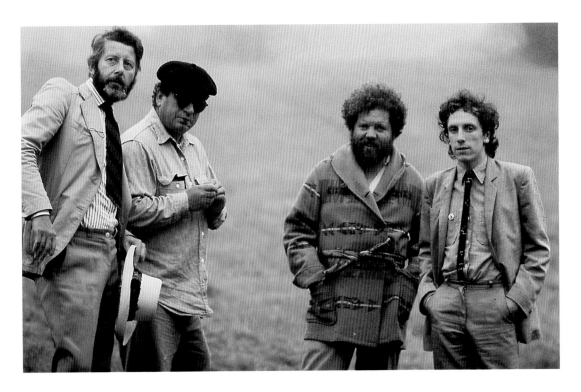

Left to right: Patrick Reyntiens, Italo Scanga, Dale Chihuly, and Brian Clarke, 1979.

new cooks came on as kitchen staff. The large student enrollment for 1979 included names familiar to Pilchuck—Anne Gould Hauberg, Boyce Lundstrom from Bullseye Glass in Portland, Sue Melikian, who had not visited since 1972, and Waine Ryzak—as well as newcomers including Mary Cozad, Stephen Dale Edwards, Joey Kirkpatrick, Carolyn Silk, and Swedish artist Ann Wåhlstrom.

Klaus Moje works on a fused and slumped mosaic vessel at Pilchuck, 1981.

Returning to Pilchuck after several years, faculty member Richard Marquis observed that "all of a sudden from the last time I'd been there—when it was just sort of free and disorganized with guys chasing women and women chasing guys—they had come to where they were actually making things. That's when it was actually possible to make decent things there." Eric Hopkins, returning for the first time since 1974, also noticed the change. "By 1979 it was a totally different scene," he remarks. "It was more about object making . . . a lot more formal. . . . Professionalism had crept in there pretty hard." "There was still experimentation and innovation, certainly," recalls Paul Marioni. "But the product became more important."

As in other summers, the faculty, and especially Dale Chihuly, set the tone at Pilchuck in 1979. Chihuly embellished his learn-by-doing approach by giving as much weight to the mix of personalities of instructors as to their qualifications. Exposure to a wide range of ideas mattered as much as, if not more than, acquisition of technique. "It really helped to have a mix," says Chihuly. "It

Art itself, the creation of art, cannot be taught directly. Although it may sound contradictory, I still believe that art can be developed, can be learned.

—Josef Albers[47]

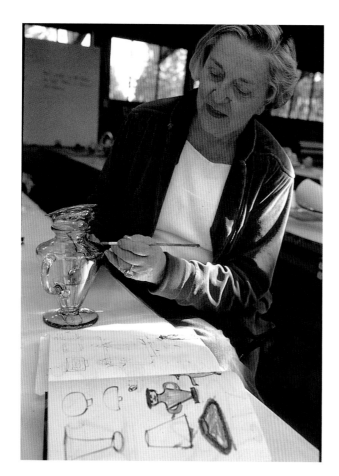

Student Anne Gould
Hauberg, 1986.

strengthened Pilchuck . . . to have the diversity there." "Dale often brought faculty . . . together in the same session that he knew were going to be polar opposites," says Marioni. "That way the students had to think for themselves." Kristine Bak, a fourth-session flat glass student, wrote in 1979: "At the Pilchuck School, international leaders in both blown and stained glass are available to students at all hours of the day and far into the night. Mornings begin with an after-breakfast lecture in the lodge. Patrick Reyntiens of England might climb up on a table and speak with Shakespearean elegance and passion on artistic involvement. Dale Chihuly, with typical generous good humor, might present practical ideas on marketing art. Ann [Wolff] . . . might relate her experiences as an artist of growing confidence and excellence in Sweden."[48]

Contributing to the school's new sense of professionalism was the introduction of glassworkers and designers from Europe. The Europeans, in return, responded to the openness to risk and experimentation displayed in the Pilchuck hot shop. Ann Wolff wrote in 1979 that the "old design ideology of the functional and formal product has led us into a dead end." But at Pilchuck, she continued, "I could take part in a feeling that almost anything is possible. We call it, in German, *amerikanischen Pioneergeist*."[49] "What you have here is a lot of freedom," observed Erwin Eisch in 1983. "You bring the people and everybody

Lino Tagliapietra in the
hot shop, 1983.

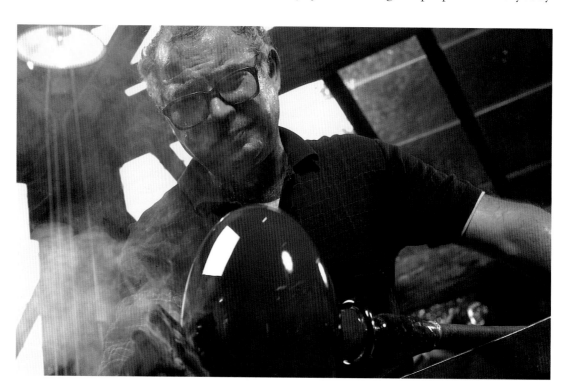

learns from the other. And this is very unusual. I know many schools in Germany, of course, and there is no place which is similar to Pilchuck." Lino Tagliapietra was amazed by the casual way in which American artists blew glass. "My first experience here was a little bit of a shock," he remembers. "If you lose one piece on the floor, in the factory, people start watching you. Maybe you are drunk." The students' freedom and lack of hesitation also made an impression. "The boldness was so new to me. On the one hand, it was a shock—the lack of a cultural base, the absence of traditions. But on the other hand it was exhilarating—very inspiring for my own work . . . the lack of restraint in the process, the exciting results."[50]

Pilchuck may have given a certain freedom to European artists, but in return Europe brought a deeper understanding of the medium to Pilchuck artists, and provided a larger context within which to see their art. It is generally accepted that glass was first cast five thousand years ago in Mesopotamia and later developed in Egypt under New Kingdom pharaohs around 1500 B.C. Glass was first blown a little more than two thousand years ago somewhere along the eastern Mediterranean seaboard, but the two periods of glass-making's greatest achievement belong to Europe, specifically to the Italians and their ancestors of imperial Rome and Renaissance Venice. For glassblowers at Pilchuck, it was also a Venetian, Lino Tagliapietra, whose influence was, and still is, unsurpassed. Tagliapietra brought his knowledge of a demanding trade whose medieval beginnings in Venice were steeped in secrecy and the arcane hierarchy of its enigmatic sibling, alchemy. Taking its form from the intangible—breath/wind, gravity, heat, light—glass was magical, a substance that medieval glassmakers, like their ancient predecessors, seemingly could transmute into precious stones: crystals, rubies, emeralds, and sapphires.[51]

The closely guarded experiments of medieval glassmakers quickly became industrial secrets as the Venetian republic grew to monopolize the European glass industry. During the Renaissance, the disclosure of glassmaking knowledge was punishable by death. Among the Venetian glassmakers of Murano today, a maestro who reveals techniques is still censured. "People sometimes say terrible things because I went to the States," says Tagliapietra. "[But] the reason I left Murano is because Murano did not give me the opportunity to stay there." In his willingness to share the secrets of Venetian glassmaking, Tagliapietra was more akin to the historic glassblowers whose industry sprouted at Altare, near the Italian city of Genoa. Unlike the secretive Venetians, the Altarists spread the craft of glassmaking by sending their members afield to found new glass operations."[52] According to glass historian Ada Polak, Angelo Barovier, the most famous of the glassmakers of Renaissance Venice, is hailed on his tombstone as a man to whom "were open all the secrets of glass."[53] Anyone at Pilchuck would agree that the same must be said of Lino Tagliapietra.

Although many of the artists teaching at Pilchuck had been to Italy and passed on the techniques they had acquired, their demonstrations were no substitute for seeing a process performed by a master. Tagliapietra offered insights into everything from how to correctly gather glass onto a pipe to how to knock the finished vessel off of it. "Lino

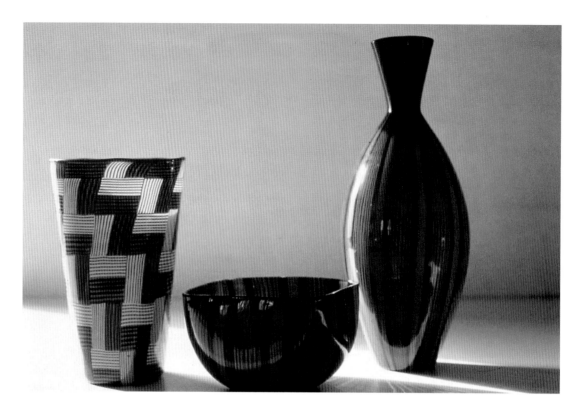

brought technique," remarks Norman Courtney. "And everybody realized that we had been doing it wrong." During his first session at Pilchuck, Tagliapietra complained that American glassblowers were working their glass too cold, that they might as well be working with clay. When Tagliapietra was blowing, remembers Paul Marioni, someone would bring him a gather and he would say, "What's this? Bring me something hot!" Courtney recalls Tagliapietra observing with despair that American glassblowing was like "working with a wood chisel—but holding the knife end in your hand and working with the handle."

No American will ever—in an overall sense—have the understanding of glass that Lino has.

—Benjamin Moore[54]

While Pilchuck was discovering Europe, America was learning about studio glass. The Corning Museum of Glass, in 1979, became the first American museum to organize an international, traveling survey exhibition of contemporary studio glass. The artworks chosen for *New Glass: A Worldwide Survey* illustrate how quickly the studio glass movement had grown since its inception in 1962.[55] Of four hundred pieces of commercial, craft, and art glass, 90 percent were made by studio glass artists, many of whom had come to Pilchuck as students, teaching assistants, or faculty.

The Glass Art Society held its 1979 conference in Corning, New York, in conjunction with the exhibition. Thomas Buechner, president of Steuben Glass and director of the Corning Museum, addressed the conference participants. "*New Glass* is about discovery," he said. "About new forms, new decoration, and new ways of making things. The history of glass has changed radically and profoundly."[56] The Corning conference, with eight hundred participants, was the largest in the society's eight-year existence. Although several glass artists and dealers felt that the exhibition was uneven in quality, and

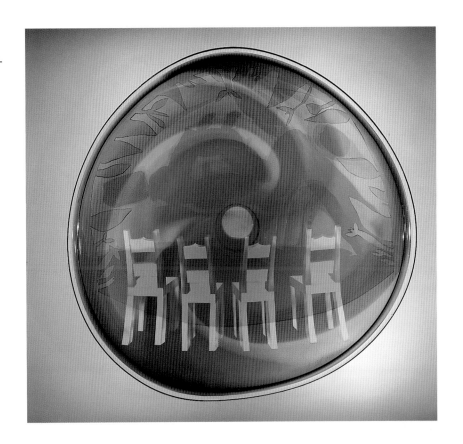

Ann Wolff (German, b. 1937), *Plate Scenery*, 1978. Blown and acid-etched glass, diam. 19⅞ in.
Corning Museum of Glass, Corning, New York.

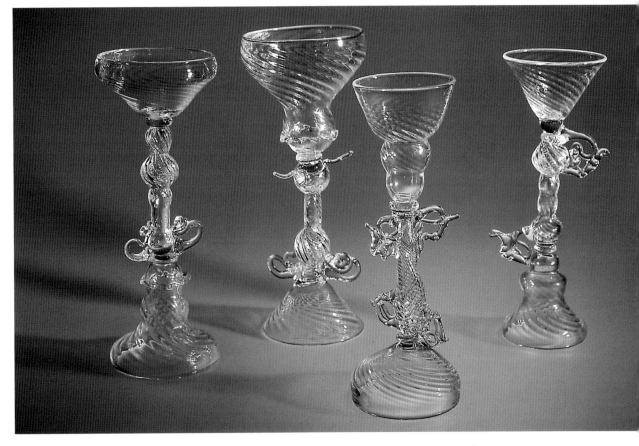

Fritz Dreisbach (American, b. 1941), *Crystal Optic Reversible Champagne and Cognac Goblets*, 1979. Optic-blown glass, greatest h. 11 in.
Courtesy Fritz Dreisbach, Seattle.

lacked good representation in flat glass and glass sculpture/installations—excluded by the maximum height limit of 4 feet—most recognized the importance of the show to the contemporary glass movement. "The Corning show was a landmark exhibition in many ways," comments glass dealer Doug Heller. "It had a very significant impact on me, and it expanded my knowledge of glass."[57] Ferd Hampson, who in 1979 changed the program at his Habatat Gallery from multiple craft to glass, describes the show as the "single-most important exhibit that has occurred in glass in years."[58] And for the artists, says Paul Marioni, "the Corning show . . . legitimized the value of what we were doing."

For the larger public, the diversity of work presented in *New Glass* was a revelation. "[My wife] Dorothy and I were looking for something to collect," remembers Pilchuck trustee George Saxe. "We were looking for something that we could do together. That we could learn together, that we could start talking about together, and have a good time working on together. And we were over at a friend's house and she had on her coffee table a copy of the catalogue of the Corning exhibition. . . . We decided that maybe [glass] was what we were looking for."[59]

"Dale Chihuly's originality and innovation have brought him increasing recognition and acclaim," wrote critic Rose Slivka in 1979. "His schedule of exhibitions and the collections in which he is represented are mounting as fast as his fame and his prices."[60] The year 1979 had begun with a show of Chihuly's recent baskets and cylinders at the prestigious Renwick Gallery of the Smithsonian Institution, in Washington, D.C., and closed with the group exhibition *Pilchuck Projects 1979*, the inaugural show at the Contemporary Art Glass Gallery (later the Heller Gallery) in Manhattan, and a group show at Seattle's Traver Gallery. *Pilchuck Projects 1979* introduced European artists Klaus Moje and Isgard Moje-Wohlgemuth and Ann Wolff, whose works—made during the 1979 sessions at Pilchuck—were shown with Chihuly's baskets. While Paul Hollister of the *New York Times* praised Wolff's elegant vessels, with their acid-etched "private imagery of her Scandinavian farm," and Klaus Moje's slumped shallow bowls, "austere" in their power "like stones in a Japanese garden,"[61] Seattle art critic Matthew Kangas found the European work to be of limited interest. In his review for the *Seattle Post-Intelligencer* of the Traver Gallery exhibition, Kangas observed that "though we may very well be going through a glass renaissance, this flourish might be better described as a quickening of activity rather than a new apex of artistic achievement."[62] It was evident by the close of 1979 that the new studio glass movement had arrived.

In the closed world of the Pilchuck board of trustees, significant changes also had taken place by 1979. Frank Kitchell stepped down as president in the summer of 1979, making way for incoming president John Hauberg, and the trustee ranks had increased to fourteen. Joining trustees Patricia Baillargeon, Anne Gould Hauberg, Johanne Hewitt, Frank Kitchell, Philip Padelford, and the Rubinsteins were John Ormsby (1977), Robert Block (father of early Pilchucker Jonathan Block), Roger Christiansen, Jack Lenor Larsen, Illsley Nordstrom (1978), and Harvey Littleton (1979).

For the first time acting as president of the school he had built, Hauberg informed the board that he would gradually reduce his financial commitment to Pilchuck. Not only had he paid for construction of the school's buildings, he every year had retired the school's deficit, which ran into the tens of thousands of dollars. "In 1979, John announced to the board . . . that he was going to lessen [his contribution] . . . by $5,000 every year," says LaMar Harrington. "I don't know if he ever did it quite that way or not. But he made this announcement."

Up to this point, the Pilchuck board had not been involved in fundraising of any kind, and Thomas Bosworth had not attracted major public or private grants, partly because of Hauberg's munificence.[63] At the end of the school's 1978 season, at a small gathering of the board and some artists, an impromptu auction of pieces made that summer had raised a little money. In 1979 a more formal auction was organized and held at the lodge at Pilchuck. Patrick Reyntiens, dressed in a leather kilt, played auctioneer to a small gathering of board members and artists, many of whom were dressed as giant slugs, according to cook Cathy Chase.[64] "John [Hauberg] and I bought almost everything," remembers Sam Rubinstein. "Just the two of us."[65] "Some of the trustees were bidding on pieces and joking with each other," recalls John Reed. "And there was this young woman, a student at Pilchuck, who was outbidding them. And that was okay until some major pieces that they wanted came up, and they were getting outbid. . . . The bidding was going up to $1,000, $1,500—then, $1,000 was a lot of money for a piece! We were ecstatic."

Pilchuck's first auction netted about $9,000. The school had found its fundraising niche: the annual auctions would, over the years, become the school's single largest source of income, thanks to the generosity of the artists—who donate their works—and Seattle's supportive and growing community of collectors.

Extensively equipped glassblowing and flat glass studios especially designed for the school . . . are in operation twenty-four hours a day. New continuous-feed glass furnaces and flat glass equipment are being installed for the 1980 season.
—1980 Pilchuck poster

Significant physical changes to the school were being planned. "Students may choose to live in walled tents on platforms equipped with sleeping platforms and mattresses (two per tent) or in heated, furnished rooms (two beds each) with adjoining shared bath in the new student housing units," said the Pilchuck recruitment poster for 1980. Thomas Bosworth had just finished the caretaker's house and had designed two student cottages for the meadow above the hot shop to be ready for the 1980 session. "The idea . . . was that they would be rubber-stamped around the campus," says John Reed. "But they turned out to be too expensive."

During the 1979 session Chihuly, Fritz Dreisbach, and Benjamin Moore took stock of the hot shop equipment. Eight furnaces, called day tanks, each held 150 to 200 pounds

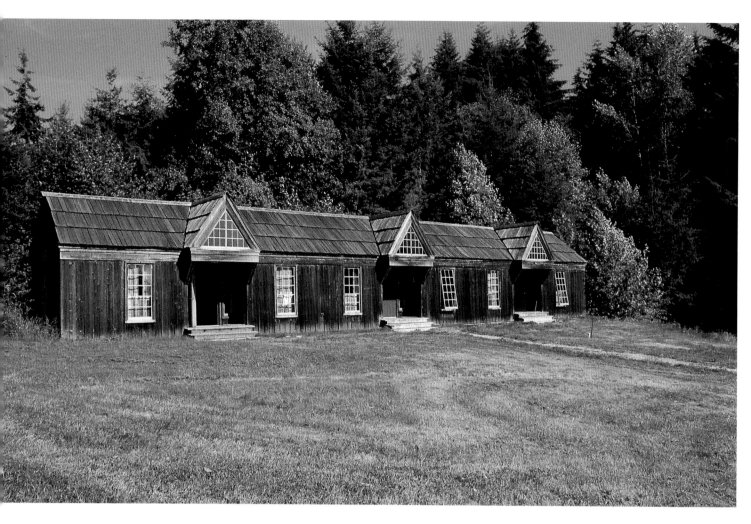

The student cottages.

of glass, which lasted only about half a day before the furnaces needed recharging. Pilchuck had ceased to batch from scratch in 1977, converting to a partial batch/cullet mix. The school purchased its cullet—made of broken-up, recycled glass—from Northwestern Glass Company in Seattle. "[The school's glass] . . . was crummy, really," remembers Norman Courtney. "It was full of seeds [bubbles], and it was greenish." "It was a constant battle trying to get the seeds out of it," adds John Reed. "We tried every chemical we had . . . and there was nothing you could do. So, Pilchuck glass became known as seedy."

In an effort to improve the quality of the glass and efficiency in the hot shop, Benjamin Moore suggested the installation of a new furnace. "With the expansion in student enrollment, there will be an obvious need to produce more glass," Moore wrote to Thomas Bosworth. "A continuous-feed furnace would facilitate such an expansion very well. . . . Pilchuck has long needed an upgrading of its furnaces; the existing system is a carryover from the school's primitive beginning."[66] The board agreed to build and install two new furnaces in the spring of 1980. Bill Gillum, who had built the furnaces for Northwestern Glass Company, was hired to design and build the new furnaces with the help of John Reed, William Morris, and others. Reed, in the fall of 1979, had helped build a continuous-melt furnace for the hot shop at the Rhode Island School of Design with artists Howard Ben Tré, James Harmon, Eric Hopkins, Pike Powers, and Steven Weinberg.

But there was one major hitch. At the very last minute, relates Reed, "the brick mason talked Bill Gillum into letting him do a corbel vault, rather than an arch, for the top of the glory hole." "It was a nightmare," added Morris. "The glory holes . . . just didn't get hot." "There was many a day," jokes Flora Mace, "that we would say to each other, 'Could someone please shine a flashlight in there and see if that thing is on?'"[67] The design of the glory holes—openings at the side of the furnace used for reheating hot glass while working it—was a serious problem. But by the time the furnaces were charged and ready for testing, it was too late to make any changes. The 1980 session was underway.

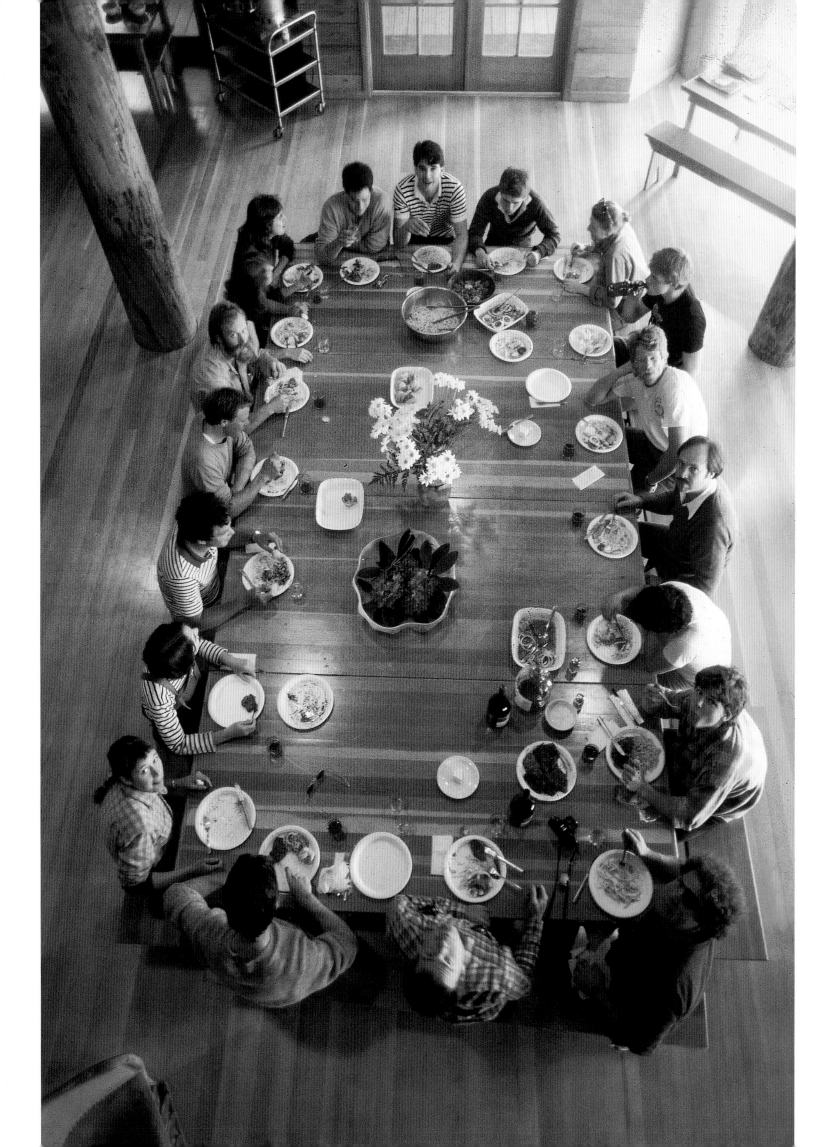

1980–1984: An International Community

The summer of 1980 was Pilchuck's tenth season. The program, the largest ever, was expanded from four to six sessions, each divided into flat glass and glassblowing sections, with instructors helped by thirty-nine teaching assistants. Artists-in-residence were a new feature of each session. They were invited to Pilchuck without teaching responsibilities to make their own work and to serve as models for the students. Visiting artists still made informal appearances at the school every summer throughout the 1980s, and, as in the 1970s, many of these visits are unrecorded. "We believe that the most effective way to learn a craft is by watching a master," states the 1980 Pilchuck poster. "And that the best way to learn about the making of art is to be in the presence of a working artist." Chihuly's now-familiar philosophy was evolving each year as students demanded more. "Pilchuck is not the place where a student should expect to complete a body of personal work," declares the poster. "Rather, it is an environment in which a student can experiment and develop a vocabulary of ideas."

Pilchuck's goal is to attract the best international glass artists as faculty and artists-in-residence who in turn will attract the most talented and interested students and teaching assistants. The very presence of all these committed people living and working together is the core of the Pilchuck philosophy.

—1980 Pilchuck poster

Three-week-long Session I featured Albinas Elskus teaching painting on glass in the flat shop, with William Bernstein in the hot shop. "Albinas Elskus . . . wasn't the first person to do painting on glass at Pilchuck," remembers John Reed, "but he had the most technical knowledge related to painting on flat glass, on blown forms, anything. . . . He did a lot of drawing on paper before he ever got near the glass."[1] Harvey Littleton, the summer's first artist-in-residence, worked on his massive, multiple-overlay glass sculptures and lectured on the history of glass and the studio movement. "The artists-in-residence painted or did sculpture or any number of things," recalls Littleton. "I, myself, instituted a glass history course. And I had a lot of trouble getting students to . . . come to lectures. . . . When there is hot glass around, it's terribly hard to get anybody to do anything but blow glass or watch it."

The relatively traditional instruction of Session I was balanced in Session II by a group of energetic and offbeat individuals. The two-week-long session brought Paul Marioni, once again, to the flat shop, with Susan Stinsmuehlen-Amend as his teaching assistant. An artist from Austin, Texas, she introduced a wild style to two-dimensional glass. "There was a big emphasis on faculty making work while they were there," recalls Stinsmuehlen-Amend. "You learned by watching artists work. . . . At that time I was

A meal in the lodge, 1980.

People get out of their cages in an environment like Pilchuck.

—Bertil Vallien[2]

gluing all kinds of things onto glass and painting with cold paints and working with the hot glass people. People thought I was pretty abusive of the material . . . [but] I think it opened people's minds to other [ways of] . . . thinking."[3]

Bertil Vallien, an accomplished artist and well-known designer for the Swedish glass firm Kosta Boda/Åfors, was in the hot shop teaching his unique methods of sand blowing and sand casting. His wife, Boda/Åfors designer and painter Ulrica Hydman-Vallien, was an artist-in-residence along with Joey Kirkpatrick, Flora Mace, and visiting artist Paul Trautman. Hot shop teaching assistants working with Vallien included Sonja Blomdahl, Norman Courtney, Stephen Dale Edwards, Walter Lieberman, and Molly Stone.

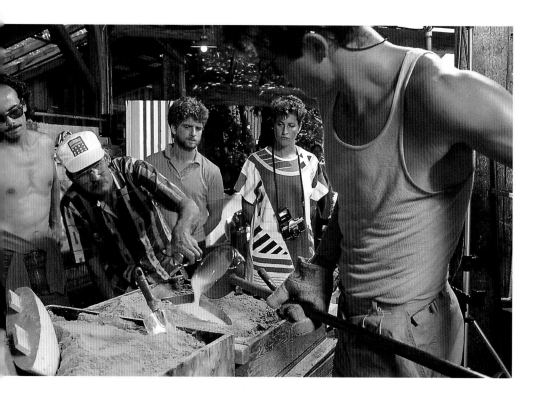

"What makes me so enthusiastic about this place is the philosophy of it," remarks Bertil Vallien. "It is a school where people come and are told not to make pretty pieces to bring home . . . or to sell. They are told to experiment and try new techniques, new ways of expressing themselves." The ethos of the school, based on openness and a strong sense of community, was vital to Vallien. "It was very thrilling . . . at that time," he recalls. "There was no path, no structure. . . . You could create your own culture on the spot. What Pilchuck offered was . . . artists. Glassblowers in the factory . . . are laborers, craftsmen. They are not working with glass artistically."[4]

Bertil Vallien, in hat, gives a sand casting demonstration; William Morris ladles the hot glass, 1984.

Bertil Vallien (Swedish, b. 1938), Untitled, 1980. Blown, sand-blasted glass, 9⁹⁄₁₆ x 11¼ x 8¾ in. Toledo Museum of Art, gift of Dorothy and George Saxe.

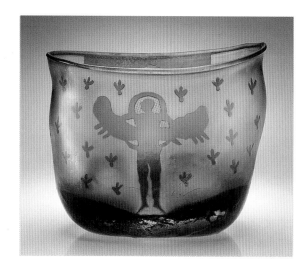

Although Paul Marioni may have been the first person at Pilchuck to teach casting, he credits Vallien with creating an impact. In a place as completely dedicated to glassblowing as the hot shop at Pilchuck, it took an inspirational personality like Vallien's to communicate the excitement of casting to students. "Bertil was certainly one of the great teachers," remarks Marioni. "He challenged

Ulrica Hydman-Vallien,
1986.

Ulrica Hydman-Vallien
(Swedish, b. 1938),
Blue Animal Bowl, 1978.
Blown, enameled glass,
h. 8⅞ x diam. 11⅜ in.
Corning Museum of Glass,
Corning, New York

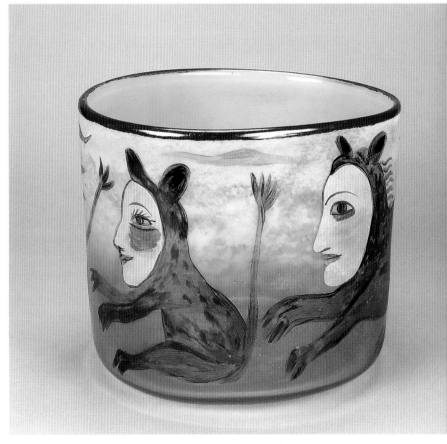

students' thinking and occasionally did something that you would never expect." Ulrica Hydman-Vallien, who painted on elegantly blown blanks (undecorated vessels) as well as thrift store glasses, was as open and free with her students as her husband. "She would follow no rules," comments Flora Mace. "If she wanted something on [a piece], she didn't care whether it stayed on for five minutes or fifteen years."

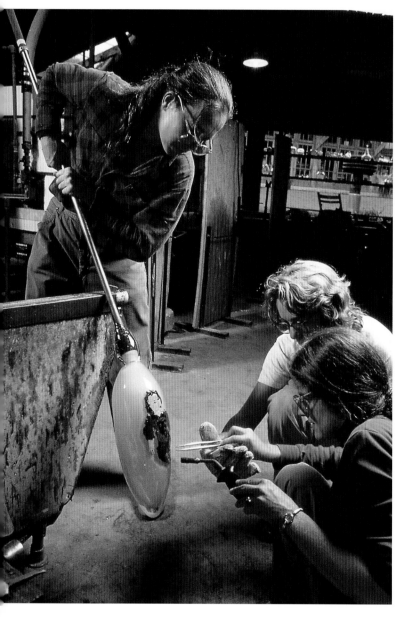

Joey Kirkpatrick applies a wire-and-glass thread drawing to a vessel held by Flora Mace, 1982.

Bertil Vallien was renowned for his performances which took place at the end of a session, when furnaces were cleaned and used materials discarded. Before the materials disappeared, Vallien figured, he and his students might as well use them. "We talked about [how] . . . to end [the class] . . . and that was the first time we did a glass performance," recalls Norman Courtney. "It took it back to more of what [Pilchuck] had been in the 1970s. It became theater." Vallien encouraged the glassblowers to make some long bars, lay them on the marver, and cover them with more hot glass. "Then, Bertil said, 'I think I'll take my shirt off and throw it on the glass,'" continues Courtney. "And he did! And the shirt caught on fire and of course the students went wild! They went running outside . . . and were ripping up stalks of dry grass and throwing them on the fire . . . and Bertil shows up with a quart can of paint thinner. And you could see the ends of the marver warping up at that point. . . . Joel Myers, who had just come in to teach his session . . . walked in . . . [and] said drily, 'I'd never let this happen in my shop.'"

For the three-week-long third session, German stained-glass artist Ludwig Schaffrath returned to the flat shop to teach architectural glass. Joel Philip Myers, whose complex sculptures combined blowing, lampworking, overlays, and color fragments, taught glassblowing in the hot shop. German artist Klaus Moje was an artist-in-residence along with Mary Shaffer, known for the wire and slumped glass sculptures she first made at the Rhode Island School of Design.

Flora Mace and Joey Kirkpatrick stayed on informally after their residency. "When . . . our two weeks as artists-in-residence were up," recalls Kirkpatrick, "Tom [Bosworth] came up and said, 'Stick around for the rest of the summer.' That's how it all started. It was that loose." Kirkpatrick and Mace had met at Pilchuck in 1979. Mace had developed her own glass-thread drawing technique and had worked with Chihuly on his Navajo-blanket-inspired series in 1975. When Kirkpatrick saw these pieces, she told Chihuly,

Joey Kirkpatrick (American, b. 1952) and Flora Mace (American, b. 1949), *First Doll Portrait/The Chinaman*, 1980. Blown glass, wire, glass threads, h. 10¼ x diam. 5⅞ in. Toledo Museum of Art, gift of Dorothy and George Saxe.

"This is what I want to do." Chihuly recommended that she confer with Mace. Kirkpatrick recalls that she "came to Pilchuck with my drawings, met Flora, and we talked about it. We thought, well, let's put those drawings on glass."[5] They began a collaboration that shows no signs of slowing, and the artists, who have returned to Pilchuck year after year, are among the school's most influential teachers.

Session IV of 1980 featured Richard Posner in the flat shop teaching "Picture Windows." In the hot shop, Fritz Dreisbach was orchestrating student participation in a collaborative project with artists-in-residence Dale Chihuly and sculptor Robert Strini. Session V occupied the last three weeks of August with Narcissus Quagliata, a well-known Bay Area stained-glass artist, in the flat shop and Dan Dailey in the hot shop. Artists-in-residence for the fifth session were James Carpenter and Italo Scanga.

"I was happy my first days there. . . . I felt lucky to be able to study with Bertil Vallien," wrote François Houdé, a Canadian glassblower who attended both the first and fifth sessions. "But where were the 'best' students, the advanced students Pilchuck was supposed to attract? Where were the stimulating exchanges of ideas? In reality, Pilchuck attracts mainly beginners in the glassblowing program. . . . Perhaps Pilchuck's real strength as a glass center lies in its stained glass studio, which involves a stronger exchange of ideas."[6] The problem of beginning and advanced students sharing classes, particularly in the hot shop, was becoming an issue as artists matured in the medium.

The last session of the summer was a month-long program similar to the masters/apprentice session Chihuly had initiated in 1974. Now, however, the focus was more on students and less on faculty. Robert Kehlmann, an influential glass artist and critic, taught traditional and nontraditional techniques in flat glass while Benjamin Moore, Michael Scheiner, and artist-in-residence Lino Tagliapietra took over the hot shop.

If there's one thing that I've learned more from Pilchuck than anything . . . it's that when I work with my crew, I want an atmosphere of open-mindedness and of people willing to share. A deduction of ego, and a real striving for the common creative effort.

—William Morris

Open to experienced glassblowers only, this workshop would focus on craftsmanship rather than glass aesthetics. "Ben believes that the true horizons of molten glass are limitless," says the 1980 poster, "provided that the glassblower possesses a good eye and hand, and a skill level developed by extensive repetition." With the arrival at Pilchuck of experienced Italian and Swedish masters, the school—and the American studio glass movement in general—was shifting from a disregard for technique to an ardent desire for it.

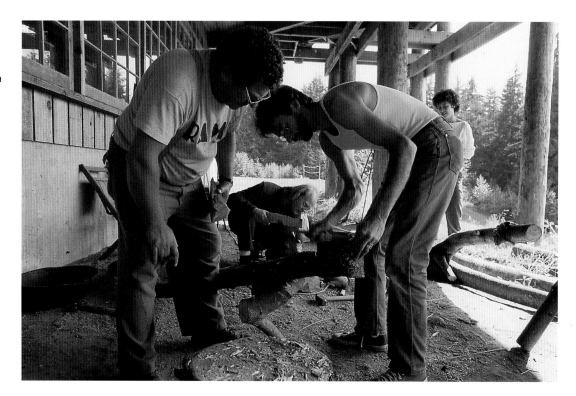

Left to right: Italo Scanga works with Charles Parriott, James Harmon, and Susan Stinsmuehlen-Amend on a sculpture installation, 1980.

Italo Scanga and Dale Chihuly with the finished sculpture installation, 1981.

The number of Pilchuck staff remained the same in 1980, although the season had expanded. Thomas Bosworth, director, and Dale Chihuly, faculty coordinator, were ultimately responsible for the program, which was carried out by manager John Reed and education coordinator Benjamin Moore with his crew William Morris, David Schwarz, and Richard Royal in the hot shop, and Fred Munro in the flat shop. For the first time a photographer, Ed Claycomb, joined the full-time summer staff.

In spite of the impressive program and the number of sessions, however, Pilchuck failed to attract as many students in 1980 as it had in 1979. Fees ranged from $430 for a two-week session in flat glass and a bunk in a forestry tent, to $885 for a three-week session in the hot shop with accommodations in a new student cottage. Tuition for the September workshop ranged from $800 to $1,100. "In 1979, Pilchuck had its largest attendance and greatest interest ever," trustee Robert Seidl later reported. "It was so encouraging to everyone that Pilchuck took a quantum leap and extended its 1980 summer program from ten weeks to seventeen. . . . [But] it was not a success financially or in terms of attendance."[7] The failure to meet the optimistic enrollment projections for 1980 created a large deficit.

To increase revenue, the board proposed that Dale Chihuly and other artists working at Pilchuck in the off-season be charged $800 a day. Such use of the facilities had become critical for faculty and staff who were prevented in the summer from making their own work by overcrowded shops, but previously artists had paid only for propane, electricity, materials, and other utilities. When Thomas Bosworth brought up off-season use at a staff meeting, he set off a spirited controversy.

Chihuly responded to the board with a proposal justifying the continuation of staff privileges. "The entire staff at Pilchuck (with the exception of some of the cooks) are young aspiring glass artists, some of whom have already made a name for themselves in the art world," wrote Chihuly. "In most cases they receive salaries that are far below minimum wage standards but obviously they are not working at Pilchuck for the salary. . . . There is no way we can function without this team of skilled individuals which has developed over the years. . . . If the Pilchuck philosophy is to continue, it is essential that the facilities (most of which we developed and built ourselves) be made available to me and the staff."[8]

The heated disagreement over off-season use was only one of the conflicts and tensions that had plagued Bosworth's directorship, and in early 1980 he applied for and was awarded a prestigious fellowship at the American Academy in Rome. The timing was appropriate. Bosworth had completed most of the school's buildings, and the school had grown enough to warrant a full-time director. "I was a part-time director," Bosworth remarks, "and the school . . . needed more."

The board immediately set out to find a new administrator. On August 9, 1980, the *Seattle Times* announced: "Alice Rooney, executive director of Allied Arts of Seattle, has been named director of Pilchuck Glass Center. The announcement was made yesterday in the office of John Hauberg, president of the

Each director had his or her own problem to solve, each one had his or her own legacy.

—Italo Scanga

Pilchuck board of directors. 'The school is assessing itself differently,' Hauberg said. 'We have always felt ourselves to be a Northwest school, but now that faculty and students are coming from all over the United States and many other countries, we feel we have transcended that image. We are a national institution. It's time we had a full-time director.'"[9]

Rooney, a pioneer in the field of arts administration, was a respected professional with experience in board development and fundraising. Under Rooney, Allied Arts—a broad-based arts advocacy organization—had assumed an active leadership role in King County and its largest municipality, the city of Seattle. Rooney recalls how she learned of the position at Pilchuck: "I got a call from John Hauberg's secretary saying Mr. Hauberg and Mr. Bosworth would like to talk to me. I honestly thought they [wanted] to talk about the National Endowment for the Arts because ever since I had come back from Washington . . . where I did contract work for the NEA . . . all kinds of people

called me . . . who wanted to get grants, especially in the visual arts. I just assumed they wanted to talk about Pilchuck."[10]

That same afternoon, June 30, 1980, Rooney met with Hauberg, Thomas and Elaine Bosworth, and trustee Johanne Hewitt. When they offered her the position as director of the school, "all I could think of was this astrologer!" laughs Rooney. She recently had been a finalist for a post at the Washington State Arts Commission but had lost it. She was rethinking her priorities and, on a whim, consulted an astrologer. "The first thing he said to me was, 'I see you're going to be offered a job on June 28, 29, or 30,'" recalls Rooney. "And I said I was just turned down for a job. And he said, 'Well, maybe the person who got it will change his or her mind.' And I said, 'I don't think so.' But the astrologer said, 'Nevertheless, I see that you're going to be offered a job.'"

The board simultaneously had started to recruit new members. "One of the many 'best kept secrets' of our Puget Sound region is the Pilchuck School," wrote John Hauberg in a solicitation letter in May 1980. "Founded in 1971 as an experiment in creative personal lifestyles with a community goal of concentration on glassblowing, Pilchuck has evolved into the preeminent experience in the glass arts in the Western world. . . . Our board of trustees desires to extend its membership to men and women who are interested in and can help us achieve [our] . . . exciting new goals. We need to let our secret out."[11] If Pilchuck was to become an independent institution, the board could no

> I'm pleased to be considered a good fundraiser, but there were many things that I did that were not just fundraising. Managing growth, for example, was very challenging.
>
> —Alice Rooney

John Hauberg and Alice Rooney, 1981.

longer be what it was: a small circle consisting of John Hauberg and his friends. Robert Seidl came onto the board in the summer of 1980 along with Thomas Bosworth. "John Hauberg took me to a very nice lunch," remembers Seidl, "and he said, 'I want to tell you about Pilchuck. You might think it's a lot of hippies running around in the woods, but . . . we're quite organized. I think you would be a useful trustee.'"[12]

The board found that one of the best ways to bring new people into the Pilchuck community was through the recently created auction. At Johanne Hewitt's suggestion and with LaMar Harrington's help, the

second auction, on September 24, 1980, was moved from Stanwood to the Henry Art Gallery of the University of Washington, and it netted nearly $16,000. "I remember that particular auction," says current trustee Susan Brotman. "It was all so new. People were buying things . . . like a nest of [Chihuly's] for $1,200 . . . or maybe a Sonja Blomdahl for $75 . . . and feeling lucky that they were able to. . . . It was at a time when [my husband] and I were trying to buy paintings and we couldn't agree on anything. But it was easy to agree on glass and it was so affordable. . . . It was an interesting and fun way to start a collection."[13]

Other collectors who got their start at the Henry Gallery auction were Jack and Rebecca Benaroya. "They asked me which piece they should buy," recalls Sam Rubinstein.

> In the early days when we would go [to Pilchuck], we got lost there. We got lost in that wonderful world of art and glass and people—you didn't know there was another world around you.
>
> —George Saxe

"So I pointed out a small Chihuly bowl, and they bought it. Now they have one of the top glass collections in Seattle." "We didn't know anything about Pilchuck," remembers Jack Benaroya. "When we arrived [at the auction] . . . we saw an array of glass but we didn't know any of the artists, nor did we know very much about studio glass even though we had been collecting Steuben since the 1940s. I then sought out Sam Rubinstein . . . and asked him to single out the best piece in the show. . . . When it came up for auction I bought it: it was a Chihuly set and that's how we started."[14]

In 1981 Rebecca Benaroya joined the Pilchuck board, along with George and Mary Davis, LaMar Harrington, C. David Hughbanks, and George and Dorothy Saxe of San Francisco, Pilchuck's first out-of-town trustees, who had begun to assemble their well-known collection of studio glass in 1980. "The Saxes were great proponents of nationalizing and internationalizing Pilchuck," noted trustee Robert Block.[15] Since the glass community was relatively small, the Saxes had become familiar with the studio movement and had met some of the artists by the time they joined the Pilchuck board. The real difficulty for them—as for others at that time—was meeting other collectors. "It was very hard to find people who were interested in glass," recalls Dorothy Saxe. "And it was hard to find publications. We tried to get exhibition catalogues. But there really weren't many books. There was *Craft Horizons* but . . . little else. So we were self-taught. And I know the first time we found collectors it was pretty exciting . . . to be able to go to someone else's house and to see glass and to share our common interests."

When Alice Rooney first came to Pilchuck, she followed what had been the school's usual practice to cover any deficit: she sent John Hauberg a statement, for a $6,000 shortfall, at the end of 1980. But this time instead of paying it, he sent it back. "John Hauberg had announced to the board before I was hired that they had to step in and raise money," says Rooney. "He could no longer be counted on to write a check every time there was a need." In 1976 the school's projected annual budget was $75,000. By 1980, with the expanded programs, it had grown to $225,000 and outgoing director Thomas Bosworth had projected a $250,000 budget for 1981. "The first year I was there,

two people had given a grand total of $1,500," recalls Rooney. "Those were the only two contributors other than John Hauberg." New trustee George Davis, with his aptitude for fundraising, was put in charge of finance. Nathaniel Page, John Hauberg's son-in-law, who joined the board in 1984, recalls: "Not only did the board have to find a way to make up for [Hauberg's decrease of funding] . . . but the school was growing; they had to find even more funding."[16]

"Our job was to expand Alice's ability to raise money," says C. David Hughbanks. "Alice took [Pilchuck] from being privately funded by John Hauberg to [being publicly funded] by recruiting board members who were in the business community and . . . in civic leadership."[17] In addition to managing growth, attaining financial stability for Pilchuck through the development of a broader base of support would be Rooney's most important legacy to the school.

Things really didn't take off until the 1980s, for any of us. . . . It took those first seven, eight, nine years at Pilchuck for all the young people to go out and start their careers, to mature.

—Rob Adamson

By 1981 Dale Chihuly had resigned as head of the sculpture department at the Rhode Island School of Design to devote more time to his own work, staying on in Providence only as an artist-in-residence. "In 1980, my sales from exhibitions equaled my salary, which at the time was $18,000," recalls Chihuly. "And I quit teaching the year that my sales matched my salary."[18] Meanwhile, glass artists had started moving to Seattle, as Chihuly himself would soon do. "Dozens of glass artists of all ages . . . have been drawn to the Seattle area from around the United States," wrote LaMar Harrington in *Northwest Arts*. "This influx is largely due to the development of Pilchuck School . . . and more recently to the opening of the Pratt Fine Arts Center in Seattle."[19]

Norman Courtney recently had started the glass program at the Pratt Fine Arts Center, and the center's first glass studio coordinator was fellow Pilchuck alumnus Therman Statom. "Therman Statom is . . . one reason that the center of innovative activity in glass has currently shifted to Seattle," wrote critic Matthew Kangas in 1981. "His presence at the new city-owned Pratt Fine Arts Center is exerting a magnetic force on other artists."[20] Even more influential than Pratt, however, was Rob Adamson's studio, the Glass Eye, where many glassblowers found much-needed work and the opportunity to practice their craft. "I saw the Glass Eye as a stepping stone for young people learning how to work in glass and building their own studios," says Adamson. "Pilchuck's influence in bringing a lot of artists to the Northwest was a key factor [in our success]."

In April 1981 the Glass Art Society held its annual conference, celebrating the society's tenth anniversary, in Seattle. Cosponsored by the Pratt Fine Arts Center, the conference occasioned the recognition of the period from April 6 to 13 as Glass Art Week in Seattle. "According to Mayor Charles Royer, during the coming week Seattle's main claim to fame will be as a center for glass art," wrote art critic Regina Hackett for the

Seattle Post-Intelligencer. "During Glass Art Week in Seattle, three hundred to four hundred glass artists from around the world will converge on the city."[21] In addition to the conference, which featured Stanislav Libenský and Italo Scanga as keynote speakers, special exhibitions and performances were held. At Seattle Center, where the conference took place, an exhibition of fifteen "Seattle Glass Artists" appeared in the Northwest Craft Center and Gallery; Foster/White Gallery featured work by Klaus Moje and Howard Ben Tré; and Traver/Sutton Gallery showed a major exhibition of nontraditional glass by Richard Cohen, Therman Statom, and Susan Stinsmuehlen-Amend, in addition to wood sculpture by Italo Scanga and a small window installation by Richard Posner. Toots Zynsky and Buster Simpson revived the early days at Pilchuck through their public "kinetic and sound performance using molten and sheet glass," while Statom and Posner closed the conference with a demonstration involving molten glass, ceramics, video, and sound media.

Pilchuck held an open house for the Glass Art Society members, featuring William Morris in the hot shop. "Persuading them to get back on the buses at 1:00 p.m. took some time since most of them apparently did not want to leave," reported Alice Rooney to the board. "All of us spent . . . time giving information to prospective students. Since so many of the classes were filled, many of the artists were disappointed."[22]

For the 1981 season, Rooney implemented only a few changes, such as pruning the school's mailing list and acquiring a nonprofit, bulk mail permit. But mostly she observed. "Right at the start," declares Benjamin Moore, "Alice sat down with John Reed and me and said, 'For this first summer, I just want to sit back and watch and see how you two operate . . . and obviously I am going to jump in when I have questions but it is pretty much your ballgame. You take the ball and run.'"

Pilchuck, by 1981, was pretty well known. Any glass school in the country, any student, virtually, that had been in a glass program for over a year, knew about Pilchuck.

—Pike Powers

The 1981 program was fully subscribed, with a long waiting list for Klaus Moje's class in slumping and fusing. The board had agreed to a cap of eighty-five people on campus, and sessions were limited to forty-two students. Students and faculty, by 1981, were undeniably international, coming from throughout the United States and Canada, Europe, Japan, and Africa. "Everything is geared toward quality of teaching and art," Alice Rooney told the *Skagit Valley Herald*. "Glass art is the hottest thing in the glass world."[23]

Summer 1981 consisted of four sessions, each divided into hot glass, stained glass, and a special class, and running for either two or three weeks. Pilchuck staff members Alice Rooney, director; assistant director John Reed; faculty coordinator Dale Chihuly; education coordinator Benjamin Moore; and administrative assistant Carolyn Silk were listed in the school's brochure along with—for the first time—the board of trustees and individual and corporate donors.

Mary Cozad, a childhood friend of John Hauberg's, had been around Pilchuck since the early 1970s and had taken classes in 1979 and 1980 with Patrick Reyntiens and

Ludwig Schaffrath. "After that, I thought I couldn't bear not to go up to Pilchuck again!" recalls Cozad. "And so I wrote . . . and said, 'Could I come and run the library?'"[24] A recently retired teacher, Cozad organized the library, created archives for the school, and acted as a reference librarian. She devoted her summers to Pilchuck for nine years, receiving as payment only her room and board. "It was just absolutely marvelous because . . . everybody who was there had a dream. It was that kind of a place. You don't run into this ever in your life unless you're very lucky. . . . I always compared it in my mind to Black Mountain College."

Session I had James Carpenter teaching in the hot shop and Albinas Elskus in the flat shop. Harvey Littleton was the session's artist-in-residence, and distinguished Swedish designer Erik Hoglund taught the special class, "Art, Architectural Commissions, and the Artist's Role in Industry." Joey Kirkpatrick and Flora Mace taught glassblowing in the hot shop during Session II. "We were the first women to teach glassblowing at Pilchuck," says Mace. "And we taught a class that was the first—as [Chihuly] puts it—'educational' class. We went right back to the basics. We set up a drawing class, we set up a problem class. They had to blow in their classes, but they had to do other projects that didn't have glass in them. We felt that you couldn't always execute your ideas in the hot shop. . . . If we found that [students'] ideas needed to be painted or lampworked, then we would run to the other classes." Mace and Kirkpatrick were the first faculty to require students to come to class and to curtail blowing hours. "And I ran into some real problems at first," Mace recalls. "At the end-of-session debriefing there was a review of the teaching philosophy. The concept had always been that students learned by observing faculty making work, with some instruction, but the focus [was not] on developing the student."

Albinas Elskus teaching in the flat shop, 1981.

Narcissus Quagliata focused on the development of artistic courage for his Session II stained-glass program. "Students come with the idea that they are going to stay the same," explains Quagliata. "And that is where the problem starts. . . . They have to change. What I require of my students is that they expand their understanding . . . of the whole subject. They can't be hobbyists and then become artists without going through a quantitative change. And when that begins to dawn on them . . . they begin to panic. Some of them begin to wonder how they got themselves into this."[25] Quagliata also coached his students about practical matters, such as how they might actually make a living as artists. "There's a conspiracy . . . of silence on the side of [university and art school] . . . faculty

Narcissus Quagliata (right) and assistant in the flat shop, working on a portrait of John Hauberg, 1984.

about how things really work. . . . Questions of high art and aesthetics and the meaning of life are hotly debated, but the issue of what you are going to do when you get out of school . . . was never once discussed. . . . The result has been that . . . about one out of ten people still make art after ten years."

Erwin Eisch returned to Pilchuck for the first time since 1972 to teach drawing for the Session II special class; Dale Chihuly was artist-in-residence. Flo Perkins, who had come to the school as a student in 1974, was a teaching assistant. Faculty for Sessions III and IV included Dan Dailey in the hot shop, followed by Bertil Vallien, and German stained-glass artist Johannes Schreiter in the flat shop, followed by Paul Marioni. Klaus Moje taught a special class in slumping, fusing, and mold making during the third session; Ulrica Hydman-Vallien offered glass painting in the fourth session. Artists-in-residence during Sessions III and IV were Italo Scanga, followed by Dale Chihuly and Susan Stinsmuehlen-Amend. Visiting artists that summer included Thomas Buechner, Marvin Lipofsky, Therman Statom, William Warmus, and Dick Weiss.

Bertil Vallien chose not to focus on the hot shop or fire for his end-of-session theater in 1981. "I said, 'Let's meet at midnight at Inspiration Point,'" recalls Vallien. "It was a wonderful night . . . warm. There were stars outside. And up there we started a theater that I will never forget. I experienced this energy. . . . People spoke and came up with dances. It was totally crazy! [At the end] people just fell and slept in the grass."

Many glassblowers were hoping that Vallien might, in fact, burn the hot shop down. The new continuous-melt furnaces were working, but the glory holes were not. John Reed was reluctant to make major design changes, since the school had just paid to construct the furnaces, but stopgap measures could not make them burn hot enough.[26] One day Jon Ormbrek, William Morris's assistant, swept into the shop and took matters into his own hands. "I remember Jon Ormbrek went in with a sledgehammer and blew the roof off the glory hole," says Flora Mace. "Within twenty-four hours, we had a round glory hole, and it worked."[27] "Jon built the first equipment at Pilchuck that really worked," remarks William Morris. "He had the gift to make it functional. We [artists] didn't care about the equipment, except for getting our work done." Over the years, Jon Ormbrek's skills have been invaluable to Pilchuck. Since his success with the glory holes, Ormbrek has developed and invented equipment for the Pilchuck hot shop that has been reproduced in glassblowing studios all over the world.

In 1981 John Hauberg and the board still questioned the long-term feasibility of Pilchuck as a single-medium school. "My thought is to authorize Alice [Rooney] and others to begin at once a study of alternatives that perhaps may never be used if our uniqueness as a glass school can be maintained," wrote Hauberg. "If we prepare for the worst, perhaps the best will happen."[29] Although the third fundraising auction—a gala dinner held at the Weyerhaeuser Company's new corporate headquarters south of Seattle—had netted $35,000, the school was struggling to achieve financial independence. Hauberg reintroduced the idea that another art medium be added to the curriculum, perhaps to take place after the glass program. Dale Chihuly and Benjamin Moore proposed bringing in master blowers to create pieces that Pilchuck could sell. Others suggested a line of limited edition glass by Pilchuck artists but hesitated to engage in a commercial venture. Alice Rooney looked into renting the Pilchuck campus off-season for retreats and conferences, adding sessions, and offering other media before or after the glass program.[30]

Trustee Robert Block suggested that a new donor category be created: a membership organization called the Pilchuck Society, which would serve as a "means of building up repeatable financial support."[31] This society of international donors, by 1995, would claim about nine hundred members. Each year the board would look for new ways to raise money for the school, and, through this process, would continue to define and restate the school's mission and philosophy.

Other board issues for 1981 centered on scholarships, which Pilchuck thus far had offered only in the form of work-study positions. "John Hauberg was not very happy with the idea of scholarships," recalls Alice Rooney. "He thought . . . money was needed for operating expenses. But you need those scholarships to get the right kind of students. And I always worried about pricing the really good students and artists out of the market." While the Pilchuck board discussed how it would fund scholarships, trustees George and Dorothy Saxe chose to foster young talent on their own through the establishment, in 1981, of the George and Dorothy Saxe Emerging Artist Award for the summer's most outstanding teaching assistant.

When Thomas Bosworth returned from Rome in the fall of 1981, he found, much to his disappointment, that some new buildings had appeared on campus. "Two cottages had been built up the hill, for staff accommodations," recalls Bosworth. "They were designed and built by itinerant carpenters . . . and to my eye they were inferior, an intrusion on the landscape." In the meantime, Rooney—who was crammed into the tiny office next to the hot shop with her assistant, Carolyn Silk—had asked John Hauberg for new office space.

The gallery/office, completed in 1982.

Below, left: The cabin built by Bruce Chao in 1973, remodeled and expanded by Rob Adamson and Benjamin Moore in the early 1980s.

Below, right: The stump house built by Guy Chambers in 1972, rebuilt by William Morris in the early 1980s.

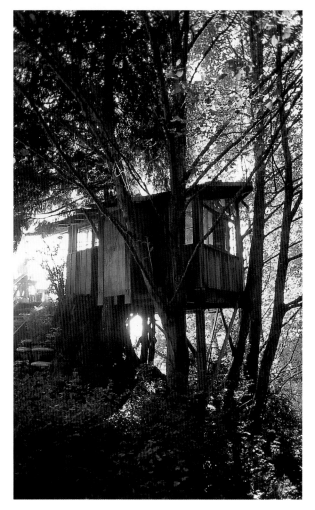

"John wanted to build a store and an office for Alice," says Bosworth, "so we got to work on that." The building, completed in 1982, was the subject of some controversy. "There was some chafing between Dale and me over this project," notes Bosworth. "Dale didn't want a store." The store was eventually designated as a gallery, says Bosworth, but "it wasn't really designed to be a gallery and it's the wrong shape for a gallery. . . . But the building had already been designed and half-built."

In the meantime, artists were remodeling many of the early hand-built structures. William Morris had completely torn down and rebuilt Guy Chambers's stump house, and as a surprise for Morris's birthday, Olwyn Rutter and Robbie Miller had installed new leaded windows. An addition with windows by Dick Weiss was built onto Dale Chihuly's cabin, which now had running water and battery-powered lights, and Benjamin Moore had attached a large deck to the old Bruce Chao/Rob Adamson place.[33] Richard Royal lived in the Carpenter/Vaessen house, which had seriously deteriorated. Buster Simpson's place and Richard Posner's "corner" house remained intact. Although Bosworth had advised Rooney not to allow any new building, when Carolyn Silk asked if she

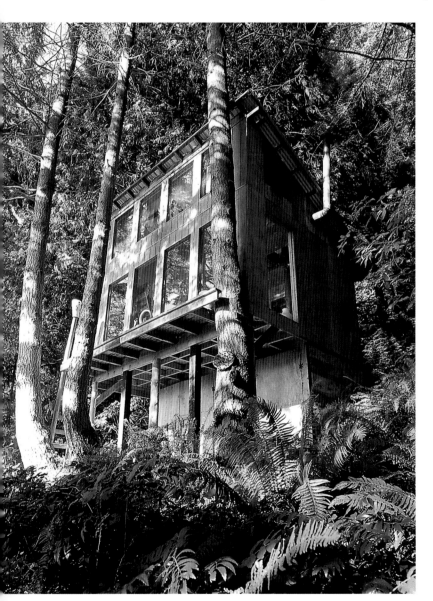

The house built in 1981 by Joey Kirkpatrick and Flora Mace.

could build a house, Rooney agreed. Silk built a "cliff house," as William Morris describes it, in the woods overlooking a large ravine. "Most of the wood came from a house that was being torn down . . . on Capitol Hill [in Seattle]," remembers John Reed. "She dragged all the wood down there and built the thing herself . . . with very little help."

At about this time, says Flora Mace, "Joey [Kirkpatrick] and I decided that the total Pilchuck experience was to build a house. [But] . . . Tom Bosworth said, 'No more funky houses. None.' Well, after a summer at Pilchuck and hearing about the history of Pilchuck, you want that experience." Mace and Kirkpatrick approached Alice Rooney and John Hauberg about building a house in the winter of 1981 and, to their delight, both agreed. "There were some stipulations," remembers Kirkpatrick. "We had to walk around with John Reed and find someplace that nobody could see, that was on school property," adds Mace. "[They said something like] . . . 'Don't blame us if anything happens to you, we are not going to give you one dime for materials, and if you do build something

that amounts to anything, then we get to keep it.' And so we picked out a place." "Flora and I went back to Pilchuck early in the spring . . . and started to build about fourteen days before we had to teach a session," continues Kirkpatrick. "We built the house with one hand saw and a bale of string. We made our own ladder. We made everything. . . . It's still standing and we built it for, I think, $2,500, which was our life savings at the time."

Mace and Kirkpatrick lived year-round in their house for four years, with only cold running water and a small stove for heat. "I'll never forget when we were ready to show it," says Kirkpatrick. "Here comes John Hauberg with six people behind him, like ducks on the water. . . . I was so nervous because I was afraid if we got too many people in the house, it would fall down the hill! And I already could see the headlines: John Hauberg Killed by Artists' House."

Mace and Kirkpatrick were the last artists to build a house at the school. Although John Hauberg was impressed by what they had accomplished, increasing legal and liability constraints became a factor, as did compliance with Skagit County building codes, which were becoming more complicated year by year.

I think Pilchuck's success will continue as long as it is possible to find artists who look at the contradiction—to teach something that cannot be taught—as a challenge.
—Jochem Poensgen[34]

Pilchuck's 1982 program was similar in concept to that of 1981, but gradually the summer sessions were becoming more complex with increasing numbers of faculty and programs. Although the number of people on campus at any one time was set at a maximum of eighty-five, this figure would soon be raised—for the final time—to a cap of one hundred. Divided into four sessions of two and three weeks' duration, 1982 featured a "middle session" at the end of July, reserved for a "fundraising event, tours of the school, and a four-day collectors' conference," the school's first extracurricular program offered to the public. Fees ranged from $570 for two weeks to $1,395 for three weeks, depending on the facilities being used. For the first time college credit was advertised in the Pilchuck brochure, which advised undergraduates and graduates to arrange for credits with their home universities. Students also could, for an additional fee, obtain credit through the Cornish College of the Arts in Seattle.

Bertil Vallien came back to the hot shop for Session I, teaching sand techniques, with an equally preeminent German stained-glass artist, Jochem Poensgen, taking charge of the flat shop. Starting in 1982, two special classes were offered each session, and the first had Michael Glancy, known for his electroplated and deeply carved vessels, teaching sandblasting and sand carving—in contrast to Vallien's "hot" sand techniques—while Richard Harned led outdoor installations and site-related sculpture. Artists-in-residence were James Harmon and collaborators Susie Krasnican and Margie Jervis, former students known for their enameled and sandblasted constructed cast-glass forms.

Joey Kirkpatrick and Flora Mace were back in the hot shop for the second session, with Albinas Elskus returning to the flat shop. Klaus Moje taught special classes in slumping and fusing, and Barbara Vaessen, a Pilchuck pioneer who had not returned to the school for several years, demonstrated multi-laminations. "I remember being sad when I came back," says Vaessen. "Sad and happy. . . . I went up to my house and my

Jochem Poensgen, 1982.

house was still there, but sort of sagging. . . . I was happy to see this place that we had started. . . . But suddenly all these toilets and showers and, you know, that kind of thing—the beautiful living with your own things was gone."[35]

Session II visiting artists were Dick Weiss and Dale Chihuly. In 1980 Chihuly had begun his signature *Seaforms* series. These fluid vessels, recalling marine life-forms, are heat and gravity shaped, sometimes nested, and primarily in subdued, pastel colors. Now the artist chose to experiment with a palette of bright colors for a new series that Italo Scanga would name *macchia,* an Italian word meaning "spotted" or "splotched." "I woke up one day and said, 'I'm going to make a series where I use all three hundred colors of the [Kugler] rods,'" recalls Chihuly. "I had never used most of them because the series that preceded this—the *Baskets* and *Seaforms*— were subtle for the most part."[36] "This session was when Dale first started doing the *macchias,*" remembers Robert Carlson. "And they were the biggest things anybody was blowing at the time. . . . [They were] monstrously huge."[37]

Trustee Susan Brotman remembers first coming to the school about this time: "The first time [my husband] Jeff and I were up there . . . the entire lawn was filled with Dale's *macchias* catching rain. It was gorgeous. I'll never forget what that looked like. And in the hot shop were Dale and Billy [Morris] and Rich [Royal] and some other guys, too. Those were the days they were wearing their undershirts, the tank shirts, with a cigarette hanging out of their mouths, and drinking Jim Beam. And the music was blaring! It was wild! It was a very sensual experience."

The power of the Pilchuck culture was driven by the number of artists that congregated there. "If you consider the faculty, the artists-in-residence, and the staff," remarks Alice Rooney, "you actually have a one-to-one teacher/student ratio. If you talk to the maintenance man or the cook, you are really talking to an artist."[38] Pilchuck's full-time staff in 1982 consisted of Rooney, John Reed, Dale Chihuly, and education coordinator Benjamin Moore, in addition to Susan Singleton, administrative assistant, and bookkeeper Dorit Brand. Summer staff added thirty teaching assistants as well as gaffers (master blowers) William Morris for Sessions II and III, and Michael Scheiner for Sessions I and IV.[39] Other glass shop staff included "techs" Jenny Langston, Richard Royal, and David Schwarz in the hot shop, and flat glass coordinators Sheryl Cotleur and Pat Patenaude.

Dale Chihuly shapes a
macchia with William
Morris's assistance,
1983.

Macchias by Dale
Chihuly on the lawn at
Pilchuck, 1983.

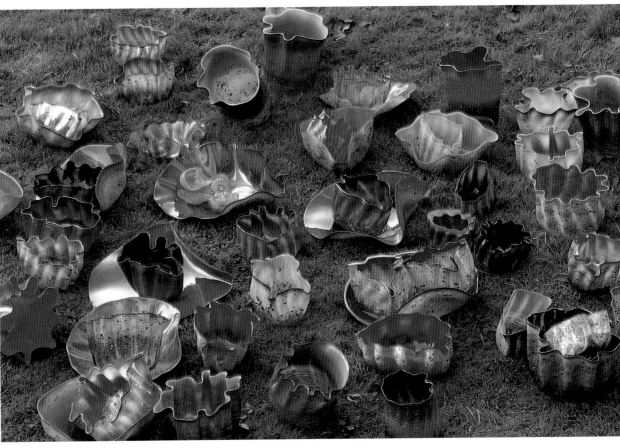

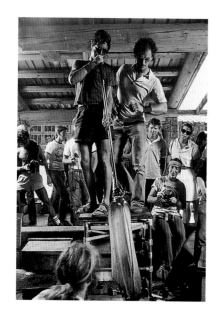

William Morris (left) and Robert Carlson working on a *Standing Stone* sculpture, 1983.

"During the summer . . . we would look forward to certain people . . . [for variation]," recalls maintenance person Connie Dahl, who married Charles Parriott that year in the first artists' wedding held at Pilchuck. "There would be sessions that would have all the same plateau of energy, and there would be, all of a sudden, someone who was doing something great."[40]

Between the second and third 1982 sessions, LaMar Harrington organized a collectors' seminar. It drew nearly sixty people—artists, collectors, museum curators, critics, and gallery owners—to discuss the hows of collecting. For this group, the whys were self-evident. "Glass has fast become the hottest new field for art collectors," wrote art critic Deloris Tarzan in the *Seattle Times*. "Whatever his aim, a collector buying the work of a living artist is influencing the market and the art form itself."[41] Seminar topics included the relationships between collector, art dealer, and artist; the roles of collectors and dealers in collecting; the pricing of glass; and connoisseurship. Artists made individual presentations. "For [collectors] . . . to see the artists at work was really exciting and stimulating," Alice Rooney told *Glass Studio* magazine. "Just being at Pilchuck was a great experience for them."[42]

Session III began the morning after the seminar. In the hot shop was Finn Lynggaard, a professor of glass and ceramics from the Royal Academy of Fine Arts and the School of Arts and Crafts in Copenhagen, and in the flat shop, Susan Stinsmuehlen-Amend.

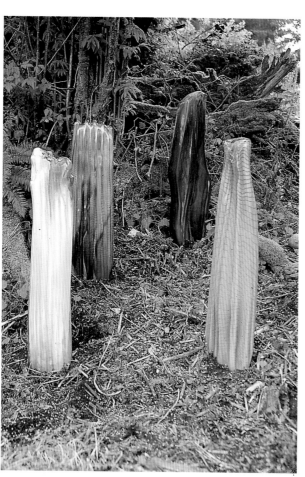

Standing Stone glass sculptures, by William Morris, in the Pilchuck forest, 1983.

"The selection of faculty that session was . . . perfect," says 1982 teaching assistant Mark McDonnell. "Finn . . . was the consummate European craftsman . . . [and] Susan Stinsmuehlen [brought] . . . a whole other attitude in flat glass . . . loosening people up so they were not so rigid."

Special classes in Session III featured Henry Halem teaching a class combining *pâte de verre* (literally, "glass paste") and lost wax casting, and designing and executing autonomous, or nonarchitectural panels. Carl Powell taught glass beveling, sculpting, and engraving. Artists-in-residence were Thomas Buechner, who

would draw and lecture, and Stanislav Libenský and Jaroslava Brychtová, artists from Czechoslovakia who would work in the United States for the first time.

"Though Libenský . . . knew almost no English, this seemed to pose few problems for him," wrote John Robinson in a 1983 article on Pilchuck for *Pacific Northwest* magazine. "The idiom of glass is as international as that of nuclear physics, and Libenský supplemented it by an extensive use of body language, friendly pats, and the kind of irresistible joie de vivre that can be found in a man who knows what he is doing in

Someone once said, "Science is a ladder which you can climb rung by rung, but art has wings."

—Stanislav Libenský [43]

life, is successful at it, and glories in it."[44] "Their presence," wrote Alice Rooney, "has always brought an intensified spirit of art and wisdom and humanness."[45]

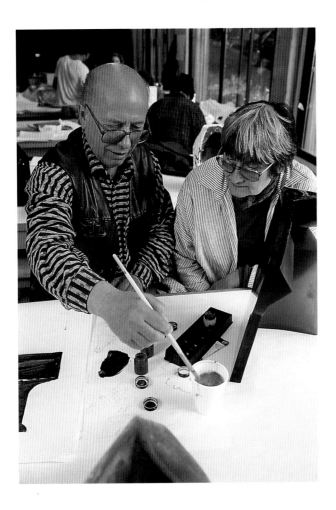

Stanislav Libenský and Jaroslava Brychtová at Pilchuck, 1987.

"They are the masters of casting," adds Paul Marioni. "As far as I am concerned, they are the top of the pyramid." Unlike Bertil Vallien, who cast in sand by ladling hot glass from the furnace into prepared sand beds, the Libenskýs cast in kilns, using plaster forms to hold chunks of glass that slowly melt and fuse, filling the mold.[46]

The Libenskýs brought to Pilchuck a much-needed intellectual, theoretical, and philosophical focus to making art with glass. With Libenský's classical training in drawing and painting, Brychtová's background in sculpture, and their common interest in theory, they inspired students to expand beyond the medium to achieve their best work in it. As artists, their understanding of cubism and mysticism found form in light-filled sculptures. "The transparency of glass is the basis of the notion of the fourth dimension," states Brychtová. "For us, glass is light," adds Libenský. "[We] . . . introduce the light dynamic into the center of the glass mass." "When Stanislav and I are working in glass," continues Brychtová, "for me, the drawing expresses everything. . . . The shapes have to be abstracted . . . [from the drawing]. That's why the drawing is so important for the understanding of the piece."[47]

The third session at Pilchuck ended with a spectacular natural phenomenon particularly appropriate to the presence of the Libenskýs: the appearance of the northern lights, or aurora borealis. "There were some incredible auroras in the early 1980s," recalls John Reed. "There was one like strobes; it emptied the hot shop. Everyone went out in the meadow . . . [to watch]." Instructor Finn Lynggaard recalled the drama of the aurora borealis:

Jaroslava Brychtová (Czech, b. 1924) and Stanislav Libenský (Czech, b. 1921), *The Prism in the Spheric Space #56220*, 1978. Glass cast in three parts, cut, polished, diam. 12 in. Corning Museum of Glass, Corning, New York.

The place: Pilchuck hot shop. The time: August 12, 1982, 2:30 a.m. There is this tense but good atmosphere which comes only when the world outside the shop is totally silent and everybody but the crew is asleep. All of a sudden, a student comes running into the shop and announces, "We have an aurora!" Everybody rushes out. . . . A fantastic light show is going on all over the night-dark sky. Flashes and bolts of light are traveling across the sky from horizon to horizon, a wild circus with light moving so fast that you do not actually see it but only sense the images it leaves in your mind. For about a quarter of an hour we are spectators to an incredible light show a million times more powerful than lasers at any rock concert. . . . I believe that the effect of Pilchuck can be as powerful and impressive. When you leave Pilchuck, you leave with an indelible impression. You know that you will never be the same person again, having seen the aurora at Pilchuck.[48]

Session IV brought together many artists long familiar to Pilchuck. Dan Dailey taught glassblowing in the hot shop, and Ray King, who specialized in large-scale constructions, took over the flat shop. Ulrica Hydman-Vallien and Linda MacNeil, known for her work in glass and precious metals, taught special classes. Pilchuck pioneers Fritz Dreisbach and Toots Zynsky were artists-in-residence.

Each person on the board is an interesting and effective and successful person in his or her own right. And they really work.
—Phillip Jacobson[49]

In January of 1983 John Hauberg made some notes on the direction of the school:

Pilchuck is entirely different today from 1971–72. Then it was spontaneous, unstructured. Also a mess of garbage and trash; achievement, if any, was hard to appraise. No buildings except a latrine. Tents for cooking, eating, and meeting—and a tent over the furnace and the oven. . . . We could not go back to that . . . [but] . . . must we grow, improve, change? Can we merely refine . . . ? At the moment, my personal feeling is that the development of full scholarships . . . would do more for Pilchuck than anything else. . . . Three to five students/artists of outstanding talent each session would make Pilchuck's summer very exciting all the time.[50]

By December 1982 the scholarship committee, founded and chaired by Patricia Baillargeon, had met to establish criteria for candidates and formulate a solicitation process. Six scholarships had been promised by participants in the collectors' seminar in addition to the recently instituted Michael and Catherine Brillson scholarship for students

from the University of Illinois or Illinois State, the Elsie and John Burton lampworking scholarship, the Corning Prize, the Sally Kitchell Memorial Fund, and the George and Dorothy Saxe Emerging Artist Award (for teaching assistants). Scholarship money was requested from and awarded by PONCHO. For the 1983 season, Pilchuck was able to offer an impressive $22,500 in full and partial scholarships, up from $6,000 in 1982, and this figure would keep increasing—due to the remarkable dedication of the trustees in finding new funding sources—almost to the point where no really talented student would be turned away.[51] "I think as long as we have those financial needs covered," said trustee Jeffrey Atkin in 1994, "we can attract the kinds of students that will keep Pilchuck as strong as it is today."[52]

The 1983 Pilchuck recruitment poster, dense with words and lists of faculty, trustees, contributors, and procedures for application, admission, and financial assistance,

I wish I could count the number of people who have said, "Pilchuck has changed my life."

—Alice Rooney[53]

mirrors the school's administrative growth, specifically the development of a complex financial support system and a corresponding increase in the number of trustees. The season was divided into four sessions—alternately two and three weeks in length—with programs in hot glass and flat glass, each open to as many as eighteen students, with special classes restricted to three to six students. Instructors were helped by thirty-one teaching assistants. Session I had Pilchuck regulars Flora Mace and Joey Kirkpatrick in the hot shop, and Narcissus

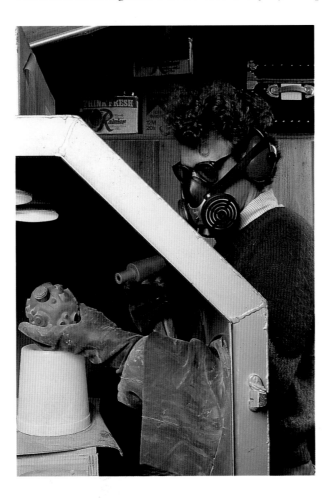

Michael Glancy sand-blasting a sculpture, 1984.

Quagliata in the flat shop. Special classes included cold glass fabrication techniques taught by William Carlson, a student at Pilchuck in 1971 and 1972, and Mary Ann Babula, also a former student. Other special classes included Pilchuck's first course in lampworking (also called flameworking or torch glassblowing), taught by Pavel Molnar, and sandblasting, carving, electroforming, and electroplating, taught by Michael Glancy and Walter Lieberman. Artists-in-residence for the session were Bruce Chao, another early Pilchuck student, who succeeded Dale Chihuly as head of RISD's glass department, and Bertil Vallien.

"Undeniably there is a difference between the Pilchuck of now and the Pilchuck I knew ten years ago," observed Bruce Chao in 1983. "Pilchuck has become more ordinary because it has dorms and lodges. . . . But the sense of informality in the learning and dispensing of information [is] really the difference between now and then." Chao's approach to glass was very much in the spirit of Pilchuck in the early 1970s. "[Chao] . . . didn't pay attention to skill, to craftsmanship," remarks Bertil Vallien. "He really tried to find a use for glass unrelated . . . to objects. He'd blow big bubbles, and fill them with plaster and stones. . . . They were beautiful forms, only touched by human breath, which then would be broken and thrown away."

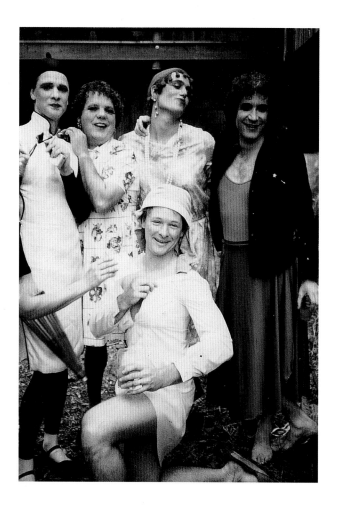

Left to right: Benjamin Moore, Dale Chihuly, William Morris, Narcissus Quagliata, and Stephen Dale Edwards dressed for a Pilchuck costume party, early 1980s.

By 1983 William Morris, Benjamin Moore, Flora Mace, and Joey Kirkpatrick were serving as an informal advisory committee to Chihuly in selecting the school's faculty. "Usually once every fall . . . Billy and Ben and Dale and Flora and I would get together," remembers Kirkpatrick. "And we'd say, 'Who do we want to come teach this year?' It was much more relaxed at that time." Session II had Bertil Vallien in the hot shop. Jochem Poensgen returned to teach an architectural stained-glass workshop in the flat shop, with special classes in glass laminations, offered again by Barbara Vaessen, and sculptural techniques for cold glass, taught by David Huchthausen. Second-session artists-in-residence were Dale Chihuly and Italo Scanga. Chihuly, who had been an artist-in-residence at RISD since his resignation from the sculpture department in 1980, moved to Seattle in 1983, setting up a studio in a building at the south end of Lake Union.[54] The move would be important for Pilchuck since Chihuly generated so much artistic activity, and the glass artists he would attract to Seattle would form a strong community over the coming years.

Bertil Vallien's end-of-session performances continued to captivate faculty, students, and teaching assistants. For the 1983 event "we did a casting," says Vallien. "It was a lot of glass, 200 to 300 pounds. . . . We . . . made a high bed. And then we made an imprint of this Japanese girl . . . a student who was a wonderful poet. We cast her. . . . And some people were starting to build a boat, a raft. . . . The idea was to cast the figure, put the figure in the boat, carry it down to the pond . . . and push the boat out onto the pond, still glowing, and have it burn."

I'll never forget the time Bertil Vallien . . . built this canoe out of glass. . . . It was spectacular.

—Mary Cozad

Pilchuck has been very important to the American glass movement but I think the results of Pilchuck School are more in the minds of people than in the work that has been made here. . . . It is the philosophical part that is Pilchuck's most [important] . . . contribution.

—Bertil Vallien, 1983[55]

"We filled the ship with dried grass to make sure it burned," says Norman Courtney. "It was going to sail out into the pond, burn up, and sink to the bottom." But someone gave the top-heavy boat too hard a push, and it tipped over. "This glowing figure sank to the bottom," relates Vallien. "This was in the middle of the night—it was glowing at the bottom of the lake! A red-hot piece of glass with her arms outstretched. . . . It was so beautiful. The terrible thing is that it cracked into millions of needles."

The third and fourth sessions of 1983 had Richard Meitner in the hot shop, followed by Jon Clark. In the flat shop, Dick Weiss was teaching stained glass in Session III, followed by Susan Stinsmuehlen-Amend teaching "Kool Glass" in Session IV. Special classes for the two sessions were offered by Albinas Elskus and Henry Halem, teaching glass painting and *pâte de verre* casting, and Erwin and Margarete Eisch, teaching glass engraving and glass painting. Artists-in-residence for Session III were Czechs Jaroslava Brychtová, Stanislav Libenský, and Dana Zámečníková, and for Session IV, Thomas Buechner, Paul Marioni, and Lino Tagliapietra.

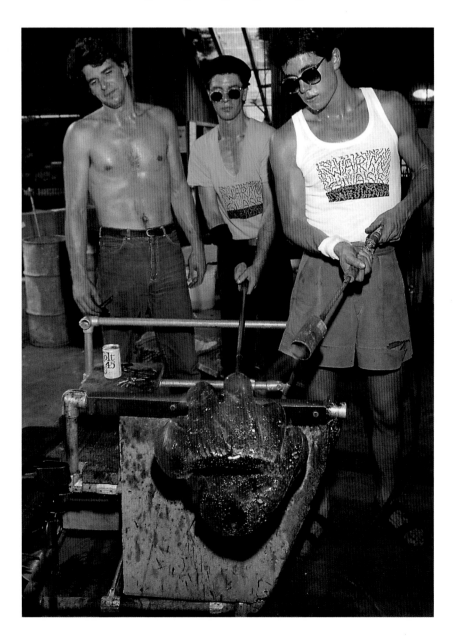

Left to right: Gaffers Richard Royal, Benjamin Moore, and William Morris in the hot shop, 1982.

"The Pilchuck School is a community of just under one hundred (this size determined by the septic drainage system), working within a set of Bunyanesque buildings," wrote art critic Lyn Smallwood for the Seattle *Weekly* in August 1983. "Besides the forty to forty-eight students, there is a staff of twenty-one. . . . Also on hand are three 'gaffers' or masters of the blowpipe, for which it is apparently helpful to be a tall, dark, and exquisitely muscled male."[56] Smallwood mentions an addition to the program that would have a major impact on the school: "Changes are being instituted which may save the school from running in place. . . . [Chihuly has] invited several well-known artists who don't usually

work with glass to next summer's session (people like Scott Burton, Christopher Wilmarth, and Michael Singer). Their presence could restore some of the school's original inventiveness." "I see the place as continuing to change," Chihuly told Smallwood. "That's the only way I know to keep anything healthy."[57]

"Students attending sessions during Pilchuck's fourteenth summer will find some changes in format and some dramatic new directions in the program," states the 1984 poster. "Overriding the entire summer program is concern for experimentation, for developing one's own vocabulary of ideas, for self-expression and design, and for integration of hot glass and cold working techniques and of glass with other media." The 1984 program was expanded from four sessions to five, alternating between two and three weeks in length. Faculty were given thirty-one teaching assistants. The beginning two-week session was the first in Pilchuck's history not to offer a class in glassblowing. Instead Ed Carpenter and Tim O'Neill taught architectural stained glass in the flat shop; Ginny Ruffner offered her revolutionary style of lampworking for the first time; Mary White taught glass painting; and Carl Powell demonstrated beveling, polishing, and engraving.

And so it is that if you are seriously working in glass today, sooner or later you will come to Pilchuck, either as a teacher or as a student, but most likely as both.

—Lutz Haufschild[58]

"Glass really changed again when Ginny came along," declares Flora Mace. "We could torch it!"[59] Ruffner introduced the use of borosilicate glass for lampworking at Pilchuck. Commonly used in the manufacture of scientific glasswares, this harder glass softened at a much higher temperature than soda-lime glass, enabling Ruffner and others to fabricate lampworked pieces on a scale previously unimaginable.

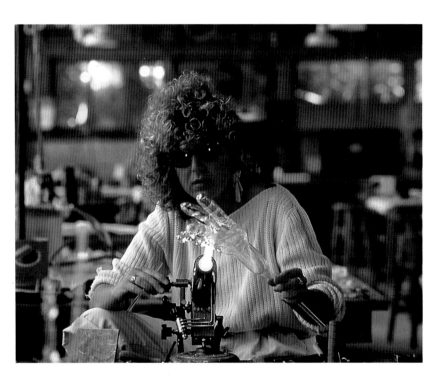

Ginny Ruffner at the torch, 1987.

"I remember a number of artists, including Ginny Ruffner, whose work just left me cold," remarks Matthew Kangas, recalling the early 1980s. "And it may or may not be that they've gotten better, but it may also be that what they were doing was so radical compared to what I was expecting that I couldn't handle it."[60] Anyone coming from a committed craft tradition would not understand what artists like Ginny Ruffner and Susan Stinsmuehlen-Amend were doing. "The first thing I said to my students," recalls Ruffner, "was 'no swans, no ships.' For years I had to really be a bitch about that. I said, 'You make it, I'll break it.'"[61] "And she did, too," adds Flora Mace. "Ginny was

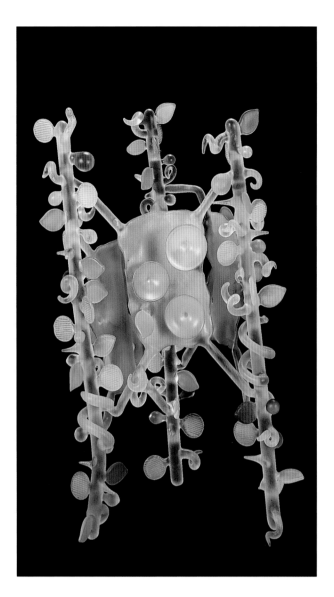

the first lampworker that wouldn't allow any of that. Her students complained so bitterly because that's what they wanted to learn. [Some] students . . . were outraged."[62] Ruffner brought her own burners with her, since her work required a super-hot flame, and the pieces her class made became so big that they took over the kilns in the hot shop to anneal them. If it hadn't been for Ruffner's engaging personality, none of the "blowboys" would have tolerated it.

Artists-in-residence for the first session were Michael Kennedy and Nancy Mee. New York sculptor Christopher Wilmarth was the sole artist-in-residence for the second session. While he did not interact with many people, the artists he did work with in the hot shop—Joey Kirkpatrick, Flora Mace, William Morris, and Richard Royal—were impressed with his intensity. The first "nonglass" artist-in-residence at Pilchuck had been sculptor Italo Scanga, and the second, painter Thomas Buechner, both of whom became very involved with the school. Mee and Wilmarth, sculptors who chose to combine glass with other materials, initiated another phase of the artist residency, which would be expanded by those who had never worked with glass, such as fifth-session artist-in-residence Lynda Benglis.

"I wanted to see whether glass could be tied in a knot," recalls Benglis. "I started doing knots again after having done them in the 1970s. I think I was among the first to handle glass with my hands [by wearing] . . . gloves and by [using] sticks. [The knots] . . . were sand-cast. . . . Usually I needed two or three . . . brave individuals to help me poke and hold up the thing. I thought I was beyond being burned if I was in tune with the elements. So physically I had to be in great shape and mentally in great shape." Thomas Buechner was also an artist-in-residence for the fifth session, following sculptor Michael

There is a certain magic and ritual about it, so that you get transformed beyond your bodily self, and you act with the fire that can destroy you. I think it is the dance . . . the play-dance activity . . . that appealed to me and [that] appeals to everybody working with glass.

—Lynda Benglis[63]

Singer and mixed-media artist John Torreano, who were artists-in-residence for Session IV, and ceramist Jun Kaneko, artist-in-residence for Session III.

Session II brought Marvin Lipofsky and Fritz Dreisbach back to the hot shop, while Katherine Bunnell taught stained glass. Special classes were offered in sandblasting and carving by Michael Glancy, glass painting by Ulrica Hydman-Vallien, and enameling and sandblasting by Margie Jervis and Susie Krasnican.

The return of Pilchuck pioneers continued into the third session with Therman Statom and Richard Marquis in the hot shop, a dynamic pair who promised to impart "various and weird hot-working techniques" in their class entitled "Secrets Revealed."[64] Special classes were offered in the integration of hot and cold working techniques by Rick Bernstein; *pâte de verre,* slumping, and fusing by Toots Zynsky; and fusing and mold making by Klaus Moje.

Toots Zynsky missed the early Pilchuck atmosphere of equality among staff, faculty, and students. "Ulrica Hydman-Vallien and I brought up some points that we thought were negative things, and they . . . got furious at us. . . . If they . . . just want people here saying, 'Everything is wonderful. Thank you for letting me be here,' this place is going to go down in the pond real fast. . . . It's often the people that are challenging something who really love it the most and don't want to see it go wrong."

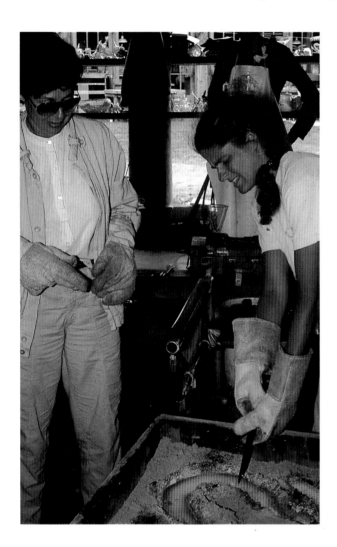

Lynda Benglis (left) and Joey Kirkpatrick making a glass knot, 1984.

With growth, Pilchuck was becoming increasingly inflexible, and Zynsky's sentiments would be echoed ten years later by others who first came to Pilchuck in the early 1980s. But Pilchuck continued to offer a protective environment where creativity and exploration were encouraged. One of Bertil Vallien's projects in 1984 was particularly inspired. Vallien and his cohorts mounded tons of sand into a channel around the hot shop and up onto the hill which they then filled with hot glass. "The guys were filling that [long] channel of glass," recalls Vallien, "and you could see this glowing, sinuous snake. It was so beautiful. And there was a gallery owner there that wanted to buy it, and Therman Statom negotiated a deal. . . . Of course, the piece shattered, and the next day, under Therman's supervision, everything was shoveled into a big container and sent to this person back east! It was crazy of them to think they could buy it!"

Sessions IV and V of summer 1984 brought Dan Dailey to the hot shop, followed by Bertil Vallien.[65] Dick Weiss and Cappy Thompson were visiting artists. Clifford Rainey offered a special class on glass sculpture, and Michael Cohn and Molly Stone

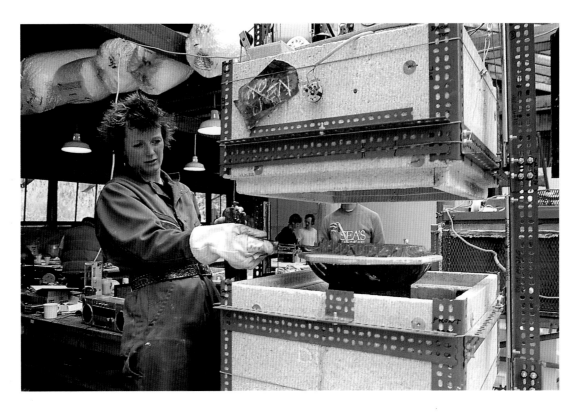

team-taught a survey of cold, warm, and hot glass processes. Paul Marioni taught stained glass for Session V. Narcissus Quagliata and Sheryl Cotleur team-taught advanced stained-glass design, in what was Pilchuck's first flat glass course to be restricted to experienced students. Paul Marioni's son, Dante Marioni, came to Pilchuck as a student in 1984, and he would later become as influen-tial at Pilchuck as his father.

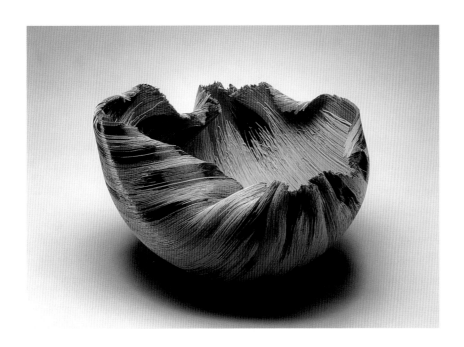

Other special classes in 1984 included drawing and sandblast-ing with Ann Wolff, and drawing, painting, and engraving with Erwin Eisch and his daughter, Kathrina Eisch. Fred Tschida demonstrated neon techniques, returning to teach a course the following year. "There are cer-tainly sessions that are total flops," observes Benjamin Moore. "And then there are sessions that you look at the names and think, 'That's going to be the most high energy, wild class.' . . . I can remember one year when Ann Wolff had an all-woman class. It was just fantastic. It was very spiritual and femi-nine, the total antithesis of macho male glassblowing; [it] was really a thing of beauty."

"Pilchuck was in its best form ever [this year]," wrote Dale Chihuly to John Hauberg in September 1984. "[The] final session was one of the best we've ever had, and then to

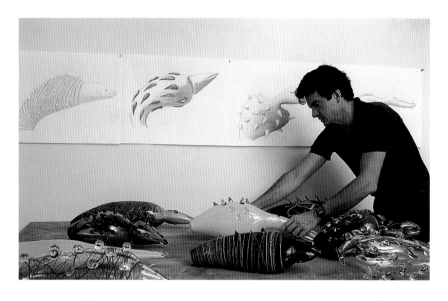

Dan Dailey, 1984.

end it up with the International Council, which everyone felt was so successful."[66] Pilchuck's board members had first discussed the formation of an international council in 1981.[67] Such a council would "promote knowledge of and support of the Pilchuck School," and "identify talented students from [other] countries who would benefit by attendance at Pilchuck."[68] Members would assist Pilchuck trustees and staff in discovering new funding sources to bring those students to Pilchuck.

"The Pilchuck School International Council, made up of a group of internationally known artists, academicians, and museum curators and directors, has been formed," stated a news article in *American Craft* magazine. "It will function in an advisory capacity to the Stanwood, Wash., school on the role of educational institutions in the glass art movement worldwide. Chairman is Thomas S. Buechner, president of the Corning Museum of Glass, New York."[69] Buechner, who was also chairman of Steuben Glass, would attract major names in glass to the new group. Council members in 1984 were Yvonne Brunhammer, curator at the Musée des Arts Decoratifs, Paris; Martin Hunt from the Royal College of Art, London; Itoko Iwata, president of the Iwata Glass Company, Tokyo; Jack Lenor Larsen; Stanislav Libenský; Harvey Littleton; Peter Rath, president of J & L Lobmeyr, Vienna; Helmut Ricke, curator at the Kunstmuseum Düsseldorf; Ludovico Santillana, president of Venini, Venice; Paul J. Smith, director of the American Craft Museum, New York; Jorgen Schou-Christensen, chief curator at the Dansk Kunstindustrimuseum, Copenhagen; Sybren Valkema, founder of the glass program at the Rietveld Academy, Amsterdam; and Bertil Vallien.[70]

The International Council convened at Pilchuck for its first meeting on August 31, 1984, at the end of the school's fifth session. Council members saw the school in session, spoke with faculty and students, and attended critiques before getting to work. European and Japanese members reported on contemporary glass in their countries, in both art and industry, and the possibility of getting glass industries to underwrite scholarships. Paul Smith discussed the state of studio glass in the United States and the strength of the market, while many of the Europeans complained of artistic stagnation and undeveloped markets for glass in their countries. To increase the international profile of Pilchuck's student body and to foster artistic exchange on a worldwide level, the council specifically aimed to identify potential scholarship sources for foreign students.[71] "I don't think that

Why do people love this place? There's an energy that exists on its own from the energy that people bring to it. . . . That's really what Pilchuck is, the people.

—Rob Adamson

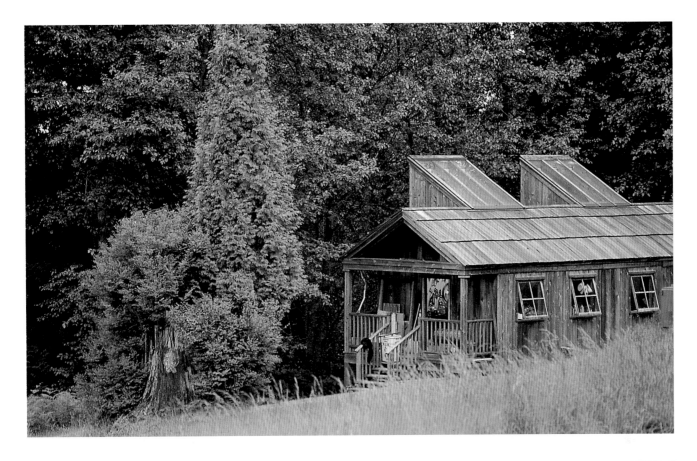

Above: The artist-in-residence studio, completed in 1983.

Right: A reception for the International Council at Dale Chihuly's cabin, 1984. Left to right: Yvonne Brunhammer, Harvey Littleton, Sybren Valkema, Sheryl Cotleur, Narcissus Quagliata, Stanislav Libenský, Veronique Valkema-Kindermans.

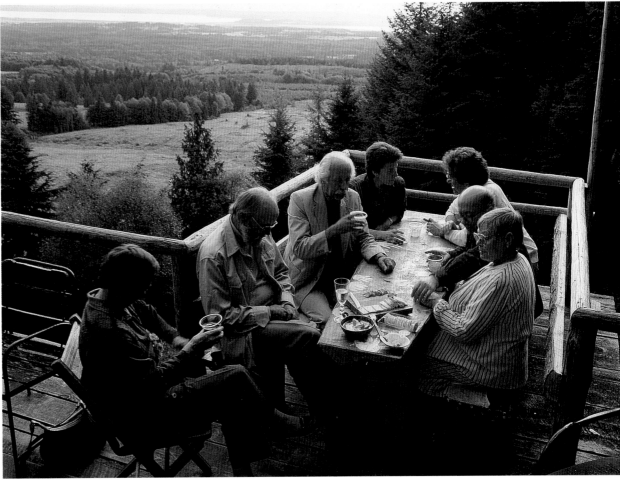

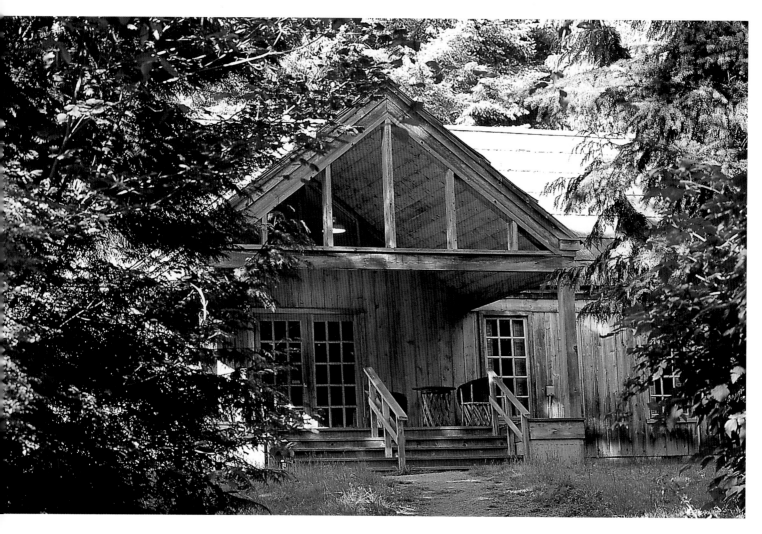

The student dormitory, completed in 1984.

the American glass movement, in a funny way, is as international now as it was then," observes British glass historian and critic Dan Klein. "I think there was a reason for its being more international then: the various individual countries had not yet built up their own glass societies or developed their own glass communities."[72] Annual council meetings continued to be held in Europe for the next several years, becoming more sporadic as members grew into their roles.

Several new trustees had come onto the Pilchuck board, including Jeffrey Atkin, Thomas Buechner, and E.W. (Ted) Nash, in 1983, and Adelaide Blomfield, Gretchen M. Boeing, and Nathaniel Page, in 1984. Jack Lenor Larsen and Harvey Littleton left the board in 1984 to focus on the International Council. The number of trustees now totaled thirty-two, and the size of the board was more or less stable for the next six years.

The Pilchuck campus was badly in need of improved living facilities. By 1983 an artist-in-residence studio, a meadow cottage, and the Sally Kitchell meadow cottage had been added, but students were still sleeping in forest-service tents. In 1984 Alice Rooney and John Hauberg asked Thomas Bosworth to design three more buildings: a large student dormitory, which was completed in 1984, and two new glassworking facilities—a studio building and a cold shop—both completed in 1986.

"In 1984 we started our first [public] . . . capital campaign," remembers John Reed. "We had already committed funds to building the big dormitory because the tents were

going by that time. Then we got a challenge grant from the National Endowment for the Arts for $100,000." "We were aiming for $785,000," remembers Rooney. "And we did it . . . [but] in a very quiet way. Hardly anybody knows that we had a capital campaign . . . from 1984 to 1986." Pilchuck won an additional $100,000 from the Kresge Foundation, John Hauberg gave another $100,000, and it did not take long to raise the remainder. "We made it!" reported trustee George Davis in April 1986. "The campaign was success-ful while hardly causing a ripple in the community . . . and Pilchuck made friends while raising money. . . . It was the support of the board that truly made the difference." The final total raised by the school's first campaign was an unexpected $865,000.[73]

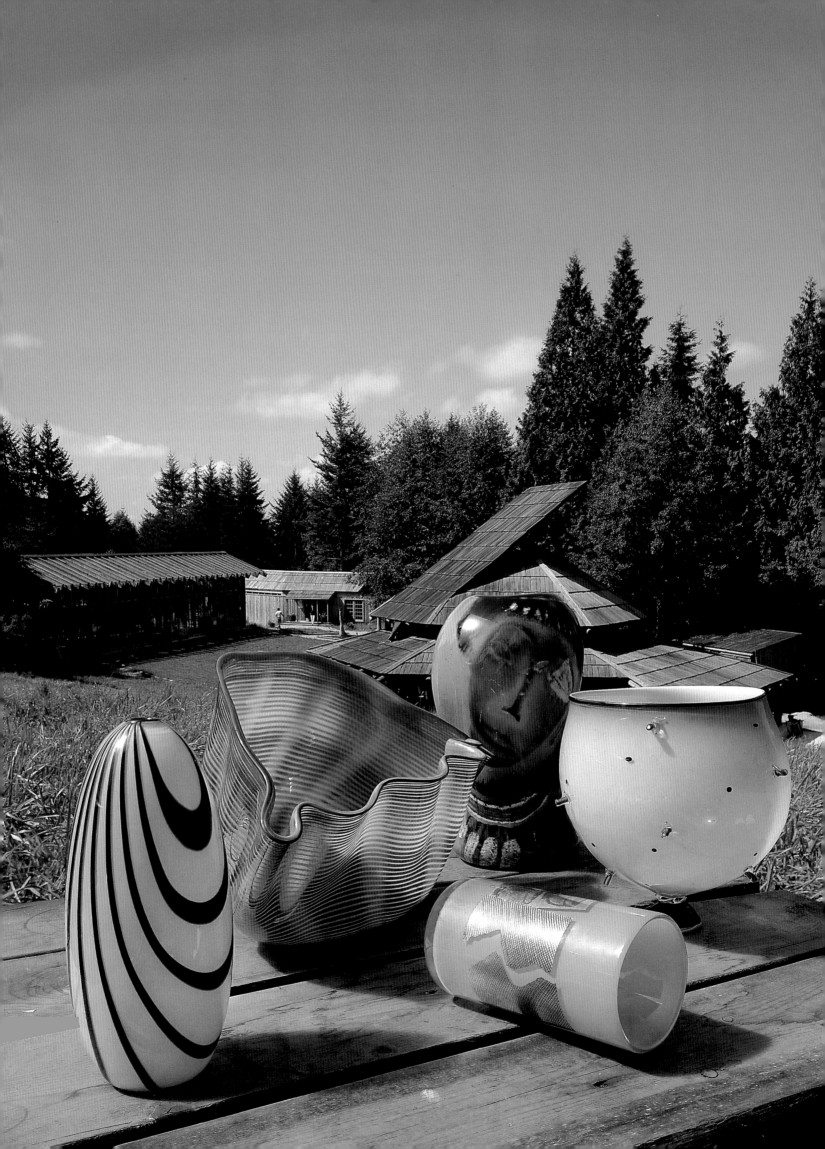

1985–1987: The Pilchuck Glass School

The fine arts were not immune to the 1980s cult of success. The new art hero was not the starving painter living in a Greenwich village walk-up. The new art hero was the promoter who knew how to make art pay.

—Nicolaus Mills, *Culture in an Age of Money*[1]

"There will soon come a time," wrote Seattle writer Fred Moody in 1985, "when the Northwest will be better known for its glass than for its timber, salmon, rain, or slugs."[2] Although glass as a Northwest commodity soon was eclipsed by coffee and computer software, the market for glass—along with the rest of the fine arts—soared during the 1980s. "I don't think that the glass market was exceptional on its own, outside of the fine arts market," observes art dealer Ruth Summers. "Glass just rode the tide along with everything else."[3] Along with rising interest in the medium came new concerns for Pilchuck: Was there such a thing as "Pilchuck glass"? Was glass a fine craft or a fine art? "Why is a Dale Chihuly group of nested forms placed in the same gallery as heat-resistant refrigerator dishes?" asked Corning Museum curator Susanne Frantz in 1985. "It is no secret that a great deal of contemporary, nonutilitarian work in glass has been saddled with the burden of proving itself as art. . . . The Chihuly piece suffers from the affliction which allows most museums to place contemporary glass sculpture within the realm of functioning containers: it is fabricated from a craft-associated material and it takes a vessel form."[4]

Let me settle the art/craft issue once and for all by saying that the division between art and craft is academic. . . . The only real difference between art and craft is price. Crafts cost less.

—John Perreault, 1984[5]

"I say, make art good enough and it won't be denied attention in the long run," stated art critic Clement Greenberg in 1984. "And don't let yourselves be closed off by . . . the notion of 'craft.'"[6]

While impassioned advocates championed the cause of glass as a fine art, articles about this "booming aesthetic medium" were covering the pages of magazines and journals ranging from the *Robb Report* and *Esquire* to *Town and Country*, *Sunset*, and *Life*. Yet art critics remained aloof from craft. "The most common question asked about the rather extraordinary state of the crafts today is perhaps the least productive: have the crafts become a form of fine art?" wrote Los Angeles critic Christopher Knight in his 1987 review of the touring exhibition *American Craft Today: Poetry of the Physical*, organized by the American Craft Museum, New York. Dismissing the issue as misdirected, Knight observed, "On the surface, things have never been better in the craft arena. For one, business is booming. . . . [But] what is the primary source of the affliction that has kept the crafts, as a whole, becalmed and bereft of anything but the most tepid excitement?"[7]

Demonstration vessels by Pilchuck faculty, 1983. Left to right: Lino Tagliapietra, Dale Chihuly, Isgard Moje-Wohlgemuth, Paul Marioni and Kelly McLain, and Henry Halem.

In her review of the same exhibition, Los Angeles critic Suzanne Muchnic wrote, "Are you perplexed by the confusion of what passes for fine art these days? Disturbed that you can't tell a drawing from a painting, a painting from a piece of sculpture, a print from a photograph? Don't look to the crafts for relief." Muchnic agreed with Knight that the art/craft issue was a "red herring."[8]

American Craft Today was a massive survey of the most recent work in ceramics, glass, wood, textiles, and precious metals. The show included work in glass by leaders in the field such as Hank Murta Adams, Howard Ben Tré, Sonja Blomdahl, William Carlson, Dale Chihuly, Michael Cohn, Dan Dailey, Fritz Dreisbach, Albinas Elskus, Henry Halem, David Huchthausen, Robert Kehlmann, Joey Kirkpatrick and Flora Mace, Marvin Lipofsky, Harvey Littleton, Paul Marioni, Richard Marquis, William Morris, Jay Musler, Joel Philip Myers, Mark Peiser, Paul Seide, Therman Statom, Susan Stinsmuehlen-Amend, Karla Trinkley, Steven Weinberg, and Toots Zynsky.[9] Although some artists, today, might hesitate to show their work in such a craft-identified context, it was a desirable avenue for artists working in glass at that time. "Only recently have critics been sharpening their pencils to write about glass," warned Dan Klein in 1987. "And there might be some uncomfortable moments ahead."[10]

There were efforts, however, to contextualize glass and other craft media in exhibitions such as *The Eloquent Object,* organized in 1987 by the Philbrook Museum of Art, Tulsa, or to present glass in new ways, such as the important exhibition of sculptural glass and glass installations organized in 1983 by Susanne Frantz, then curator at the Tucson Museum of Art.[12] And in the early 1980s, in

I think I do not yet warm to a medium that is still concerned with exploring itself primarily as a medium rather than as a vehicle for aesthetic ideas. . . . There is still an anxiety, a self-consciousness about this medium that makes me somewhat uncomfortable.

—Grace Glueck, 1985[11]

Seattle's Belltown neighborhood, artists such as Buster Simpson, John Landon, Ann Gardner, and Therman Statom kept the experimental spirit alive. "Therman did his first installation at the Traver Gallery. It was called *Tornado,*" recalls critic Matthew Kangas. "I was just blown away, partly by the adventurousness of it, but also by how [the Belltown group] . . . were all so enthusiastic about doing their own thing." As

How many times are you around during an important renaissance that you can still get in on—even if you don't live in Seattle?

—*Art & Auction,* 1985[13]

prices rose, the nature of people's work changed. "Well, fortunately, or unfortunately . . . a tremendous market [was created] . . . for this work," noted Mark McDonnell in 1983. "So it became more perfected, more slick."

"Six years ago you could count the number of local glass artists on two hands," observed Rob Adamson in 1986. "Now there are more than one hundred in the [Seattle] area."[14] "This is the only art form that I know in which the artist can be self-supporting

1985–1987: The Pilchuck Glass School

The fine arts were not immune to the 1980s cult of success. The new art hero was not the starving painter living in a Greenwich village walk-up. The new art hero was the promoter who knew how to make art pay.

—Nicolaus Mills, *Culture in an Age of Money*[1]

"There will soon come a time," wrote Seattle writer Fred Moody in 1985, "when the Northwest will be better known for its glass than for its timber, salmon, rain, or slugs."[2] Although glass as a Northwest commodity soon was eclipsed by coffee and computer software, the market for glass—along with the rest of the fine arts—soared during the 1980s. "I don't think that the glass market was exceptional on its own, outside of the fine arts market," observes art dealer Ruth Summers. "Glass just rode the tide along with everything else."[3] Along with rising interest in the medium came new concerns for Pilchuck: Was there such a thing as "Pilchuck glass"? Was glass a fine craft or a fine art? "Why is a Dale Chihuly group of nested forms placed in the same gallery as heat-resistant refrigerator dishes?" asked Corning Museum curator Susanne Frantz in 1985. "It is no secret that a great deal of contemporary, nonutilitarian work in glass has been saddled with the burden of proving itself as art. . . . The Chihuly piece suffers from the affliction which allows most museums to place contemporary glass sculpture within the realm of functioning containers: it is fabricated from a craft-associated material and it takes a vessel form."[4]

Let me settle the art/craft issue once and for all by saying that the division between art and craft is academic. . . . The only real difference between art and craft is price. Crafts cost less.

—John Perreault, 1984[5]

"I say, make art good enough and it won't be denied attention in the long run," stated art critic Clement Greenberg in 1984. "And don't let yourselves be closed off by . . . the notion of 'craft.'"[6]

While impassioned advocates championed the cause of glass as a fine art, articles about this "booming aesthetic medium" were covering the pages of magazines and journals ranging from the *Robb Report* and *Esquire* to *Town and Country*, *Sunset*, and *Life*. Yet art critics remained aloof from craft. "The most common question asked about the rather extraordinary state of the crafts today is perhaps the least productive: have the crafts become a form of fine art?" wrote Los Angeles critic Christopher Knight in his 1987 review of the touring exhibition *American Craft Today: Poetry of the Physical*, organized by the American Craft Museum, New York. Dismissing the issue as misdirected, Knight observed, "On the surface, things have never been better in the craft arena. For one, business is booming. . . . [But] what is the primary source of the affliction that has kept the crafts, as a whole, becalmed and bereft of anything but the most tepid excitement?"[7]

Demonstration vessels by Pilchuck faculty, 1983. Left to right: Lino Tagliapietra, Dale Chihuly, Isgard Moje-Wohlgemuth, Paul Marioni and Kelly McLain, and Henry Halem.

In her review of the same exhibition, Los Angeles critic Suzanne Muchnic wrote, "Are you perplexed by the confusion of what passes for fine art these days? Disturbed that you can't tell a drawing from a painting, a painting from a piece of sculpture, a print from a photograph? Don't look to the crafts for relief." Muchnic agreed with Knight that the art/craft issue was a "red herring."[8]

American Craft Today was a massive survey of the most recent work in ceramics, glass, wood, textiles, and precious metals. The show included work in glass by leaders in the field such as Hank Murta Adams, Howard Ben Tré, Sonja Blomdahl, William Carlson, Dale Chihuly, Michael Cohn, Dan Dailey, Fritz Dreisbach, Albinas Elskus, Henry Halem, David Huchthausen, Robert Kehlmann, Joey Kirkpatrick and Flora Mace, Marvin Lipofsky, Harvey Littleton, Paul Marioni, Richard Marquis, William Morris, Jay Musler, Joel Philip Myers, Mark Peiser, Paul Seide, Therman Statom, Susan Stinsmuehlen-Amend, Karla Trinkley, Steven Weinberg, and Toots Zynsky.[9] Although some artists, today, might hesitate to show their work in such a craft-identified context, it was a desirable avenue for artists working in glass at that time. "Only recently have critics been sharpening their pencils to write about glass," warned Dan Klein in 1987. "And there might be some uncomfortable moments ahead."[10]

There were efforts, however, to contextualize glass and other craft media in exhibitions such as *The Eloquent Object*, organized in 1987 by the Philbrook Museum of Art, Tulsa, or to present glass in new ways, such as the important exhibition of sculptural glass and glass installations organized in 1983 by Susanne Frantz, then curator at the Tucson Museum of Art.[12] And in the early 1980s, in

> **I think I do not yet warm to a medium that is still concerned with exploring itself primarily as a medium rather than as a vehicle for aesthetic ideas. . . . There is still an anxiety, a self-consciousness about this medium that makes me somewhat uncomfortable.**
>
> —Grace Glueck, 1985[11]

Seattle's Belltown neighborhood, artists such as Buster Simpson, John Landon, Ann Gardner, and Therman Statom kept the experimental spirit alive. "Therman did his first installation at the Traver Gallery. It was called *Tornado*," recalls critic Matthew Kangas. "I was just blown away, partly by the adventurousness of it, but also by how [the Belltown group] . . . were all so enthusiastic about doing their own thing." As

> **How many times are you around during an important renaissance that you can still get in on—even if you don't live in Seattle?**
>
> —*Art & Auction*, 1985[13]

prices rose, the nature of people's work changed. "Well, fortunately, or unfortunately . . . a tremendous market [was created] . . . for this work," noted Mark McDonnell in 1983. "So it became more perfected, more slick."

"Six years ago you could count the number of local glass artists on two hands," observed Rob Adamson in 1986. "Now there are more than one hundred in the [Seattle] area."[14] "This is the only art form that I know in which the artist can be self-supporting

from day one," said glass dealer Ferd Hampson, quoted in a 1985 article by Sue Berkman.[15] "Today," Berkman wrote, "according to a census of leading dealers, prices for American studio glass are increasing at a rate of 100 percent a year, while an estimated one thousand independent artists are doing nicely . . . [with] artwork that is frequently priced in the five-figure bracket."[16] Unlike some cities, Seattle never had to convince its buying public that glass was "art," since the best studio glass was not shown in a craft context. "Don't forget that we never had glass galleries in Seattle the way that other cities had, where they would ghettoize glass into one setting," comments Matthew Kangas. "Here, it was always shown side by side with painting and sculpture and other materials." "Among the several galleries [in Seattle] carrying glass," adds Nancy Love in *Art & Auction,* "those that have the reputation for the most serious commitment are fine arts galleries."[17]

These fine arts galleries were William Traver Gallery (formerly Traver/Sutton), Linda Farris Gallery, and Foster/White, each of which, from the beginning, had promoted the new glass coming out of Pilchuck. "We felt it was important to support Pilchuck as a glass center," said Seattle artist Johanna Nitzke Marquis in 1985, then director at Foster/White. "If we do, it comes back and supports us."[18] William Traver recalls:

The market here is now very strong, but in [the early] . . . days it was very difficult and often very frustrating, because you could see the originality of the work. When I look back on it, the work was fairly crude and amateurish in terms of technique and scale. And now we can see that, but at the time . . . we just saw it as this exciting, wonderful, new work. The prices were so low. And you had to sell a lot in order to make it worthwhile. But there was a community spirit about it. . . . Then as the market became more competitive, these artists became more important, and . . . everything was elevated. The prices were getting better. The publicity was getting better. The notoriety was better. There was writing beginning to occur about the work, it was beginning to be seen around the nation. And, over the years, the importance of Pilchuck and what it represented became more and more apparent.

Pilchuck received a record 329 applications for its 1985 session. $161,500 in tuitions came from 213 students, representing, with application fees, just under 40 percent of the operating budget, and $27,500 was awarded in scholarships. The student body was getting older. Most students in 1985 were between twenty-five and fifty years old, while in 1981 the majority fell in the eighteen to thirty-five age group. Records indicate that 1985 was the first year in which Pilchuck's administration made a real attempt to develop statistical profiling to be used in long-range planning. "It was an international summer as never before," noted Alice Rooney in an undated report. "Students, TAs, and faculty [came] . . . to Pilchuck from Canada, Czechoslovakia, Australia, Japan, Honduras, Mexico, Sweden, Germany, Great Britain, France, the Netherlands, Venezuela, Singapore, and Italy. The driest summer in one hundred years

. . . it was also a summer where 30 percent of the students were returning from previous years and where student enrollment had increased 20 percent over previous years."[19]

"In 1985, the artist-in-residence program . . . [coordinated] . . . by Flora Mace and Joey Kirkpatrick . . . will be expanded," wrote Karen Chambers in an article for *Craft International*. "The length of the session will vary from two to two-and-one-half to three weeks, and the glassblowing classes will all be team-taught by two artists, for example Italian master Lino Tagliapietra and American Dan Dailey. As always, the emphasis will be on teaching the aesthetics of glass although the techniques will not be neglected."[20]

Glass is settling into a new phase. What is done on the blowpipe was once the end result. Now, that's just the beginning.

—Doug Heller, 1985[21]

Summer 1985 was light-years away from the sessions offered only in "molten" and "architectural" glass in the 1970s. The biggest difference was in the explosion of cold working processes and the so-called warm techniques such as casting and fusing. Session I featured lampworking with Ginny Ruffner; neon fabrication, for the first time, with Fred Tschida; casting with Bert van Loo; and slumping and fusing taught by Ruth Brockman and Richard LaLonde. During Session II Ed Carpenter and Tim O'Neill taught architectural stained glass, Steven Weinberg presented slumping and mold making, William Carlson taught cold working, and Richard Marquis and Therman Statom were in charge of blowing in the hot shop. Artists-in-residence for the first session included Richard Posner and Norie Sato, known for her work in glass and metals, and, during Session II, Debra Sherwood and Pilchuck pioneer Robert Naess—working at Pilchuck for the first time since 1973.

"Cross-fertilization and collaboration between classes, among instructors and artists-in-residence, was an enriching experience for students," Alice Rooney wrote, "who

Neon artist Fred Tschida in front of the flat shop, 1987.

Jirí Harcuba engraving a vessel, 1984.

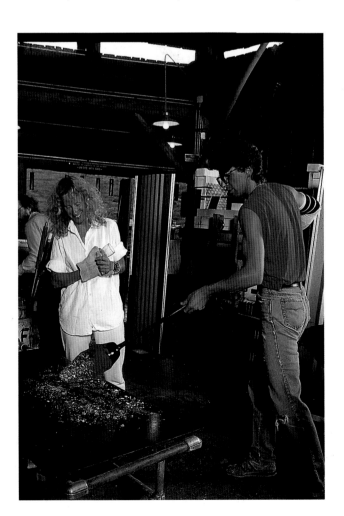

Ann Gardner with Richard Royal, picking up color from the marver onto a vessel, 1985.

were able to watch as many demonstrations and listen to as many lectures as the days' schedules and their notebooks would accommodate."[22] Judy North took over the flat shop during Session III, teaching a variety of flat glass techniques. Albinas Elskus taught glass painting. Jay Musler worked with cold techniques in his cold glass and cold paint course, and Andrew Magdanz and Susan Shapiro took over the hot shop. Session IV found Jan-Erik Ritzman teaching with Sonja Blomdahl and Amy Roberts in the hot shop. Joachim Klos and Lutz Haufschild team-taught stained glass, Michael Glancy presented sandblasting and sand carving, and Dana Zámečníková taught laminating. Artists-in-residence in Session III were Fritz Dreisbach and Robert Kehlmann, and, in Session IV, Ann Gardner, Barbara Vaessen, and master engraver Jirí Harcuba, from Czechoslovakia. "[Pilchuck] . . . is an international university for creativity in glass," commented Harcuba, whose 1985 course was his first at Pilchuck. "In Europe we seem to be fixed on one discipline, while Pilchuck is growing in a more interdisciplinary way. If you consider the lectures given by teachers, artists-in-residence, and teaching assistants throughout the summer, you are given a larger picture of all the different techniques and approaches to the medium of glass."[23]

Session V was particularly energetic. Dan Dailey and Lino Tagliapietra took over the hot shop. In the flat shop Susan Stinsmuehlen-Amend taught flat glass, and Jirí Harcuba offered engraving. Clifford Rainey presented his glass sculpture class once again, and critic, historian, and former Corning Museum curator William Warmus taught a history of glass course. An impressive group of artists-in-residence for the final session included Lynda Benglis, Dale Chihuly, Paul Marioni, Italo Scanga, Bertil Vallien, and Dana Zámečníková.

One of the highlights of the last session was the Pilchuck Glass Seminar, a three-day conference, organized by William Warmus, which focused on connoisseurship, collecting, and "hands-on" experience with various hot and cold techniques. Critics, collectors, and curators Walter Darby Bannard, Susanne Frantz, Henry Geldzahler, John Hauberg, and Dan Klein lectured on assorted topics, and

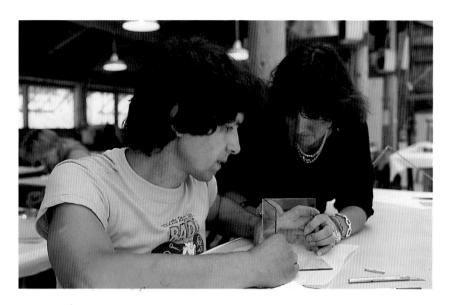

artists Jirí Harcuba, Paul Marioni, Clifford Rainey, Italo Scanga, Susan Stinsmuehlen-Amend, Bertil Vallien, and Dana Zámečníková spoke about their work. A number of artists, including Sonja Blomdahl, Joey Kirkpatrick and Flora Mace, Benjamin Moore, William Morris, Richard Royal, Lino Tagliapietra, and others, demonstrated various techniques. The

Marian Karel and Dana Zámečníková, 1985.

conference ended with a rousing auction of sixteen objects created during its course, raising $19,000 for student scholarships.[24]

In 1984 trustee Robert Seidl, chairman of the board's long-range planning committee, had submitted a twenty-page report on the state of the school, presenting its history and a slate of issues and options for its future. The board was prompted to hold a long-range planning retreat in September 1985, the first of what would become an annual event. "A long-range plan speaks to the future, of course, but a review of the past is an appropriate preamble," wrote Seidl. "Indeed, it is basic to review history because what came before expresses the character of the organization and its objectives, which either need reaffirmation or change."[25] Seidl asked trustees to revisit the mission of the school and proposed consideration of a new name to clarify the purpose of the school, which was referred to as both the Pilchuck School and the Pilchuck Glass Center. Programmatic issues such as size versus quality of courses, class structure, expansion of the facilities, equipment, and, especially, the quality of Pilchuck's glass also were in need of review. Seidl suggested a reexamination of the structure of the board of trustees, given John Hauberg's imminent retirement and the necessity of finding a new leader, and a review of funding sources and committee responsibilities.

Pilchuck adopted a new mission statement on November 8, 1985, which focused on several goals. These were "to develop a stimulating environment of excellence, creativity, experimentation, artistic expression, and share experience primarily in glass on an international basis; to be the premier school for teaching and expression of art involving glass; to seek and maintain superior faculty and teaching assistants who will, in turn, attract superior students; and to create . . . a center of communication and a continually expanding public interest in glass art." Finally, Pilchuck would "operate with a global view, with participation on an international basis."[26]

With the exception of Dale Chihuly, artists had been conspicuously absent from the board retreat. Chihuly wrote to Alice Rooney: "So many of our functions, including board meetings and the retreats, have lacked the presence of the artists who have played

such a fundamental role in shaping Pilchuck. I feel that artists like Bill [Morris] and Ben [Moore] and Rich [Royal] and others should be present whenever possible. These people have a better feeling for Pilchuck's past and future than anyone else."[27] But the board still considered the admission of artists to its ranks controversial, and the issue was tabled.

Deeply involved in a capital campaign, long-range planning, and self-examination, the board finally had taken ownership of the school, much to John Hauberg's satisfaction. Thanks to the artists' generous donations of artworks, the annual auction was proving to be a steadily increasing revenue source. The 1983 auction, underwritten by Safeco Insurance, had netted $68,000, and the 1984 and 1985 totals rose to $90,000, an impressive 20 percent of the school's $450,000 operating budget. Pilchuck Society membership had increased to more than 250 individuals in 1985. The board set professional guidelines for itself, including trustee attendance at a minimum of three board events every year; membership in the Pilchuck Society; activity on at least one standing or special committee per year; service as an officer or committee chairman once every three-year term; and where possible, donation of personal funds to the school or the solicitation of donations from others.[28] "The [Pilchuck] . . . board is probably the most committed board we have ever served on," remarks trustee George Saxe. "They see a job to do, and they do it. And they don't make a whole lot of noise about doing it. . . . Nothing seems to be a burden to them. They just do what it is necessary to do."

We should consider a more aggressive recruitment program to seek out talented art students who may not be closely connected with the glass world.
—Dale Chihuly[29]

In 1986, for the first time, every class offered by Pilchuck had a waiting list. Although there would always be hobbyists only looking to hone technique, most students had the talent and experience to match their high expectations. "The consensus among instructors was that this year's students were the best ever," wrote Alice Rooney. "Our 1986 summer program was outstanding—no matter how you define the term. . . . For that, we can be grateful to a good staff . . . [including] John Reed, Ben Moore, Penny Berk, Nancy Barr, Bill Morris, Paul DeSomma."[30] "The most important piece of advice about Pilchuck seems to be go," wrote Nola Anderson for *Craft Australia* magazine. "Go with a view to experiment, learn, and exchange, and the experience will last much longer than one summer."[31]

For the 1986 season, a new studio building and cold shop, designed by Thomas Bosworth, had been added to alleviate crowded working conditions, but reactions to the facilities and their impact on the school community were mixed. "The new buildings isolate people into separate classes," noted Paul Marioni in a staff meeting, "so that there is [no longer] . . . a group consciousness."[32]

The five-session 1986 program was dynamic. For session I, Paul Dufour taught stained glass, and Albinas Elskus again offered painting on glass. Warren Langley taught

experimental kiln techniques, and Henry Halem offered a course focusing on glass as a collage material. Artists-in-residence were painter Joan Ross Blaedel and David Huchthausen for Session I, followed by mixed-media artist Jerry Pethick and designer Peter Shire in Session II.

Flora Mace and Joey Kirkpatrick taught their popular glassblowing class for the second session, while Ginny Ruffner taught "nontraditional" lampworking, this time spelling out her focus in the catalogue: "Lampworking [will be] . . . used as a means of abstract sculptural expression: no swans, bunnies, unicorns, or wishing wells." Stanislav Libenský and Jaroslava Brychtová returned to teach drawing and casting to advanced students with Charles Parriott. William Warmus offered a special class on the "art and history of glass," and Fred Tschida returned as an instructor in the secrets of neon. "There is a competitive side [to neon]," observes Tschida's former teaching assistant, Deborah Dohne. "Because the neon sign business is so cutthroat, there was no way to learn it, really. . . . [Neon] has become accessible to artists only fairly recently."[33]

Susan Stinsmuehlen-Amend and Therman Statom collaboratively taught an advanced course in hot glass for Session III. Richard Harned and Diane Katsiaficas worked with students on environmental works exploring large-scale sculptural and performance ideas, and Paul Marioni taught architectural cast glass. Michael Glancy once again presented sandblasting, sand carving, and electroforming, and Sydney Cash taught "Metaphysical Glass Forming," beginning his classes every day, Benjamin Moore remembers, with a spiritual meditation by the pond. Artists-in-residence included Louis Mueller, who worked in metals, and sculptor Ed Wicklander.

The high energy of the third session resulted in the school's first serious mishap when a mud wrestling free-for-all got out of hand. "What could be more innocent than high spirits and mud wrestling?" remarked Alice Rooney. "[But] a girl slipped, hit her head, and ended up with a concussion and a perforated ear drum."[34] "About half the school was for it, and half was against it," remembers Paul Marioni. "It was the first competitive situation I had ever seen at Pilchuck." The incident frightened everyone: some attributed it to anger, others to drinking. Instructor Sydney Cash felt students were overloaded, pushed by their teachers to take things to the limit. Flat glass students blamed the event on the tone set by the hot shop.[35]

The negativity created by the accident was offset by the student-to-student auctions, instigated by Flora Mace and Joey Kirkpatrick to raise money for scholarships and equipment. Jovial and raucous, the student auctions quickly became a regular feature at the school. "Flora Mace and Joey Kirkpatrick nearly singlehandedly orchestrated the 'student-to-student' auctions held during Sessions II and V," wrote Dale Chihuly. "For me, these auctions . . . [which] raised an additional $12,000 for scholarship funds, were the high point of the summer."[36] Unlike the student scholarship auction held the previous year, guidelines now established that faculty could bid only on student pieces, students and staff could bid on everything, and visitors could bid on nothing. "Thus one student

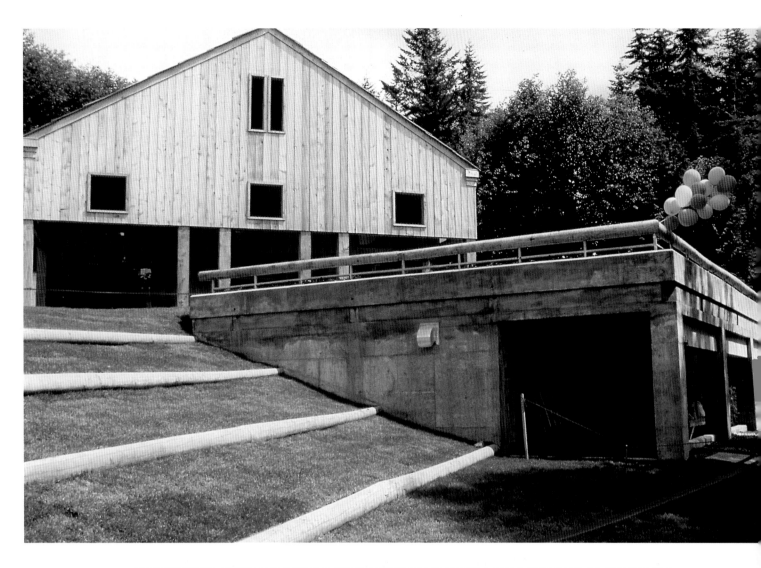

Above: The studio build-
ing, 1986.

Right: The cold shop,
1986.

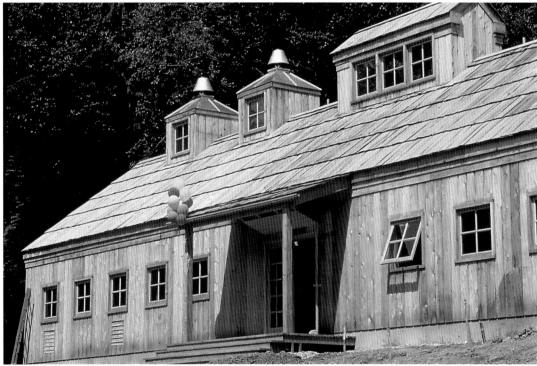

was able to acquire a small Chihuly for $300 and another bought a Bertil Vallien boat for $600," reported Alice Rooney. "A guest . . . was a New York dealer, and her frustration was amazing to behold when she could not bid on any pieces."[37]

The fourth and fifth sessions had an international faculty. For Session IV Joel Philip Myers and Swedish master Jan-Erik Ritzman were in the hot shop; Ulrica Hydman-Vallien taught painting on blown glass; Klaus Moje presented slumping, fusing, and mold making; and Czech master engraver Jiří Harcuba taught engraving. Session V had Bertil Vallien and Norman Courtney teaching sand casting and blowing in the hot shop, and Ann Wolff and Swedish artist Channa Bankier offered drawing and sandblasting on blown forms. Drawing, painting, sandblasting, and engraving were also offered by Erwin Eisch, and stained glass by the legendary Hans Gottfried von Stockhausen. Dale Chihuly and Kate Elliott, a Pilchuck pioneer who later would open her own gallery in Seattle, taught a special course on professional practices. Artists-in-residence were Howard Ben Tré, Dale Chihuly, and Italo Scanga (assisted by Flora Mace and Joey Kirkpatrick) for Session IV, and Thomas Buechner and Eric Hopkins for Session V.

"Dale and I decided to teach a class in professional practices," recalls Elliott. "[We taught] . . . how to prepare and send out slide portfolios and how to approach galleries. We had people come in [and talk about] legal issues and copyright law." Chihuly and Elliott would offer the class again in 1987, but after that, says Elliott, "I realized Pilchuck was not the appropriate place to be teaching that kind of class . . . because in two-and-a-half weeks, I felt that students should be working with the material and experimenting, not thinking about business."

In the fall of 1986 the board turned to a reconsideration of the official name of the school, which was alternately called the Pilchuck School and the Pilchuck Glass Center. Director Alice Rooney and board member C. David Hughbanks sent a list of possible names to trustees and artists as a ballot. Pilchuck Glass School emerged the winner, and

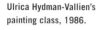
Ulrica Hydman-Vallien's painting class, 1986.

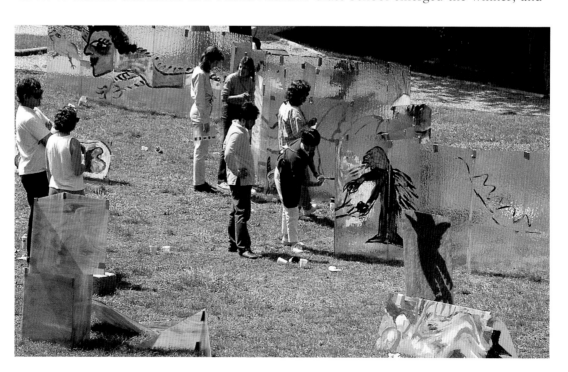

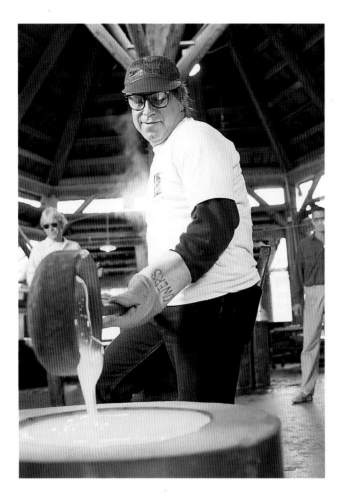

Howard Ben Tré casting, 1991.

by the end of October 1986, the school had adopted the new name and a new logo, a stylized rendering, in a deep teal green, of the hot shop.

Since 1983 Pilchuck's course offerings steadily had expanded beyond blowing and stained glass with special classes in cold and "warm" techniques. In spite of this, many non-glassblowing faculty felt that their processes were not promoted enough at the school or in the marketplace. "That's been the main thrust for the school forever: the hearth, the hot shop," observes Susan Stinsmuehlen-Amend. "I felt discriminated against because I wasn't a hot glass person. [I thought] . . . how can I create as much interest in the flat shop, or in the studio building, that people will want to wander in at night to see what's going on there rather than gravitate automatically to the hot shop? . . . And I think it went hand in hand that the other processes of working glass were something that women did, more than hot glass. . . . It's hard to separate the idea of feminism from the hierarchy of the [glassblowing] process. . . . All the crafts were low on the totem pole back then. Glass overcompensated with machoism . . . to prove that it was a serious material."

"Whether you're male or female, glassblowing is incredibly macho," observes 1994 artist-in-residence Maya Lin. "I don't know why. Pottery isn't. I think it's because of the

Thomas Buechner, 1986.

Susan Stinsmuehlen-Amend with a work in progress, 1981.

Summer months of inspiration, energy, fantasy, and some reality. . . . Italo's Italian operas at highest volume . . . snakes in the grass and moths in the cold shop . . . night dancing at Inspiration Point. . . . Warm, deep, and wonderful are my memories of Pilchuck.

—Ulrica Hydman-Vallien[39]

fire [and] . . . the weight and the hefting around of things."[38] Issues surrounding glassblowing and women in glass dovetailed in the hot shop. "In the early days . . . there weren't that many of us," recalls Kate Elliott. "There was me and Sue Melikian and Debbie Goldenthal and Toots Zynsky. And . . . Erica Friedman. We were all pretty much subservient." Women in the hot shop became less subordinate with Flora Mace and Joey Kirkpatrick as role models, but as late as 1995, the school had had only three female gaffers. "There were certainly a lot less women around in the earlier days," remarks Sonja Blomdahl. "And the roles they had were not the main ones. They were on the blowing floor, bringing the puntys, or chopping the Kugler." Flo Perkins, a 1974 student, notes, "It was pretty much half men and half women when I was at Pilchuck. But the sad part is, what happened to all the women?"[40]

While preparing a slide lecture on women sculptors working in glass, Ginny Ruffner found the subject of why women were—or were not—in glass more intriguing than who was doing it. "I contacted sculptors, educators, critics, gallery owners, and interested bystanders in and out of the glass field, both men and women," wrote Ruffner in a 1988 article for *American Craft* magazine. "Contradiction proved to be the most obvious constant. For instance, the most commonly noted aspect of working in glass was the sheer physicality of the process. While some cited this as intimidating to women, others saw it as . . . a real attraction."[41] "Pilchuck always had lots of women," declares Italo

Maya Lin, 1994

Scanga. "Toots, Ruth Tamura. . . . All the people that helped me were always women. Men never helped me in my career." "The macho myth in glass predominates," adds Charles Parriott, "because males are more powerful glassblowers. But they're not more powerful artists."

Women artists met in a special-interest group for the first time at the Glass Art Society conference at Kent State University in 1988. Both studio problems and more speculative matters were discussed, noted Robert Kehlmann in a news article for *American Craft* magazine. "Primary among these was the question of the degree to which imagery in women's work is trapped by the stereotypes of a patriarchal society," Kehlmann reported. "The group members came to the agreement that women artists should give more weight in their work to feminine experiences and perspectives."[42] The issues of hot glass versus other techniques and of women in glass would continue to be significant, although less divisive, for the glass community into the 1990s. By then, the larger and more disturbing problem of changing attitudes toward art and freedom of expression, espoused by such conservative firebrands as U.S. Senator Jesse Helms, would draw all artists together.

My prediction is by the year 2000, Pilchuck will become a women's art colony. . . . Almost all the staff are women, the . . . director is a woman, the faculty is at least half women, the students are at least two-thirds women, the visiting artists are almost all women. It's the direction of glass.

—Charles Parriott, 1994

Pilchuck staff for 1986 numbered twenty-five in addition to about forty teaching assistants. Benjamin Moore, to everyone's dismay, announced that 1986 would be his last summer at Pilchuck. He had spent thirteen seasons there since he first arrived as a student in 1974. "Throughout the years, and particularly in the beginning, we would always try something new and different," says Moore. "But after a while . . . I found a certain sequence that worked well. And I locked myself into those ways. . . . The last two years I realized that if I was not going to keep changing, we would be stuck. So it was time for me to move on." Norman Courtney, another Pilchuck veteran, was hired to replace Moore as education coordinator, but he would stay only a year.

Summer staff was rearranged in 1987, in part due to Benjamin Moore's departure. Paul DeSomma was head of the hot shop, where Karen Willenbrink was in charge of batching; Curtiss Brock supervised the cold working studio; and Cappy Thompson managed the studio building. Gaffers for the summer included Michael Jaross, Dante Marioni, William Morris, and Richard Royal, with their assistants. "A measure of the kind of interest there is in working at Pilchuck," wrote Alice Rooney to the board, "is that everyone pays his or her own transportation to the school. They receive room and board and a modest salary . . . and the staff is allowed to blow glass on Sunday. Other than that, they do not have access to the hot shop. . . . But many staff do their own work in their free time, finding studio and table space wherever they can."[43]

Staff growth and the increasing complexity of programming—along with some rumblings about where the school was headed—led Dale Chihuly to organize an artists' conference at Pilchuck in mid August 1987 with the stated aim to "explore ideas about Pilchuck's future." Topics included program and session length; off-season use of facilities; student selection and recruitment; interpreters; class size, length, and direction; and selection and compensation of faculty, artists-in-residence, and teaching assistants. Buildings and equipment, staff, and the function of the International Council were also presented as subjects for discussion.

Participants—invited by Dale Chihuly and Alice Rooney—included Pilchuck "regulars" Sonja Blomdahl, Dorit Brand, Norman Courtney, Dan Dailey, Fritz Dreisbach, Kate Elliott, Joey Kirkpatrick, Flora Mace, Paul Marioni, Benjamin Moore, William Morris, John Reed, Richard Royal, Ginny Ruffner, Italo Scanga, Susan Stinsmuehlen-Amend, and Dick Weiss as well as faculty and resident artists Jiří Harcuba, Ursula Huth, John Leighton, Richard Marquis, Klaus Moje, Narcissus Quagliata, Susan Shapiro, Jiří Suhajek, Lino Tagliapietra, and John Torreano. Auditors included office staff and some summer staff, librarian Mary Cozad, and Pilchuck pioneer John Landon. This group evaluation of Pilchuck by the artists who participated in its continual re-creation underlined the need for artists' input at the board level.[44]

The 1987 program, in five sessions, once again demonstrated the diversity of popular glassmaking techniques. The summer opened with Judy North and Katherine Bunnell teaching stained glass; *pâte de verre* casting taught by Diana Hobson; and a course in surface decoration on glass—sandblasting, engraving, electroforming, and enameling—offered by KéKé Cribbs and Patrick Wadley. Artists-in-residence for Session I included Albinas Elskus, Joey Kirkpatrick, and Flora Mace. Artists-in-residence for Session II were Walter Lieberman, painter Maxine Martell, and film critic Lucy Mohl. Mace and Kirkpatrick were back in their usual hot shop slot for Session II, Ginny Ruffner taught lampworking, Paul Marioni offered architectural cast glass, and Fred Tschida taught neon.

Benjamin Moore, 1985.

"It's wonderful to put light out in that landscape because it's so very monochromatic and dark at night," says Tschida. "Each year we would take one of the vehicles at Pilchuck and outfit it with a wood latticework so we could put 200 or 300 feet of neon

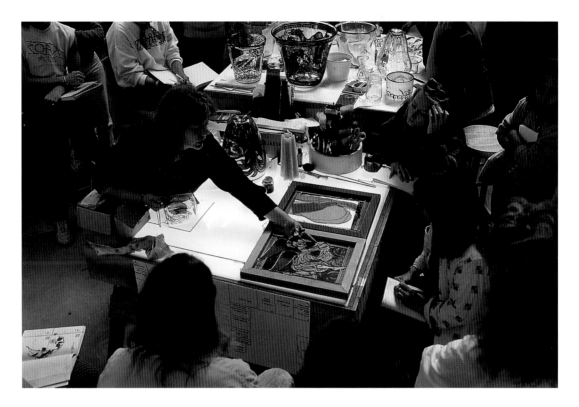

tubing on top of it. And we would [light it] . . . and drive it around. Pilchuck was like a roller coaster: you would get on the first day, and you couldn't get off until the last person left."

Over in the hot shop, Flora Mace and Joey Kirkpatrick complained about the poor quality of the glass, noting, for the administration's benefit, that pieces donated to the annual auction would not be of the best quality as a result. John Reed looked into buying glass from Harvey Littleton's Spruce Pine Glass Company, which promised to be more refined, but was considerably more expensive.[45] "It's a virgin batch [for] continuous-melt [furnaces] or day tanks," explains Littleton. "It melts very nicely in a small furnace and that's the whole purpose of it. And it is pelletized so that it is relatively dust free. Each pellet has all the ingredients necessary to make glass. . . . It's premixed. You just shovel it in and melt it." Pilchuck finally switched one of its furnaces to the Spruce Pine melt in 1991, limiting the use of fluxed bottle cullet (recycled glass) to casting.

Session III brought Stanislav Libenský and Jaroslava Brychtová back to teach kiln casting. Karla Trinkley taught her unique brand of *pâte de verre* casting, and William Dexter and James Harmon offered glassblowing. William Warmus taught his popular glass history course for the third time, and Harvey Littleton introduced what he termed vitreography, or printmaking from glass plates. Developed by Littleton, the technique involved abrading the glass plates with acid, by sandblasting, or with mechanical and hand tools; inking the glass sheets; and then passing them through a traditional intaglio printing press. Session IV had Andrew Magdanz and Jirí Suhajek in the hot shop; Susan Stinsmuehlen-Amend taught flat glass; Susan Shapiro taught sandblasting and enameling; and master Jirí Harcuba offered engraving. Artists-in-residence for Session III were Anna Carlgren, William Morris, and glass artists Durk Valkema and Sybren Valkema, followed

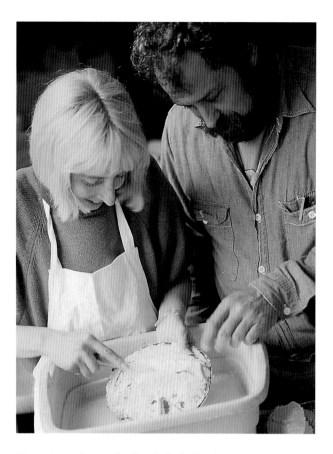

Diana Hobson and Norman Courtney, 1987.

by John Torreano and Italo Scanga in Session IV. Session V brought Lino Tagliapietra, Benjamin Moore, and Amy Roberts to the hot shop. Narcissus Quagliata returned to teach stained glass, Klaus Moje taught fusing, and David Hopper instructed in glass painting for the first time. Dale Chihuly and Kate Elliott offered their professional practices course, and Thomas Buechner, Dan Dailey, and Ursula Huth came as artists-in-residence.

When Session V was over, Chihuly invited Tagliapietra to his studio in Seattle, and together they began a new series called the *Venetians*, inspired by 1930s art deco Venetian glass which Chihuly had seen in a private collection in Venice.[46] The series combined Tagliapietra's brilliant talent for traditional forms with Chihuly's reckless color and baroque decoration.

Harvey Littleton (right) discussing vitreography with David Wharton, 1987.

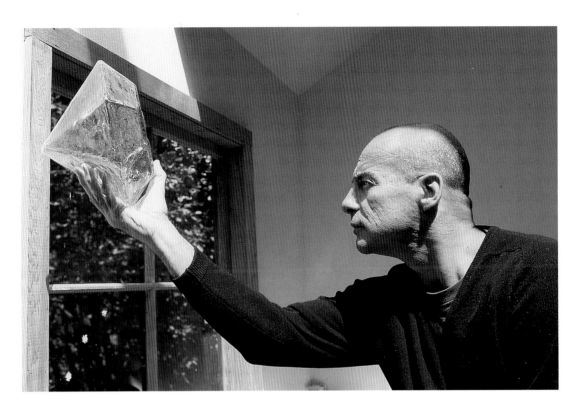

Bertil Vallien planned a major performance to close the summer:
*A student named Josh Cohen . . . wanted to take over the role of masterminding the glass
theater. We solved [the leadership issue] . . . by forming three groups. . . . We each had a ton
of sand and a full tank of glass. . . . My team's piece was a volcano of sand that we filled
with molten glass. We ran a hose in under the sand and up through the glass, and pumped
compressed air through the hose so the volcano would erupt in blown glass bubbles. . . . But
Cohen's piece was fantastic. He had this metal barrel filled with glass . . . which he cranked
up high, using chains and a hoist. Cohen had made big holes in the bottom of the barrel,
which created the most incredible glass rain. It was amazing: 2,000-degree glass just coming
down like rain. And then . . . the barrel was moved over a steel grating. The glass rain fell on
the grating, and it created a structure, like a bird's nest, made of glass. And Cohen was sit-
ting inside! It was all glowing. It was very dangerous and Cohen had a big leather hat on [to
protect himself]. . . . Those were spectacular events.*

Pilchuck's operating budget was growing annually at about 12 percent, from
$525,000 in 1986 to $585,000 in 1987, with a projected budget of $660,000 for 1988.[47]
The school's 1986 auction, held in November at the Four Seasons Olympic Hotel in
downtown Seattle, was successful, but for the third straight year net earnings held steady
at around $90,000. It seemed as if
the elusive $100,000 mark might
never be reached. "I feel that the
auction has probably peaked in its present form," John Hauberg told the trustees that
November, "and we must consider an additional annual fundraising event." This an-
nouncement prompted discussions about how the auctions might be improved.[48] A silent
auction was adopted in 1987, but net proceeds still hovered around $90,000.

You knew that Pilchuck was the mecca of glass.

—Karen Willenbrink

Illsley Nordstrom retired from the board in 1985, followed by Mary Davis, John Hewitt, Philip Padelford, and Sam Rubinstein in 1986. New trustees Tom Alberg, John N.

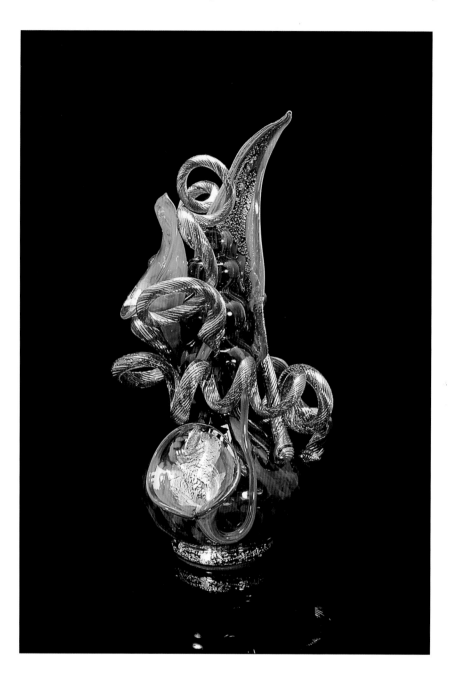

Anderson, Mark Haley, and Douglass Raff joined in 1986, maintaining the board size at about thirty members. In 1987 Adelaide Blomfield and Robert Thurston elected not to renew their terms, while newcomers Susan Brotman, Cindy McNae, Babo Olanie, J. Thurston Roach, and Mary Shirley were welcomed. "John Hauberg said he'd like to make a comment specifically to the new trustees," read the minutes of the 1986 annual meeting. "Pilchuck operates in the black because of conservative budgeting . . . and if we have dreams we can't fund, we put them off until we can find ways to fund them." "Our tin cup," added Robert Block, "is as underplated as most."[49] But thanks to John Hauberg's generosity over the years, Pilchuck had never acquired a deficit, and the board's dedicated fundraising, combined with Alice Rooney's "notoriously tight" bookkeeping, kept it that way.[50]

Dale Chihuly (American, b. 1941), *Cadmium Red Venetian #317*, 1990. Blown glass with applied furnace-worked elements, 20 x 11 x 10 in. Courtesy Dale Chihuly, Seattle.

The board added a new category of high-level membership in 1986, the Pilchuck Glass Collectors, which provided an important source of regular revenue in addition to the growing general membership of the Pilchuck Society. An endowment fund for the school was first established in 1986, with the help of an unexpected grant of $100,000 from the Steele-Reese Foundation (Pilchuck had applied for only $20,000), and the capital campaign had drawn to a successful close. As always, much-needed assistance for operating expenses came in the form of an increasingly greater number of federal, state, corporate, and community grants from such longtime Pilchuck supporters as the Corning Glass Works Foundation, the National Endowment for the Arts, PONCHO, Safeco Insurance Company, the Washington State Arts Commission, and the Wyman Youth Trust.[51] Many individual contributors, trustees

among them, kept the school afloat. In their fundraising efforts, Alice Rooney and the board had the good fortune of having George Davis as chairman of their ways and means committee. Board treasurer Jeffrey Atkin explains: "George liked [fundraising] . . . and he was good at it."

General scholarship funds had increased by 1986, with 1982 named scholarships supplemented by scholarships from Gretchen M. Boeing, Dan Klein, Mazda Distribution Northwest, Robert J. Orton Jr., Peter Rath, Robert Smith, and the Sheffield Phelpses. PONCHO continued to fund partial scholarships and a new, endowed scholarship was established by Ann Homer Hauberg for John H. Hauberg, joined, in 1987, by the Dale Chihuly Scholarship Fund. From the first partial scholarships disbursed in 1982, totaling $6,000, available funds had reached more than $45,000 in 1986, and by 1990 nearly $80,000 would be awarded. In 1996 scholarship donors would include Dale and Doug Anderson, Stanley Bernhard, Joan Bornstein, Charles and Andrea Bronfman, Frank Everett, E.W. Nash, Benson and Francine Pilloff, Kiki Smith, George Stroemple, and Samuel and Althea Stroum. Scholarships also would be established in honor of Alice Rooney, and in memory of Kotaro Hamada, Ann Lawrence, Loredano Rosin, and Hilbert Sosin.[53]

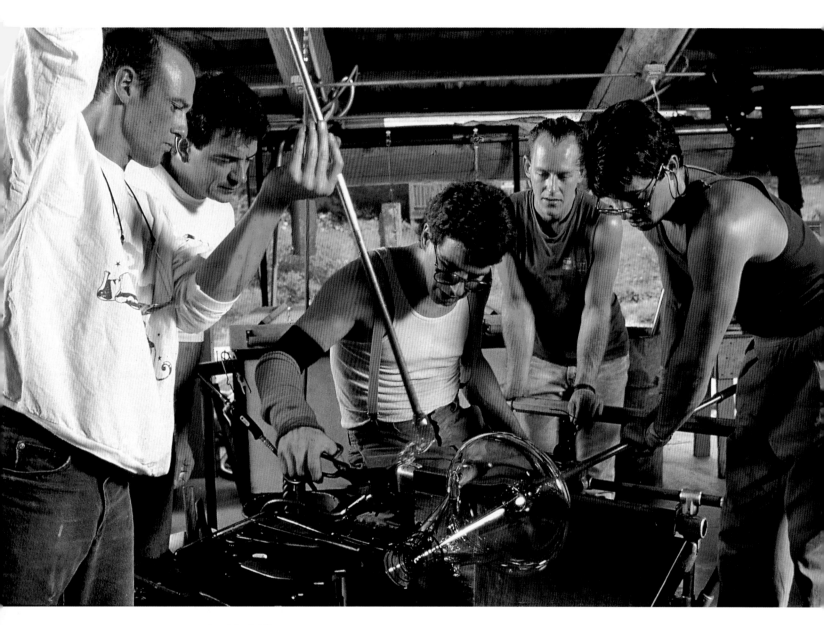

Left to right: Robbie
Miller, Dan Dailey,
Richard Royal, Peter
Hundreiser, and William
Morris in the hot shop,
1987.

1988–1990: New Directions in Art

None of the other craft-related materials have got the cachet of glass [and] . . . I think a lot of it has to do with Pilchuck. . . . Everybody has always been captivated by the glassblowers of Murano and talked about the grace and the beauty. . . . But nobody made it a phenomenon . . . [like] Dale Chihuly.

—Susanne Frantz[1]

"As the cutting edge of American studio glass, Pilchuck does not have any identifiable 'look,'" writes critic Ron Glowen, "but rather has fostered the idea of using glass as a material language to address formalist and content-derived concerns."[2] The popularity of glass at the end of the 1980s spawned collectors looking for "Pilchuck glass," exhibitions of "Pilchuck glass," and a wealth of articles about Pilchuck and glass in the Northwest, many making no real distinction between "Pilchuck" and "glass," let alone "Chihuly" and "glass." Was there such a breed of object as Pilchuck glass? Pilchuck veterans such as Fritz Dreisbach emphasize that no one style or technique can be identified as typically Pilchuck, and others agree. "For the past ten years I've been a juror on [Corning's] *New Glass Review*," remarks Corning Museum curator Susanne Frantz. "Every year we get over three thousand slides from all over the world and when we look at them, they are [unmarked]. . . . We don't know who made them unless we recognize the work. And I have never recognized a Pilchuck or Pacific Northwest style at all. I no longer see national or regional styles."

But some do see identifiable regional activity. "I don't know if there is a Pilchuck style, but there does seem to be a sense that Seattle is a major national and international center of glassmaking," comments New York critic Donald Kuspit. "There is an attitude, that might be regarded as common through the community, which is an experimental attitude. I think that comes from Chihuly. And Pilchuck is no doubt instrumental in furthering that attitude."[3] "I'm not sure if you can actually separate Pilchuck from Seattle," adds Toledo Museum of Art curator Davira Taragin. "Because of the fact that so many people who have gone to Pilchuck end up in Seattle. And the school has had such an important influence. There's much more of a concern for form on the East Coast, while coming out of Pilchuck, and coming out of Seattle, there is a greater sense of color, more multi-element installations, [interest in] scale . . . and the vessel form."[4] "When I think of Pilchuck," notes art dealer Ruth Summers, "I think of artists in collaboration more than anything else. Working as a team."

"As far as glassblowing goes, Seattle now is definitely the center," remarks Benjamin Moore. "There is no question about that as far as the number of studios and the number of proficient glassblowers, and that is really because of Pilchuck." "And we have a style here, too, I think," adds Sonja Blomdahl. "I think we are becoming very Italian and Kugler and big. There is that emphasis on size."

"When you look at glass that's made on the East Coast," observes Dante Marioni, "you see mostly cut and polished [pieces]. Everything in the Northwest pretty much

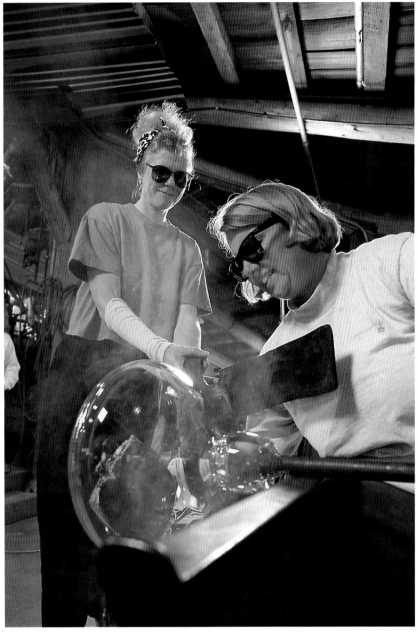

Sonja Blomdahl (left) and gaffer Ruth King, 1992.

started with Chihuly, and a lot of people followed his lead. Somebody came into my studio and said he was told that being a glassblower and moving to Seattle was like being an abstract expressionist in the 1950s and moving to New York. I thought that was a flattering analogy."[5] Some see Dale Chihuly as the Peter Voulkos of glass, distinct from—yet heir to—the abstract-expressionist tradition in ceramics, in which case such an analogy would be apt. And as the 1980s gave way to the new decade, Seattle—the "Manhattan of glass," as artist Ginny Ruffner christened the city—was unquestionably the place to be for artists working in glass.[6]

"Pilchuck 1988 may seem a far cry from Pilchuck 1971, yet the Pilchuck experience remains essentially the same," wrote Dale Chihuly in the 1988 Pilchuck catalogue. "Pilchuck started with the idea that art cannot be taught in the same way that other disciplines are. . . . Pilchuck is about ideas. Pilchuck is not about creating finished work or perfecting technical skills. . . . In 1988 we will be inviting only artists [in residence] . . . who do not use glass as their primary medium. And an experiment called the Pilchuck Graduate Workshop . . . will require participants to have two years of art experience but not necessarily experience with glass." Session I had Flora Mace and Joey Kirkpatrick in the hot shop teaching surface decoration on blown glass; Cappy Thompson teaching stained glass painting; Patrick Wadley and Mary White teaching surface decoration—engraving, sandblasting, electroforming, and painting—and Paul Stankard teaching soft glass lampworking with Elizabeth Mapelli and Daniel Schwoerer.

Pilchuck strikes me as having an extraordinary community experience, which is different from anything that I have seen at any art school or university art department.

—Donald Kuspit

Warren Langley, 1986.

Flora Mace and Joey Kirkpatrick were back in the hot shop for the second session, Ginny Ruffner taught lampworking, and Fred Tschida taught neon. John Leighton offered a course on the casting process, and Warren Langley taught fusing. "You walk into the place and there's fifteen people blowing glass," a visitor told Michelle Gyure in an article for *Glass Art Magazine*. "And over here there's a bunch of people casting, and back in another hall, there's people working on fused wares and painted wares. You can go in there and OD on any sort of glass-decorating methods available."[7]

Artists-in-residence worked with gaffers Dante Marioni, William Morris, and Richard Royal. As in the early years at Pilchuck, artist-in-residence sculptors and painters such as Nicholas Africano, Andrew Keating, Jerry Pethick, Pike Powers, Italo Scanga, John Torreano, and visiting artist Bill Woodrow stayed for days or weeks to make work. Visiting glass artists that summer included Ann Gardner and neon artists Deborah Dohne and Fred Tschida.

In the third session, Fritz Dreisbach and Marvin Lipofsky taught hot glass; Johannes Schreiter presented stained glass; Michael Glancy offered sandblasting, sand carving, and electroforming; and Diana Hobson taught *pâte de verre*. It would have been easy for a school as narrowly focused as Pilchuck to ossify, but Chihuly's frequent programmatic

Artist-in-residence Nicholas Africano, 1989.

changes and recruitment of a varied faculty and visiting artists over the years kept the school supplied with a steady infusion of new energy. Nevertheless, by 1988, many of Pilchuck's long-time faculty were restless. Session III was Fritz Dreisbach's first time back at Pilchuck in three years, and Paul Marioni made Session V his last as a teacher. "I [also] . . . think it's important not to come back year after year," remarks Bertil Vallien. "For the first three or four years everything was new to me. . . . Then I became like staff." For Vallien, the spontaneity was gone and "it just didn't work."

Session IV of 1988 had William Morris in the hot shop, with brothers Loredano and Dino Rosin teaching solid glass sculpture, described in the course catalogue as an

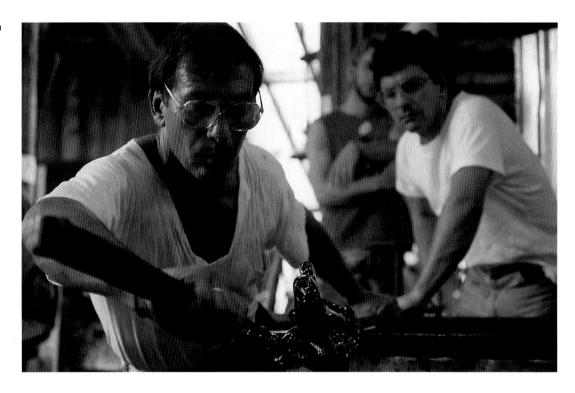

Loredano and Dino Rosin in the hot shop, 1988.

"Italian approach to the methods of sculpting solid masses of hot glass with extensive bit application." Bitwork is commonly part of the glassblowing process—bits, or pieces, are applied to make handles, for example—but used sculpturally, it involves building a form by applying successive pieces of hot glass onto the pipe, and then shaping or cutting or pulling them. Ludwig Schaffrath taught architectural glass, Ulrica Hydman-Vallien taught glass painting, and Jirí Harcuba taught engraving, this time with Ronald Pennel.

I realize Pilchuck is not really about doing only personal work but is in fact a place to gather force for when you're not there.

—Laura Donefer, artist[8]

The fifth session was the most unusual. Called a "graduate workshop," one juried class of forty-three advanced students was team-taught by Katherine Bunnell, Henry Halem, Paul Marioni, Judy North, Clifford Rainey, Bertil Vallien, and ten teaching assistants. Students would experience the process of making work—from beginning idea to finished product—with a diverse faculty of experienced artists.

The increasing length of the summer program over time necessitated additional part-time personnel, and by 1988, summer staff had grown to thirty people, plus forty-one teaching assistants. The kitchen crew had expanded to seven, and each

Walter Lieberman, 1989.

studio building had at least two coordinators. Norman Courtney had been rehired as a special artists-in-residence liaison, and Walter Lieberman was asked to be the overall coordinator for Session V. Full-time staff had stabilized at seven people: Rooney, Chihuly, Reed, registrar Cheryl Smith, development officer Janice Dilworth, bookkeeper Sabrina Haber, and maintenance man Richard Nisonger. In June 1989 Chihuly would request that Joey Kirkpatrick become assistant artistic director—essentially taking over part of

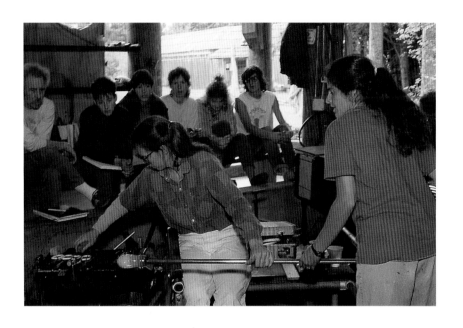

the position vacated by Benjamin Moore.[9] Kirkpatrick held the job for only four months, feeling that she was ill-suited to it. William Morris succeeded her in October 1989.

Pilchuck's 1989 magazine-format catalogue of course offerings brimmed with application procedures; class descriptions; lists of Pilchuck staff, trustees, and councils; and records of contributors. The five-session program was particularly ambitious,

Flora Mace (left) and Joey Kirkpatrick teaching in the hot shop, 1989.

offering a special masters class for advanced students with Stanislav Libenský and Jaroslava Brychtová, and a graduate workshop. Session I brought Flora Mace and Joey Kirkpatrick to the hot shop, Ginny Ruffner taught lampworking, Diana Hobson offered *pâte de verre,* Fred Tschida investigated neon, and David Wharton and Judy North taught vitreography.

During Session II Therman Statom returned to teach hot glass. Cappy Thompson and Walter Lieberman taught glass painting, David Hopper offered glass painting on blown forms, Mary Shaffer taught kiln-formed sculpture, and David Huchthausen presented sculptural techniques for cold glass in the cold working studio. Session III was given over to the graduate workshop, which attracted more than forty students, team-

Pilchuck . . . is infectious, it's exciting, it's exploring, there's no such thing as no.

—Dale Anderson, trustee[10]

taught by José Chardiet, Henry Halem, Pike Powers, Clifford Rainey, Amy Roberts, Susan Stinsmuehlen-Amend, and ten

teaching assistants. Artists-in-residence during the first three sessions included painter/ sculptor Nicholas Africano, photographers Marsha Burns and Michael Burns, and sculptors Judy Pfaff and Bill Woodrow.

Stanislav Libenský and Jaroslava Brychtová's five-week masters class, taught with the assistance of Charles Parriott, bridged Sessions IV and V. While the seminar emphasized casting techniques, students also practiced nature studies, drawing, creating models, and building three-dimensional compositions. Students worked on small, individual pieces

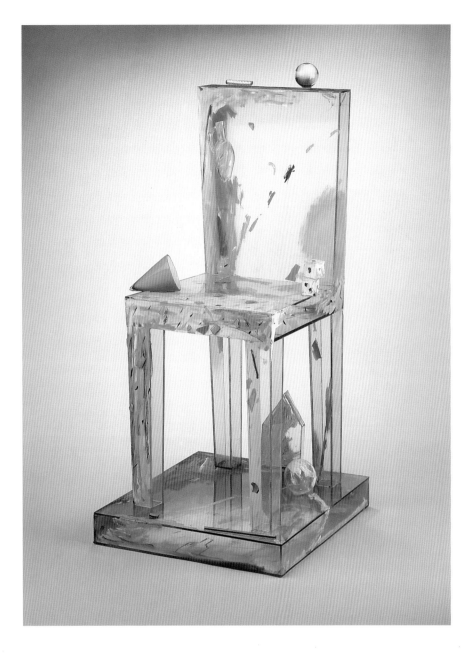

Therman Statom
(American, b. 1953),
Chair, 1987. Assembled,
glued, painted glass,
h. 48 in.
Los Angeles County Museum
of Art, Black American Artists
Fund.

Students drawing from
life in an exercise for the
masters class taught by
Jaroslava Brychtová and
Stanislav Libenský,
1989.

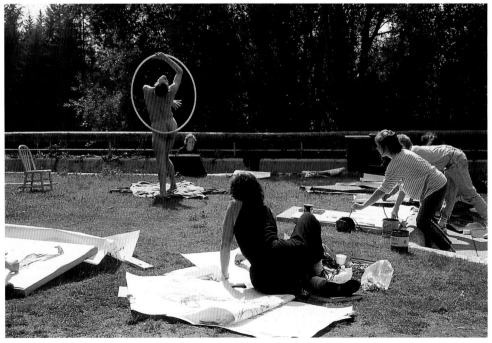

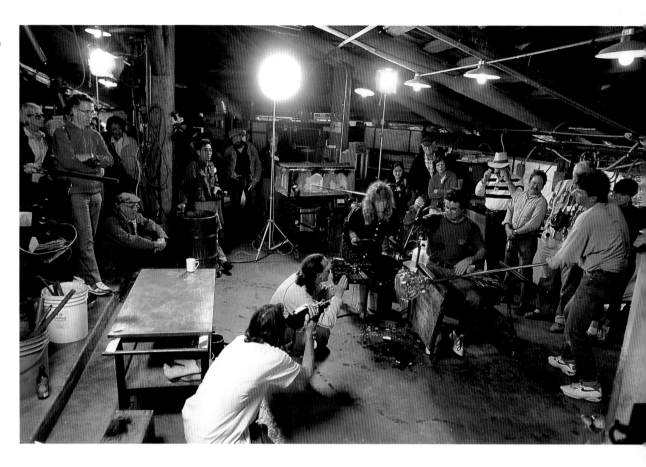

as well as assisted the Libenskýs in creating a large sculpture. Session IV also offered
stained glass taught by Paul Dufour and Rachel Mesrahi, surface decoration on glass and
mixed media with KéKé Cribbs, sand casting and sand-mold blowing with Robert Carl-
son, and hot glass sculpture with William Morris and master Italian glass sculptor Pino
Signoretto. Artists-in-residence, in Session IV, were sculptors Dennis Oppenheim and
Italo Scanga, and, in Session V, John Torreano and sculptor Robin Winters.

Pino Signoretto, like most European glass artists at Pilchuck, was delighted to expe-
rience absolute freedom of expression. "Whenever I tried to get beyond a certain point
[in Murano], there was always a wall created by those before me, or those that were
supposedly teaching me," says Signoretto. "They would say, 'You can't do this, you're
not supposed to try that.' . . . I want to give everything I can to the students: I don't like
the way there have always been trade secrets in Murano, the professional skills that the
maestro hid from you, that you were supposed to go off and discover on your own. I
want to take away that barrier between teacher and student. We are all walking along
the same road." For Signoretto, seeing women in the hot shop was a revelation. "If I had
ever thought women were incapable, I was wrong," remarks Signoretto. "Men are used
to first using their strength and then maybe their heads. Women are the opposite, they
must use their brains before their strength, and if I hadn't come to America, I might not
have learned that."[11]

Pilchuck's last session brought Lawrence Jasse, Ann Wåhlstrom, and Richard Royal
to teach "Hot Glass Design: Art and Craft," while Jiří Harcuba taught engraving. Dana
Zámečníková taught "Illusory Space in Glass" with Marian Karel, and Bertil Vallien—in

his tenth consecutive summer at Pilchuck—taught his annual casting course for the last time, returning to teach only sporadically in the 1990s. For Vallien, it was particularly hard to give up the end-of-session glass theaters. "[In 1992] . . . we had all this pressure from the other classes to create a drama. . . . So I decided just to make it very [simple]. . . . We only worked with four candles and sand and no glass. And it came out . . . very beautifully, but there was no drama." The 1989 performance, however, had been another matter, with people dressed in black, chanting the Apocalypse, and a ritualistic near-burning of the hot shop. "If any of the locals had come up here," recalls Alice Rooney, "they would have thought we were a satanic cult!"

The board is vigorous and ready to accept a new leader as I step down (but not out) next April.
—John Hauberg, 1987[12]

As early as 1983 John Hauberg had announced his intention to resign his position as president of Pilchuck's board of trustees. "I would like to remain president three more years," he wrote to Robert Seidl. "I would tolerate two more years, but would clearly prefer not to remain president until 1988. I would refuse to serve after that."[13] Pilchuck's board strung along John Hauberg's presidency as long as they could, but he kept good on his promise: come the annual meeting of 1988, Hauberg stepped down, after ten years as president of the board. "We knew John as the 'benevolent dictator,'" Seidl remarks. "He did exactly what he wanted because of his immense influence, and what he did was always right. But he recognized that this couldn't go on forever." It took C. David Hughbanks four hours and an equal number of martinis to convince Seidl to accept the presidency because, as Hughbanks puts it, "nobody wanted to be the next John Hauberg."

In his first year as president, Robert Seidl faced many transition issues: increasing conflict between Alice Rooney and Dale Chihuly, programmatic changes, the need for additional staff housing, and board welfare. "A slogan I often used when I was president was that I liked 'respectful combat' because out of that came some very good things," says Seidl. "I was in the middle of some pretty violent debates and discussions about changes in the structure of the organization. . . . Artists and administrators, well, they are sort of natural enemies. . . . But everybody rose above the problems."

Without Hauberg's firm guidance, everything—the board's structure, committees, building endowment, facilities upgrading, the annual auction, and broadening of the board's geographic base—needed group affirmation, something much harder to come by than action from one skilled decision maker. "While John was president, we didn't have to do much," comments 1995 board president Mark Haley. "We weren't expected to give if we didn't want to. . . . We weren't expected to raise [large amounts] . . . of money. We were expected to show up and give ideas."[14] Now, with board presidents changing every two years, the trustees would be obliged to draw together and function effectively as a group. "If you look at a start-up company in a new area which is very successful, two

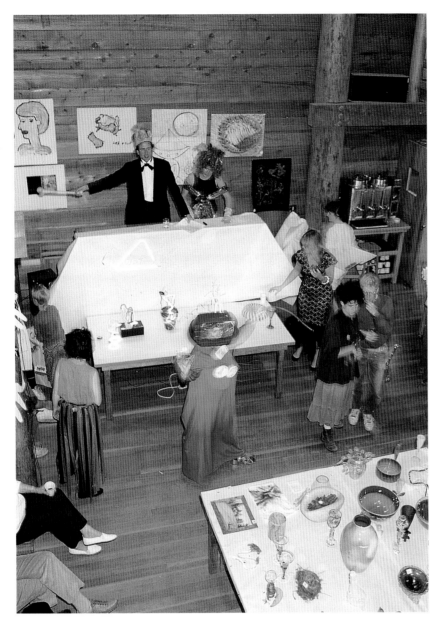

Student-to-student auction with auctioneers Craig Graham and Ginny Ruffner, 1989.

out of three times that company will disappear at the point of transition from the entrepreneurial founder to broader public support," observes trustee Douglass Raff. "It may go public, but it never gets over losing the charismatic leader. It's hard to imagine now [in 1995], but I can see that Pilchuck might have disappeared."

Thanks to auction cochairs Babo Olanie and Mary Shirley, neither Seidl nor the board had to worry about the 1988 fundraiser. The event was attended by six hundred people who participated in live and silent auctions. For the first time, glass table centerpieces were specially made at Pilchuck for the event and sold to the highest bidder. Total revenue for the evening was an astonishing $217,000, with net proceeds of more than $170,000.[15] The 1989 auction would bring in around $200,000, and although expenses were higher in 1989—primarily due to increased advertising—the school still netted more than $156,000.

LaMar Harrington and Gary Glant retired from the board in 1988, the same year that James Anderson and Parks Anderson joined. In 1989 Alan Black, Mary Alice Cooley, Ann McCaw, and Jack Benaroya were new trustees. Sam Rubinstein returned in 1989, after an absence of three years, to help the board during its transition from the Hauberg era. Longtime trustees Robert Block and John Ormsby left in 1989, as did Laura Partridge, bringing the total number of trustees to thirty-six.

With the growth of the board and the absence of Hauberg's unilateral governance, an executive committee—charged to act between meetings, if necessary, on behalf of the entire board—was deemed a necessity. Formed in July 1989, the committee was chaired by Robert Seidl and included John Anderson, Dale Chihuly, Gretchen M. Boeing, John Hauberg, Alice Rooney, and Sam Rubinstein, with Jack Benaroya as an alternate.[16] "The board is strong because it is a board that is diverse in the right ways," observes Douglass Raff. "Because they are people who all have a common interest in what the

school does, they have a common ground where they can always talk politely with each other, [even when] . . . they disagree. . . . When they had to do the tough things, they did them right away."

Spring 1990 began poorly for the school. Tensions had brewed to boiling between Alice Rooney and Dale Chihuly over the budget, issues of new staff housing, the addition of a print program, and a new fall residency program for emerging artists that Chihuly wanted to implement but which Rooney felt the school could not afford. And other longtime Pilchuck faculty had begun to feel left out of the loop. Artists at Pilchuck had minimal contact with the board, although some had been assigned to advisory committees and they could attend board meetings. But no glass artists sat on the board. "I think it always gets down to the struggle about whose school it really is," observes John Anderson, who succeeded Robert Seidl as board president in 1990. "The people who are and historically have been vocal against [the administration] . . . are the ones who were there in the beginning and feel a sense of ownership."[17]

In April, 1990 Anderson sent a memo to Alice Rooney and assistant artistic director

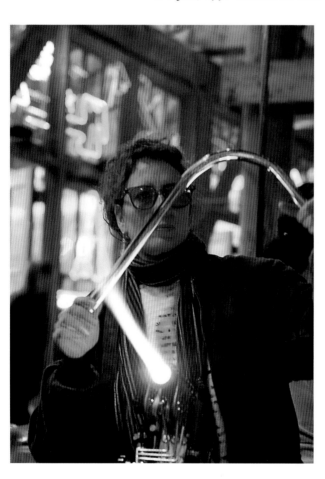

Susan Plum, 1987.

Opposite:
Richard Royal, 1989.

William Morris announcing a temporary leave for Chihuly: "This will confirm the commitment that I have worked out with Dale. He has decided to take a six-month sabbatical leave from Pilchuck . . . and during his leave, he will be available only . . . to Bill Morris or me. At the end of the six-month period, he will decide what his association will be at the school."[18]

In spite of internal tensions, Pilchuck offered a promising 1990 season. "The sense of opportunity is inherent in our summer program," Rooney wrote in the catalogue. "Opportunity to participate in classes taught by internationally respected artists and enhanced by the presence of artists in residence who are outstanding painters [and] sculptors."[19] Summer 1990, like the 1989 season, was stabilized at five two-and-a-half-week sessions with five classes each. Tuition, room, and board ranged from $1,300 to $1,700 per session which, compared with 1982 costs, showed an increase of about 40 percent over eight years, while the budget had climbed more than 150 percent during the same period, from almost $300,000 in 1982 to nearly $800,000 in 1990.[20] Despite increasing operating expenses, Rooney noted in the 1990 catalogue, "Pilchuck's board of trustees . . . voted not to increase tuition, housing, and board fees this year. . . . In addition, they voted to increase the amount of scholarships in 1990."

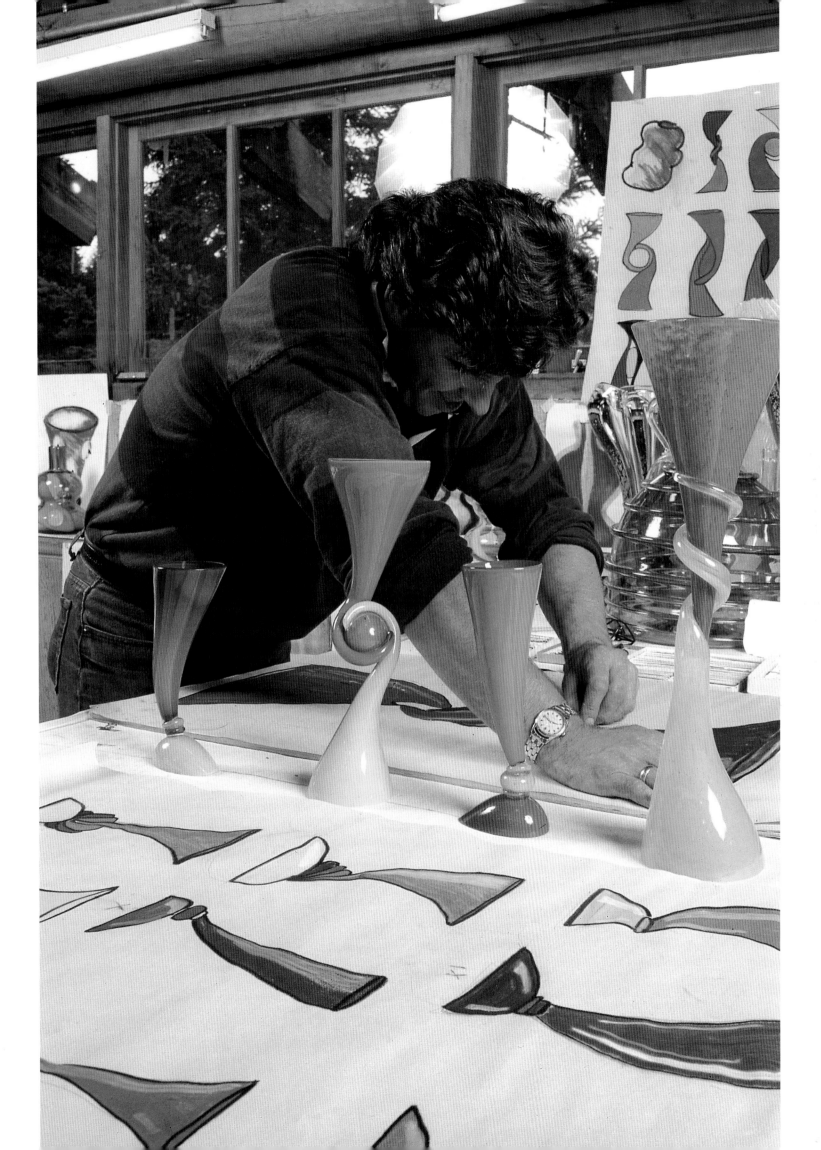

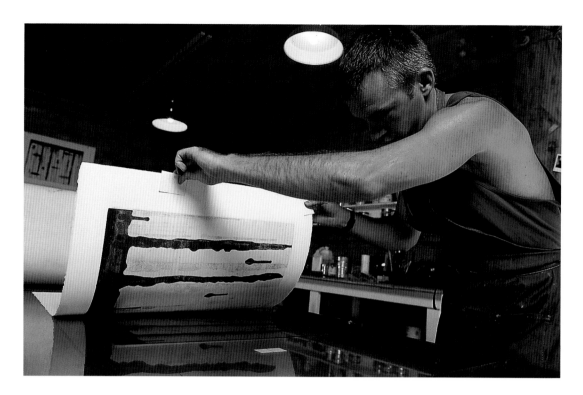

The first session of the summer began with Flora Mace and Joey Kirkpatrick teaching in the hot shop. Susie Krasnican taught painting and sandblasting, British artist David Reekie demonstrated lost wax and *pâte de verre* casting for sculpture, and Henner Schroder presented sand casting. Susan Plum introduced her unique brand of large-scale lampworking. Artists-in-residence for Session I were sculptor/painter Judy Pfaff and painter William T. Wiley. "I felt privileged to teach at a place which had been known to me since the late seventies as a mecca for glass artists," wrote David Reekie. "Compared to what I was used to in England it was a glassmaker's paradise with pine trees and real wildlife. . . . I had a great bunch of students . . . who were all very keen and worked incredibly hard. . . . It was incredible how a group of people who, for the most part, had never met before became such a strong community within a few days."[21]

For the second session, Richard Royal taught glassblowing, while Dante Marioni offered goblet and vessel making, followed in Session III by Amy Roberts's course called "New Visions in Hot Glass" and José Chardiet's class in sand casting. Fred Tschida taught neon during the second session; Liz Mapelli gave a course on slumping, fusing, and public art; and Ginny Ruffner taught lampworking in her seventh straight summer. They were followed in Session III by Jan Mares teaching engraving and cold working, Paul Stankard teaching lampworking, and Stanislav Libenský and Jaroslava Brychtová, who, with Henry Halem, conducted part one of a masters class for advanced students. Artists-in-residence in Session II were painter Laddie John Dill and sculptor Michele Blondel, followed in Session III by sculptors Dennis Oppenheim and Donald Lipski.

Session IV brought William Morris and Pino Signoretto to the hot shop for a class in hot glass sculpture; Mark Peiser taught designs in solid glass. The Libenskýs continued with the second part of their masters casting class, while Albinas Elskus returned to teach

Susan Stinsmuehlen-Amend (American, b. 1948), *Bacchante Texana*, 1985. Cut, leaded, etched, engraved, and laminated glass, mixed media, 48¼ x 16¾ in. Corning Museum of Glass, Corning, New York.

stained glass painting. Susan Stinsmuehlen-Amend introduced a class in glass and mixed media, and John Torreano was artist-in-residence.

The once-controversial print program was new in 1990 and very popular. "The print program is 110 percent successful educationally," reported assistant artistic director William Morris at the July board meeting. "It seems that there are not enough hours in a day to print. All but one artist-in-residence have printed. . . . There is a different master printer every session [and] . . . it is a very significant program for the school."[22]

Summer 1990 closed with Michael Scheiner offering "Glass as a Sculptural Medium" in the hot shop, Robert Carlson teaching glass casting and sand-mold blowing, and Dan Dailey—back as an instructor for the first time since 1985—teaching surface decoration for hot glass. Klaus Moje offered a course on kiln-forming techniques and Hans Gottfried von Stockhausen taught glass painting and glass printing. Artists-in-residence in Session V were painter Tom Marioni, Paul Marioni's brother, and Italo Scanga, working at Pilchuck in his fifteenth summer. Other artists-in-residence that summer included nonglass artists Nancy Bowen, James Drake, and Barbara Schwartz.

Tensions in the Pilchuck community did not go unobserved. "I have been coming to Pilchuck for seven years, first as an artist-in-residence and then as a teacher working with glass casting," said Stanislav Libenský at a faculty debriefing. "I can say to you that this school does not exist anywhere else in the world. The artistic problems spoken of here will always exist. An artist without doubts is not an artist."[23] Other faculty noted that students appeared to have become more conscious of the political advantages of attending Pilchuck. "The idealism and camaraderie of the 1970s and 1980s seem to have been pre-empted by self-promotion, status seeking, and political cronyism," explained Susan Stinsmuehlen-Amend in a memo. "Generally, I can accept this turn of events as part of the natural process of a dissolving revolution. . . . Within the microcosm of Pilchuck, experiencing these changes painfully amplifies the loss of community spirit."[24]

It's too bad because I never really had any conflict with Alice. She was very easy to get along with. But there was this weirdness going down.

—Dale Chihuly

It was absolutely strange. . . . I don't know what it was that Dale was so upset about.

—Alice Rooney

"Pilchuck really is a family, with lots of different members in it," Alice Rooney told Karen Mathieson of the *Seattle Times* in the fall of 1990. "And as in so many families," Mathieson continued, "'irreconcilable differences' has become the polite code phrase for divorce. In late September, just a few days short of her tenth anniversary as Pilchuck's executive director, Rooney resigned. Simultaneously, Pilchuck's longtime artistic director, Dale Chihuly, left that role to take a seat on Pilchuck's board of trustees."[25] Rooney's forced departure created a storm of controversy, and rumors

spread throughout the glass community. The local press speculated on the surprising chain of events. "Rooney did not share [Chihuly's] . . . expansionist outlook," wrote Bruce Barcott for the *Seattle Weekly*. "The bitterness between Chihuly and Rooney built up gradually over the past few years . . . [and] to solve what had become an intractable problem, the executive committee . . . [of the board of trustees] decided to replace Rooney as well as Chihuly." "Friends of Rooney who knew the 'real story,'" continued Barcott, "were outraged at her treatment."[26]

The glass community was stunned by the suddenness of the changes, and both artists and trustees felt betrayed by the unilateral decision of the executive committee. Kate Elliott observes that "it was ugly. It's always ugly. But administrators come and go while visionaries do not." "[John] Anderson circulated a damage-control memo to Pilchuck artists and staff on October 1, two days after a *Seattle Post-Intelligencer* story broke the news of Rooney's resignation," wrote Barcott. "Anderson announced that he had volunteered to serve as director/manager of the school until a new director was found. . . . He also encouraged people to talk with him directly about their concerns, [saying] . . . 'Rumors without full facts can do more to harm the school than anything I can think of.'"[27]

"After Alice Rooney left," wrote John Anderson in 1994, "I volunteered to become the interim director of the school while an international search was made for a new director. . . . William Morris acted as the artistic director and Kate Elliott acted as the key person in the office."[28] Elliott remembers that the office situation

The years that Alice Rooney put in [at Pilchuck] . . . transformed that school from tents in the woods to a national institution with an international reputation.
—Robert Carlson

was difficult. The development officer, Cheryl Smith, had given Rooney notice, but stayed to help with the annual auction. "It was simply crisis management," says Elliott. "John Anderson was trying to make everything go as smoothly as possible . . . and he wasn't there wielding his power. Basically, we were all in charge . . . and in a funny way I liked it because it was more democratic. It was truly a team effort."

While the administration was reorganizing in its winter office in Seattle, the first fall residency for emerging artists had begun up at Pilchuck. Fall artists-in-residence Stephen Paul Day, Deborah Dohne, Roberta Eichenberg, Amy Hamblin, and Jill Reynolds had use of all studios except the hot shop (which was rented off-season by William Morris) and stayed at the school from mid-September through mid-December. At the end of the residency, Dohne wrote a letter in support of the program to the board of trustees (who had originally opposed the idea): "I certainly hope this program will continue so that other artists can enjoy a similarly outstanding experience. . . . It was one of the best experiences I have ever had. . . . Pilchuck provided the ideal environment for me to work and think . . . and as I leave, I leave with many fresh ideas, new work, and some very special new friends."[29]

Pilchuck continued to weather the fallout from Rooney's departure. "There was a lot of ill feeling in the art community during that year," recalls John Anderson. "And I met with every single person that complained. I went to about twenty different studios and just sat and talked to people. . . . I'm not saying that the people close to Alice ever agreed with the decision, but I think they might have understood it better." Paul Marioni remembers that when Rooney left, many artists considered boycotting Pilchuck but he protested, feeling that it would hurt the school. "Schools can end over things like this and what really happens?" asks Marioni. "You convince the board that yes, they were wrong, but the school might be sacrificed in the process."

Anderson became convinced that the friction between the artists and Pilchuck's administration might dissipate if artists were sharing in decisions being made at the board level. Although some trustees objected, in 1991 four artists were invited to serve on the board—Joey Kirkpatrick, Benjamin Moore, William Morris, and Ginny Ruffner—joining Dale Chihuly, who had been appointed in 1990 (Daniel Baty also came on the board in 1990, replacing outgoing trustee James Anderson). "It felt a lot more comfortable," observes trustee Susan Brotman, "to have artists on the board being part of the solutions."

The one positive note in an otherwise bleak fall was the 1990 auction, celebrating Pilchuck's twentieth anniversary. The event netted $232,000, while a new feature, the Collectors' Weekend, had brought in an additional $3,700, for a total net of $236,000, an impressive $60,000 more than any other auction in the school's history.[30] Heading into its third decade, Pilchuck had remained an extraordinary achievement. The "wonderful institution in the Stanwood forest"[31] was entering into another energetic period of change and growth with the leadership of a restructured board and, soon, a new director.

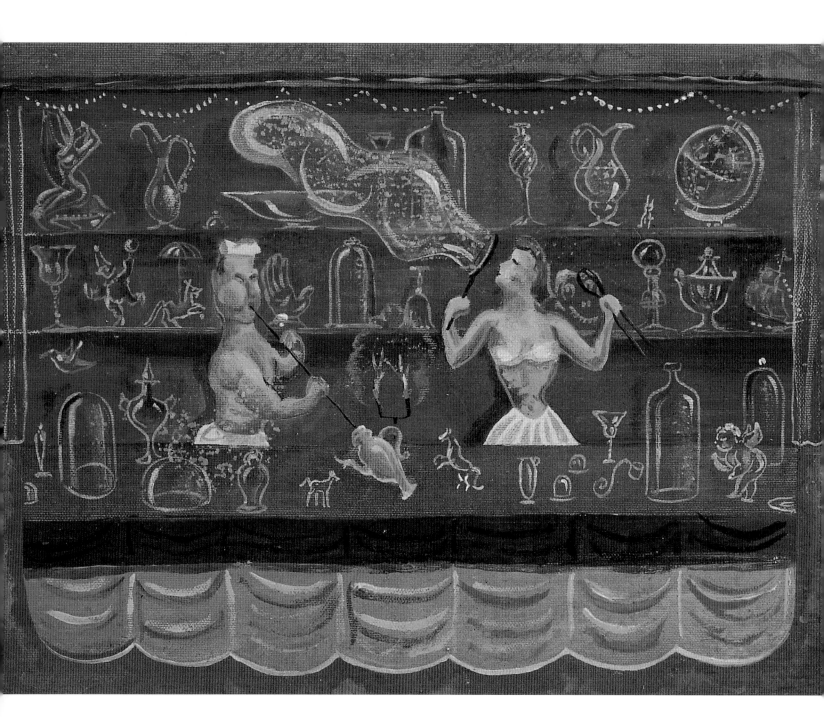

Pike Powers (American,
b. 1956), *Artists in
Glass*, 1995. Oil on can-
vas, 11 x 14 in.
Courtesy Elliott Brown Gallery,
Seattle.

The 1990s: Pilchuck at 25 Years

I feel like we're part of living history.

—Francine Pilloff, trustee[1]

While a board committee searched for a new director of the Pilchuck Glass School, acting director John Anderson, artistic director William Morris, and office manager Kate Elliott planned the school's 1991 season. "It was an exciting period," remembers Anderson. "People whom everybody thought indispensable were gone, yet we had a greater attendance and things worked better than they ever had. The biggest challenge was . . . to get everybody working together again."

The search committee was helped in its quest by trustee George Saxe, who recommended Marjorie Levy for the directorship. Levy, a ceramist, wanted to step down from her position as dean of the art school at the University of Michigan, Ann Arbor. Although she had found her niche as an academic administrator, she was ready for a change after five years at Michigan, preceded by fifteen years as instructor, then professor and chairman of the art and design division at Purdue University. Levy had planned to go to Bali and design silver jewelry, but instead ended up in Stanwood, at Pilchuck.

A trustee of both the American Craft Council and the National Council on Education for the Ceramic Arts, Levy knew the Saxes and other collectors as well as a number of glassmakers. She was familiar with Pilchuck (she had even seen the school's first poster in 1971 at her alma mater, the Philadelphia College of Art), and she was acquainted with Alice Rooney. "The Pilchuck job came across my path [as a] regular mailing," recalls Levy. "And I looked at it and thought it might be interesting. . . . Then [the search firm] called me directly and were very aggressive. I saw there were opportunities [and] . . . I felt I had knowledge of a number of worlds that Pilchuck touched. It sounded like a challenge, a nice, doable challenge."[2] Yet Levy was not sure she wanted the job to displace her upcoming sabbatical leave from Michigan. Sam Rubinstein, the chair of the search committee, had made it clear that she had the position on her terms, if she wanted it, but it took a fax from Chihuly—then in Tokyo—to convince her. "I wondered what the stability of all this really was," says Levy. "Would the funding continue, or would I find debt? And there had been some awkwardness between Alice and Chihuly. I was waffling . . . and they had stopped calling me. And I thought, 'That's too bad because I would have liked that job.' Then I got a fax from Chihuly saying 'You'll be great at Pilchuck. You're the right person [and] I hope you accept the job.'"

Levy arrived at Pilchuck in August 1991. She faced the immediate tasks of defining her role at the school and her relationship with the board which, Levy remembers, "was

History is such a beautiful thing when it's born. It makes such an impression, people want to talk about it and pay attention to it and lead their lives by it. And that's when it becomes a big suffocating weight, you know, history.

—Pino Signoretto

Marjorie Levy, 1996.

in fine shape and quite well-organized." John Anderson resigned from his position as board president that fall, having devoted more than a year to the school. He was succeeded by the sixth board president, C. David Hughbanks. "That first summer was not easy," remembers Hughbanks. "I'm not sure what the artists wanted to see happen to the school. . . . We felt our way down the rocky path of that first year or so, and it took time for things to mellow out." With his background in boardsmanship and committee structure, Hughbanks moved to balance the representation of ages and interests among trustees. "He was able to help us mature as a board," remarks Mark Haley. "In terms of understanding our roles, accepting our roles, and educating us in our roles."

On the recommendation of the board operations committee, the trustees approved the formation of a Pilchuck Glass School Advisory Council in 1992. The council's stated purpose was to enable individuals who had made extraordinary contributions to the school to continue their relationship without the burden of a trustee's responsibilities.

Marge landed running, and we weren't ready for someone who knew more about Pilchuck than we did.

—Babo Olanie, trustee[3]

The first members of the new Advisory Council, elected to membership for staggered terms, included founder Anne Gould Hauberg and former trustees Thomas Buechner, George and Mary Davis, LaMar Harrington, and Joseph McCarthy. By 1995 these members had been joined by John Anderson, Thomas Bosworth, Johanne Hewitt, Frank Kitchell, Mimi Pierce, and Jon and Mary Shirley.[4]

Joining the board in 1991 were Dale and Doug Anderson, Randall Rubenstein, and Richard Swanson. Tom Alberg, Parks Anderson, and Ann McCaw left the board that year, as did longtime trustees Thomas Bosworth and George Davis. In 1992 Ann Croco, Francine Pilloff, Sheri Kersch-Schultz, and Patricia Wallace came on the board, succeeding Mary Alice Cooley, Vicki Glant, and longtime trustee Frank Kitchell. The makeup of the board was gradually changing as younger people—both local and out of state—and artists became trustees. Trustees like the Saxes and Ted Nash in California; the powerful

fundraising duo Dale and Doug Anderson, living in New York and Florida; and Ohioans Francine Pilloff and her husband, Benson, who joined the board in 1993, provided invaluable support for the school outside the Pacific Northwest. "I have watched the board expand to a national and international board, and the new members, both local and out of town, are responsible for much of the current growth and success," notes John Anderson.[5] "To quote a friend," adds Robert Seidl, "the new trustees average down the age and up the intelligence of the entire board. I have been delighted with their vibrancy and initiative."[6]

Students watch Bertil Vallien casting in the hot shop, 1992.

One of the younger trustees, Richard Swanson, was appointed to manage the board's long-range planning effort in May 1992. A planning retreat resulted in a comprehensive report that outlined recommendations on seven topics critical to the school—mission, educational programs, students and summer staffing, facilities, finances, administration, and trustee governance. "We have frequently asked the question, 'Who owns Pilchuck?'" wrote Swanson in the foreword to the report, distributed to the trustees in July 1993. "As a dynamic educational and artistic environment, Pilchuck belongs to those whose lives, values, and creativity it has influenced—whether student or faculty, trustee or staff, artist or visitor. Like most successful educational and nonprofit organizations, Pilchuck's owners are constantly changing. It is the responsibility and privilege of those whose lives have been enriched by the 'Pilchuck experience' to help find ways to impart it to others."[7]

> **We started to get younger board members who were the same age as the artists. . . . Their ability to connect with each other was completely different than with the older board members.**
> —C. David Hughbanks

Fritz Dreisbach polishing the surface of an engraved commemorative goblet for the Corning Museum of Glass in celebration of the thirtieth anniversary of the studio glass movement, 1992.

Pilchuck's mission in 1990 had remained essentially unchanged from its 1985 form, with some interesting exceptions: one of the school's 1985 objectives—"serving as a center of communication concerned with the continual expansion of public interest in glass art"—was no longer felt to be part of the school's mission. "Developing a stimulating environment of excellence and creativity" had become the school's primary objective in its 1990 statement, replacing the 1985 position of Pilchuck as the "premier school for teaching and expression of art involving glass." The board also had amended the mission in 1990 with a statement of their intention to pursue excellence tempered by responsibility in funding. Revisiting the mission during the 1992 long-range planning retreat, the board reinstated the school's primary objective as being the "premier school . . . for art involving glass."[8]

Issues and tasks that surfaced in the long-range planning process included organizing a reunion celebration of the school's twenty-fifth anniversary, commissioning a publication on the school's history, establishing a major endowment for scholarships, and completing a master plan for campus housing, studio spaces, and a learning center. A development committee was assembled to address the funding of these projects. "One of the things that came out of the long-range planning process," observes Richard Swanson, "was the confirmation that we should see the board as a place where artists and their concerns come together with the perspective of trustees from the business and philanthropic community. Up to that point, I think that the board had been viewed more as just the benefactors."[9]

The long-range planning process also stimulated recognition of the need for additional year-round staff, specifically an artistic director and a development director.[10] Levy had been expected to take on both of these responsibilities, which soon proved overwhelming. Concerns about the artistic direction of the school, in particular, had been developing long before Levy's tenure. Trustees had been edging into ownership of artistic and educational programming, domains previously held exclusively by artists, who felt themselves best qualified to make decisions about how artists are educated. The ultimate solution—the establishment of two new directors who, with the director of operations,

would report to the executive director—was deceptively simple. Engineered by Mark Haley, the idea had to be sold to the board. "It was a big investment and people still think it's rather expensive," says C. David Hughbanks. "But the truth is, it has proved to be the right [decision]."

In 1993 Pike Powers, a painter, sculptor, and glassblower who received an MFA in sculpture from Yale University in 1987, was hired as artistic program director. She came

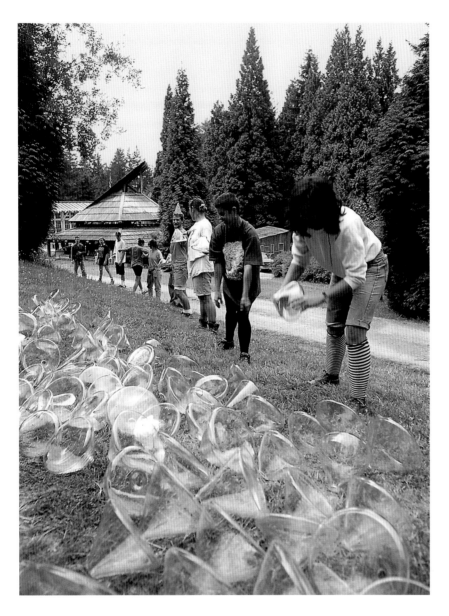

into her position citing the "preservation of the Pilchuck spirit" as one of her most important responsibilities and began working with the newly established artistic program advisory committee.[11] Michelle Hasson, formerly with the Northwest AIDS Foundation, Seattle, became Pilchuck's development director in 1993, and the board's longstanding development committee became her domain.

The Pilchuck board saw significant growth in 1993 and 1994. David Bennett, Fritz Dreisbach, Henry Hillman Jr., Gaylord Kellogg, Ginny Meisenbach, Benson Pilloff, Eric Russell, and Susan Steinhauser became trustees in 1993 as John Anderson, Daniel Baty, Alan Black, Johanne Hewitt, William Morris, and Mary Shirley rotated off the board. "There is a lot of talent on the board, a lot of commitment," remarks Sheri Kersch-Schultz. "Other organiza-

Artistic program director Pike Powers working with staff and students on a multiples project, 1994.

tions that I have been involved with are typically much quieter."[12]

Mark Haley became the board's seventh president in 1994, succeeding C. David Hughbanks. Gaylord Kellogg left the board, as Chap Alvord, Jim Henderson, Paul Isaki, Dan Levitan, Ruby Love, Darle Maveety, and Sherry Paulsell became trustees. By 1995 the number of trustees had swelled to fifty-two with newcomers including Ron Brill, Sarah Davies, Robert Fisher, Jackie Kotkins, Josiah McElheny, Betsy Rosenfeld, and Linda Stone, who replaced outgoing trustees Ann Croco, Ruby Love, and Sherry Paulsell.

Mary Shirley took Pilchuck's 1992 auction to a new level. With her husband, Jon, Shirley began by procuring major underwriting for the auction and then dissected the

event. "We had a 'laundry list' and our challenge was to tick off every single item on the list that we felt should be changed or improved," recalls Jon Shirley. "We changed the venue, moving it from the Sheraton to the Westin. We changed the auctioneer; Mary recruited Kip Toner, [who] educated himself about glass. We changed the day of the week. We instituted a preview night. We improved the menu. We changed virtually everything."[13] The Shirleys' favorite part about the evening? "The results!" laughs Shirley. "[We netted] over $400,000." The Shirleys give some of the credit to Marjorie Levy for the success of their event. "Marge has been doing a great job in finding ways to raise money for the school," says Jon Shirley. "She has been very clever in . . . getting more out-of-state participation in the auctions and that has made a tremendous [difference]." By 1995 the auction had achieved its next goal: more than half a million dollars were spent on glass in one evening, a success that no one attending that first, tiny auction in the Pilchuck lodge, sixteen years earlier, ever would have predicted.

I think the acid test, for Pilchuck, is that new people continue to come and be influenced and . . . touched at some deep level.

—Richard Swanson

The format of Pilchuck's summer program stabilized in the 1990s at five two-and-a-half-week sessions of five classes, each averaging about ten students. In addition to faculty and teaching assistants, two artists-in-residence from various disciplines attended each session. Enrollment reached its limit of approximately 250 students per summer.[14] Compared to the 1970s and early 1980s, when the school's administrative structure was relatively simple, Pilchuck appears to have grown administratively top-heavy in the 1990s. "The school hasn't really grown in numbers," explains John Reed. "But the world and the system and the program have become so much more complex. The number of people we choose from to set up the faculty, for example, or the number of suppliers that I deal with. . . . The only way a smaller group of people could do that—which we did in the early days—would be to work day and night."

The greatest expansion occurred at the board level, in both new trustees as well as guests invited to serve on various committees. Pilchuck could afford its nominal administration and maintain its insularity in the early days, but expanding programs, added scholarships, and growing facilities—plus a more or less static tuition—created a funding gap that had to be closed with community involvement. "Pilchuck has gotten bigger because we are exploring more aspects of the medium," says Mark Haley. "As the school has gotten more sophisticated, as the people involved in the school have expanded their horizons, so have the horizons of the school expanded. . . . It is the scope of the school that has gotten bigger."

"Technically, the school is about the same as it was in 1988," remarks Pike Powers. "The balance of Pilchuck's development has gone into the administration, and there is now a certain ease in the way registration takes place, how communication happens."

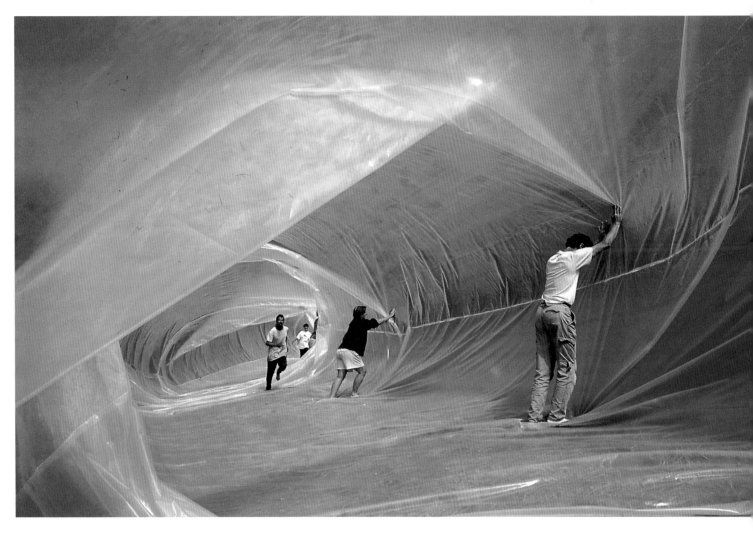

Students preparing an outdoor installation, 1994.

"Our philosophy is to be the best glass school in the world," adds John Reed. "But we don't necessarily have to be the best technically. We [aim] to have the best equipment for what we do here . . . but there are so many more glass studios out there, so much more sophisticated equipment. Yet we've learned over the years that there is no such thing as an optimum [setup]. What works for one class may not work for another . . . so we can't design equipment that is too specific. We try to remain flexible."

During the early 1990s, increasing numbers of experienced glass artists matured in the medium while new artists continued to flood the field, physically expanding the ranks of glassworkers and introducing novel techniques and materials. By 1995 it was estimated that nearly three hundred artists were working in glass between Portland, Oregon, and Bellingham, Washington, underscoring the influence of the Pacific Northwest—and

John Reed, 1993

Pilchuck—on the rapidly expanding, international movement.[15] In the United States and abroad, by 1995, students could choose from among 145 schools offering programs in glass.[16]

Course listings for 1991 previewed the significant programmatic

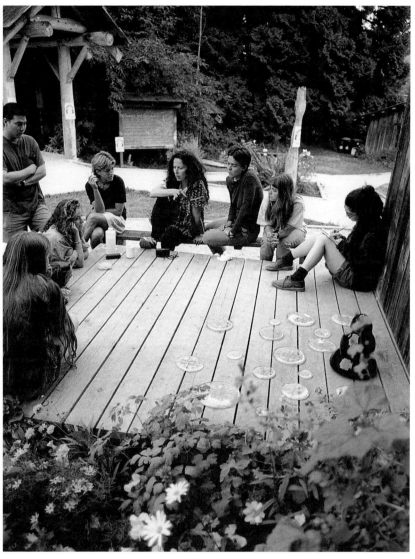

Kiki Smith and students, 1994.

changes that would take place at the school during the 1990s, changes which reflected developments in the larger glass community. These included the addition of more classes reserved for advanced students and the practice of jurying classes (1992); specialty classes and seminars; a winter lecture series (1995); and the inclusion of more nonglass artists-in-residence during the summer and fall (emerging-artist-in-residence) programs.

Although students accepted to Pilchuck were originally admitted to classes on a first-come, first-served basis—and later by lottery—prerequisites and jurying were established for advanced classes. Advanced/juried classes focusing on the development of glassmaking skills were offered in stained glass, glassblowing, neon, and sand casting. Other specialty classes, usually open to all students, explored nontraditional approaches to glass. Alternative techniques, materials, and uses were investigated in "Glass and Mixed Media," taught by Susan Stinsmuehlen-Amend and, later, Therman Statom (1991 on); "Photographic Techniques and Glass," presented by Mary van Cline (1993) and Bonnie Biggs (1995); and Judith Schaechter's "Stained Glass as a Painting Medium" (1992, 1995). "Ideas as Objects," with Pike Powers (1992); Damian Priour's "Exploring Creativity" (1993); and "Creating with Everything," team-taught by Ginny Ruffner and Steve Kursh (1995), focused on processes of thinking and making. Special seminars included a "Masterpieces" session (1991) as well as public symposia on collecting (1992); glass, art, and architecture (1994, 1995); and the content/context of glass as an art medium (1995, in collaboration with the Seattle Art Museum).

Judith Schaechter, 1992

It's well and good to look at the past twenty-five years. . . . But what is most crucial now is the next twenty-five years, to see what Pilchuck will have created for itself. We should lead the field, not follow it.

—Ginny Ruffner

[At Pilchuck] you face the fact that your art and your life are intertwined. There's a possibility of intense focus that won't be regarded as foolish or naive. Although what can happen up there may be foolish and naive. But that's what is so beautiful about it.

—Robert Carlson

Richard Marquis designing a *murrine* vessel, 1995.

The first major survey exhibition of works in glass by artists associated with Pilchuck—entitled *Clearly Art: Pilchuck's Glass Legacy*—was curated in 1992 by Lloyd E. Herman, former director of the Renwick Gallery, Washington, D.C. Organized by the Whatcom Museum of History and Art in Bellingham, Washington, the exhibition traveled throughout the United States, ending its lengthy itinerary with a final showing at Seattle's Museum of History and Industry in 1996. Other notable exhibitions included *Glass: Material in the Service of Meaning,* a survey of twenty-three noncraft artists working in glass, curated by Ginny Ruffner and organized by the Tacoma Museum of Art (1992); *Glass Installations,* curated by Janet Kardon for the American Craft Museum, New York (1993); and *Dale Chihuly: Installations 1964–1992,* curated by Patterson Sims, and *Holding the Past: Historicism in Northwest Glass Sculpture,* curated by Patterson Sims and Vicki Halper, for the Seattle Art Museum (1992, 1995).

Although the growth of the individual as an artist is central to the Pilchuck curriculum, technical development always has played a primary role. One interesting approach in which technique was combined with history was the 1991 "Masterpieces" seminar, organized by William Warmus. Its aim, according to Warmus, was to "extend my history course [from] just lecturing about objects to lecturing about objects and then making them."[17] A high-powered faculty—Dale Chihuly, Richard Marquis, Lino Tagliapietra, and Warmus—combined forces with other skilled artists such as Fritz Dreisbach, Ruth King, Dante Marioni, Pino Signoretto, Josh Simpson, Preston Singletary, Boyd Sugiki, Thomas Tisch, Karen Willenbrink, and a team composed of sculptor James Drake (an artist-in-residence in 1991) and glassblowers David Levi and Dimitri Michaelides. All the faculty demonstrated historical techniques and/or techniques that they had pioneered.[18] "It was hard to get all those people organized properly," recalls Warmus, "but it was fascinating. We didn't really set out to investigate how historic objects were actually made but how they inspired creative misinterpretations."

Warmus yearned to revive a glass marquetry technique developed by turn-of-the-twentieth-century French glassmaker Emile Gallé. "We were trying to make Gallé-like objects, [investigating] techniques which no one has [legitimately] tried to reproduce," says Warmus. "The biggest stumbling block [was that it was] an incredibly time-consuming process, so we could only do little pieces of vessels in the time we had." Josiah McElheny, who had enrolled in the seminar, remembers that "Lino Tagliapietra made the best *reticello* bowl he has ever made in his life. Green over white *reticello*, and all the bubbles were perfect."[20] A virtuoso technique first developed by Venetian glassmakers in the sixteenth century, *reticello* is a colorless glass incorporating white and/or colored canes crisscrossing in a netlike fashion. The hallmark of the technique is the bubble of air trapped within each diamond-shaped crossing of the "net."

The first time I came here, I was so happy [because] it was one of the first times in my life when people helped me in an active manner, gave me an opportunity to expand myself and my vocabulary. And fed me, sheltered me, and facilitated me [in making] my version of the world. That was a profound, unique experience.
—Kiki Smith[19]

Dale Chihuly's conception of Pilchuck as a place where artists would meet and work in glass, and the tone set by the eclectic mix of personalities that he gathered together for the school's first few summers, set Pilchuck apart from other summer art/craft programs. "Artists-in-residence need not be interested in teaching, but they should be exceptional artists of international notoriety [whose] work primarily [is] not in glass," wrote Chihuly to the board of trustees in June 1989. "The concept is that they help balance the technical with the artistic."[21] During the 1990s the artists-in-residence program would focus increasingly on established painters, sculptors, and other artists coming from outside the glass mainstream. Sculptors and installation and mixed-media artists teamed up with glass-workers to present glass in a larger artistic context in courses such as "Hybrids," offered by Kiki Smith and Thomas Farbanish (1994); "Image/Object/Language," with Maria Porges and Stephen Paul Day (1995); and "The Theater of Objects" (1995), presented by mixed-media artist Robin Winters and Randy Walker.

Lino Tagliapietra finishing a *vetro a reticello* goblet, 1992.

Willie Cole, 1994.

Paul Marioni (left) and Dante Marioni in the hot shop, 1995.

Joyce Scott, 1995.

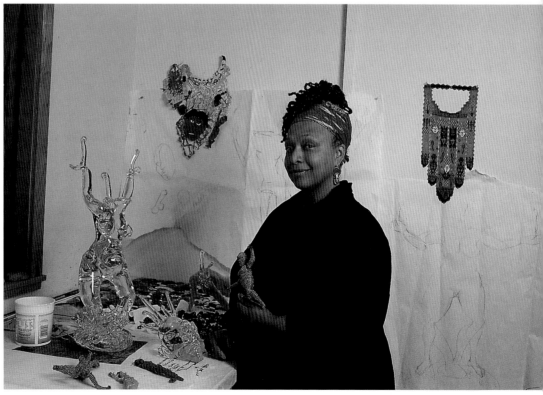

Other artists-in-residence and visiting artists at Pilchuck during the 1990s came from diverse backgrounds to work with hot glass—either blown or cast—or to make prints from glass plates. They included architect Steven Holl; architect/sculptor Maya Lin; ceramists Viola Frey, Deborah Horrall, and Jim Melchert; designer and printmaker Akira Kurosaki; glass artists Howard Ben Tré, Jaroslava Brychtová and Stanislav Libenský, Dale Chihuly, Dan Dailey, Ann Gardner, Brian Kerkvliet, Steve Kursh (also a painter) and Ginny Ruffner, Paul Marioni, Robbie Miller, Benjamin Moore, Charles Parriott, and Cappy Thompson; installation/environmental artists Ann Hamilton, Raimund Kummer, Jean Lowe, Heather McGill, and Buster Simpson; painters Squeak Carnwath, Fay Jones, Roberto Juarez, Jacob Lawrence, Kim MacConnell, Joseph Marioni, Izhar Patkin, and Elizabeth Sandvig; performance artist Trimpin; photographer Lorna Simpson; sculptors Lynda Benglis, Willie Cole, James Drake, Lauren Ewing, Nancy Graves, Eve André Laramée, Donald Lipski, Maria Porges, Italo Scanga, and Buzz Spector; sculptors/mixed-media artists Peter Boynton, Jeffry Mitchell, Joel Otterson, Joyce Scott, Kiki Smith, Jana Sterbak, and Robert Tannen; and sculptor/painter Judy Pfaff.

Everybody has the look of Joan of Arc on their face after a day of glassblowing. They have that beatific glow.
—Robin Winters[22]

Installation of bubbles on Pilchuck pond, 1994.

Dedicated gaffers and shop assistants are crucial to the success of the artist-in-residence program. "Everything I said to the staff, they said, 'Sure, we can do that,'" recalls Lauren Ewing. "I tried a number of different things about which I really knew nothing, but there was plenty of help, tremendous generosity, and [consummate] professionalism in the way that people dealt with me, dealt with my questions, and helped me deal with the materials."[23] Lynda Benglis remarks, "People were so open and giving. There was so much available to me. I was amazed at how collaborative the whole system was." "Once, I had Pino Signoretto gaff for me," remembers Kiki Smith. "I had wanted to make this piece [in glass] for five years—a fetus inside of a figure—and no one could make it [with me]. They said it was too complicated. But Pino could make it, and he's probably one of the few people in the world who could make it. That opened up for me an enormous possibility of what could be done. Coming [to Pilchuck] affords artists the opportunity of adding glass to their vocabulary and an introduction not only to the material, but to the [glass] world."

One quality of working with hot glass that always impresses and challenges artists is not the skill or strength required to work the material, but the fact that it cannot be touched. "The hard part is getting your hand and your mind around the material, bending around it conceptually," observes Ann Hamilton. "As responsive as glass is to subtle nuances [of handling], you can't actually touch it."[24] "I have found as many ways as possible to get around that," adds Robin Winters. "I use clay molds, for example. I push my fingers into the wet clay and then when I blow into the mold, it's almost like a monotype." Although the glass cannot be touched, the process of working the hot material has been described as sensual, even seductive. "The material alone shouldn't convince us of an object's artistic significance," notes former Seattle Art Museum curator and associate director Patterson Sims.[25] Yet only in glass does the process of collecting have so much to do with the medium and how the artist manipulates it. "I think that one of the main [reasons the] . . . popularity of hot glass soared . . . was because of the performance aspects of it," explains Susan Stinsmuehlen-Amend. "You don't watch [other artists] make artwork."

Some glass artists work against the perceived powers of the medium. "I have never dealt with glass as a transparent material [but as] an expressionistic material," remarks Henry Halem. "And up to a certain point, I was seduced by the process of it. That's where I made the wrong turn. I [no longer] have a love of glass as a seductive material. I look at glass in a way with disdain, to be conquered, to be controlled."[26] For others, glassworking is more about sensuality and spirit than intellect. "The idea of somebody actually making something in glass was, for me, like the discovery of fire," recalls sculptor and lampworker Susan Plum. "I was so amazed at what I saw. It was like following the energy of something invisible . . . [like] catching the etheric shadow."[27] According to art critic and cultural historian Dave Hickey, "Glass goes both ways: it speaks to enlightenment ideology and the embodied work." But perhaps most significantly, as Hickey has observed, a primary glass metaphor is that glass, being translucent, captures and holds light like the spirit is held in the body. And therein lies the essence of its power and attraction.[28]

Pilchuck is a facility that doesn't produce products but producers.
—Doug Anderson[29]

Through the years Pilchuck has grown up—and stayed young. No ideology, no dogmatism, no calcification, no bloated administration. . . . Pilchuck was always a dream for Europe. . . . As American as it is . . . [with its] young, revolutionary, no-holds-barred spirit . . . the Pilchuck idea has found its successors in diverse places.
—Helmut Ricke, director, Glasmuseum Hentrich, Ehrenhof, Germany[30]

Pilchuck is an example of the positive change wrought by the now oft-maligned cultural revolution that took place in America during the late 1960s and early 1970s. A product of counterculture thinking, energy, and dedication, Pilchuck has matured into an institution, yet the school still looks to its idealistic roots to

connect with the essence of its spirit, the core of the unique experience that it offers. In 1993 artistic program director Pike Powers listed as one of her immediate goals the building of a recycled-glass structure by students, a project designed to rekindle the Pilchuck spirit of experimentation and innovation.[31] Faculty member Hank Murta Adams fulfilled Powers's objective with his plans for a cast cement and glass structure, known as the Trojan Horse, which was started in a 1994 course and completed during 1995.[32] The preparation, planning, and successful execution of a new, communal structure built by artists brought a special sense of community back to Pilchuck and enabled the school to reassert its original identity.

The leaders of the Greeks . . . contrived, with [the goddess Athena's] help, a horse as big as a mountain. They wove its sides with planks of fir, pretending [the wooden horse] was an offering [to the goddess]. So rumor had it. But inside they packed, in secret, into the . . . belly's cavern . . . the fittest [Greek] warriors. . . . [The city of] Troy threw open its gates [and] . . . stared in wonder at the horse.

—Virgil, *The Aeneid*

When Adams first proposed the idea of organizing a class around the building of a structure, the administration was skeptical. While it was fine to construct ephemeral installations that would be removed at the end of a session, the permanent siting of a project had not been considered since the early 1980s. The last permanent artist-made building on campus was the Mace/Kirkpatrick cottage, built by special petition in 1981, and school policy proscribed any further building of shelters by students, faculty, or staff. But, intrigued by Adams's proposal, the administration agreed on the condition that the structure could be disassembled at any time if the school so decided. Inspired by the eccentric cast-concrete structures of tilemaker and outsider architect Henry Mercer,

Students building the Trojan Horse, 1994.

Adams developed a rudimentary floorplan for an elliptical ferro-cement and glass shelter, which could be easily dismantled with wirecutters. The shelter would measure a tiny 120 square feet, the maximum allowable footprint for official single housing units on the Pilchuck campus.

Specifications for size, shape, and materials for the project were handed over to the students who, with Adams, used cement, rebar, and found objects as molds to cast the glass elements. For the walls Adams devised his own system of interlocking tongue and groove modules of cast cement held in place by rebar hooks

cinched with wire. The cast cement and glass front door was hung on rebar hinges and a temporary wood roof, installed in 1994, was scavenged from the ruins of the neighboring Carpenter/Vaessen house. "I didn't want to teach a class just on the technique of glass casting," explains Adams. "I wanted to make something that would be useful to the school and [also] spiritual. . . . But I had never cast a building. I had never even mixed concrete. I have never done anything like this and it was a real challenge for me and for the students."[33] At the end of the two-and-a-half-week session, working late into the night, a handful of students still found it necessary to stay a few extra days to finish what they could, leaving installation of a cement roof for the following summer. Among its simple, rustic wooden neighbors, the now-domed ellipsoid looks highly unconventional, as fantastic and exotic as a traditional Islamic-style mosque set in the middle of a small New England town.

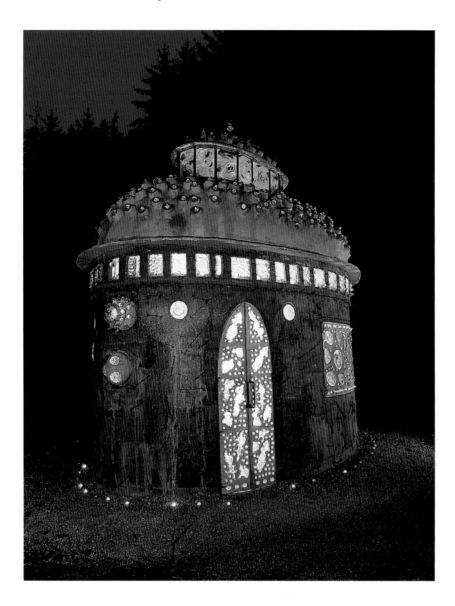

The Trojan Horse, 1995.

Adams originally had proposed that the structure be built in the meadow on Inspiration Point, a prime location but not within the boundaries of the school. An alternate, less visible location was recommended. "The site was changed on me and I'm glad [it was]," remarks Adams. "I think it fits with the theme of this project, to be hidden in an alcove."

"There was discussion about how we didn't want to encourage people to make structures," remarks Fritz Dreisbach. "So Hank said, 'Okay, I'll build it so it can be taken down. And if you don't want it, I'll take it . . . somewhere else.' But everybody loves it and they'll never let him have it."[34] The elements of negotiation, contrivance, and circumvention of established policy were key ingredients in the success of the Trojan Horse. Like early Pilchuck, the project was realized in spite of unfavorable odds, and in the process of creation, some of the school's pioneering spirit was recaptured. "I had originally envisioned the Trojan Horse as a shanty, a place to live," says Adams. "The students wanted to make it a more spiritually designated place. And my feeling was that it can't help but be spiritual, no matter what it is." The Trojan Horse functions mostly as a

votive monument, enshrining that essence of Pilchuck that remains undefinable while acting as a ship of sorts, carrying a precious cargo into an uncertain future.

When questioned about Pilchuck's most pressing challenges for the years ahead, optimists say it is accommodating success. So do pessimists. Some wonder if the Pilchuck "spirit" is an endangered species, threatened with extinction, while others see it as maturing and inspiring new forms of education and outreach. Some ask if Pilchuck is too absorbed in its own history to move forward, while others fear that the early history and identity of the school will be lost in the race for growth. Artists, trustees, and the school's administration all agree, however, that the most pressing issues revolve around the school's creative atmosphere—maintaining and refining programs and facilities, expanding outreach, and, most important, staying small. In terms of facilities, the wish list is reasonable: more housing, improved hot and cold glassworking facilities, expansion of the library, and development of an audiovisual archive. The prospect of expanding to year-round operation of the school is more controversial, as is improving accessibility to the site and buildings, since such enhancements might compromise the landscape.

By becoming established you become part of the Establishment. I suppose that's the usual challenge of an institution that is losing the vigor of youth.

—Thomas Buechner

The twenty-fifth anniversary reunion at Pilchuck, 1995.

If physical expansion is not a future possibility for Pilchuck—and most agree that the school must grow better, not bigger—then the school must expand artistically and

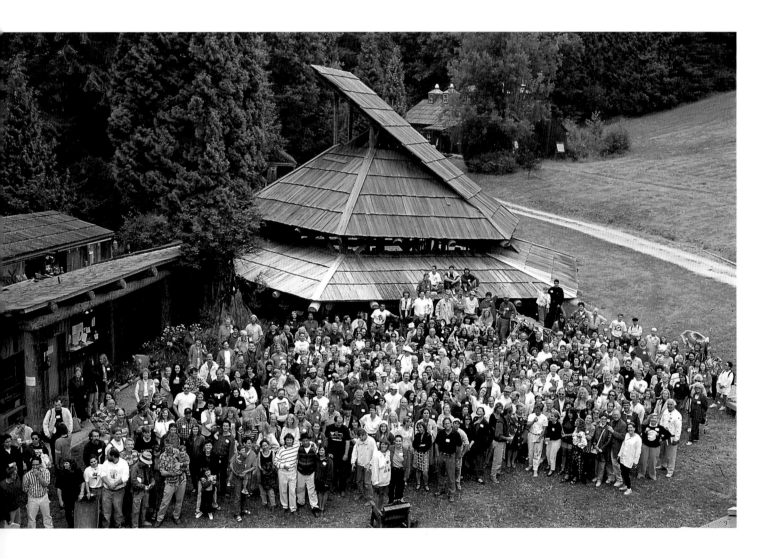

intellectually. "For the larger Seattle community, Pilchuck is an untapped resource," says *Seattle Post-Intelligencer* art critic Regina Hackett. "The school brings all kinds of artists here [and] if Pilchuck wanted to [have more of a presence] in Seattle, they would find a way of getting those artists . . . [down] there. . . . What is Pilchuck's mission . . . [besides] advancing glass as a medium? Do they feel a commitment to the Northwest? Or do they see themselves more as a world forum?"[35] In its first attempt at public education and outreach, Pilchuck instituted a winter lecture series in Seattle in 1995, and in January 1996 Pilchuck announced its new site on the World Wide Web. The Web site offers illustrated catalogue information with a virtual campus tour, faculty biographies, and event information.

In its twenty-fifth year, the Pilchuck Glass School commemorated its history and celebrated its future. Now, the people who have created, and continue to reinvigorate, the school—founders, artists-in-residence, faculty, students, staff, and trustees—will gather together as Pilchuck seeks its ideal balance in the years ahead, a place somewhere between the pioneer camp of the early 1970s and the global campus of tomorrow.

Notes

Throughout the notes, Pilchuck Glass School is abbreviated as "PGS."

Interviews conducted by the author were done with the cooperation of the Pilchuck Glass School, where interview transcripts are held. All material quoted from these interviews is courtesy Pilchuck Glass School. Unless noted otherwise, the names of board members, faculty, staff, and teaching assistants were drawn from the records of the Pilchuck Glass School.

The Pilchuck Tree Farm

1. *An Illustrated History of Skagit and Snohomish Counties* (Chicago: Interstate Publishing Company, 1906), pp. 381–82.

2. Robert Hitchman, *Place Names of Washington* (Tacoma: Washington State Historical Society, 1985); James W. Phillips, *Washington State Place Names* (Seattle: University of Washington Press, 1971); Duane Weston, conversation with the author, June 12, 1995; Dennis Blake Thompson, *Logging Railroads in Skagit County* (Seattle: NorthWest Short Line, 1989), p. 1.21.

3. *Illustrated History,* pp. 349–50.

4. Thompson, *Logging Railroads,* p. 1.6; Agnes Danielson, "Victoria: Then & Now," *Arlington (Wash.) Times: Diamond Jubilee Edition,* 1964, unpaginated.

5. Thompson, *Logging Railroads,* p. 1.6.

6. Duane Weston, interview with the author, May 15, 1995. Subsequent comments by Weston are quoted from this interview. Weston says that the grades were cut by Tyee Logging Company, which was bought by English Lumber Company. Several Tyee camps were taken over by English, including the Tyee Camp 3 at the Victoria mill. A note on the area map in Thompson, *Logging Railroads,* mentions that "Ed English controlled the Tyee Logging Company and logged Tyee timberlands in the course of English Lumber Company business." It is assumed here that Tyee was a subsidiary of English Lumber Company.

7. *Illustrated History,* p. 400.

8. Ibid.

9. Ibid., p. 110.

10. Ibid., pp. 443–44; Hitchman, *Place Names,* pp. 290–91; Robin K. Wright, ed., *A Time of Gathering: Native Heritage in Washington State* (Seattle: University of Washington Press, Thomas Burke Memorial Museum and University of Washington, 1991), pp. 24–25.

11. *Illustrated History,* p. 110.

Coming Northwest

1. Dale Chihuly, introduction in Lloyd Herman, *Clearly Art: Pilchuck's Glass Legacy* (Bellingham, Wash.: Whatcom Museum of History and Art, 1992), p. 10.

2. Keith Melville, *Communes in the Counter-Culture* (New York: William Morrow, 1972), p. 67.

3. Susanne K. Frantz, *Contemporary Glass: A World Survey from the Corning Museum of Glass* (New York: Harry N. Abrams, 1989), p. 49.

4. Jonathan Fineberg, *Art Since 1940: Strategies of Being* (Englewood Cliffs, N.J.: Prentice Hall, 1995), p. 286.

5. LaMar Harrington, *Ceramics in the Pacific Northwest* (Seattle: University of Washington Press, 1979), p. 68.

6. Joseph Monsen, interview with the author, September 25, 1994. Unless noted otherwise, subsequent comments by Monsen are quoted from this interview.

7. Harrington, *Ceramics in the Pacific Northwest,* pp. 111–12; Patricia Failing, *Howard Kottler: Face to Face* (Seattle: University of Washington Press, 1995), p. 48.

8. From Emile Gallé, *Ecrits pour l'art: floriculture, art décoratif, notices d' exposition 1884–1889,* quoted in William Warmus, *Emile Gallé: Dreams into Glass* (Corning, N.Y.: Corning Museum of Glass, 1984), p. 17.

9. Frantz, *Contemporary Glass,* p. 11.

10. Ibid., p. 17.

11. Ibid., pp. 45–50.

12. Fritz Dreisbach notes that Littleton had first approached both the Corning Museum of Glass, Corning, New York, and Alfred University, Alfred, New York, as possible hosts for the workshop, but was turned down; conversation with the author, December 1995.

13. Ibid., and Frantz, *Contemporary Glass,* pp. 50–51.

14. Quoted in Failing, *Face to Face,* p. 48.

15. Ibid.

16. On Russell Day and Stephen Fuller, see Matthew Kangas, "Pacific Northwest Crafts in the 1950s," in Barbara Johns et al., *Jet Dreams: Art of the Fifties in the Northwest* (Tacoma: Tacoma Art Museum, 1995), pp. 91–92.

17. Quoted in ibid., p. 92.

18. Russell Day, conversation with the author, December 27, 1995.

19. Fritz Dreisbach, conversation with the author, December 26, 1995.

20. Harvey Littleton, interview with the author, April 7, 1995. Unless noted otherwise, subsequent comments by Littleton are quoted from this interview.

21. Paul Inveen, interview with the author, February 24, 1995.

22. Bonnie J. Miller, *Out of the Fire: Contemporary Glass Artists and Their Work* (San Francisco: Chronicle Books, 1991), p. 10.

23. Dale Chihuly, taped compilation of lectures given at Tacoma Community College, February 1994; Seattle Art Fair/The Bon Marche, Seattle, February 1994; and M & M Art Gallery, Rochester, N.Y., April 1994 (hereafter Chihuly, compilation of lectures).

24. Chihuly studied under Hope Foote, an internationally known designer with whom textile designer Jack Lenor Larsen also studied.

25. Chihuly, compilation of lectures.

26. Jack Lenor Larsen remembers that he also suggested Chihuly study with Harvey Littleton, whom he had known at the Cranbrook Academy of Art as a potter; Jack Lenor Larsen, interview with the author, April 25, 1995.

27. Miller, *Out of the Fire*, p. 12; Russell Day, conversation with the author, December 27, 1995.

28. Chihuly, compilation of lectures.

29. Ibid.

30. Chihuly, in Herman, *Clearly Art*, p. 10; Linda Norden, *Chihuly Glass* (Pawtuxet Cove, R.I.: n.p., 1982), p. 10.

31. Charles Russell, "Heat's On at Bellevue Art Fair," *Seattle Post-Intelligencer*, July 28, 1968, p. 15.

32. Thomas Bosworth, interview with the author, October 3, 1994. Unless noted otherwise, subsequent comments by Bosworth are quoted from this interview. See also Norden, *Chihuly Glass*, p. 11.

33. Ron Glowen and Dale Chihuly, *Venetians: Dale Chihuly* (Altadena, Calif.: Twin Palms Publishers, 1989), unpaginated.

34. Norden, *Chihuly Glass*, p. 12.

35. Erwin Eisch, interview with LaMar Harrington, August 23, 1983, Division of Manuscripts and University Archives, University of Washington, Seattle. Unless noted otherwise, subsequent comments by Eisch are quoted from this interview.

36. Harvey Littleton, "Glass by Erwin Eisch," *Craft Horizons* 23, no. 3 (May/June 1963), p. 15, quoted in Frantz, *Contemporary Glass*, p. 55.

37. Quoted in Karrie Jacobs and Dick Busher, "Art Glass from the Pilchuck School," *Alaska Fest Magazine*, April 1981, p. 26.

38. Patterson Sims, *Dale Chihuly: Installations 1964–1992* (Seattle: Seattle Art Museum, 1992), p. 11.

39. Chihuly, in Herman, *Clearly Art*, p. 10.

40. Fred Tschida, interview with the author, April 27, 1995. Subsequent comments by Tschida are quoted from this interview.

41. Ron Glowen, "Visualize Tacoma: Italo Scanga in the Northwest," in *Italo Scanga* (Seattle: Portland Press, 1993), p. 32; Chihuly, in Herman, *Clearly Art*, p. 13.

42. Chihuly, in Herman, *Clearly Art*, p. 10.

43. Dale Chihuly, typed statement, undated [late 1960s/early 1970s?], PGS.

The Idea Is Born

1. Abbie Hoffman, *Woodstock Nation* (New York: Random House, 1969), p. 74.

2. Hunter S. Thompson, *Fear and Loathing in Las Vegas: A Savage Journey to the Heart of the American Dream* (New York: Random House, 1972), pp. 178, 180, 202.

3. "Student Strikes Called at Most R.I. Colleges," *Providence Journal*, May 5, 1970, p. 1; Hamilton F. Allen, "Artists Fight 'Kentbodia,'" *Providence Evening Bulletin*, May 23, 1970, p. 1; "Striking Students at RISD Display Distorted U.S. Flag," *Providence Journal*, May 28, 1970, p. 15.

4. John Landon, interview with the author, August 23, 1994. Subsequent comments by Landon are quoted from this interview.

5. George Popkin, "RISD Sign Authenticity Questioned," *Providence Evening Bulletin*, June 10, 1970.

6. Chihuly, in Herman, *Clearly Art*, p. 10.

7. Popkin, "RISD Sign." At RISD Chihuly was technically an instructor in the ceramics department, although he taught only glass.

8. Fritz Dreisbach, interview with the author, June 23, 1994. Unless noted otherwise, subsequent comments by Dreisbach are quoted from this interview.

9. Chihuly, in Herman, *Clearly Art*, p. 10.

10. Mary Ann (Toots) Zynsky, interview with the author, June 2, 1994. Unless noted otherwise, subsequent comments by Zynsky are quoted from this interview.

11. Marshall Borris, interview with LaMar Harrington, September 14, 1984, Division of Manuscripts and University Archives, University of Washington, Seattle. Subsequent comments by Borris are quoted from this interview.

12. Ruth Tamura, interview with the author, September 27, 1994. Subsequent comments by Tamura are quoted from this interview.

13. "Glass Blowing in Sylvan Setting," *Puget Sound Panorama Weekend Magazine, Everett Herald*, October 2, 1971, p. 3.

14. Chihuly, in Herman, *Clearly Art*, p. 10.

15. Cliff Danielson, "In Victoria—Students Help Revive 'Dying' Art of Glass Blowing," *Stanwood (Wash.) News*, July 7, 1971, p. 8; Herman, *Clearly Art*, p. 20.

16. Chihuly, in Herman, *Clearly Art*, p. 10.

17. Dale Chihuly, Safeco Arts Leadership award ceremony, Art Fair Seattle, February 4, 1995.

18. John Hauberg, interview with the author, July 13, 1994; interview with Sue Ragen for the Archives of Northwest Art, January 9, 1978, Division of Manuscripts and University Archives, University of Washington, Seattle (hereafter Hauberg/Ragen interview). Unless noted otherwise, subsequent comments by Hauberg are quoted from the July 13, 1994, interview.

19. Philip Padelford, interview with the author, April 5, 1995.

20. Anne Gould Hauberg, interview with the author, March 14, 1995. Unless noted otherwise, subsequent comments by Anne Gould Hauberg are quoted from this interview.

21. Chihuly, in Herman, *Clearly Art*, p. 11.

22. Hauberg interview.

23. Hauberg/Ragen interview.

24. Ibid.

25. Anne Gould Hauberg, interview with the author, August 15, 1994.

26. Quoted in Ned Heagerty, "Behind the Arts in Seattle," *Madison Park Post*, June 1981, p. 1.

27. Anne Gould Hauberg interview, August 15, 1994.

28. Dale Chihuly, interview with the author, September 15, 1994. Unless noted otherwise, subsequent comments by Chihuly are quoted from this interview.

29. Chihuly, in Herman, *Clearly Art*, p. 11.

30. Ibid.

1971: The Peanut Farm

1. Chihuly, in Herman, *Clearly Art*, p. 12.

2. James Carpenter, interview with the author, August 10, 1994. Unless noted otherwise, subsequent comments by Carpenter are quoted from this interview.

3. Viola Chihuly told the RISD group that they would be going to Stanwood because Paul Inveen had "changed his mind" (Toots Zynsky, interview with LaMar Harrington, July 23, 1984, Division of Manuscripts and University Archives, University of Washington, Seattle [hereafter Zynsky/Harrington interview]). Inveen remembers that he may have had trouble getting his family's permission to use the Rosedale property (Inveen interview).

4. Weather information culled from the *Seattle Times*, June 1 to July 15, 1971.

5. John Hauberg, Safeco Arts Leadership award ceremony, Art Fair Seattle, February 4, 1995.

6. Peet Robison, interview with the author, August 30, 1994. Subsequent comments by Robison are quoted from this interview.

7. Student names and schools were gathered from interviews with Dale Chihuly, Kate Elliott, Michael Nourot, and Toots Zynsky; 1971 newspaper articles; and a questionnaire distributed by Ruth Tamura after the first summer.

8. Zynsky interview; Zynsky/Harrington interview.

9. Dale Chihuly and Buster Simpson, first Pilchuck catalogue, 1972, p. 1, PGS.

10. Thomas L. Bosworth, "Hand-Built at Pilchuck," *Craft Horizons* 39, no. 2 (April 1979), p. 37; Bosworth interview.

11. Anne Gould Hauberg interview, August 15, 1994.

12. Richard Marquis, interview with the author, March 27, 1995. Subsequent comments by Marquis are quoted from this interview.

13. Zynsky interview; Zynsky/Harrington interview.

14. Quoted in Herman, *Clearly Art*, p. 21.

15. Michael Nourot, interview with the author, November 6, 1994. Subsequent comments by Nourot are quoted from this interview.

16. Chihuly, in Herman, *Clearly Art*, p. 11.

17. Ibid., pp. 11–12.

18. John Landon, conversation with the author, December 1995. Michael Nourot believes that he, James Carpenter, and Toby Kahn helped Landon and Hendrickson on the swan bench.

19. Danielson, "In Victoria," p. 8.

20. Chihuly, compilation of lectures.

21. Danielson, "In Victoria," p. 8.

22. John Reed, Pilchuck's present director of operations, mentions that Chihuly brought back Kugler rods from Europe in 1979, using them off-season in his blows and gradually working them into the summer program; interview with the author, March 6, 1995. Unless noted otherwise, subsequent comments by Reed are quoted from this interview.

23. Lewis (Buster) Simpson, interview with the author, August 1, 1994. Subsequent comments by Simpson are quoted from this interview.

24. Zynsky interview; Tamura interview; Robison interview.

25. Italo Scanga remembers that Hendrickson was his student and that he was responsible for sending him to Pilchuck; Italo Scanga, interview with the author, July 6, 1994.

26. Rob Adamson, interview with LaMar Harrington, February 29, 1984, Division of Manuscripts and University Archives, University of Washington, Seattle (hereafter Adamson/Harrington interview).

27. Marty Streich, conversation with the author, January 23, 1996.

28. Anne Gould Hauberg interview, August 15, 1994.

29. John Hauberg, conversation with the author, May 5, 1994.

30. "Glass Blowing in Sylvan Setting," p. 3.

31. Chihuly to Merritt, undated [1971], Francis Sumner Merritt papers, Archives of American Art, Smithsonian Institution.

32. Chihuly interview; Chihuly, compilation of lectures; Chihuly, Safeco Arts Leadership award ceremony, Art Fair Seattle, February 4, 1995.

33. Stephanie Miller, "Renaissance in Glass-Blowing," *Seattle Post-Intelligencer (Book World)*, December 5, 1971, p. 9.

34. Zynsky/Harrington interview; Borris interview; Friends of the Crafts brochure, Anne Gould Hauberg papers, Division of Manuscripts and University Archives, University of Washington, Seattle.

35. Rita Reif, quoting her 1971 article in "Glass on a Grand Scale," *New York Times,* October 23, 1994.

36. Pilchuck questionnaire, fall 1971, Anne Gould Hauberg papers.

37. Dale Chihuly, Pilchuck proposal, 1972, PGS.

38. First Pilchuck catalogue, 1972, PGS.

39. Kate Elliott, interview with LaMar Harrington, July 23, 1984, Division of Manuscripts and University Archives, University of Washington, Seattle (hereafter Elliott/Harrington interview).

40. First Pilchuck catalogue, 1972.

41. Chihuly, Pilchuck proposal, 1972. Chihuly had intended to offer two sessions in 1972, but at the suggestion of Anne Gould Hauberg and John Hauberg, he cut back to one ten-week course (Chihuly to Anne and John Hauberg, February 1972, Anne Gould Hauberg papers).

42. Chihuly, Pilchuck proposal, 1972.

43. Chris Johanson and William Morrow to John Hauberg, April 1972, Anne Gould Hauberg papers.

44. Chihuly to Anne and John Hauberg, March 5, 1972; Chihuly to Anne and John Hauberg, February 1972; Chihuly to Anne and John Hauberg and James Plaut, April 3, 1972, Anne Gould Hauberg papers.

45. James L. Hazeltine, executive director, PNAC, to Clark Mitze, state director, National Endowment for the Arts, February 1972; David Sennema, assistant director, state and community operations, National Endowment for the Arts, to James Plaut, April 12, 1972, Anne Gould Hauberg papers; Hauberg interview.

1972: The Pilchuck Commune

1. Rosa Barovier-Mentasti, introduction to Antonio Neri, *L'arte vetraria* (Milan: Edizioni Il Polifilo, 1980), p. 41.

2. Ada Polak, *Glass: Its Traditions and Its Makers* (New York: G.P. Putnam's Sons, 1975), p. 35.

3. Richard Posner, interview with the author, September 5, 1994. Subsequent comments by Posner are quoted from this interview.

4. Posner interview; original materials from the collection of second-year student Bruce Bartoo.

5. Caroline Bates, "The Pacific Northwest: A Majestic View," *Gourmet,* May 1972, p. 38.

6. Doug Hollis, interview with the author, February 13, 1995. Subsequent comments by Hollis are quoted from this interview.

7. Ruth Reichl, interview with the author, February 13, 1995. Subsequent comments by Reichl are quoted from this interview.

8. John Hauberg to Dale Chihuly, June 1, 1972, Anne Gould Hauberg papers.

9. Dale Chihuly to Francis Merritt, November 20, 1972, Francis Sumner Merritt papers. In August, Chihuly had given a student count of thirty-two to the *Seattle Post-Intelligencer*; see Stephanie Miller, "Pilchuck Workshop: A Place—Perchance To Treasure Hunt," *Seattle Post-Intelligencer (Book World),* August 6, 1972, p. 23. There are no formal records of Pilchuck's 1972 students. The roster of second-year people was compiled from a list sent by Bruce Bartoo, interviews, 1972 expense records, and a tape made by Bartoo of the 1972 Pilchuck graduation ceremonies. Richard Posner remembers that filmmaker Jules Backus was there in 1972 or 1973. Kate Elliott and Posner both talk about the Pilchuck population sign that was made that year; Posner remembers that Guy Chambers made it (Posner interview and Kate Elliott, interview with the author, August 15, 1994. Unless noted otherwise, subsequent comments by Elliott are quoted from this interview).

10. Barbara Vaessen, interview with the author, July 16, 1994; Barbara Vaessen, interview with LaMar Harrington, July 15, 1983, Division of Manuscripts and University Archives, University of Washington, Seattle (hereafter Vaessen/Harrington interview). Unless noted otherwise, subsequent comments by Vaessen are quoted from the July 16, 1994, interview.

11. Bruce Bartoo, interview with the author, September 11, 1994. Subsequent comments by Bartoo are quoted from this interview.

12. Ro Purser, interview with the author, April 24, 1995. Subsequent comments by Purser are quoted from this interview.

13. Elliott/Harrington interview.

14. Both Robert Naess and Michael Kennedy remember that the shop ran on propane, while Fritz Dreisbach and Ruth Reichl recall a propane stove in the makeshift kitchen. Others remember a gas refrigerator, although Ruth Reichl wasn't sure there was one; Robert Naess, interview with the author, May 5, 1995; Michael Kennedy, interview with the author, December 5, 1994. Subsequent comments by Naess and Kennedy are quoted from their respective interviews.

15. Chihuly to Merritt, November 20, 1972; Chihuly to Dean Tollefson, Union of Independent Colleges of Art, November 16, 1972, Anne Gould Hauberg papers.

16. Marquis interview.

17. Mark McDonnell, interview with LaMar Harrington, August 23, 1983, Division of Manuscripts and University Archives, University of Washington, Seattle. Subsequent comments by McDonnell are quoted from this interview.

18. Miller, "Pilchuck Workshop."

19. Eisch to Merritt, September 25, 1972, Frances Sumner Merritt papers.

20. Matthew Kangas, "Glass as Element: 5 Artists," unpublished manuscript, 1981, p. 8.

21. Regarding the marver at Pilchuck, see Herman, *Clearly Art,* p. 24. The definition of marver is from W. B. Honey, *Glass* (London: Ministry of Education, 1946), p. 5, n. 1.

22. Vaessen interview; Vaessen/Harrington interview.

23. Miller, *Out of the Fire,* p. 11; Rob Adamson, interview with the author, August 1, 1994; Norman Courtney, interview with the author, December 6, 1994. Unless noted otherwise, subsequent comments by Adamson and Courtney are quoted from their respective interviews. See also Steve Meltzer, "Seattle's Traveling Glassblowers," *Seattle Times (Sunday Pictorial),* March 3, 1974, pp. 16–17.

24. Bosworth, "Hand-Built at Pilchuck," p. 38.

25. John Hauberg's agreement with Dale Chihuly stated that any vandalism of tree farm property—which included "defacement, removal of boards or materials of any kind . . . [and] pieces of interiors of old buildings"—would not be tolerated; all existing buildings were to be respected as "historic" structures. This refutes the notion that the handmade structures at Pilchuck were fashioned from materials scavenged from barns on tree farm property. See Hauberg to Chihuly, June 1, 1972, Anne Gould Hauberg papers.

26. From the foreword to Art Boericke and Barry Shapiro, *Handmade Houses: A Guide to the Woodbutcher's Art* (San Francisco: Scrimshaw Press, 1973).

27. Ibid.

28. Fritz Dreisbach, interview with the author, October 4, 1994.

29. Joseph McCarthy, interview with the author, September 26, 1994. Unless noted otherwise, subsequent comments by McCarthy are quoted from this interview.

30. Patricia Baillargeon, interview with the author, August 17, 1994. Unless noted otherwise, subsequent comments by Baillargeon are quoted from this interview.

31. Tamura interview.

32. Kate Elliott identified Dan Holmes's shelter in a photograph from an article by Dale Chihuly, "Pilchuck '72," *Glass Art Magazine,* April 1973, p. 44.

33. *Skagit County Times,* January 22, 1903, quoted in Dave Bohn and Rodolfo Petschek, *Kinsey Photographer: A Half-Century of Negatives by Darius and Tabitha Kinsey,* vol. 1 (San Francisco: Prism Editions, 1978), p. 102.

34. Kate Elliott identified Guy Chambers's stump house in a photograph in Chihuly, "Pilchuck '72," p. 44.

35. John Hauberg, interview with the author, February 23, 1995.

36. Karen Willenbrink, interview with the author, April 30, 1995. Subsequent comments by Willenbrink are quoted from this interview.

37. Brian O'Doherty, "A New Conservatism in the Seventies?," *Art in America* 55, no. 2 (March/April 1971), p. 23.

38. Fineberg, *Art Since 1940,* pp. 311, 331, 336.

39. Quoted in ibid., p. 336.

40. Chihuly to Merritt, November 20, 1972.

41. Fritz Dreisbach remembers that it was always a problem keeping students occupied when only a few people could use the hot shop at once.

42. Barbara Haskell, *Blam!: The Explosion of Pop, Minimalism and Performance 1958–1964* (New York: Whitney Museum of American Art, 1984), p. 49.

43. John G. Hanhardt, "The American Independent Cinema 1958–1964" in ibid., p. 123.

44. Simpson's video/audio project was described by Robert Naess and his nighttime photos by Kangas, *Glass as Element,* p. 8.

45. Zynsky interview; Zynsky/Harrington interview. Most of the people interviewed from 1972 mentioned the increasing split between the two "camps" under Chihuly and Simpson.

46. Simpson interview.

47. Chihuly to Merritt, November 20, 1972.

48. Vaessen interview; James Carpenter to the Haubergs, November 25, 1972, Anne Gould Hauberg papers.

49. Dale Chihuly, interview with LaMar Harrington, July 23, 1984, Division of Manuscripts and University Archives (hereafter Chihuly/Harrington interview); Chihuly interview.

50. Chihuly to John Hauberg, November 23, 1972, Anne Gould Hauberg papers.

51. Chihuly to John Hauberg, December 13, 1972, Anne Gould Hauberg papers.

52. Chihuly to Tollefson, November 16, 1972.

53. Ibid.

54. Ibid.

1973: Defining a School

1. Italo Scanga, interview with the author, July 6, 1994. Unless noted otherwise, subsequent comments by Scanga are quoted from this interview.

2. Dale Chihuly, National Endowment for the Arts grant application, December 1972, PGS.

3. Dale Chihuly, letters, May 1973, PGS.

4. Chihuly to Sally Vanover (?), April 23, 1973, PGS.

5. Third-year faculty and students reconstructed from interviews; Chihuly 1973 letters, PGS; Chihuly/Harrington interview; Scanga interview.

6. Dale Chihuly, 1973 Pilchuck statement, PGS.

7. Dan Dailey, interview with the author, July 11, 1994. Subsequent comments by Dailey are quoted from this interview.

8. Chihuly to Erica Friedman and Anne Schwab, May 1973, PGS.

9. Chihuly, 1973 Pilchuck statement.

10. Bosworth, "Hand-Built at Pilchuck," pp. 37–38.

11. Chihuly to Michael Kennedy, undated [1973], PGS. On the hot shop, see Jim Murphy, "Timber and Glass," *Progressive Architecture*, June 1981, p. 100; George Burley, "Unique Glass Center Grows on Hauberg Tree Farm," *Northwest Arts* 2, no. 15 (August 20, 1976), p. 4; Chihuly to Grace Bartlett, Anne Gould Hauberg, John Hauberg, and Thomas Bosworth, December 5, 1972, Anne Gould Hauberg papers. In the letter Chihuly suggests that James Carpenter and Fritz Dreisbach review the hot shop plans.

12. Adamson/Harrington interview.

13. Charles Parriott, interview with the author, July 24, 1994. Subsequent comments by Parriott are quoted from this interview. Interviews with Buster Simpson, Dan Dailey, and Michael Kennedy also contributed to this portrait of Hass.

14. In addition to the individuals mentioned in the text, Toots Zynsky, Bruce Chao (interview with LaMar Harrington, July 1, 1983, Division of Manuscripts and University Archives, University of Washington, Seattle; subsequent comments by Chao are quoted from this interview), Barbara Vaessen, and Charles Parriott supplied information on housing in 1973.

15. Therman Statom, interview with the author, September 7, 1994. Subsequent comments by Statom are quoted from this interview.

16. On the hot shop and its equipment, see Posner to Chihuly, March 17, 1973, courtesy Richard Posner; Zynsky interview; Chao/Harrington interview.

17. Chihuly to Gordon Roessler, president of Northwestern Glass Company, May 14, 1973, PGS.

18. Richard Posner remembers a "Tom, Dick, Harry, and Mabel" system of rotating chores; see also Herman, *Clearly Art*, p. 25.

19. Adamson/Harrington interview.

20. Posner interview; Herman, *Clearly Art*, p. 25.

21. Landon interview.

22. Chihuly, in Herman, *Clearly Art*, pp. 12–13.

23. Italo Scanga, *Pilchuck Projects*, November 1973, back cover.

24. Norbert Guterman, ed., *A Book of Latin Quotations* (Garden City, N.J.: Doubleday, 1966), p. 105.

25. Lino Tagliapietra, interview with the author, July 9, 1994. Unless noted otherwise, subsequent comments by Tagliapietra are quoted from this interview.

26. Anne Gould Hauberg interview, August 15, 1994.

27. Kangas, *Glass as Element*, p. 7.

1974–1976: The Pilchuck Glass Center

1. C. David Hughbanks, "History: Pilchuck Glass School," unpublished manuscript, July 22, 1992, p. 2.

2. John Voorhees, "Myriad Possibilities for P.N.A.C.'s Future," *Seattle Times*, July 23, 1972, p. D1.

3. Ibid.

4. Plaut to John Hauberg, November 24, 1972, Anne Gould Hauberg papers. Tom Wilson and Mimi Pierce also commented on the PNAC.

5. Maggie Hawhorn, "Museum President Is No Newcomer to NW Arts," *Seattle Post-Intelligencer (Arts & Book World)*, March 11, 1973, p. 4.

6. Mimi Pierce, interview with LaMar Harrington, February 23, 1984, Division of Manuscripts and University Archives, University of Washington, Seattle (hereafter Pierce/Harrington interview).

7. Pierce to C. David Hughbanks, May 23, 1992, PGS.

8. Pierce/Harrington interview.

9. Mimi Pierce, PNAC report on plans for 1974, October 1973, Mimi Pierce papers, Division of Manuscripts and University Archives, University of Washington, Seattle.

10. Mimi Pierce, PONCHO grant application, October 1973, Anne Gould Hauberg papers.

11. Pierce/Harrington interview.

12. Pierce, PONCHO grant application.

13. 1974 Pilchuck poster, PGS.

14. Parriott interview; Benjamin Moore, interview with the author, August 22, 1994. Unless noted otherwise, subsequent comments by Moore are quoted from this interview.

15. Stan Price, interview with LaMar Harrington, May 2, 1984, Division of Manuscripts and University Archives, University of Washington, Seattle. Subsequent comments by Price are quoted from this interview.

16. Lists of students were compiled from Mimi Pierce's records.

17. Paul Marioni, interview with the author, August 14, 1994. Subsequent comments by Marioni are quoted from this interview.

18. Hughbanks, "History," p. 2.

19. Adamson/Harrington interview.

20. LaMar Harrington, interview with the author, July 25, 1994. Unless noted otherwise, subsequent comments by Harrington are quoted from this interview.

21. Mimi Pierce, memo to Pilchuck students, May 21, 1974, courtesy Mimi Pierce.

22. Mimi Pierce, "Pilchuck's Golden Rules," memo to faculty, staff, and students, summer 1974, courtesy Mimi Pierce.

23. Mimi Pierce, interview with the author, July 17, 1994. Unless noted otherwise, subsequent comments by Pierce are quoted from this interview.

24. Adamson/Harrington interview; Adamson interview.

25. Pierce/Harrington interview.

26. Eric Hopkins, interview with the author, July 31, 1994. Subsequent comments by Hopkins are quoted from this interview.

27. Waine Ryzak, interview with the author, April 10, 1995. Subsequent comments by Ryzak are quoted from this interview.

28. Pierce/Harrington interview.

29. Pike Powers, interview with the author, March 27, 1995. Subsequent comments by Powers are quoted from this interview.

30. Rick Bernstein, interview with LaMar Harrington, July 26, 1984, Division of Manuscripts and University Archives, University of Washington, Seattle. Subsequent comments by Bernstein are quoted from this interview.

31. Dale Chihuly, ed., *RISD Glass 1974* (Providence: Rhode Island School of Design, 1974). These works appeared again in a RISD photo essay edited by Dale Chihuly for *Glass Art Magazine* 4, no. 7 (October 1976), with new works by James Carpenter, Dan Dailey, Kate Elliott, Erica Friedman, Michael Glancy, Richard Harned, Eric Hopkins, Seaver Leslie, Benjamin Moore, Italo Scanga, and Richard Yelle.

32. Fritz Dreisbach, introduction to special issue on the Rhode Island School of Design, *Glass Art Magazine* 4, no. 7 (October 1976), p. 7.

33. George Ghetia, "The Dreisbach Experience: Glass Workshop at Cleveland State University," *Glass Art Magazine* 3, no. 4 (June 1975), p. 49.

34. 1975 Pilchuck application brochure, PGS; lists of faculty, staff, and students recorded by Mimi Pierce, courtesy Mimi Pierce.

35. Chihuly, compilation of lectures; Chihuly interview.

36. Ranny Green and Roy Scully, "Pilchuck Center—Prestige School for Glassblowing," *Seattle Times (Sunday Pictorial)*, October 6, 1974, p. 21.

37. Hauberg to Seattle Art Museum members, August 15, 1975, John Hauberg papers, Division of Manuscripts and University Archives, University of Washington, Seattle.

38. Hauberg/Ragen interview.

39. Mimi Pierce, PNAC program schedule, undated [1974], Mimi Pierce papers; Pierce interview.

40. Larsen to McCarthy, August 8, 1975, Mimi Pierce papers.

41. Joseph McCarthy, "Report of the Pacific Northwest Arts Council," *The Annual Report of the Seattle Art Museum 1975–1976*, unpaginated.

42. Hauberg/Ragen interview; Hauberg interview, July 13, 1994.

43. Pierce/Harrington interview.

44. Steven K. Waite, "Welcome to Pilchuck," *Bellevue Journal-American (The Artful Dodger)*, August 20, 1976, p. 7.

45. "Articles of Incorporation of Pilchuck Glass School," filed in 1976 and amended in 1987, PGS.

46. Johanne Hewitt, interview with the author, April 24, 1995. Subsequent comments by Hewitt are quoted from this interview.

47. Mimi Pierce, PONCHO grant application, October 29, 1976, Mimi Pierce papers.

48. Mimi Pierce, press release, April 1976, PGS.

49. Bosworth, "Hand-Built at Pilchuck," p. 38.

50. Patricia Baillargeon, "Pilchuck Glass Center," *Pacific Search Magazine (The Arts)*, July/August 1976, p. 31.

51. Bosworth, "Hand-Built at Pilchuck," p. 38.

52. Reed interview; Ryzak interview.

53. 1976 Pilchuck poster, PGS.

54. Norden, *Chihuly Glass*, pp. 14–15; Bannard and Geldzahler, *Chihuly*, pp. 125–26; Burley, "Unique Glass Center," p. 4.

55. Pierce to Moore, February 17, 1976, PGS.

56. Burley, "Unique Glass Center," p. 4; Mimi Pierce, Pilchuck student orientation sheet, June 1976, PGS.

57. Mimi Pierce, press release, July 1976, PGS.

58. Frank Kitchell, interview with the author, April 10, 1995. Subsequent comments by Kitchell are quoted from this interview.

1977–1979: Building a Campus

1. Larsen to Pilchuck trustee Phillip Jacobson, December 7, 1994, PGS.

2. Thomas Bosworth, lecture, "The Pilchuck Glass School," 1990, courtesy Thomas Bosworth.

3. Ann Wolff (formerly Wärff), letter to the author, May 1995. Unless noted otherwise, subsequent comments by Wolff are quoted from this letter.

4. Thomas L. Bosworth, "Cows in a Field," *Journal of Architecture and Building Science* (Tokyo), no. 6 (1984), p. 46.

5. Quoted in Dale Douglas Mills and Dick Busher, "Pacific Northwest Living," *Seattle Times (Sunday Pictorial Magazine)*, October 15, 1978, p. 40.

6. Karrie Jacobs and Dick Busher, "Art Glass from the Pilchuck School," *Alaska Fest Magazine*, April 1981, p. 29.

7. Bosworth, "Hand-Built at Pilchuck," p. 38.

8. Bosworth, "Cows in a Field," p. 52; Bosworth interview.

9. Quoted in R. M. Campbell, "The Extraordinary Pilchuck Glass Center," *Seattle Post-Intelligencer,* October 9, 1977, p. G6.

10. 1977 Pilchuck poster, PGS.

11. See Appendix, page 279–81, for a complete listing of summer teaching assistants.

12. 1977 Pilchuck application brochure, PGS; Mimi Pierce, NEA application, October 15, 1976, Mimi Pierce papers.

13. Chris Aronson, "Camp Pilchuck," *Studio,* January/February 1978, p. 12.

14. Ibid., p. 13.

15. Ibid., p. 17.

16. Marioni interview; Reed interview.

17. Bosworth, lecture.

18. Campbell, "The Extraordinary Pilchuck Glass Center," p. G6.

19. Ibid.

20. Chihuly, compilation of lectures.

21. Ibid.

22. Adamson interview; Parriott interview.

23. Chihuly, compilation of lectures.

24. Invoice for Chihuly basket, Foster/White Gallery, October 1977, Anne Gould Hauberg papers.

25. Kenneth M. Wilson, "Third Annual National Glass Show," *Glass Art Magazine* 3, no. 4 (October 1975), p. 56.

26. Doug Heller, interview with the author, April 9, 1995. Unless noted otherwise, subsequent comments by Heller are quoted from this interview.

27. Jeanne H. Metzger, "High-Class Glass among the Pilchuck Trees," *The Everett Herald,* October 13, 1977, p. 6D.

28. Patterson Sims, *Dale Chihuly: Installations 1964–1992* (Seattle: Seattle Art Museum, 1992), p. 12.

29. Campbell, "The Extraordinary Pilchuck Glass Center," p. G6.

30. Patrick Reyntiens, "The Experience 1978: Pilchuck Revisited," *Glass Studio* 6 (December 1978), p. 9.

31. Schorr's class was canceled due to underenrollment, and Roger Ek and Jerry Rhodes apparently had to bow out unexpectedly; Dan Dailey stepped in to teach the furnace workshop; see Chihuly to Bosworth, July 4, 1978, PGS.

32. Sonja Blomdahl, interview with the author, April 12, 1995. Subsequent comments by Blomdahl are quoted from this interview.

33. Stephen Procter to Thomas Bosworth, July 22, 1978, PGS; Reyntiens, "The Experience 1978," p. 11.

34. Reyntiens, "The Experience 1978," p. 10.

35. William Morris, interview with the author, January 6, 1995. Subsequent comments by Morris are quoted from this interview.

36. Price interview; Bosworth interview; Blomdahl interview.

37. Quoted in Reyntiens, "The Experience 1978," p. 14.

38. Littleton to Chihuly and Bosworth, August 13, 1978, PGS.

39. Chihuly to Bosworth, November 12, 1978, PGS.

40. Hauberg interview, July 13, 1994.

41. William Traver, interview with the author, April 14, 1995. Subsequent comments by Traver are quoted from this interview.

42. Chihuly to Hauberg and Bosworth, June 28, 1978, PGS.

43. Minutes, board of trustees meeting, November 1978, PGS.

44. Glancy to Bosworth, March 1979, PGS.

45. Moore to Bosworth, February 23, 1979, PGS.

46. Chihuly to Bosworth, June 24, 1979, PGS.

47. Quoted in Haufschild, "The Pilchuck Glass School," p. 39.

48. Kristine Bak, "Pilchuck, Glass and Architects," *The Quarterly (Journal of the College of Architecture and Urban Planning, University of Washington),* Winter 1980, p. 7.

49. Quoted in Erwin Eisch, "Foreign Glass Artists: Erwin Eisch," *Glass Art Society Journal* 1979, 1980, p. 11; Ann Wolff, letter to the author, May 1995.

50. Natalie de Combray, "Conversation: Lino Tagliapietra and Natalie de Combray," *Glass Magazine,* no. 39 (1990), p. 13; Tagliapietra interview.

51. Barovier-Mentasti, in Neri, *L'arte vetraria,* p. 51.

52. Honey, *Glass,* pp. 37, 56.

53. Polak, *Glass,* p. 65.

54. Victoria Milne, "Conversation: Victoria Milne with Benjamin Moore," *Glass Magazine,* no. 56 (Summer 1994), p. 13.

55. Frantz, *Contemporary Glass,* p. 159. The Corning Museum of Glass organized its first survey of glass, also an important traveling exhibition, in 1959.

56. Thomas S. Buechner, "Address to the Glass Art Society, May 15, 1976," *Glass Art Newsletter,* 1976, p. 3. See also Katherine Pearson, "Glass: A Major Museum Show of This Once Minor Craft Is Now Touring America," *Horizon Magazine,* May 1979, p. 62.

57. Heller interview.

58. Ferd Hampson, interview with the author, April 6, 1995. Subsequent comments by Hampson are quoted from this interview.

59. George and Dorothy Saxe, interview with the author, April 24, 1995. Subsequent comments by the Saxes are quoted from this interview.

60. Rose Slivka, "A Touch of Glass," *Quest/79* 3, no. 6 (September 1979), p. 84.

61. Paul Hollister, "International Artists Exhibit Their Glass," *New York Times,* November 8, 1979, p. C3.

62. Matthew Kangas, "Cheers for Sperry's Pottery—and a Touch of Glass," *Seattle Post-Intelligencer,* December 20, 1979, p. E4.

63. Bosworth interview.

64. Cathy Chase, conversation with the author, June 24, 1995.

65. Sam and Gladys Rubinstein, interview with the author, November 6, 1995. Subsequent comments by the Rubinsteins are quoted from this interview.

66. Moore to Bosworth, February 23, 1979, PGS.

67. Flora Mace, interview with the author, April 28, 1995. Unless noted otherwise, subsequent comments by Mace are quoted from this interview.

1980–1984: An International Community

1. Reed interview, October 4, 1994.

2. Bertil Vallien, interview with the author, November 16, 1994. Unless noted otherwise, subsequent comments by Vallien are quoted from this interview.

3. Susan Stinsmuehlen-Amend, interview with the author, April 24, 1995. Unless noted otherwise, subsequent comments by Stinsmuehlen-Amend are quoted from this interview.

4. Bertil Vallien, interview with LaMar Harrington, July 15, 1983, Division of Manuscripts and University Archives, University of Washington, Seattle (hereafter Vallien/Harrington interview).

5. Joey Kirkpatrick, interview with the author, July 18, 1994. Subsequent comments by Kirkpatrick are quoted from this interview.

6. François Houdé, "An Essay on Pilchuck Glass Center," *CraftNews* (Toronto) 6, no. 4 (May 1981), pp. 1–2.

7. Robert Seidl, memo to Alice Rooney, undated [1988], PGS.

8. Dale Chihuly, "Some Thoughts on Pilchuck's Survival," August 22, 1980, PGS.

9. "Alice Rooney to Direct Pilchuck," *Seattle Times,* August 9, 1980, p. B5.

10. Alice Rooney, interview with the author, April 7, 1995. Unless noted otherwise, subsequent comments by Rooney are quoted from this interview.

11. John Hauberg, letter dated May 27, 1980, PGS.

12. Robert Seidl, interview with the author, July 13, 1994. Unless noted otherwise, subsequent comments by Seidl are quoted from this interview.

13. Susan Brotman, interview with the author, May 1, 1995. Subsequent comments by Brotman are quoted from this interview.

14. Jack Benaroya, letter to the author, August 10, 1994; Jack Benaroya, interview with the author, April 20, 1995.

15. Robert Block, interview with the author, April 3, 1995.

16. Nathaniel Page, interview with the author, May 9, 1995.

17. C. David Hughbanks, interview with the author, April 11, 1995. Subsequent comments by Hughbanks are quoted from this interview.

18. Chihuly, compilation of lectures.

19. LaMar Harrington, "Chihuly's Glass Creations Come Home to Tacoma," *Northwest Arts* 7, no. 13 (July 3, 1981), p. 8.

20. Matthew Kangas, "Tradition and New Vision in Glass," *Artweek* 12, no. 12 (March 28, 1981), p. 4.

21. Regina Hackett, "Glass Gets Its Chance," *Seattle Post-Intelligencer,* April 3, 1981, p. D5. See also Deloris Tarzan, "Glass Artists Don't Do Windows," *Seattle Times,* April 9, 1981, p. E1.

22. Alice Rooney, memo to board of trustees, April 15, 1981, PGS.

23. Quoted in Jim Segaar, "Glass Art: Pilchuck School Is Haven for the Masters," *Skagit Valley Herald,* July 18, 1981, p. 1.

24. Mary Cozad, interview with the author, May 1, 1995. Subsequent comments by Cozad are quoted from this interview.

25. Narcissus Quagliata, interview with LaMar Harrington, June 30, 1983, Division of Manuscripts and University Archives, University of Washington, Seattle.

26. Reed interview, October 4, 1994.

27. Flora Mace, interview with the author, October 4, 1994.

28. Buechner to John Hauberg, July 28, 1981, PGS.

29. Hauberg to board of trustees, 1981, PGS.

30. Minutes, board of trustees meetings, 1981, PGS.

31. Ibid.

32. Ted Bunker, "Unorthodoxy Is Constant Approach for Artist," *Seattle Post-Intelligencer,* August 16, 1981, p. 12.

33. William Morris, Paul Marioni, and Benjamin Moore described the remodeling of artists' houses.

34. Quoted in Haufschild, "The Pilchuck Glass School," p. 38.

35. Vaessen interview; Vaessen/Harrington interview.

36. Chihuly, compilation of lectures.

37. Robert Carlson, interview with the author, April 13, 1995. Unless noted otherwise, subsequent comments by Carlson are quoted from this interview.

38. Quoted in Haufschild, "The Pilchuck Glass School," p. 35.

39. Richard Royal remembers that William Morris was the gaffer in the first session, although Scheiner is listed in the 1982 brochure; Royal, interview with the author, October 4, 1994.

40. Connie Dahl Parriott, conversation with the author, July 24, 1994.

41. Deloris Tarzan, "Classy Creations Crafted in Glass," *Seattle Times,* August 18, 1982, p. C1.

42. "Good Art/Good Business: Pilchuck Hosts Collectors' Program," *Glass Studio* 33 (1982), p. 51.

43. Kate Elliott and Katya Kohoutová Garrow, *Stanislav Libenský and Jaroslava Brychtová,* exh. cat. (Seattle: Elliott Brown Gallery, 1995), p. 6.

44. John S. Robinson, "A Glass Menagerie," *Pacific Northwest Magazine* 17, no. 10 (December 1983), pp. 31–32.

45. Alice Rooney, "Two Decades of the Pilchuck Glass School," *Glass Art Society 1990 Journal,* 1990, p. 86.

46. Frantz, *Contemporary Glass,* p. 27.

47. Elliott and Garrow, *Stanislav Libenský and Jaroslava Brychtová,* pp. 7–8.

48. Lynggaard to Phillip Jacobson, January 1995, PGS.

49. Phillip Jacobson, interview with the author, August 12, 1995.

50. John Hauberg, "Random Thoughts about the Future," January 1983, PGS.

51. Minutes, board of trustees meetings, 1982–83, PGS.

52. Jeffrey Atkin, interview with the author, March 30, 1995. Subsequent comments by Atkin are quoted from this interview.

53. Rooney, "Two Decades," p. 87.

54. Bannard and Geldzahler, *Chihuly,* p. 124.

55. Vallien/Harrington interview.

56. Lyn Smallwood, "House of Glass: Fame and Fortune in the Shadow of Mt. Pilchuck," *The Weekly,* August 17–23, 1983, p. 43.

57. Ibid., p. 45.

58. Haufschild, "The Pilchuck Glass School," p. 39.

59. Mace interview, October 4, 1994.

60. Matthew Kangas, interview with the author, April 3, 1995. Unless noted otherwise, subsequent comments by Kangas are quoted from this interview.

61. Ginny Ruffner, interview with the author, April 4, 1995. Unless noted otherwise, subsequent comments by Ruffner are quoted from this interview.

62. Mace interview, October 4, 1994.

63. Lynda Benglis, interview with the author, May 4, 1995. Subsequent comments by Benglis are quoted from this interview.

64. 1984 Pilchuck poster, PGS. Stained glass with Patrick Reyntiens was advertised but canceled.

65. Several fourth-session classes were canceled, including a special class on design in industry and a stained glass class.

66. Chihuly to John Hauberg, September 25, 1984, PGS.

67. Minutes, board of trustees meetings, 1981, PGS.

68. John Hauberg, notes on the Pilchuck School International Council, undated [ca. 1981–82]; long-range planning materials, 1985, PGS.

69. "People and Places," *American Craft,* December 1984/January 1985, p. 93.

70. Press release, August 30, 1984, PGS.

71. Minutes, International Council meeting, August/September 1984, PGS.

72. Dan Klein, interview with the author, May 17, 1995.

73. Long-range planning materials, 1985; minutes, board of trustees annual meeting, April 1986, PGS.

1985–1987: The Pilchuck Glass School

1. Nicolaus Mills, "The Culture of Triumph and the Spirit of the Times," in *Culture in an Age of Money: The Legacy of the 1980s in America,* edited by Nicolaus Mills (Chicago: Ivan R. Dee, 1990), p. 21.

2. Fred Moody and Betty Udesen, "Glass: Northwest Artists Shatter the Plebeian Image of This Booming Aesthetic Medium," *Seattle Times/Seattle Post-Intelligencer (Pacific Magazine),* August 18, 1985, p. 6.

3. Ruth Summers, interview with the author, April 10, 1995. Subsequent comments by Summers are quoted from this interview.

4. Susanne Frantz, "This Is Not a Minor Art: Contemporary Glass and the Traditions of Art History," *Glass Art Society Journal 1985–1986,* 1985, p. 7.

5. John Perreault, "Transparency: Seeing Through Art Criticism," *Glass Art Society Journal,* 1984, p. 19.

6. Clement Greenberg, "Glass as High Art," *Glass Art Society Journal,* 1984, p. 15.

7. Christopher Knight, "American Craft Today," in *Last Chance for Eden: Selected Art Criticism by Christopher Knight 1979–1994,* edited by Malin Wilson (Los Angeles: Art Issues Press, 1995), pp. 289–90, 292.

8. Suzanne Muchnic, "Crafts Keep 'Em Guessing," *Los Angeles Times (Calendar),* August 16, 1987, p. 3.

9. See Paul J. Smith and Edward Lucie-Smith, *American Craft Today: Poetry of the Physical,* exh. cat. (New York: American Craft Museum, 1986).

10. Dan Klein, "Buying New Glass a Second Time Around," *The 1987 Journal: Glass Art Society,* 1987, p. 36.

11. Grace Glueck, "A Critical Response to 'Americans in Glass,'" *Glass Art Society Journal,* 1985–1986, 1985, p. 24.

12. See Marcia and Tom Manhardt, eds., *The Eloquent Object* (Tulsa: Philbrook Museum of Art, 1987), and Susanne Frantz, *Sculptural Glass,* exh. cat. (Tucson: Tucson Museum of Art, 1983).

13. Nancy Love, "Seattle Is the Home of the Art-Glass Renaissance," *Art & Auction*, December 1985, p. 47.

14. Quoted in Lorianne Denne, "Art Glass: A Puget Sound Renaissance," *Puget Sound Business Journal*, February 24, 1986, p. 1.

15. Quoted in Sue Berkman, "Art Glass: Clearly Hot," *The Robb Report*, January 1985, p. 46.

16. Ibid., p. 50.

17. Love, "Seattle Is the Home," p. 44.

18. Quoted in ibid., p. 44.

19. Alice Rooney, "Student Statistics," undated [1986], PGS.

20. Karen S. Chambers, "The Pilchuck Experience," *Craft International*, January/March 1985, p. 35.

21. Quoted in Sue Berkman, "Material Value: Breaking into Glass," *Esquire* 103 (February 1985), p. 13.

22. Alice Rooney, draft report on 1985 and 1986 summer seasons, undated [1986], PGS.

23. Jirí Harcuba, "Remarks about Pilchuck," undated, PGS.

24. "Pilchuck Scholarship Auction Fund" list, 1985, PGS.

25. Robert Seidl, "The Pilchuck School Long-Range Plan," 1984, PGS.

26. Mission statement, November 8, 1985, PGS.

27. Chihuly to Rooney, May 7, 1986, PGS.

28. "Pilchuck School: Responsibilities of Board Members," 1985, PGS.

29. Dale Chihuly, memo to board of trustees, September 1986, PGS.

30. Alice Rooney, "Summer '86," undated [1986], PGS.

31. Nola Anderson, "Pilchuck Go," *Craft Australia*, Spring 1988, p. 115.

32. Quoted in minutes, Session II faculty and staff meeting, 1986, PGS.

33. Deborah Dohne, interview with the author, April 14, 1995. Unless noted otherwise, subsequent comments by Dohne are quoted from this interview.

34. Rooney, "Summer '86."

35. Minutes, Session II faculty and staff meeting.

36. Chihuly, memo to board of trustees.

37. Rooney, "Summer '86."

38. Maya Lin, interview with the author, August 10, 1994.

39. Ulrica Hydman-Vallien, letter to Phillip Jacobson, November 1994, PGS.

40. Flo Perkins, interview with the author, September 19, 1994.

41. Ginny Ruffner, "Speaking of Glass," *American Craft* 48, no. 5 (October/November 1988), p. 32.

42. Robert Kehlmann, "Coming Home: Glass Artists Take Stock at Kent State Gathering," *American Craft* 48, no. 4 (August/September 1988), p. 66.

43. Alice Rooney, memo to board of trustees, May 1987, PGS.

44. Alice Rooney and Dale Chihuly, letter to conference participants, and artists' conference agenda and attachments, July 14, 1987, PGS.

45. Faculty and staff notes, 1987, PGS.

46. Glowen and Chihuly, *Venetians*.

47. Operating budgets, 1986–88, PGS.

48. Minutes, board of trustees meeting, November 11, 1986, PGS.

49. Minutes, board of trustees annual meeting, 1986, PGS.

50. Bruce Barcott, "Chihuly: The Imperial Wizard of Glass," *Seattle Weekly*, November 14, 1990, p. 44.

51. 1987 Pilchuck catalogue (which reports 1986 contributions) and contributors listed in 1983–86 catalogues, PGS.

52. Douglass Raff, interview with the author, April 28, 1995. Subsequent comments by Raff are quoted from this interview.

53. Information on scholarships from Alice Rooney, letter to Dale Chihuly, November 24, 1987; Jeffrey Atkin, letter to John N. Anderson, November 21, 1989, PGS; and Marjorie Levy, conversation with the author, April, 1996.

1988–1990: New Directions in Art

1. Susanne Frantz, interview with the author, May 3, 1995. Unless noted otherwise, subsequent comments by Frantz are quoted from this interview.

2. Ron Glowen, "Glass on the Cutting Edge," *Artweek* 21 (December 6, 1990), p. 25.

3. Donald Kuspit, interview with the author, May 1, 1995. Subsequent comments by Kuspit are quoted from this interview.

4. Davira Taragin, interview with the author, May 8, 1995. Subsequent comments by Taragin are quoted from this interview.

5. Dante Marioni, interview with the author, April 26, 1995.

6. Ginny Ruffner, quoted in Matthew Kangas, "Manhattan of Glass: Seattle's New Role in Craft," *Neues Glas*, January 1994, p. 19.

7. Seattle engineer Karl Platt, quoted in Michelle Gyure, "Seattle: The Glass Hot Spot," *Glass Art Magazine* (September/October 1988), p. 5.

8. Donefer to Rooney, February 25, 1988, PGS.

9. Chihuly to Robert Seidl, June 30, 1989, and Chihuly to board of trustees, November 1, 1989, PGS.

10. Dale Anderson, interview with the author, May 4, 1995.

11. Pino Signoretto, interview with the author, August 21, 1994 (interpreted by Teresa Salvato).

12. Hauberg to LaMar Harrington, August 10, 1987, PGS.

13. Hauberg to Robert Seidl, undated [1983], PGS.

14. Mark Haley, interview with the author, March 30, 1995. Subsequent comments by Haley are quoted from this interview.

15. Minutes, board of trustees meeting, November 7, 1988, PGS.

16. Minutes, board of trustees meeting, July 26, 1989, PGS.

17. John Anderson, interview with the author, April 9, 1995. Subsequent comments by Anderson are quoted from this interview.

18. Anderson to Rooney and Morris, April 16, 1990, PGS.

19. Alice Rooney, "Introduction," 1990 Pilchuck catalogue, PGS.

20. See Barcott, "Chihuly," p. 43; see also 1982 and 1990 budgets, PGS.

21. Reekie to Phillip Jacobson, November 1994, PGS.

22. Minutes, board of trustees meeting, July 26, 1990, PGS.

23. Stanislav Libenský, statement on Pilchuck, Session III faculty meeting, July 23, 1990, PGS.

24. Susan Stinsmuehlen-Amend, "Impressions of Pilchuck 1990, Session IV," September 19, 1990, PGS.

25. Karen Mathieson, "Glass Magnets," *Seattle Times/ Seattle Post-Intelligencer,* November 18, 1990, p. L1.

26. Barcott, "Chihuly," p. 44.

27. Ibid.

28. John Anderson, letter to the author, August 29, 1994.

29. Dohne to board of trustees, December 11, 1990, PGS.

30. Minutes, board of trustees meetings, May 17, 1990, and December 13, 1990, PGS.

31. Barcott, "Chihuly," p. 45.

The 1990s: Pilchuck at 25 Years

1. Francine Pilloff, interview with the author, May 12, 1995.

2. Marjorie Levy, interview with the author, April 3, 1995. Subsequent comments by Levy are quoted from this interview.

3. Babo Olanie, interview with the author, April 25, 1995.

4. Report on the Advisory Council, April 23, 1992, PGS.

5. John Anderson, letter to the author, August 29, 1994.

6. Robert Seidl, letter to the author, April 3, 1995.

7. Richard Swanson, foreword, Pilchuck Glass School long-range plan, July 1993, p. 5.

8. Long-range plan, p. 8; "1984–1992 Comparisons," background material for the long-range planning retreat, p. 2, PGS.

9. Richard Swanson, interview with the author, May 11, 1995. Subsequent comments by Swanson are quoted from this interview.

10. Long-range plan, p. 23.

11. Minutes, board of trustees meeting, August 19, 1993, PGS.

12. Sheri Kersch-Schultz, interview with the author, May 1, 1995.

13. Jon and Mary Shirley, interview with the author, May 1, 1995. Subsequent comments by the Shirleys are quoted from this interview.

14. "Summary of Purpose: Artistic and Educational Programs," April 1992, PGS.

15. "Artists Working with Glass in the Pacific Northwest," July 1995, PGS.

16. "Glass Art Society Membership and Education Roster," 1995.

17. William Warmus, interview with the author, April 10, 1995. Subsequent comments by Warmus are quoted from this interview.

18. "Pilchuck Glass School, 1991, Session 5: Masterpieces," notes compiled by Alan Goldfarb, Burlington, Vermont, 1992, PGS.

19. Kiki Smith, interview with the author, August 21, 1994. Subsequent comments by Smith are quoted from this interview.

20. Josiah McElheny, interview with the author, March 24, 1995.

21. Chihuly to board of trustees, June 30, 1989, PGS.

22. Robin Winters, interview with the author, November 4, 1995. Subsequent comments by Winters are quoted from this interview.

23. Lauren Ewing, interview with the author, April 22, 1995.

24. Ann Hamilton, interview with the author, November 3, 1995.

25. Quoted in Victoria Milne, "Conversation: Patterson Sims and Victoria Milne," *Glass Magazine,* Summer 1993, p. 12.

26. Henry Halem, lecture at Pilchuck Glass School, summer 1982, recorded by LaMar Harrington, Division of Manuscripts and University Archives, University of Washington, Seattle.

27. Susan Plum, interview with the author, April 17, 1995.

28. Dave Hickey, "Glass and the Beauty Thing," lecture notes for the seminar *"Contemporary Glass: Seduction vs. Intellect,"* Seattle Art Museum, July 22, 1995.

29. Doug Anderson, comments at board of trustees meeting, May 14–15, 1993, PGS.

30. Helmut Ricke, letter to Phillip Jacobson, December 1994, PGS (author's translation).

31. Pike Powers, minutes, board of trustees meeting, August 19, 1993, PGS.

32. Hank Murta Adams's classes were "Casting the Trojan Horse," in 1994, and "Coifing the Trojan Horse," in 1995.

33. Hank Murta Adams, Pilchuck Glass, Art, and Architecture Symposium, August 1994, PGS. Subsequent comments by Adams are quoted from this symposium.

34. Fritz Dreisbach, interview with the author, October 4, 1994.

35. Regina Hackett, interview with the author, April 18, 1995.

Author Acknowledgments

But wee be frayle as glasse and also bretyll.

—Libelle, 1436

The many wonderful tales and experiences that are part of Pilchuck's legacy could fill the pages of several books. Fortunately this history is not the first to be written about Pilchuck, and it is surely not the last.

For my research, 126 interviews with founders, artists, administrators, and trustees (including 15 by LaMar Harrington recorded in 1983 and 1984) provided core material, representing a cross section, through time, of the many individuals who have contributed to Pilchuck. Because of limits of time, some important participants could not be interviewed, and I appreciate their understanding of the inevitable restrictions imposed on the project.

My most sincere and appreciative thanks go to managing editor Suzanne Kotz, who transformed a long and unwieldy text crammed with photographs into a trim, flowing, sensibly illustrated narrative, and to designers Katy Homans and Phil Kovacevich, for their sensitive interpretation of the materials. All were generously patient, kind, supportive, and most important, enthusiastic. Russell Johnson, Art Hupy, Roger Schreiber, and other known and unknown photographers have supplied a true and immediate history that no words can match. This book is as much a product of the dedication of all these individuals as it is of mine.

I would like to give special recognition to the following people who graciously allowed me to interview them: Rob Adamson, Dale and Doug Anderson, John Anderson, Jeffrey Atkin, Patricia Baillargeon, Bruce Bartoo, Jack Benaroya, Lynda Benglis, Rick Bernstein, Robert Block, Sonja Blomdahl, Marshall Borris, Thomas Bosworth, Susan Brotman, Thomas Buechner, Robert Carlson, James Carpenter, Bruce Chao, Dale Chihuly, Norman Courtney, Mary Cozad, Dan Dailey, Deborah Dohne, Fritz Dreisbach, Erwin Eisch, Kate Elliott, Albinas Elskus, Lauren Ewing, Susanne Frantz, Regina Hackett, Mark Haley, Ann Hamilton, Ferd Hampson, LaMar Harrington, Anne Gould Hauberg, John Hauberg, Douglas Heller, Lloyd Herman, Johanne Hewitt, Doug Hollis, Eric Hopkins, C. David Hughbanks, Paul Inveen, Phillip Jacobson, Matthew Kangas, Michael Kennedy, Sheri Kersch-Schultz, Ruth King, Joey Kirkpatrick, Frank Kitchell, Dan Klein, Donald Kuspit, John Landon, Jack Lenor Larsen, Marjorie Levy, Maya Lin, Marvin Lipofsky, Harvey Littleton, Christina Lockwood, Flora Mace, Dante Marioni, Paul Marioni, Richard Marquis, Joseph McCarthy, Mark McDonnell, Josiah McElheny, Joseph Monsen, Benjamin Moore, William Morris, Robert Naess, Edward Nash, Michael Nourot, Babo Olanie, Philip Padelford, Nathaniel Page, Charles Parriott, Flo Perkins, Mimi Pierce, Francine Pilloff, Susan Plum, Richard Posner, Pike Powers, Stan Price, Ro Purser, Narcissus Quagliata, Douglass Raff, John Reed, Ruth Reichl, Thurston Roach, Peet Robison, Alice Rooney, Gladys and Sam Rubinstein, Ginny Ruffner, Waine Ryzak, Dorothy and George Saxe, Italo Scanga, Judith Schaechter, Joyce Scott, Robert

Seidl, Jon and Mary Shirley, Pino Signoretto, Buster Simpson, Kiki Smith, Therman Statom, Susan Steinhauser, Susan Stinsmuehlen-Amend, Ruth Summers, Richard Swanson, Lino Tagliapietra, Ruth Tamura, Davira Taragin, Cappy Thompson, William Traver, Fred Tschida, Barbara Vaessen, Bertil Vallien, William Warmus, Duane Weston, Karen Willenbrink, Tom Wilson, Robin Winters, and Toots Zynsky.

Special thanks go to the following individuals who provided additional information and documentation: Hank Murta Adams, Margery Aronson, Bruce Bartoo, William Carlson, Judith Cederblom, Dale Chihuly, Hollie Clark, Russell Day, Kate Elliott, Patricia Failing, John Filo, Henry Halem, LaMar Harrington, Anne Gould Hauberg, John Hauberg, C. David Hughbanks, Ulrica Hydman-Vallien, Phillip Jacobson, Finn Lynggaard, Paul Marioni, Benjamin Moore, Robert Naess, Osamu Noda, Ethel Norway, Michael Nourot, Isabel de Obaldia, John Olbrantz, Sylva Petrová, Robert L. Pfanne-becker, Susan Plum, David Reekie, Ruth Reichl, Helmut Ricke, René Roubíček, Richard Royal, Judith Schwartz, Holle Simmons, Buster Simpson, Lorna Simpson, Patterson Sims, Marty Streich, Cappy Thompson, Duane Weston, and Ann Wolff. Judith Cederblom, Diana Gawle, Susan Lindsay, and Jacke Vautrin provided thoughtful and accurate inter-view transcriptions, and Peter Herzberg and Rayne Roper gave invaluable support.

At Pilchuck Glass School, warmest thanks go to the Pilchuck Twenty-Fifth Anniversary Book Committee, its chair, Doug Anderson, and committee members Patricia Baillargeon, Gretchen M. Boeing, Dale Chihuly, Fritz Dreisbach, John Hauberg, Joey Kirkpatrick, Benjamin Moore, and Robert Seidl; to executive director Marjorie Levy; and to Randall Rubenstein, president of the board of trustees, and Mark Haley, past president. Manuscript readers Benjamin Moore and Marjorie Levy gave helpful comments, while reader and assiduous fact-checker Fritz Dreisbach provided valuable corrections and much-needed technical advice. The assistance of Pilchuck Glass School staff Kelly Coller, Jeff Crandall, Michele Hasson, Anne Jacobsen, and Pike Powers was greatly appreciated, as was the able help of intern Kelly Schroeder.

Sincere thanks go to the following institutions whose staffs helped me gain access to much valuable information and provided photographs: Archives of American Art, Smithsonian Institution; Corning Museum of Glass, Corning, New York; Los Angeles County Museum of Art; Oakland Museum of California; Pilchuck Glass School; Provi-dence Public Library; Toledo Museum of Art; Division of Manuscripts and University Archives, and Division of Special Collections and Preservation, Suzallo Library, Univer-sity of Washington, Seattle; and the Whatcom Museum of History and Art, Bellingham, Washington.

Lastly, all of us associated with the project are indebted to the Seattle Fire Depart-ment. Their timely rescue of computer disks and original photographs from a fire that threatened the designers' studio enabled publication to proceed as planned.

Tina Oldknow

Appendix

Board of Trustees, Advisory Council, and International Council

1971–1995

1971
Pilchuck operates without a board in its first season.

1972
A board is established with trustees from the Pacific Northwest Arts Center.
Patricia M. Baillargeon, Anne Gould Hauberg, John H. Hauberg, Joseph L. McCarthy, Philip S. Padelford.

1973
Joseph McCarthy becomes the first president of the Pilchuck board of trustees.
Patricia M. Baillargeon, Anne Gould Hauberg, John H. Hauberg, Joseph L. McCarthy *(president)*, Philip S. Padelford.

1974
The Pacific Northwest Arts Center becomes the Pacific Northwest Arts Council of the Seattle Art Museum.
Patricia M. Baillargeon, Anne Gould Hauberg, John H. Hauberg, Joseph L. McCarthy *(president)*, Philip S. Padelford.

1975
Patricia M. Baillargeon, Anne Gould Hauberg, John H. Hauberg, Joseph L. McCarthy *(president)*, Philip S. Padelford.

1976–1977
Pilchuck separates from the Pacific Northwest Arts Council of the Seattle Art Museum and incorporates as an independent nonprofit educational organization. Joseph McCarthy is succeeded by Frank Kitchell, second board president.
Patricia M. Baillargeon, Anne Gould Hauberg, John H. Hauberg, Johanne B. Hewitt, Frank R. Kitchell *(president)*, Philip S. Padelford, Gladys S. Rubinstein, Samuel Rubinstein.

1977–1978
Patricia M. Baillargeon, Anne Gould Hauberg, John H. Hauberg, Johanne B. Hewitt, Frank R. Kitchell *(president)*, John W. Ormsby, Philip S. Padelford, Gladys S. Rubinstein, Samuel Rubinstein.

1978–1979
Patricia M. Baillargeon *(vice president)*, Robert J. Block, Roger N. Christiansen, Anne Gould Hauberg, John H. Hauberg, Johanne B. Hewitt, Frank R. Kitchell *(president)*, Jack Lenor Larsen, Illsley B. Nordstrom, John W. Ormsby, Philip S. Padelford, Gladys S. Rubinstein, Samuel Rubinstein.

1979–1980
Frank Kitchell is succeeded by John Hauberg, third board president.
Patricia M. Baillargeon *(third vice president)*, Robert J. Block *(treasurer)*, Roger N. Christiansen *(secretary)*, Anne Gould Hauberg, John H. Hauberg *(president)*, Johanne B. Hewitt, Frank R. Kitchell, Jack Lenor Larsen, Harvey K. Littleton, Illsley B. Nordstrom, John W. Ormsby *(second vice president)*, Philip S. Padelford, Gladys S. Rubinstein, Samuel Rubinstein *(first vice president)*.

1980–1981
Patricia M. Baillargeon *(third vice president)*, Robert J. Block *(treasurer)*, Thomas L. Bosworth, Roger N. Christiansen *(secretary)*, John H. Hauberg *(president)*, Johanne B. Hewitt, Frank R. Kitchell, Jack Lenor Larsen, Harvey K. Littleton, Illsley B. Nordstrom, John W. Ormsby *(second vice president)*, Philip S. Padelford, Gladys S. Rubinstein, Samuel Rubinstein *(first vice president)*, Robert J. Seidl.

1981–1982
Patricia M. Baillargeon *(second vice president)*, Rebecca Benaroya, Robert J. Block, Thomas L. Bosworth, Roger N. Christiansen *(secretary)*, George L. Davis, Mary Lund Davis, LaMar Harrington, John H. Hauberg *(president)*, Johanne B. Hewitt *(third vice president)*, C. David Hughbanks, Frank R. Kitchell, Jack Lenor Larsen, Harvey K. Littleton, Illsley B. Nordstrom, John W. Ormsby *(first vice president)*, Philip S. Padelford, Gladys S. Rubinstein, Samuel Rubinstein, Dorothy Saxe, George B. Saxe, Robert J. Seidl *(treasurer)*.

1982–1983
Patricia M. Baillargeon *(first vice president)*, Rebecca Benaroya, Robert J. Block *(secretary)*, Thomas L. Bosworth, George L. Davis, Mary Lund Davis, Gary Glant, Vicki Glant, LaMar Harrington, John H. Hauberg *(president)*, Johanne B. Hewitt *(second vice president)*, John Hewitt, C. David Hughbanks, Phillip Jacobson, Frank R. Kitchell, Jack Lenor Larsen, Harvey K. Littleton, Christina A. Lockwood, Illsley B. Nordstrom, John W. Ormsby, Philip S. Padelford, Laura Partridge, Gladys S. Rubinstein, Samuel Rubinstein, Dorothy Saxe, George B. Saxe *(third vice president)*, Robert J. Seidl, Robert H. Thurston.

1983–1984
Jeffrey Atkin, Patricia M. Baillargeon *(first vice president)*, Rebecca Benaroya, Robert J. Block *(secretary)*, Thomas L. Bosworth, Thomas S. Buechner, George L. Davis, Mary Lund Davis, Gary Glant, Vicki Glant, LaMar Harrington, John H. Hauberg *(president)*, Johanne B. Hewitt *(second vice president)*, John Hewitt, C. David Hughbanks, Phillip Jacobson, Frank R. Kitchell, Jack Lenor Larsen, Harvey K. Littleton, Christina A. Lockwood, E. W. Nash, Illsley B. Nordstrom, John W. Ormsby, Philip S. Padelford, Laura Partridge, Gladys S. Rubinstein, Samuel Rubinstein, Dorothy Saxe, George B. Saxe *(third vice president)*, Robert J. Seidl *(treasurer)*, Robert H. Thurston.

Libenský, Harvey K. Littleton, Peter Rath, Helmut Ricke, Jorgen Schou-Christensen, Paul Smith, Sybren Valkema, Bertil Vallien, David Wright.

1990–1991
Robert J. Seidl is succeeded by John N. Anderson, fifth board president.
Tom Alberg, John N. Anderson *(president)*, Parks Anderson, Jeffrey Atkin *(treasurer)*, Patricia M. Baillargeon, Daniel Baty, Jack Benaroya, Rebecca Benaroya, Alan F. Black, Gretchen M. Boeing *(vice president)*, Thomas L. Bosworth, Susan Brotman *(vice president)*, Thomas S. Buechner, Dale Chihuly, Mary Alice Cooley, George L. Davis *(vice president)*, Vicki Glant, Mark T. Haley, John H. Hauberg, Johanne B. Hewitt, C. David Hughbanks, Phillip Jacobson, Frank R. Kitchell, Christina A. Lockwood, Ann McCaw, Cindy McNae, E. W. Nash, Babo Olanie, Nathaniel Page, Douglass A. Raff *(secretary)*, J. Thurston Roach, Gladys S. Rubinstein, Samuel Rubinstein, Dorothy Saxe, George B. Saxe, Robert J. Seidl, Mary Shirley.

International Council: Yvonne Brunhammer, Thomas S. Buechner *(chair)*, Dale Chihuly, LaMar Harrington, Itoko Iwata, Dan Klein, Jack Lenor Larsen, Stanislav Libenský, Harvey K. Littleton, Peter Rath, Helmut Ricke, Jorgen Schou-Christensen, Paul Smith, Sybren Valkema, Bertil Vallien, David Wright.

1991–1992
Dale Anderson, Doug Anderson, John N. Anderson *(president)*, Jeffrey Atkin *(treasurer)*, Patricia M. Baillargeon, Daniel Baty, Jack Benaroya, Rebecca Benaroya, Alan F. Black, Gretchen M. Boeing, Susan Brotman *(vice president)*, Thomas S. Buechner, Dale Chihuly, Mary Alice Cooley, Vicki Glant, Mark T. Haley, John H. Hauberg, Johanne B. Hewitt, C. David Hughbanks, Phillip Jacobson *(vice president)*, Joey Kirkpatrick, Frank R. Kitchell, Christina A. Lockwood *(vice president)*, Cindy McNae, Benjamin P. Moore, William Morris, E. W. Nash, Babo Olanie, Nathaniel Page, Douglass A. Raff *(secretary)*, J. Thurston Roach, Randall Rubenstein, Gladys S. Rubinstein, Samuel Rubinstein, Ginny Ruffner, Dorothy Saxe, George B. Saxe, Robert J. Seidl, Mary Shirley, Richard S. Swanson.

International Council: Yvonne Brunhammer, Thomas S. Buechner *(chair)*, Dale Chihuly, LaMar Harrington, Itoko Iwata, Dan Klein, Jack Lenor Larsen, Stanislav Libenský, Harvey K. Littleton, Peter Rath, Helmut Ricke, Jorgen Schou-Christensen, Paul Smith, Sybren Valkema, Bertil Vallien, David Wright.

1992–1993
John N. Anderson is succeeded by C. David Hughbanks, sixth board president.
Dale Anderson, Doug Anderson, John N. Anderson, Jeffrey Atkin *(treasurer)*, Patricia M. Baillargeon, Daniel Baty, Jack Benaroya, Rebecca Benaroya, Alan F. Black, Gretchen M. Boeing, Susan Brotman, Thomas S. Buechner, Dale Chihuly *(vice president)*, Anne E. Croco, Mark T. Haley *(vice president)*, John H. Hauberg, Johanne B. Hewitt, C. David Hughbanks *(president)*, Phillip Jacobson, Sheri Kersch-Schultz, Joey Kirkpatrick, Christina A. Lockwood, Cindy McNae, Benjamin P. Moore, William Morris, E. W.

Nash, Babo Olanie *(vice president)*, Nathaniel Page, Francine Pilloff, Douglass A. Raff *(secretary)*, J. Thurston Roach, Randall Rubenstein, Gladys S. Rubinstein, Samuel Rubinstein, Ginny Ruffner, Dorothy Saxe, George B. Saxe, Robert J. Seidl, Mary Shirley, Richard S. Swanson *(vice president)*, Patricia Wallace.

Advisory Council: Thomas S. Buechner, George L. Davis, Mary Lund Davis, LaMar Harrington, Anne Gould Hauberg, Joseph McCarthy.

International Council: Yvonne Brunhammer, Jaroslava Brychtová, Dale Chihuly, Erwin Eisch, Susanne K. Frantz, Françoise Guichon, Itoko Iwata, Dan Klein, Jack Lenor Larsen, Stanislav Libenský, Harvey K. Littleton, Finn Lynggaard, Richard Meitner, Klaus Moje, Pilar Muñoz, Osamu Noda, Sylva Petrová, Peter Rath, David Reekie, Helmut Ricke, Eliseo Garza Salinas, Jorgen Shou-Christensen, Lino Tagliapietra, Sybren Valkema, Bertil Vallien, David Wright.

1993–1994
Dale Anderson, Doug Anderson, Jeffrey Atkin *(treasurer)*, Patricia M. Baillargeon, Jack Benaroya, Rebecca Benaroya, David Bennett, Gretchen M. Boeing, Susan Brotman, Dale Chihuly *(vice president)*, Anne E. Croco, Fritz Dreisbach, Mark T. Haley, John H. Hauberg, Henry Hillman Jr., C. David Hughbanks *(president)*, Phillip Jacobson, Gaylord Kellogg, Sheri Kersch-Schultz, Joey Kirkpatrick, Christina A. Lockwood, Cindy McNae, Ginny Meisenbach, Benjamin P. Moore, E. W. Nash, Babo Olanie, Nathaniel Page, Benson Pilloff, Francine Pilloff, Douglass A. Raff *(secretary)*, J. Thurston Roach, Randall Rubenstein, Gladys S. Rubinstein, Samuel Rubinstein, Ginny Ruffner, Eric Russell, Dorothy Saxe, George B. Saxe, Robert J. Seidl, Susan Steinhauser, Richard S. Swanson *(vice president)*, Patricia Wallace.

Advisory Council: John N. Anderson, Thomas L. Bosworth, Thomas S. Buechner, George L. Davis *(chair)*, Mary Lund Davis, LaMar Harrington, Anne Gould Hauberg, Johanne B. Hewitt, Frank R. Kitchell, Joseph L. McCarthy, Mimi Pierce, Jon Shirley, Mary Shirley.

International Council: Yvonne Brunhammer, Jaroslava Brychtová, Dale Chihuly, Erwin Eisch, Susanne K. Frantz, Françoise Guichon, Itoko Iwata, Phillip Jacobson *(chair)*, Dan Klein, Jack Lenor Larsen, Stanislav Libenský, Harvey K. Littleton, Finn Lynggaard, Richard Meitner, Klaus Moje, Pilar Muñoz, Osamu Noda, Sylva Petrová, Peter Rath, David Reekie, Helmut Ricke, Eliseo Garza Salinas, Jorgen Shou-Christensen, Lino Tagliapietra, Sybren Valkema, Bertil Vallien, David Wright.

1994–1995
C. David Hughbanks is succeeded by Mark T. Haley, seventh board president.
Cindy Abrahamson, Chap Alvord, Dale Anderson, Doug Anderson, Jeffrey Atkin *(treasurer)*, Patricia M. Baillargeon, Jack Benaroya, Rebecca Benaroya, David Bennett, Gretchen M. Boeing, Susan Brotman, Dale Chihuly *(vice president)*, Anne E. Croco, Fritz Dreisbach, Mark T. Haley *(president)*, John H. Hauberg, Jim Henderson, Henry Hillman Jr.,

C. David Hughbanks, Paul Isaki, Phillip Jacobson, Sheri Kersch-Schultz, Joey Kirkpatrick, Dan Levitan, Christina A. Lockwood, Ruby Love, Darle Maveety, Ginny Meisenbach, Benjamin P. Moore, E. W. Nash, Babo Olanie, Nathaniel Page, Sherry Paulsell, Benson Pilloff, Francine Pilloff, Douglass A. Raff *(secretary)*, J. Thurston Roach, Randall Rubenstein *(vice president)*, Gladys S. Rubinstein, Samuel Rubinstein, Ginny Ruffner *(vice president)*, Eric Russell, Dorothy Saxe, George B. Saxe, Robert J. Seidl, Susan Steinhauser, Richard S. Swanson, Patricia Wallace.

Advisory Council: John N. Anderson, Thomas L. Bosworth, Thomas S. Buechner, George L. Davis *(chair)*, Mary Lund Davis, LaMar Harrington, Anne Gould Hauberg, Johanne B. Hewitt, Frank R. Kitchell, Joseph L. McCarthy, Mimi Pierce, Jon Shirley, Mary Shirley.

International Council: Yvonne Brunhammer, Jaroslava Brychtová, Dale Chihuly, Erwin Eisch, Susanne K. Frantz, Françoise Guichon, Ulrica Hydman-Vallien, Itoko Iwata, Phillip Jacobson *(chair)*, Dan Klein, Jack Lenor Larsen, Stanislav Libenský, Harvey K. Littleton, Finn Lynggaard, Richard Meitner, Klaus Moje, Pilar Muñoz, Osamu Noda, Sylva Petrová, Peter Rath, David Reekie, Helmut Ricke, Eliseo Garza Salinas, Jorgen Shou-Christensen, Lino Tagliapietra, Sybren Valkema, David Wright.

1995–1996
Cindy Abrahamson, Chap Alvord, Dale Anderson, Doug Anderson, Jeffrey Atkin *(treasurer)*, Patricia M. Baillargeon, Jack Benaroya, Rebecca Benaroya, David Bennett, Gretchen M. Boeing, Ron Brill, Susan Brotman, Dale Chihuly *(vice president)*, Sarah Davies, Fritz Dreisbach, Robert Fisher, Mark T. Haley *(president)*, John H. Hauberg, Jim Henderson, Henry Hillman Jr., C. David Hughbanks, Paul Isaki, Phillip Jacobson, Sheri Kersch-Schultz, Joey Kirkpatrick, Jackie Kotkins, Dan Levitan, Christina A. Lockwood, Darle Maveety, Josiah McElheny, Ginny Meisenbach, Benjamin P. Moore, E. W. Nash, Babo Olanie, Nathaniel Page, Benson Pilloff, Francine Pilloff, Douglass A. Raff *(secretary)*, J. Thurston Roach, Betsy Rosenfeld, Randall Rubenstein *(vice president)*, Gladys S. Rubinstein, Samuel Rubinstein, Ginny Ruffner *(vice president)*, Eric Russell, Dorothy Saxe, George B. Saxe, Robert J. Seidl, Susan Steinhauser, Linda Stone, Richard S. Swanson, Patricia Wallace.

Advisory Council: John N. Anderson, Thomas L. Bosworth, Thomas S. Buechner, Mary Lund Davis, Anne Gould Hauberg, Johanne B. Hewitt *(chair)*, Frank R. Kitchell, Joseph L. McCarthy, Mimi Pierce, Jon Shirley, Mary Shirley.

International Council: Yvonne Brunhammer, Jaroslava Brychtová, Dale Chihuly, Erwin Eisch, Susanne K. Frantz, Françoise Guichon, Ulrica Hydman-Vallien, Itoko Iwata, Phillip Jacobson *(chair)*, Dan Klein, Jack Lenor Larsen, Stanislav Libenský, Harvey K. Littleton, Finn Lynggaard, Richard Meitner, Klaus Moje, Pilar Muñoz, Osamu Noda, Sylva Petrová, Peter Rath, David Reekie, Helmut Ricke, Eliseo Garza Salinas, Jorgen Shou-Christensen, Lino Tagliapietra, David Wright.

Faculty, Visiting Artists, and Artists-in-Residence 1971–1995

Faculty listings for 1971–1973 are incomplete since little distinction was made between faculty, students, and staff in those years. Listings of visiting artists (VA) for all years are incomplete since many visitors were unrecorded. Artists-in-residence are indicated by (AR).

1971
James Carpenter, Dale Chihuly, Robert Hendrickson, John Landon, Buster Simpson, Ruth Tamura, Art Wood.

1972
John Benson, Nick Bertoni (VA), James Carpenter, Guy Chambers, Dale Chihuly, Fritz Dreisbach, Erwin Eisch (VA), Bob Hanson, Robert Hendrickson, Doug Hollis, Chris Johanson, John Landon, William Morrow, Robert Naess, Buster Simpson, Ruth Tamura, Barbara Vaessen, Martha Wehrer (VA), Art Wood.

1973
Harry Anderson, James Carpenter, Clair Colquitt (VA), Dale Chihuly, Fritz Dreisbach, Frank Ferrell (VA), Richard Fleischner (VA), Mark Graham (VA), Roni Horn (VA), Michael Kennedy (VA), John Landon, Robert Naess, Pat Oleszko (VA), Italo Scanga, Buster Simpson, Barbara Vaessen, Art Wood.

1974
James Carpenter, Dale Chihuly, Fritz Dreisbach, Marvin Lipofsky, Harvey Littleton (VA), Paul Marioni, Italo Scanga.

1975
Fritz Dreisbach, Paul Marioni, Mark Peiser, Jack Schmidt.

1976
James Carpenter, Dale Chihuly, Dan Dailey, Fritz Dreisbach, Seaver Leslie (VA), Paul Marioni, Italo Scanga, Jack Schmidt.

1977
James Carpenter (VA), Dale Chihuly, Dan Dailey, Fritz Dreisbach, Seaver Leslie (VA), Marvin Lipofsky (VA), Paul Marioni, Richard Posner (VA), Italo Scanga, Ludwig Schaffrath, Ann Wolff, Art Wood (VA).

1978
Dale Chihuly, Michael Cohn, Dan Dailey, Robert Kehlmann, Harvey Littleton, Checco Ongaro (VA), Richard Posner (VA), Stephen Procter (VA), Patrick Reyntiens, Jan-Erik Ritzman (VA), Italo Scanga, Ludwig Schaffrath, Dick Weiss (VA).

1979
Wilke Adolfsson (VA), Dale Chihuly, Brian Clarke, Dan Dailey, Fritz Dreisbach, Paul Marioni, Richard Marquis, Isgard Moje-Wohlgemuth, Klaus Moje, Benjamin Moore, Joel Phillip Myers, Patrick Reyntiens, Italo Scanga, Ludwig Schaffrath, Lino Tagliapietra (VA), Ann Wolff.

1980

The artist-in-residence program begins.
William Bernstein, James Carpenter (AR), Dale Chihuly (AR), Dan Dailey, Fritz Dreisbach, Albinas Elskus, Ulrica Hydman-Vallien (AR), Robert Kehlmann, Joey Kirkpatrick (AR), Harvey Littleton (AR), Flora Mace (AR), Paul Marioni, Klaus Moje (AR), Benjamin Moore, Joel Phillip Myers, Richard Posner, Narcissus Quagliata, Italo Scanga (AR), Mary Shaffer (AR), Ludwig Schaffrath, Robert Strini (AR), Lino Tagliapietra (AR), Paul Trautman (VA), Bertil Vallien.

1981

Thomas Buechner (VA), James Carpenter, Dale Chihuly (AR), Dan Dailey, Erwin Eisch, Albinas Elskus, Erik Hoglund, James Houston (VA), Ulrica Hydman-Vallien, Joey Kirkpatrick, Marvin Lipofsky (VA), Harvey Littleton (AR), Flora Mace, Paul Marioni, Klaus Moje, Narcissus Quagliata, Italo Scanga (AR), Johannes Schreiter, Therman Statom (VA), Susan Stinsmuehlen-Amend (AR), Bertil Vallien, William Warmus (VA), Dick Weiss (VA).

1982

Jaroslava Brychtová (AR), Thomas Buechner (AR), Dale Chihuly (AR), Dan Dailey, Fritz Dreisbach (AR), Albinas Elskus, Michael Glancy, Henry Halem, James Harmon (AR), Richard Harned, Ulrica Hydman-Vallien, Margie Jervis (AR), Ray King, Joey Kirkpatrick, Susie Krasnican (AR), Stanislav Libenský (AR), Finn Lynggaard, Flora Mace, Linda MacNeill, Klaus Moje, Jochem Poensgen, Carl Powell, Susan Stinsmuehlen-Amend, Barbara Vaessen, Bertil Vallien, Dick Weiss (AR), Toots Zynsky (AR).

1983

Mary Ann Babula, Jaroslava Brychtová (AR), Thomas Buechner (AR), William Carlson, Bruce Chao (AR), Dale Chihuly (AR), Jon Clark, Erwin Eisch, Margarete Eisch, Albinas Elskus, Michael Glancy, Henry Halem, David Huchthausen, Joey Kirkpatrick, Stanislav Libenský (AR), Walter Lieberman, Flora Mace, Paul Marioni (AR), Richard Meitner, Pavel Molnar, Jochem Poensgen, Narcissus Quagliata, Italo Scanga (AR), Susan Stinsmuehlen-Amend, Lino Tagliapietra (AR), Barbara Vaessen, Bertil Vallien (also AR), Dick Weiss, Dana Zámečníková (AR).

1984

Lynda Benglis (AR), Rick Bernstein, Thomas Buechner (AR), Katherine Bunnell, Ed Carpenter, Karen Chambers (VA), Michael Cohn, Bill Concannon (VA), Sheryl Cotleur, Dan Dailey, Fritz Dreisbach, Erwin Eisch, Katherina Eisch, Michael Glancy, Ulrica Hydman-Vallien, Margie Jervis, Jun Kaneko (AR), Michael Kennedy (AR), Susie Krasnican, Marvin Lipofsky, Paul Marioni, Richard Marquis, Nancy Mee (AR), Klaus Moje, Tim O'Neill, Jerry Pethick (VA), Carl Powell, Narcissus Quagliata, Clifford Rainey, Ginny Ruffner, Michael Singer (AR), Therman Statom, Molly Stone, Cappy Thompson (VA), John Torreano (AR), Fred Tschida (VA), Bertil Vallien, Dick Weiss (VA), Mary White, Christopher Wilmarth (AR), Ann Wolff, Toots Zynsky.

1985

Larry Ahvakana (VA), Lynda Benglis (AR), Sonja Blomdahl, Ruth Brockman, William Carlson, Ed Carpenter, Dale Chihuly (AR), Dan Dailey, Fritz Dreisbach (AR), Albinas Elskus, Ann Gardner (AR), Michael Glancy, Jirí Harcuba (AR), Lutz Haufschild, Robert Kehlmann (AR), Joachim Klos, Richard LaLonde, Andrew Magdanz, Paul Marioni (AR), Richard Marquis, Jay Musler, Robert Naess (AR), Judy North, Tim O'Neill, Richard Posner (AR), Clifford Rainey, Jan-Erik Ritzman, Amy Roberts, Ginny Ruffner, Norie Sato (AR), Italo Scanga (AR), Susan Shapiro, Debra Sherwood (AR), Therman Statom, Susan Stinsmuehlen-Amend, Lino Tagliapietra, Fred Tschida, Barbara Vaessen (AR), Bertil Vallien (AR), Bert Van Loo, William Warmus, Steven Weinberg, Dana Zámečníková (AR).

1986

Channa Bankier, Howard Ben Tré (AR), Joan Ross Blaedel (AR), Jaroslava Brychtová, Thomas Buechner (AR), Sydney Cash, Dale Chihuly (also AR), Norman Courtney, Paulo Dufour, Erwin Eisch, Kate Elliott, Albinas Elskus, Michael Glancy, Henry Halem, Jirí Harcuba, Richard Harned, Robert Hodges (VA), Eric Hopkins (AR), David Huchthausen (AR), Ulrica Hydman-Vallien, Diane Katsiaficas, Joey Kirkpatrick, Warren Langley, Stanislav Libenský, Flora Mace, Paul Marioni, Klaus Moje, Louis Mueller (AR), Joel Phillip Myers, Ron Onoroto (VA), Charles Parriott, Jerry Pethick (AR), Jan-Erik Ritzman, Ginny Ruffner, Italo Scanga (AR), Peter Shire (AR), Therman Statom, Susan Stinsmuehlen-Amend, Fred Tschida, Bertil Vallien, Hans Gottfried von Stockhausen, William Warmus, Ed Wicklander (AR), Ann Wolff.

1987

Walter Darby Bannard (VA), Dorit Brand (VA), Jaroslava Brychtová, Thomas Buechner (AR), Katherine Bunnell, Anna Carlgren (AR), Dale Chihuly (also AR), KéKé Cribbs, Dan Dailey (AR), William Dexter, Albinas Elskus (AR), Kate Elliott, Jirí Harcuba, James Harmon, Diana Hobson, David Hopper, Ursula Huth (AR), Joey Kirkpatrick (also AR), Stanislav Libenský, Walter Lieberman (AR), Harvey Littleton, Flora Mace (also AR), Andrew Magdanz, Paul Marioni, Maxine Martell (AR), Lucy Mohl (AR), Klaus Moje, Benjamin Moore, William Morris (AR), Judy North, Danny Perkins (VA), Narcissus Quagliata, Amy Roberts, Ginny Ruffner, Italo Scanga (AR), Susan Shapiro, Susan Stinsmuehlen-Amend, Jirí Suhajek, Lino Tagliapietra, John Torreano (AR), Karla Trinkley, Fred Tschida, Durk Valkema (AR), Sybren Valkema (AR), Patrick Wadley, William Warmus, David Wharton.

1988

Nicholas Africano (AR), Katherine Bunnell, Deborah Dohne (VA), Fritz Dreisbach, Ann Gardner (VA), Michael Glancy, Henry Halem, Jirí Harcuba, Diana Hobson, Ulrica Hydman-Vallien, Andrew Keating (AR), Joey Kirkpatrick, Warren Langley, John Leighton, Marvin Lipofsky, Flora Mace, Liz Mapelli, Paul Marioni, William Morris, Judy North, Ronald Pennell, Jerry Pethick (AR), Pike Powers (AR), Clifford Rainey, Dino Rosin, Loredano Rosin, Ginny Ruffner, Italo Scanga (AR), Ludwig Schaffrath,

Johannes Schreiter, Dan Schwoerer, Paul Stankard, Cappy Thompson, John Torreano (AR), Fred Tschida, Bertil Vallien, Patrick Wadley, Mary White, Bill Woodrow (VA).

1989
Nicholas Africano (AR), Jaroslava Brychtová, Marsha Burns (AR), Michael Burns (AR), Robert Carlson, José Chardiet, KéKé Cribbs, Paulo Dufour, Henry Halem, Jirí Harcuba, Diana Hobson, David Hopper, David Huchthausen, Lawrence Jasse, Marian Karel, Joey Kirkpatrick, Stanislav Libenský, Walter Lieberman, Flora Mace, Rachel Mesrahi, William Morris, Judy North, Dennis Oppenheim (AR), Charles Parriott, Judy Pfaff (AR), Pike Powers, Clifford Rainey, Amy Roberts, Richard Royal, Ginny Ruffner, Italo Scanga (AR), Mary Shaffer, Pino Signoretto, Therman Statom, Susan Stinsmuehlen-Amend, Cappy Thompson, John Torreano (AR), Fred Tschida, Bertil Vallien, Ann Wåhlstrom, David Wharton, Robin Winters (AR), Bill Woodrow (AR), Dana Zámečníková.

1990
Michele Blondel, Jaroslava Brychtová, Robert Carlson, José Chardiet, Dan Dailey, Laddie John Dill (AR), James Drake (AR), Albinas Elskus, Henry Halem, Joey Kirkpatrick, Susie Krasnican, Stanislav Libenský, Donald Lipski (AR), Flora Mace, Liz Mapelli, Jan Mares, Dante Marioni, Tom Marioni (AR), Klaus Moje, William Morris, Dennis Oppenheim (AR), Mark Peiser, Judy Pfaff (AR), Susan Plum, David Reekie, Amy Roberts, Richard Royal, Ginny Ruffner, Italo Scanga (AR), Michael Scheiner, Henner Schroder, Pino Signoretto, Paul Stankard, Susan Stinsmuehlen-Amend, John Torreano (AR), Fred Tschida, Hans Gottfried von Stockhausen, William T. Wiley (AR).

1991
Judy Bally Jensen, Arlon Bayliss, Curtiss Brock, Dale Chihuly, Bill Concannon, James Drake (AR), Ann Hamilton (AR), Diana Hobson, Roberto Juarez (AR), Mark Kobasz, Warren Langley, John Lewis, Donald Lipski (AR), Jan Mares, Dante Marioni, Joseph Marioni (AR), Richard Marquis, Izhar Patkin (AR), Judy Pfaff (AR), Susan Plum, Damian Priour, Narcissus Quagliata, Clifford Rainey, David Reekie, Patrick Reyntiens, Loredano Rosin, Cesare Toffol Rossit, Louis Scalfani, Henner Schroder, Kiki Smith (AR), Susan Stinsmuehlen-Amend, Lino Tagliapietra, Thomas Tisch, Fred Tschida, Kurt Wallstab, William Warmus, James Watkins, Hiroshi Yamano.

1992
Curtiss Brock, Robert Carlson, Bill Concannon, Norman Courtney, KéKé Cribbs, Deborah Dohne, Fritz Dreisbach, Viola Frey (AR), Nancy Graves (AR), Robin Grebe, Ann Hamilton (AR), Kisao Iburi, Makoto Ito, Fay Jones (VA), Ruth King, Warren Langley, Jacob Lawrence (VA), Michal Machat, Jan Mares, Dante Marioni, Jim Melchert (VA), Rick Mills, James Minson, Jeffry Mitchell (AR), Petr Novotny, Charles Parriott, Pike Powers, Ann Robinson, Italo Scanga (AR), Judith Schaechter, Joyce Scott (AR), Pino Signoretto, Paul Stankard, Jana Sterbak (AR), Susan Stinsmuehlen-Amend, Cappy Thompson, Thomas Tisch, Bertil Vallien, David Wright.

1993
Martin Blank, Dan Dailey (VA), Laura Donefer, Lauren Ewing (AR), Thomas Farbanish, Ann Gardner (VA), Jirí Harcuba, Fred Kahl, Gene Koss, Steve Kursh (AR), Walter Lieberman, Jean Lowe (AR), Kim MacConnell (AR), Cork Marcheschi, Dante Marioni, Heather McGill (AR), Robbie Miller (VA), James Minson, Felice Nittolo, Osamu Noda, Yumiko Noda, Judy Pfaff (AR), Maria Porges (AR), Pike Powers, Damian Priour, Clifford Rainey, David Reekie, Cesare Toffol Rossit, Richard Royal, Ginny Ruffner (AR), Gisela Sabokova, Elizabeth Sandvig (VA), Italo Scanga (AR), Judith Schaechter, Michael Scheiner, Pino Signoretto, Buster Simpson (VA), Kiki Smith (AR), Therman Statom, Lino Tagliapietra, Cappy Thompson (VA), Oiva Toikka, Mary Van Cline, Dick Weiss.

1994
Tina Aufiero, Martin Blank, Peter Boynton (AR), Squeak Carnwath (AR), Willie Cole (AR), Bill Concannon, Debora Coombs, Dan Dailey, Stephen Paul Day, Thomas Farbanish, Rudi Gritsch, Richard Harned, Ruth King, Gene Koss, Raimund Kummer (AR), Akira Kurosaki (VA), Eve André Laramée (AR), Maya Lin (AR), Josiah McElheny, Robert Mickelsen, Felice Nittolo, Lukas Novotny, Petr Novotny, Baker O'Brien, Flo Perkins, René Roubíček, Italo Scanga (AR), Pino Signoretto, Lorna Simpson (AR), Anna Skibska, Kiki Smith, Therman Statom, Susan Stinsmuehlen-Amend, Lino Tagliapietra, Robert Tannen (AR), Trimpin (AR), James Watkins, Hiroshi Yamano, Dana Zámečníková

1995
Hank Murta Adams, Howard Ben Tré (VA), Lynda Benglis (AR), Bonnie Biggs, Jaroslava Brychtová (AR), Robert Carlson, Dale Chihuly (VA), Stephen Paul Day, Laura Donefer, Fritz Dreisbach, Irene Frolic, Jan Frydrych, Ann Gardner (VA), Steven Holl (VA), Deborah Horrall (AR), Sidney Hutter, Judy Jensen, Brian Kerkvliet (VA), Susie Krasnican, Steve Kursh, Stanislav Libenský (AR), Walter Lieberman (VA), Cork Marcheschi, Dante Marioni, Paul Marioni (VA), Richard Marquis, Robert Mickelsen, Benjamin Moore (VA), Nick Mount, Felice Nittolo, Petr Novotny, Checco Ongaro, Joel Otterson (AR), Charles Parriott (VA), Susan Plum, Maria Porges (VA), Ginny Ruffner, Junnel Sahlin, Italo Scanga (AR), Judith Schaechter, Joyce Scott (AR), Pino Signoretto, Buzz Spector (AR), Therman Statom, Lino Tagliapietra, Barbara Vaessen, Bertil Vallien, Randy Walker, Robin Winters, Ann Wolff.

Teaching Assistants

1975–1995

1975
Teaching assistants are assigned for the first time.
Rick Bernstein, Lark Dalton, Robert Levin, Benjamin Moore, Paul Neuman, Art Reed.

1976
Rick Bernstein, Richard Duggan, Erica Friedman, Andrew Magdanz, June Marsh, Benjamin Moore, Stan Price, Art Reed, Jack Wax.

1977
Gary Beecham, Howard Ben Tré, Barbara Cataldo, Norman Courtney, William Dexter, David Fernandez, Erica Friedman, Michael Glancy, James Harmon, John Leighton, Stan Price, Michael Scheiner, Mark Stanley, Peter Vanderlaan, Scott White.

1978
Jim Andrews, Sonja Blomdahl, Richard Cohen, William Dexter, Dennis Elliot-Smith, Michael Glancy, Ann Harakawa, James Harmon, Paul Housberg, Sidney Hutter, Shelley Jurs, Ray King, Edward McIlvane, Doug Navarra, Michael Scheiner.

1979
Jim Andrews, Howard Ben Tré, Clive Blewchamp, Katherine Bunnell, Michael Burns, Richard Cohen, Lark Dalton, William Dexter, Jody Fine, Patty Green, Doug Hansen, Ann Harakawa, Eric Hopkins, Larry Jasse, Jenny Langston, Flora Mace, Charles Parriott, Margie Robinson, Waine Ryzak, Michael Scheiner, Robert Sherwood, Karla Trinkley, Jack Wax, Scott White.

1980
Lorrie Anderson, Jim Andrews, Linda Autio, Lynn Barretti, Sonja Blomdahl, Sheryl Cotleur, Norman Courtney, Stephen Dale Edwards, Dennis Elliot-Smith, Jody Fine, Joe Frangiosa, Peter Greenwood, Mark Gulsrud, Richard Harkness, James Holmes, Mark Kobasz, Jenny Langston, Walter Lieberman, Linda Lynch, Meredith McLeod, Rachel Mesrahi, Rick Nicholson, Keith Ogilvie, Elizabeth Pannell, Patricia Patenaude, Dan Read, Dan Reiser, Peter Reuthlinger, Peter Ridabock, Christine Robbins, Michael Scheiner, Lynn Sexton, Susan Stinsmuehlen-Amend, Molly Stone, James Templeton, David Traub, Mary Warren, James Watkins, Mark Weiner, Toots Zynsky.

1981
Hank Murta Adams, Valerie Arber, Mary Ann Babula, Sonja Blomdahl, Sheryl Cotleur, Norman Courtney, Peter Drobney, Neal Drobnis, Stephen Dale Edwards, Hanneke Fokkelman, Michael Glancy, Karen Greiffenberg, Ursula Huth, Katherine Iff, Conchetta Mason, Flo Perkins, Tom Philabaum, Pike Powers, Amy Roberts, Michael Scheiner, Carol Schreitmuller, Kenneth Van Roenn, Mark Weiner.

1982
Valerie Arber, Mary Barclay, Melodie Baylik, Bernie d'Onofrio, Stephen Dale Edwards, Pam Haight, Karin Hall, Lutz Haufschild, Werner Heymann, Robert Hodges, Larry Jasse, Kreg Kallenberger, David Kerner, Mark Kobasz, Christine Mallet, Peter Mangan, Mark McDonnell, Karen Mesmer, Osamu Noda, Flo Perkins, Dan Reed, Robert Ricciardelli, David Ruth, Kurt Swanson, James Templeton, Ann Wåhlstrom, Mark Weiner, Ronnie Wolf, Sara Young, Karen Zoot.

1983
Melodie Baylik, Thom Beckett-Smith, Rodney Bender, Rachel Berwick, Beliz Brother, José Chardiet, Norman Courtney, Martha Croasdale, Garth Edwards, Larry Fielder, Lutz Haufschild, Robert Hodges, Ursula Huth, Kimiko Kogure, Daniel Johnson, Richard LaLonde, Phil Lopez, Stephen Nelson, Osamu Noda, Yumiko Noda, Jackie Pancari, Charles Parriott, Jeremy Popelka, Pike Powers, Robert Ricciardelli, Amy Roberts, Marc Rubin, Carol Schreitmueller, Cappy Thompson, James Van Deurzen, Janusz Walentynowicz.

1984
Melodie Baylik, Hal Bond, Curtiss Brock, Ruth Brockman, Bird Brother, Jeff Burnett, José Chardiet, Chip Corradetti, Norman Courtney, Richard Dodge, Neal Drobnis, Steven Hansen, Robert Herhusky, Lee Hervey, Elodie Holmes, Jim Holmes, Lawrence Huff, Richard LaLonde, Warren Langley, John Leighton, David Leppla, Meredith MacLeod, Kelly McLain, Joseph Morelli, Vincent Olmstead, Danny Perkins, Carola Nan Roach, Linda Ross, Bruce Smith, Steven Tobin, Sara Young.

1985
Carol Acquilano, Michael Aschenbrenner, Jeffrey Becker, Curtiss Brock, José Chardiet, Daniel Clayman, Kathleen Corcoran, KéKé Cribbs, Linda Denning, Nancy Dilley, Scott Dunham, Loretta Eby, Greg Englesby, Hanneke Fokkelman, Mary Fox, Andrew Giddings, Dieter Goldkuhle, Steven Hansen, David Hasslinger, Randy Hester, Bob Hodges, Michael Jaross, Bettina Klos, Karyn Kozak, John Leighton, David Levi, Jack Malis, Elizabeth Marx, Steven McCarroll, Peter Mollica, Nick Mount, Stephen Powell, Marilyn Puschak, Gil Reynolds, James Reynolds, Carol Schreitmueller, Mary Kay Simoni, Chris Tedesco, Cynthia Welton, Regina Zelaya.

1986
Tom Anderson, Paula Bartron, Melodie Baylik, Robert Carlson, Einar de la Torre, Deborah Dohne, Neil Drobnis, Stephen Dale Edwards, Eberhard Eisch, Linda Either, Thomas Farbanish, John T. Feige, Gail Gill, Becca Gruliow, Eric Hopkins, Peter Hundreiser, Frederick Kahl, Walter Lieberman, Chris Lubinski, John McComish, Kelly McLain, Michael Metcalf, Mike Mikula, Claude Monod, Danny Perkins, Amanda Jane Pierce, Tisha Powell, Marilyn Puschak, Gerhard Ribka, Sarah Richardson, Jaroslav Rona, Thomas Scoon, Sharon Sherman, Preston Singletary, Gayle Sokol, Diane Testa, Paul Trautman,

Ann Troutner, Eva Vlasakova, Patrick Wadley, Jaroslav Zahradnik, Regina Zelaya, Peter Zelle.

1987
Peter Andres, Andrew Antoniou, Keith Brocklehurst, Annabel Buckley, Ronny Carlsson, Nedra Carrol, Carla Caruso, John Chiles, Meg Chiles, Janet Christensen, John DeWit, Deborah Dohne, Laura Donefer, Thomas Farbanish, Ian Forbes, Mary Fox, Tracy Glover, John Greig, Page Hazelgrove, Fred Kahl, Elidih Keith, Brian Kerkvliet, John Leighton, Dante Marioni, Dimitri Michaelides, Priscilla Morgan, Nick Mount, Roger Nachman, Charles Parriott, Brian Pike, Kirstie Rea, Joe Thomas, Veruska Vagen, Susan Von Trotha, Barbara Wallace, Mark Weiner, Maureen Williams, Jaroslav Zahradnik, Peter Zelle.

1988
John Anderson, Tom Anderson, Sue Bannon, Eric Bladholm, Astrid Brunner, Annabel Buckley, Robert Carlson, Paul Counts, Cynthia Daiboch-England, Robert Dane, Anne Dietrich, Deborah Dohne, Laura Donefer, Thomas Farbanish, Karen Fishburn, Mark Fleming, John Forster, Tracy Glover, Tony Hanning, Judy Hill, Donna Hunt, Eileen Jager, Dale Johnson, Brian Kerkvliet, Karen Klim, John Leighton, Mark Lorenzi, Josiah McElheny, Gail O'Neill, Susan Plum, Mark Rosenbaum, Linda Ross, Louis Scalfani, Jeff Seely, Beverly Soja, Ivana Solcova, Joe Thomas, Roger Thomas, Susan Von Trotha, Leah Wingfield.

1989
Tom Anderson, Lubos Baudys, Arlon Bayliss, Martin Blank, Annabel Buckley, Thor Bueno, Ronny Carlsson, Josh Cohen, Paul Counts, Giselle Courtney, Norman Courtney, Laura Donefer, Mark Ferguson, Mark Fleming, Johannes Hollander, Fred Kahl, Gunilla Kihlgren, Ruth King, Richard LaLonde, Kenneth Leap, Patrick Martin, Linda Matti, Josiah McElheny, James Minson, Kimberly Petro, Mark Rosenbaum, Carol Schreitmuller, Henner Schroder, Mary Kay Simoni, Beverly Soja, Boyd Sugiki, Elizabeth Tapper, Kazumi Tsuji, Veruska Vagen, Charles Vannata, Mark Weiner, Sue Williams, Jaroslav Zahradnik.

1990
Lubos Baudys, Melodie Baylik, Dennis Brienning, Radovan Brychtová, Annabel Buckley, Thor Bueno, Paul Cunningham, Anthony Davlin, John DeWit, Rick Dodson, Phillipa Edwards, Thomas Farbanish, Kellmis José Fernandez, Randi Finkel, Mary Fox, Edward Frances, Linda Fraser, Rachel Gaspers, Mitchell Gaudet, Heather Gray, Hitoshi Kakizaki, Kevin Kilkenny, Ruth King, Tom Kreager, Karen LaMonte, Reddy Lieb, Walter Lieberman, Kevin Lockau, Jan Mares, Patrick Martin, Josiah McElheny, James Minson, Setsko Miura, Michele Muennig, Karen Naylor, Anthony Parker, Brian Pike, Jill Reynolds, Shelley Robinson, Mark Rosenbaum, Christiano Rossi, Teresa Salvato, Henner Schroder, Walter Uptmoor, Richard Whiteley, Sue Williams, Leah Wingfield.

1991
Records for this year are incomplete.
Thor Bueno, Elin Christopherson, Max Cregar, Paul Cunningham, Anthony Davlin, Deborah Dohne, John Farrell, Mary Fox, Mark Gibeau, Rudi Gritsch,

Ritama Haaga, Ruth King, David Levi, Yoji Matsuoka, James Minson, Jim Mongrain, Ryuichi Morisaki, Brian Pike, Janusz Pozniak, Jocelyne Prince, Carola Nan Roach, Keiko Saito, Louis Scalfani, Graham Scott, Seichi Shiraishi, Preston Singletary, Andrew Stenerson, Robert Stern, Boyd Sugiki, Ferdinand Thieriot, Alicia Tyler, Veruska Vagen, Karla Verges, Evelyn Wagner, Barbara Wells, Geoffrey Wichert, Harumi Yukutake.

1992
Rick Beck, Thor Bueno, Ricardo Conde, Max Cregar, Randy Dalby, Anthony Davlin, Ben Edols, Scott Fitzel, Mark Gibeau, Tracy Glover, Katherine Gray, Hitoshi Kakizaki, Kim Kelzer, Gabrielle Kuestner, Leslie Israelson, Karen LaMonte, Paul Larned, Eileen Lester, Lisabeth Levine, Ian Lewis, Dimitri Michaelides, Patrick Morrissey, Nick Mount, Xan Palay, Mark Parsons, Eric Portrais, Janusz Pozniak, Jocelyne Prince, Carola Nan Roach, Joellyn Rock, Keiko Saito, Louis Scalfani, Rebecca Silva, Will Stokes, Woo Mee Suh, David Svenson, Ferdinand Thieriot, Joseph Thomas, James Thompson, Martin Velichek, Geoffrey Wichert, Harumi Yukutake.

1993
Artist assistants were first assigned in 1993 and are listed here with teaching assistants.
Ruth Allen, Jean Amann, Karel Bartonichek, Tina Betz, Randy Birch, Kathy Budd, Thor Bueno, Natalie Cargill, Silvia Causin-Nittolo, Cathy Chase, Sarah Chase, Debora Coombs, Max Cregar, Patricia Davidson, Anthony Davlin, Donna Day, Benjamin Edols, Mary Fox, Mitchell Gaudet, Tracy Glover, Laura Goodwin, Kotaro Hamada, Bengt Hokanson, Ken Ikushima, Masami Koda, Paul Larned, Trevor Lunn, Patrick Martin, Josiah McElheny, Heather Moore, Nick Mount, Douglas Ohm, Brian Pike, Janusz Pozniak, Catherine Rahn, Kait Rhoads, Alison Ruzsa, Teresa Salvato, Peet Sasaki, Louis Scalfani, Corey Elizabeth Stein, Yoji Suzuki, Ferdinand Thieriot, Morna Tudor, Yuki Uchimura, Susan Von Trotha, Nancy Meli Walker, Barbara Wallace.

1994
Rik Allen, Ruth Allen, Sam Andreakos, Scott Benefield, Marsha Blaker, Thor Bueno, Gary Carlton, Silvia Causin-Nittolo, Sarah Chase, Scott Chaseling, John Christie, B. Jane Cowie, Brock Craig, Martha Croasdale, Patricia Culbert, Deborah Czeresko, Scott Darlington, Carol Davidson, Anthony Davlin, Lucinda Doran, Benjamin Edols, Roberta Eichenberg, Kathy Elliott, Kellmis José Fernandez, Scott Fitzel, John Fitzwilliam, Mitchell Gaudet, Ellen Grevey, Neil Harshfield, Amber Hauch, Kristen Hove, Frederick Kahl, Hitoshi Kakizaki, Gene Klingler, Max Kregar, Clay Logan, Patrick Martin, Xan Palay, Mark Parsons, Kimberly Petro, Kenny Pieper, Jenny Pohlman, Jocelyne Prince, Kait Rhoads, Renée Ridgway, Alison Ruzsa, Teresa Salvato, Alison Sheafor, Daisuke Shintani, Preston Singletary, Marianne Solberg, Robert Stern, Christian Stock, Boyd Sugiki, Peet Susaki, Pamina Traylor, Christopher Vespermann, Karen Willenbrink, Ishigaki Yukihide.

1995

Lysbeth Ackerman, Miho Aoki, Lea Bartneck, Theresa Batty, Clare Belfrage, Scott Benefield, Gretchen Bennett, Gary Bolt, Heidi Brant, Emma Camden, Alison Chism, Elin Christopherson, Trish Culbert, René Culler, Sandra DeClerck, Susan Edgerly, Benjamin Edols, Roberta Eichenberg, Patty Green, David Ture Gustafson, Kotaro Hamada, Amber Hauch, Robert Hickman, Robert Hodges, Jeff Holmwood, Peter Blackwood Houk, Peter Ivy, Doris Kappner, Ruth King, Tom Kreager, Ian Lewis, Simone Little, Josiah McElheny, Kurt McVay, Dimitri Michaelides, Jenny Pohlman, Janusz Pozniak, Bryan Rubino, Asa Sandlund, Peet Sasaki, Johnathon Schmuck, Alison Sheafor, Daisuke Shintani, Bjorn Stern, Robert Stern, Boyd Sugiki, Norwood Viviano, Patricia Weyer, Karen Willenbrink, Harumi Yukutake, Jeff Zimmerman.

Year-Round and Summer Staff
1974–1995

Staff listings for 1971–1973 are not included since little distinction was made between faculty, students, and staff until 1974. Year-round staff was first maintained in 1980–1981, and their names precede those of summer staff in the following list.

1974
Mimi Pierce is hired as director by Pilchuck's parent organization, the Pacific Northwest Arts Center, in December 1973.
Rob Adamson, Dale Chihuly, Norman Courtney, Fritz Dreisbach, Kate Elliott, Mimi Pierce, Marge Siegel.

1975
Rob Adamson, Dale Chihuly, Norman Courtney, Fritz Dreisbach, Kate Elliott, Mimi Pierce, Marge Siegel.

1976
Rob Adamson, Dale Chihuly, Norman Courtney, Fritz Dreisbach, Mimi Pierce.

1977
Thomas Bosworth is hired as director.
Rob Adamson, Libby Anderson, Thomas Bosworth, Dale Chihuly, Tuck Edelstein, Mark Graham, Richard Harned, Benjamin Moore, Mimi Pierce, Robin Stengel, Donna Tauscher, JoAnn Tonellato.

1978
Mark Anderson, Tom Batey, Sonja Blomdahl, Thomas Bosworth, Dale Chihuly, Phil Dahl, Patty Green, Betsy Haight, Celia Hemer, Benjamin Moore, William Morris, Colleen Price, Stan Price, John Reed, Richard Royal.

1979
Thomas Bosworth, Cathy Chase, Dale Chihuly, Betsy Haight, Joni Harmon, Richard Harned, Edward McIlvane, Benjamin Moore, William Morris, Stan Price, John Reed, Olwyn Rutter, David Schwarz, Carolyn Silk, Faith Swinburne, Roland Wolke.

1980
Alice Rooney is hired as director.
Robyn Archambault, Thomas Bosworth, Dorit Brand, Cathy Chase, Dale Chihuly, Corrie Haight, Todd Hall, Tony Jojola, Kelly McLain, Robbie Miller, Benjamin Moore, William Morris, Fred Munro, John Reed, Alice Rooney, Richard Royal, Olwyn Rutter, David Schwarz, Carolyn Silk.

1981
For the first time, staff is maintained year-round.
Dale Chihuly, Benjamin Moore, John Reed, Alice Rooney, Carolyn Silk. *Summer:* Dorit Brand, Cathy Chase, Mary Cozad, Joe Frangiosa, Pam Haight, Tony Jojola, Lee Koveleski, Walter Lieberman, Kelly McLain, Robbie Miller, William Morris, Fred Munro, Patricia Patenaude, Richard Royal, David Schwarz.

1982
Dorit Brand, Dale Chihuly, Benjamin Moore, John Reed, Alice Rooney, Susan Singleton. *Summer:* Cathy Chase, Sheryl Cotleur, Mary Cozad, Connie Dahl, Corrie Haight, Susan Jones, Lee Koveleski, Jenny Langston, Naomi McCormack, William Morris, Joel Muller, Patricia Patenaude, Gregg Powell, Richard Royal, Olwyn Rutter, Michael Scheiner, David Schwarz.

1983
Dorit Brand, Dale Chihuly, Benjamin Moore, John Reed, Alice Rooney, Susan Singleton. *Summer:* Jefferson Allen, Robert Carlson, Cathy Chase, Sheryl Cotleur, Mary Cozad, Tom Fenter, Michele Haviar, James Horton, Tracy Jacob, Kreg Kallenberger, Eunice Kauffman, Lee Koveleski, William Morris, Laureen O'Toole, Tina Riedel, Richard Royal, Mary Ann Schlosser, David Schwarz, Diane Shepardson.

1984
Nancy Barr, Penny Berk, Dale Chihuly, John Drury, Benjamin Moore, John Reed, Alice Rooney. *Summer:* Sheryl Cotleur, Mary Cozad, Bob Hodges, James Horton, Peter Hundreiser, Barbara Joffe, Susan Jones, Manette Jungels, Peggy Juvé, Joey Kirkpatrick, Flora Mace, Marina Marioni, Ben Marks, Rick McNett, Robbie Miller, William Morris, Jim Novak, Richard Royal, Iris Sandkuhler, David Schwarz, Rob Snyder, Pat Tyler, Martha Warsinske.

1985
Nancy Barr, Penny Berk, Dale Chihuly, Benjamin Moore, John Reed, Alice Rooney. *Summer:* Charles Bigger, Martin Blank, Sooze Bloom, Sheryl Cotleur, Mary Cozad, Pam Haight, Peter Hundrieser, Marina Marioni, Robbie Miller, William Morris, Nancy Pobanz, Richard Royal, David Schwarz, Meg Stuart-Magee, Dierk Van Keppel, Mark Weiner, Laura Wessel, Martha White, Leah Wingfield.

1986
Nancy Barr, Penny Berk, Dale Chihuly, Benjamin Moore, John Reed, Alice Rooney. *Summer:* Charles Bigger, Curtiss Brock, Marsha Conn, Sheryl Cotleur, Mary Cozad, Paul DeSomma, John Drury, Michael Dunn, Linda Fraser, Carl Frode, Pam Haight,

Lyle Hildahl, John Hylton, Tom Kreager, Dante Marioni, Robbie Miller, William Morris, Shari Moren, Chris Robertson, Richard Royal, David Schwarz, Meg Stewart-Magee, Harry Turner, Martha White, Leah Wingfield.

1987

Nancy Barr, Penny Berk, Dale Chihuly, Norman Courtney, Janice Dilworth, John Reed, Alice Rooney, Cheryl Smith. *Summer:* Geoff Beetem, Don Bellinger, Scott Benefield, Charles Bigger, Curtiss Brock, Esther Cohen, Jim Cook, Mary Cozad, Matthew Deschner, Paul DeSomma, Pam Haight, Carol Hall, Kim Holl, Peter Hundreiser, John Hylton, Michael Jaross, Tom Kreager, Robbie Miller, Leslie Moody, William Morris, Joseph Rossano, Richard Royal, Louis Scalfani, Meg Stewart-Magee, Cappy Thompson, Harry Turner, Karen Willenbrink.

1988

Dale Chihuly, Janice Dilworth, Richard Nisonger, John Reed, Alice Rooney, Cheryl Smith. *Summer:* Sarah Asmus, Sherry Boyd, Curtiss Brock, Cathy Chase, Esther Cohen, Jim Cook, Sheryl Cotleur, Norman Courtney, Mary Cozad, Dani Crinklaw, Joseph DeCamp, Paul DeSomma, John Drury, Roberta Eichenberg, Michael Gemberling, Laura Goldberg, Carol Hall, Peter Hundreiser, Sabrina Knowles, Tom Kreager, Walter Lieberman, Lori Lovering, Dante Marioni, William Morris, Juris Plesums, Joseph Rossano, Richard Royal, Bryan Rubino, Edward Schmid, Preston Singletary, Meg Stewart-Magee, Diane Testa, Cappy Thompson, Laura Wessel, Karen Willenbrink.

1989

Dale Chihuly, Janice Dilworth, Richard Nisonger, John Reed, Alice Rooney, Cheryl Smith. *Summer:* Sarah Asmus, Persis Bigger, Michael Bray, Curtiss Brock, Melissa Burkland, Cathy Chase, Lynn Combs, Mary Cozad, Dani Crinklaw, Joseph DeCamp, Paul DeSomma, John Drury, Roberta Eichenberg, Mitchell Gaudet, Laura Goldberg, Carol Hall, Amy Hamblin, Doug Hitch, Peter Hundreiser, Shannon Kirby, Joey Kirkpatrick, Sabrina Knowles, Vilija Kontrimas, Tom Kreager, Judith LaScola, John Leggot, Walter Lieberman, Dante Marioni, Tere Nisonger, Rachel Pitinga, Greg Powell, Richard Royal, Bryan Rubino, Teresa Salvato, Edward Schmid, Louis Scalfani, Preston Singletary, Ferdinand Thieriot, Cappy Thompson, Charles Vannata, Laura Wessel, Karen Willenbrink.

1990

John Anderson, Dorothy Bocian, Dale Chihuly, Kate Elliott, Sharon Meyer, William Morris, Richard Nisonger, Carrie Lee Pierson, John Reed, Alice Rooney, Cheryl Smith, Linda Wenham. *Summer:* Lysbeth Ackerman, Persis Bigger, Marc Boutté, Michael Bray, Cate Brigden, Connie Brochu, Curtiss Brock, Robin Brown, Melissa Burkland, Cathy Chase, Lynn Combs, Dani Cox, Joseph DeCamp, Paul DeSomma, Roberta Eichenberg, Frank Englesby, Mitchell Gaudet, Laura Goldberg, Carol Hall, Amy Hamblin, Doug Hitch, Sabrina Knowles, Joni Kost, Steve Kursh, David Levi,

Myrna Linden, Meredith MacLeod, Dante Marioni, Patrick Martin, Dimitri Michaelides, Robbie Miller, Kelsey Nicholson, Tere Nisonger, Jenny Pohlman, Greg Powell, Jill Reynolds, Karen Richardson, Bryan Rubino, Christopher Sandell, Preston Singletary, Viktoria Sepitova, Boyd Sugiki, Cappy Thompson, Randy Walker, Karen Willenbrink.

1991

Marjorie Levy is hired as director.
John Anderson, Dorothy Bocian, Kate Elliott, Marjorie Levy, Sharon Meyer, William Morris, Richard Nisonger, John Reed, Ginger Robinson, Linda Wenham. *Summer:* Lysbeth Ackerman, Scott Benefield, Martin Blank, Marc Boutté, Michael Bray, Cate Brigden, Connie Brochu, Curtiss Brock, Melissa Burkland, Elin Christopherson, Lynn Combs, Dani Cox, Randy Dalbey, Jill Davis, Greg Dietrich, Paul DeSomma, Kevin DuBois, Roberta Eichenberg, Tony Garcia, Ann Gardner, David Gignac, Heather Gray, Ritama Haaga, Amy Hamblin, Lemma Hatton, Sabrina Knowles, Joni Kost, Steve Kursh, Judith LaScola, David Levi, Meredith MacLeod, Patrick Martin, Josiah McElheny, Zesty Meyers, Dimitri Michaelides, Kelsey Nicholson, Tere Nisonger, Douglas Ohm, Jesse Overby, Noah Overby, Greg Powell, Jill Reynolds, Karin Richardson, Joseph Rossano, Christopher Sandell, Randy Walker, Mark Weiner, Karen Willenbrink.

1992

Dorothy Bocian, Marjorie Levy, Sharon Meyer, Richard Nisonger, John Reed, Ginger Robinson, Linda Wenham. *Summer:* Tina Betz, Martin Blank, Marc Boutté, Michael Bray, Cate Brigden, Curtiss Brock, R. John Buczek, Melissa Burkland, Cathy Chase, Alison Chism, Elin Christopherson, Lynn Combs, Randy Dalbey, Joseph DeCamp, Paul DeSomma, Greg Dietrich, Kevin DuBois, Roberta Eichenberg, Laura Freeman, Ann Gardner, Mitchell Gaudet, Laura Goodwin, Ritama Haaga, Bengt Hokanson, Sabrina Knowles, Joni Kost, Judith LaScola, David Levi, Josiah McElheny, Kelly McLain, Dante Marioni, Patrick Martin, Zesty Meyers, William Morris, Douglas Ohm, Jesse Overby, Noah Overby, Daylon Owen, Dennis Palin, Brian Pike, Jenny Pohlman, Jill Reynolds, Karin Richardson, Joseph Rossano, Marilyn Roy, Bryan Rubino, Christopher Sandell, Holle Simmons, Peggy Taylor, Veruska Vagen, Randy Walker, Nancy Weiss, Karen Willenbrink, Jeff Zimmerman.

1993

Dorothy Bocian, Michele Hasson, Marjorie Levy, Richard Nisonger, Pike Powers, John Reed, Ginger Robinson, Linda Wenham. *Summer:* Lea Bartneck, Kelly Beard, Patty Beard, Scott Benefield, Michael Bray, Kevin Brening, Cate Brigden, R. John Buczek, Alison Chism, Elin Christopherson, Lynn Combs, Randy Dalbey, Paul DeSomma, Todd DeVriese, Greg Dietrich, Kevin DuBois, Elena Enos, Mitchell Gaudet, Mark Gibeau, Patty Green, Ritama Haaga, Lemma Hatton, Denny Juge, Ruth King, Sabrina Knowles, Judith LaScola, Richard Lent, Clay Logan, Sharon Meyer, Zesty Meyers, John Miller, Steve Myers, Jesse Overby, Noah Overby, Daylon Owen, Ed Parker, Meg Pederson, Brian Pike, Kathryn Reeves, Jill Reynolds,

Joseph Rossano, Richard Royal, Bryan Rubino, Boyd Sugiki, Edward Schmid, Peggy Taylor, Veruska Vagen, Randy Walker, Nancy Weiss, Karen Willenbrink, Jeff Zimmerman.

1994
Dorothy Bocian, Jeff Crandall, Michele Hasson, Ann Jacobson, Marjorie Levy, Richard Nisonger, Pike Powers, John Reed. *Summer:* Jill Arnow, Scott Benefield, Gretchen Bennett, Michael Blackwell, Kevin Brenning, R. John Buczek, Albert Burkland, Karen Carston, Cathy Chase, Alison Chism, Elin Christopherson, Benjamin Coombs, Paul Cunningham, Randy Dalbey, Scott Darlington, Patricia Davidson, Paul DeSomma, Todd DeVriese, Greg Dietrich, Sam Drumgoole, Kevin DuBois, Elena Enos, Will Flanders, Mitchell Gaudet, Dina Gewing, Mark Gibeau, Julie Haack, Kotaro Hamada, Carl Hasse, Lemma Hatton, Mark Joy, William Kavesh, Sabrina Knowles, Karen LaMonte, Paul Larned, Clay Logan, Alison Marioni, Dante Marioni, Dimitri Michaelides, John Miller, Jim Mongrain, William Morris, Steve Myers, Douglas Ohm, Jesse Overby, Noah Overby, Bob Park, Mary Jane Parker, Meg Pederson, Jenny Pohlman, Janusz Pozniak, Michael Scheiner, Edward Schmid, David Svenson, Veruska Vagen, Frances Valesco, Randy Walker, Laura Wessel, Karen Willenbrink, Jeff Zimmerman, Mark Zirpel.

1995
Jeanne Brennan, Kelly Coller, Jeff Crandall, Michele Hasson, Ann Jacobson, Marjorie Levy, Don Nisonger, Richard Nisonger, Pike Powers, John Reed. *Summer:* Rik Allen, Randy Birch, Marsha Blaker-DeSomma, Marc Boutté, R. John Buczek, Suzanne Charbonnet, Cathy Chase, Jonathan Christie, Teresa Cole, Rachel Collier, Benjamin Coombs, Carmen Cortez, Dani Cox, Paul Cunningham, Karen Cutler, Deborah Czeresko, Scott Darlington, Patricia Davidson, Chase DeForest, Paul DeSomma, Todd DeVriese, Greg Dietrich, Sam Drumgoole, Kevin DuBois, Kathy Elliott, Elena Enos, Laura Freeman, Katcha Fritzsche, Mitchell Gaudet, Mark Gibeau, Ellen Grevey, Julie Haack, Ritama Haaga, Lemma Hatton, Heather Horton, John Hylton, Mark Joy, William Kavesh, Sabrina Knowles, Joni Kost, Karen LaMonte, Paul Larned, Dante Marioni, Mark McGee, John Miller, James Mongrain, William Morris, Douglas Ohm, Jesse Overby, Noah Overby, Meg Pederson, Brian Pike, Jill Reynolds, Kait Rhoads, Karen Richardson, Teresa Salvato, Edward Schmid, Linda Shiosaki, Pamina Traylor, Veruska Vagen, James Vella, Randy Walker, Laura Wessel, Mark Zirpel.

Selected Bibliography

Key sources consulted in the preparation of this book are listed below. Additional specific references are cited in the notes.

Books

Bannard, W. B., and Henry Geldzahler. *Chihuly: Form from Fire*. Daytona Beach: The Museum of Arts and Sciences in association with University of Washington Press, 1993.

Buechner, Thomas S., et al. *New Glass: A Worldwide Survey*. Corning, N.Y.: Corning Museum of Glass, 1979.

Chihuly, Dale, ed. *RISD Glass 1974*. Providence: Rhode Island School of Design, 1974.

Frantz, Susanne K. *Contemporary Glass: A World Survey from the Corning Museum of Glass*. New York: Harry N. Abrams, 1989.

————. *Sculptural Glass*. Tucson: Tucson Museum of Art, 1983.

Geldzahler, Henry, and Patterson Sims. *William Morris: Glass, Artifact and Art*. Seattle: University of Washington Press, 1989.

Glowen, Ron, and Dale Chihuly. *Venetians: Dale Chihuly*. Altadena, Calif.: Twin Palms Publishers, 1989.

Glowen, Ron, ed. *Italo Scanga*. Seattle: Portland Press, 1993.

Grover, Ray, and Lee Grover. *Contemporary Art Glass*. New York: Crown Publishers, 1975.

Herman, Lloyd E. *Clearly Art: Pilchuck's Glass Legacy*. Bellingham, Wash.: Whatcom Museum of History and Art, 1992.

Honey, W. B. *Glass*. London: Ministry of Education, 1946.

Kangas, Matthew. *Breaking Barriers: Recent American Craft*. New York: American Craft Museum, 1995.

Kardon, Janet, and Nancy Princethal. *Glass Installations*. New York: American Craft Museum, 1993.

Klein, Dan. *Glass: A Contemporary Art*. New York: Rizzoli, 1989.

Lindqvist, Gunnar. *Bertil Vallien*. Stockholm: Carlsson Bokförlag, 1990.

Miller, Bonnie J. *Out of the Fire: Contemporary Glass Artists and Their Work*. San Francisco: Chronicle Books, 1991.

Newman, Harold, ed. *An Illustrated Dictionary of Glass*. London: Thames and Hudson, 1977.

Norden, Linda. *Chihuly Glass*. Pawtuxet Cove, R.I.: n.p., 1982.

Polak, Ada. *Glass: Its Traditions and Its Makers*. New York: G. P. Putnam's Sons, 1975.

Ricke, Helmut. *Neues Glas in Europa/New Glass in Europe*. Düsseldorf: Verlanganstalt Handwerk, 1991.

Ruffner, Ginny, Ron Glowen, and Kim Levin. *Glass: Material in the Service of Meaning*. Tacoma: Tacoma Art Museum in association with University of Washington Press, 1992.

Sims, Patterson. *Dale Chihuly: Installations 1964–1992*. Seattle: Seattle Art Museum, 1992.

Smith, Paul J., and Edward Lucie-Smith. *American Craft Today: Poetry of the Physical*. New York: American Craft Museum, 1986.

Taragin, Davira, ed. *Contemporary Crafts and the Saxe Collection*. New York: Hudson Hills Press and the Toledo Museum of Art, 1993.

Trapp, Kenneth, and William Warmus. *Contemporary American and European Glass from the Saxe Collection*. Oakland, Calif.: The Oakland Museum, 1986.

Wittmann, Otto, et al. *Toledo Glass National III*. Toledo: Toledo Museum of Art, 1970.

————. *Toledo Glass National II*. Toledo: Toledo Museum of Art, 1968.

————. *Toledo Glass National I*. Toledo: Toledo Museum of Art, 1966.

Articles

Adams, Loch. "Blow Hards." *Seattle Weekly*, November 17, 1993, p. 95.

Ament, Deloris Tarzan. "A Glass Act." *Seattle Times*, June 15, 1989, p. E5.

———. "Bellevue's Pilchuck Show Offers Progress Report on Glass Art." *Seattle Times/Seattle Post-Intelligencer*, March 27, 1988, p. L4.

Anderson, Judith. "Pictures Drawn in Molten Glass." *San Francisco Chronicle*, January 30, 1981, p. 21.

Anderson, Nola. "Pilchuck Go." *Craft Australia*, Spring 1988, pp. 114–15.

Aronson, Chris. "Camp Pilchuck." *Studio*, January/February 1978, pp. 12–17.

Arteus, Margareta, and Bertil Vallien. "Kosta Boda: 'Glasugnarna vibrerar i natten!' The Pilchuck Experience: Bertil Vallien som glasprofessor i USA" (interview), *Glas och Porslin* 57, no. 6 (1987), pp. 16–18.

Baillargeon, Patricia. "Pilchuck Glass Center." *Pacific Search*, July/August 1976, p. 31.

Bak, Kristine. "Pilchuck, Glass and Architects." *The Quarterly (Journal of the College of Architecture and Urban Planning, University of Washington)*, Winter 1980, pp. 6–7.

Barcott, Bruce. "Chihuly: The Imperial Wizard of Glass." *Seattle Weekly*, November 14, 1990, pp. 38–45.

Berkman, Sue. "Material Value: Breaking into Glass." *Esquire* 103 (February 1985), pp. 13–14.

———. "Art Glass: Clearly Hot." *The Robb Report*, January 1985, pp. 44–55.

Berkson, Bill. "Report from Seattle." Parts 1 and 2. *Art in America* 74 (July 1986), pp. 68–82 ff; 74 (September 1986), pp. 29–45.

Biskeborn, Susan. "Pilchuck School and the 25-Year Old Art Glass Movement." *The Weekly*, July 15–21, 1987, pp. 33, 40.

Bosworth, Thomas L. "Cows in a Field." *Journal of Architecture and Building Science* (Tokyo), no. 6 (1984), pp. 46–52.

———. "The Pilchuck School: Office/Gallery." *Architecture and Urbanism*, June 1983, pp. 85–90.

———. "Hand-Built at Pilchuck." *Craft Horizons* 39, no. 2 (April 1979), pp. 36–38.

Breck, John. "Glass with Class: The World-Acclaimed Art of Dale Chihuly." *Stanwood/Camano News (Soundings)*, April 22, 1987, pp. 12–14.

Brewster, Todd, and Mitchell Funk. "Avant Glass: New Techniques Alter an Ancient Art." *Life Magazine*, February 1982, pp. 78–82.

Burley, George. "Unique Glass Center Grows on Hauberg Tree Farm." *Northwest Arts*, August 20, 1976, pp. 1, 4.

Campbell, R. M. "The Extraordinary Pilchuck Glass Center." *Seattle Post-Intelligencer*, October 9, 1977, p. G6.

———. "The Resurgence in Glass-Making." *Seattle Post-Intelligencer (What's Happening)*, August 20, 1976, p. 17.

Chambers, Karen S. "The Pilchuck Experience." *Craft International*, January/March 1985, p. 35.

———. "The Pilchuck Story." *New Work* (New York Experimental Glass Workshop), Winter/Spring 1984, pp. 33–36.

Chihuly, Dale. "Pilchuck '72." *Glass Art Magazine*, April 1973, pp. 43–47.

Danielson, Cliff. "In Victoria—Students Help Revive 'Dying' Art of Glass Blowing," *Stanwood (Wash.) News*, July 7, 1971, p. 8.

Danto, Arthur C. "Lamps and Vessels: Some Thoughts on the Critical Language in Glass." *American Ceramics* 11, no. 4 (1995), pp. 12–13.

———. "Fine Art and the Functional Object." *Glass Magazine*, Spring 1993, pp. 24–29.

Denne, Lorianne. "Art Glass: A Puget Sound Renaissance." *Puget Sound Business Journal*, February 24, 1986, pp. 1, 23.

Dissanayake, Ellen. "The Pleasure and Meaning of Making." *American Craft* 55 (April/May 1995), pp. 40–45.

Ehlers, Jake. "Living and Breathing Glass: Pilchuck Glass Center." *Madison Park News Magazine*, June 1981, pp. 3, 20.

Farr, Sheila. "Glass Art Now." *Seattle Weekly*, July 26, 1995, pp. 27–29.

Frantz, Susanne K. "This Is Not a Minor Art: Contemporary Glass and the Traditions of Art History." *Glass Art Society Journal*, 1985–1986, 1985, pp. 7–10.

"Glass as Art." *Sunset Magazine* 177 (October 1986), pp. 96–97, 99–100.

"Glass Blowing in Sylvan Setting." *Everett Herald (Puget Sound Panorama Weekend Magazine)*, October 2, 1971, p. 3.

Glowen, Ron. "Glass on the Cutting Edge." *Artweek* 21 (December 6, 1990), p. 25.

———. "Glass Art in Washington State: A Brief History." *Artist Trust*, March 1990, pp. 1, 12.

———. "Area's Strength Is Clear in Shows of Studio Glass." *Everett Herald (The Key)*, July 13, 1989, p. 6.

Glueck, Grace. "A Critical Response to 'Americans in Glass.'" *Glass Art Society Journal, 1985–1986*, 1985, pp. 24–26.

Godden, Jean. "Making a Pilgrimage to the Pilchuck Glass School." *Seattle Times/Seattle Post-Intelligencer*, May 17, 1992, pp. J1, J12.

Green, Ranny, and Roy Scully. "Pilchuck Center—Prestige School for Glassblowing." *Seattle Times (Sunday Pictorial)*, October 6, 1974, pp. 21–23.

Greenberg, Clement. "Glass as High Art." *Glass Art Society Journal*, 1984, pp. 14–15.

Gyure, Michelle. "Seattle: The Glass Hot Spot." *Glass Art Magazine*, September/October 1988, pp. 4–8.

Hackett, Regina. "Celebrating with Glass: New and Old Team Up at Museum." *Seattle Post-Intelligencer*, May 16, 1992, pp. C1–2.

———. "Surprising Diversity Makes Strong Pilchuck Glass Show." *Seattle Post-Intelligencer*, March 29, 1988, pp. C1, C3.

———. "Glass Gets Its Chance." *Seattle Post-Intelligencer*, April 3, 1981, p. D5.

Hallinan, Michael. "Seattle's Glass Menagerie." *Art News* 94 (May 1995), p. 104.

Hammel, Lisa. "The Highly Skilled Teamwork behind the Master Craftsman." *New York Times (Home Section)*, August 29, 1985, p. C1.

Haufschild, Lutz. "The Pilchuck Glass School—Teaching What Cannot Be Taught." *Stained Glass*, Spring 1983, pp. 35–39.

Hollister, Paul. "International Artists Exhibit Their Glass." *New York Times*, November 8, 1979, p. C3.

Houdé, François. "An Essay on Pilchuck Glass Center." *Craft News* (Toronto) 6, no. 4 (May 1981), pp. 1–2.

Hunter-Stiebel, Penelope. "Contemporary Art Glass: An Old Medium Gets a New Look." *Art News* 80 (Summer 1981), pp. 130–34.

Ives, Rich. "Where Fire Meets Water: A School for Glass Artists." *Art & Antiques*, April 1987, pp. 112–15.

Jacobs, Karrie, and Dick Busher. "Art Glass from the Pilchuck School." *Alaska Fest Magazine*, April 1981, pp. 24–30.

Jarosewitsch, Rena. "'The purpose of Art . . . ': The Johannes Schreiter Experience at Pilchuck Glass School." *New Zealand Crafts* 27 (Autumn 1989), pp. 23–27.

Jepson, Barbara. "Glorious Glass: Hot New Art Medium." *Town & Country*, January 1984, pp. 123–27.

Johns, Linda. "Pilchuck Artists Lend New Dimensions to Art of Glass." *Argus*, April 1, 1983, p. 9.

Kangas, Matthew. "Manhattan of Glass: Seattle's New Role in Craft." *Neues Glas*, January 1994, pp. 8–23.

———. "Tradition and New Vision in Glass." *Artweek* 12 (March 28, 1981), p. 4.

Kehlmann, Robert. "Coming Home: Glass Artists Take Stock at Kent State Gathering." *American Craft* 48 (August/September 1988), pp. 13 ff.

Kendall, Sue Ann. "Pilchuck School's Glass Artistry." *Seattle Times*, December 2, 1981, p. F8.

Klein, Dan. "Buying New Glass a Second Time Around." *The 1987 Journal: Glass Art Society*, 1987, pp. 33–37.

Koplos, Janet. "Criticism and Glass." *Glass Magazine*, Spring 1994, pp. 30–33.

———. "Art with Glass." *Horizon Magazine*, January/February 1985, pp. 9–16.

Lichtman, Linda. "Pilchuck: Two Views." *Glass Magazine*, January 1977, pp. 15–19.

Lindberg, Ted. "The Glass People." *Reflex* 9, no. 7 (August/September 1995), pp. 4–5.

Lösken, M. "From Hadamar to Pilchuck." *Neues Glas*, January/March 1988, p. 42.

Love, Nancy. "Seattle Is the Home of the Art-Glass Renaissance." *Art & Auction*, December 1985, pp. 42–47.

Lyke, M. L. "The Glass Edge." *Seattle Post-Intelligencer*, June 27, 1994, pp. C1, C4.

Manuel, Bruce. "The Glass Blower's Delicate, Demanding Art." *Christian Science Monitor*, June 28, 1989, pp. 10–11.

Mathieson, Karen. "Glass Magnets." *Seattle Times/Seattle Post-Intelligencer*, November 18, 1990, pp. L1–5.

Meltzer, Steve. "Seattle's Traveling Glassblowers." *Seattle Times (Sunday Pictorial)*, March 3, 1974, pp. 16–17.

Metzger, Jeanne H. "High-Class Glass among the Pilchuck Trees." *Everett Herald*, October 13, 1977, p. D6.

Miller, Stephanie. "Pilchuck Workshop: A Place—Perchance—To Treasure Hunt." *Seattle Post-Intelligencer (Book World)*, August 6, 1972, pp. 9, 23.

Milne, Victoria. "Conversation: Victoria Milne with Benjamin Moore." *Glass Magazine*, Summer 1994, pp. 12–15.

Monaghan, Peter. "A Striking Campus Attracts a Rare Assembly of Artists in Glass." *The Chronicle of Higher Education*, August 7, 1991, p. A3.

Moody, Fred, and Betty Udesen. "Glass: Northwest Artists Shatter the Plebian Image of This Booming Aesthetic Medium." *Seattle Times/Seattle Post-Intelligencer (Pacific Magazine)*, August 18, 1985, pp. 6–10, 14.

Murphy, Jim. "Timber and Glass." *Progressive Architecture*, June 1981, pp. 98–101.

Nokkentved, N. S., and Martin Waidelich. "Fire & Ice: Heat of Pilchuck's Kiln." *Bellingham Herald*, September 6, 1987, pp. C1, C3.

Pearson, Katherine. "Glass: A Major Museum Show." *Horizon Magazine*, May 1979, p. 62.

Perreault, John. "Transparency: Seeing Through Art Criticism." *Glass Art Society Journal*, 1984, pp. 19–20.

"The Pilchuck Experience." *International Sculpture*, September/October 1986, p. 41.

"Pilchuck: School of Glass Has Open House." *Skagit Valley Herald (Arts and Entertainment)*, July 24, 1986, p. 19.

Reif, Rita. "Glass on a Grand Scale." *New York Times*, October 23, 1994, sect. 2, p. 43.

Reyntiens, Patrick. "The Experience 1978: Pilchuck Revisited." *Glass Studio*, December 1978, pp. 8–14.

Robinson, John S. "A Glass Menagerie." *Pacific Northwest Magazine* 17, no. 10 (December 1983), pp. 28–33.

Rooney, Alice. "Two Decades of the Pilchuck Glass School." *Glass Art Society 1990 Journal*, 1990, pp. 85–87.

Rosenberg, Harold. "Art and Work." *Craft International*, Summer 1981, pp. 24–25.

Ruffner, Ginny. "Speaking of Glass." *American Craft* 48 (October/November 1988), pp. 32–35, 64.

Russell, Charles. "Heat's On at Bellevue Art Fair." *Seattle Post-Intelligencer*, July 28, 1968, p. 15.

Segaar, Jim. "Glass Art: Pilchuck School Is Haven for the Masters." *Skagit Valley Herald*, July 18, 1981, pp. 1–2.

Signor, Randy Michael. "Pilchuck Glass School Celebrates 20 Years." *Crafts Report*, January 1991, pp. 1, 28–30.

Slivka, Rose. "A Touch of Glass." *Quest/79* 3, no. 6 (September 1979), pp. 84–86.

Smallwood, Lyn. "Playing with Glass." *The Weekly*, August 15-21, 1984, pp. 43–44.

———. "House of Glass: Fame and Fortune in the Shadow of Mt. Pilchuck." *The Weekly*, August 17-23, 1983, pp. 43–45.

Tarzan, Deloris. "The Best in Glass Is On Display." *Seattle Times (Tempo)*, December 20, 1985, p. 10.

———. "Classy Creations Crafted in Glass." *Seattle Times*, August 18, 1982, p. C1.

———. "Through a Glass Brightly." *Seattle Times/Seattle Post-Intelligencer (Pacific Magazine)*, January 24, 1982, pp. 11–19.

———. "Glass Artists Don't Do Windows." *Seattle Times*, April 9, 1981, p. E1.

Tsutakawa, Mayumi. "Glassblowing Is Fragile Art." *Seattle Times*, September 10, 1978, p. M6.

Updike, Robin. "Pilchuck Puts Seattle on the Map: Capital of Glass." *Seattle Times*, August 27, 1995, pp. M1, M8.

"U.S. Workshop of the Year: Pilchuck Glass Center." *Craft Horizons*, April 1974, p. 41.

Waite, Steven K. "Welcome to Pilchuck." *Bellevue Journal-American*, August 20, 1976, p. 7.

Warmus, William. "Art Makes the Maker." *Craft International*, Summer 1981, p. 26.

Wellings, Marjorie. "Pilchuck Glass Having Reputation." *Davis Enterprise*, October 24, 1985, pp. 10–11.

Wilson, Kenneth M. "Third Annual National Glass Show." *Glass Art Magazine*, October 1975, pp. 56–59.

"Workshops: Pilchuck Summer Programs." *Professional Stained Glass*, April 1986, p. 36.

Wright, Diane. "Pilchuck Glass School Offering New Dimensions." *Everett Herald (The Key)*, February 7, 1992, p. 7.

Index

Italic type indicates an illustration; boldface type indicates an illustration of an artwork.

Photo Credits

Photographs not otherwise attributed are courtesy of Pilchuck Glass School. Photographs of artworks are courtesy of their owners, unless noted otherwise below.

Philip Amdahl: 219, 221
Harry Anderson: 99 (bottom), 100 (bottom), 112 (bottom), 114, 117 (bottom), 120 (top), 121, 122
Bruce Bartoo: 30–31, 82, 86, 87 (bottom), 89, 96, 104 (top), courtesy: 83, 85, 103, 105
John Benson: 85
Courtesy Dale Chihuly: 39, 42, 51, 62, 67, 70, 75, 87 (top), 95, 120 (bottom), 156, 158, 161, 162 (bottom), 170, 174, 189, 216, 222
Edward Claycomb: 51, 150, 176
Corning Museum of Glass: 34 (middle), 35, 36, 37, 46 (top), 136, 165 (top), 173, 192, 197, 237
Mary Cozad: 154 (top)
Rod Del Pozo: 93 (top), 138
Kate Elliott: 88, 92, 93 (bottom), 102, 240, courtesy: 97 (bottom)
William Eng: 46
Sue Everett: 67 (bottom right), 73
Courtesy The Everett Herald: 62 (bottom), 71
John Filo: 44
Nick Gunderson: 191, 215 (top), 236
Art Hupy: 57 (right), 63, 65, 70 (top), 75 (bottom), 77, 99, 101, 112 (top), 113, 115 (bottom), 130 (bottom), 131, 132, 137 (top), 152 (bottom), 153 (top), 154 (bottom)
Russell Johnson: 6, 8, 10, 13, 14, 18, 21, 143, 150–51, 185, 186, 201 (top), 202, 216 (bottom), 226, 231, 243, 244, 245, 247, 248, 249, 250, 251, 252, 254, 255, 256
Courtesy Joey Kirkpatrick and Flora Mace: 134 (bottom), 198
Courtesy Howard Kottler Testamentary Trust: 34 (bottom), 46 (bottom)
Courtesy John Landon: 194
Marjorie Levy: 2–3
Los Angeles County Museum of Art: 33, 41, 230
Courtesy Paul Marioni: 145
Ben Marra: 208, 220 (top), 224, 234
Courtesy Joseph McCarthy: 147
Benjamin P. Moore: 40, courtesy: 164
Michael Nourot: 58 (bottom), 68, 72, courtesy: 78–79
Oakland Museum of California: 34 (top)
Tina Oldknow: 134 (top), courtesy: 100 (top)
Courtesy Robert L. Pfannebecker: 47
Courtesy Pilchuck Tree Farm: 49
Jack Ramsdale: 47
John Reed: 242
Courtesy Ruth Reichl: 91
Peet Robison: 70 (bottom)
Morgan Rockhill: 75 (top)
Roger Schreiber: 64 (bottom), 153 (bottom), 157, 161 (bottom), 162, 172 (top), 174, 178, 182, 183, 188, 189 (top), 190, 193, 195, 196, 199 (top), 200, 204, 209, 210, 215 (bottom), 216 (top), 222, 228 (top), 229, 235
Buster Simpson: 90, 91, 97, 107, 110 (top) 117, 119, 124, courtesy: 99, 100, 110 (bottom), 112, 120 (top)
Hugh Stratford: 62 (bottom), 71
Mark Sullo: 168, 227 (bottom), 228 (bottom), 230
Toledo Museum of Art (Tim Thayer): 40, 172 (bottom), 175, 199
Courtesy Whatcom Museum of History and Art: 26, 28
Kim Zumwalt: 173 (top), 214